W9-CLG-472

VISIONS:

Contemporary Art in Canada

VISIONS
Contemporary Art in Canada

Essays by Alvin Balkind,
Gary Michael Dault, Terrence Heath,
John Bentley Mays, Diana Nemiroff
and Charlotte Townsend-Gault

Edited by Robert Bringhurst,
Geoffrey James, Russell Keziere
and Doris Shadbolt

Douglas & McIntyre · Vancouver / Toronto

DOUGLAS & MCINTYRE LTD.
1615 Venables Street
Vancouver, British Columbia V5L 2H1

Printed and bound in Canada

Canadian Cataloguing in Publication Data:

Main entry under title:

Visions

 Includes index.
 Bibliography: p.
 ISBN 0-88894-392-X

1. Art, Canadian – History – Addresses, essays,
lectures. 2. Art, Modern – 20th century – Canada –
Addresses, essays, lectures. I. Balkind, Alvin.
II. Bringhurst, Robert, 1946 –
N6545.V585 709'.71 C83-091224-X

Canadian Pacific,

in commemoration of its centennial,

provided funding for the creation of

both a television series and a book

about contemporary Canadian art.

Visions the television series

was produced by TVOntario.

This is *Visions* the book.

Acknowledgements

Books, no matter how private and sometimes selfish the labour of writing them, are always in the end collaborations. It was so in the days of vellum and papyrus, when they were written out by hand in winter daylight in the study of Cassiodorus; it was more so in the days of the wooden composing stick and the handpress; it is more so still in the days of the phototypesetting machine and the four-colour scanner. This book, however, has been a more thoroughgoing collaboration than most, and has been aided into being by artists, curators and photographers from Stuttgart to Victoria and from Paris to Saskatoon.

We were fortunate indeed – one could say blessed – to have as our photo researcher Dennis Taylor in Toronto, and as our logistical coordinator Margaret Reynolds in Vancouver. We were fortunate too to have the enduring good will and considerable patience of Rosina Daillie, Diana Orris and Linda Rainsberry at TVOntario, who were involved in the project from its earliest stages.

Tom Moore crisscrossed the country on our behalf shooting 8 × 10 transparencies. By far the largest share of the photographs in this book is his, and for the rest we have had the considerable benefit of his technical expertise in making the final selections. (Some of the works we have reproduced were, of course, transitory creations, and for them we have used such photographic records as we could find.)

Linda Gilbert also warped her life around the book for weeks, performing the text and its endless variations in silent concerts at sudden, improbable hours on Douglas & McIntyre's computer.

Through it all, we have had an extraordinary amount of good-natured help from the staff of the Art Gallery of Ontario, the National Gallery of Canada and the Vancouver Art Gallery, and from the librarians at the Vancouver Art Gallery and the University of British Columbia.

Even when the work proceeds from love, it still costs money, and the making of books has also, from the earliest days, required subventions. It was Canadian Pacific's generous financial support which allowed us to give this book, this idea – which many people have thought of and some people have dreamed of – physical form at last.

Since it has fallen to me to make these acknowledgements, I can record here also my private gratitude to the six writers whose book this is, for their shared intelligence, and to Doris Shadbolt, Geoffrey James and Russell Keziere for some of the finest – and incidentally some of the longest – conversations I have ever known.

ROBERT BRINGHURST

6

Contents

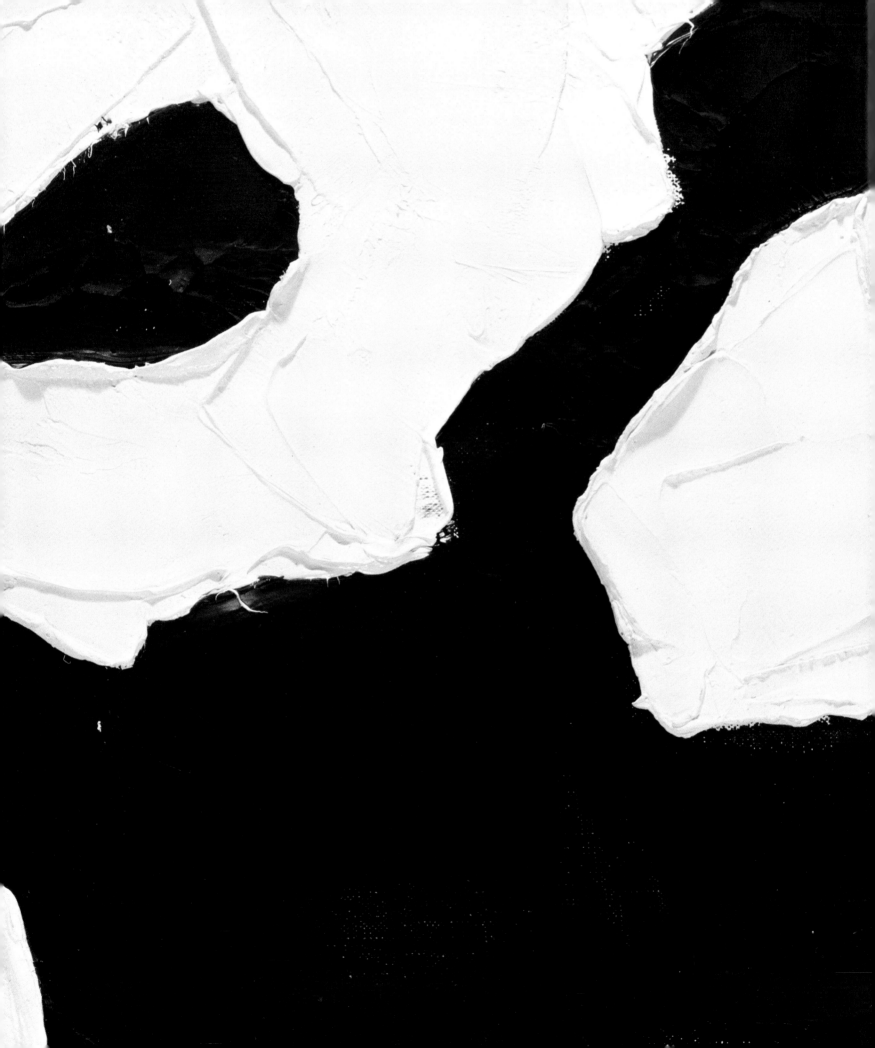

Editors' Foreword

This is a multiple cross-section, not a survey, not a history, of Canadian art since the Second World War. It was not our aim to produce a book based on the conventional classifications by region or medium. Nor did we wish to produce a chronological review of recent art in terms of the schools, groups and movements which have succeeded one another decade after decade. Handy though they are, such classifications and chronologies frequently serve to discourage dialogue and to obscure the complexity, liveliness and perseverence of ideas. We wanted, so to speak, to toss the art of four decades into the air and allow it to settle into fresh configurations, so that artists of different generations and regions, working in different media and on different approaches, could turn up in sometimes surprising and provocative juxtapositions.

We proposed, therefore, a book which, after an introductory survey, would investigate postwar art along five of the paths which recent artists have taken: art as response to place, art as art, art as social response, art as personal statement, art as idea. Many or most artists have more than one address in such an intertwining structure, for none is guided by a simple or single impulse. But this made the structure more instead of less useful, for its purpose was not to catalogue but to explore. We had in mind a book organic in structure, full of overlaps and intersections: a synoptic, pluralist view of the diversity and vigour of contemporary art in Canada. Another model that came frequently to mind was the jazz sextet. We proposed that certain themes and chords be shared, but that each writer should be able to blow his own horn by his own lights. Each of them has.

The result is a series of essays which it is not absolutely necessary to read in sequence, yet which has a prickly unity and order of a kind, and which adds up, we believe, to an enlightening and engaging, though certainly not exhaustive, exploration of the ideas and images in Canadian art of the last forty years.

Not every artist deserving of mention is here. Indeed, there are some major ones whose work is scarcely touched on. No artist's œuvre is analyzed; no one's full development is traced. The focus is on attitudes and meanings, on the issues which contemporary art in Canada addresses, not the careers which it has spawned.

Those who write about art, like those who make it, are naturally driven by multiple impulses and disinclined to fit into preconceived structures. No one among the editors agrees with every sentence in each of these essays, nor should they. There would be no art and no life of the mind at all – and of course no Canada as we know it – if such rigorous consensus were the rule.

ROBERT BRINGHURST, GEOFFREY JAMES, RUSSELL KEZIERE, DORIS SHADBOLT

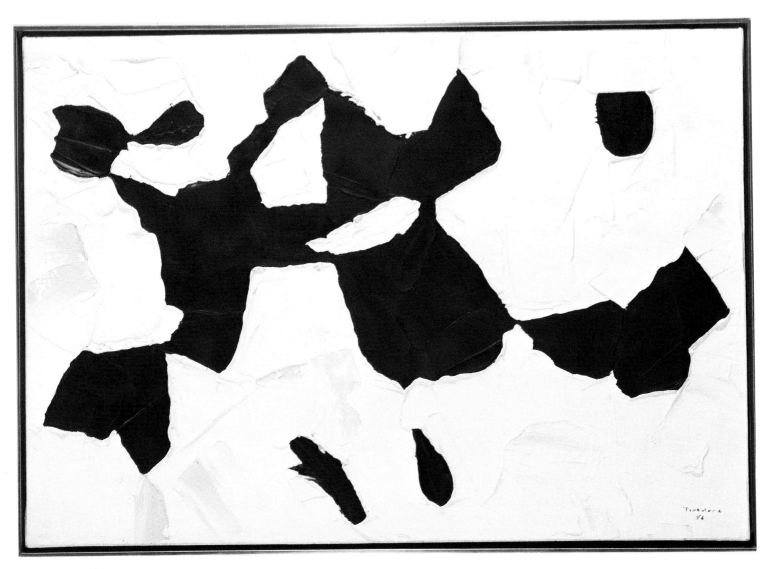

PAUL-ÉMILE BORDUAS
Sans titre (1956)
Oil on canvas, 80 × 115 cm
Toronto Dominion Bank collection, Toronto
On page 8 is a detail from the same painting shown actual size.

When the Second World War ended, in 1945, Canada, like Europe, was culturally debilitated – but unlike Europe, it was not economically and physically ruined. The social and political ferment of the 1930s, which had found some expression in the work of painters such as Miller Brittain, had been undercut by wartime patriotism and wartime prosperity. The Group of Seven had exhausted its purpose and had ceased to inspire younger artists who, in their turn, were casting about in an unrealized search for a source of invigoration. Art in Canada floated in a purgatory of gentility. The few figures of talent and individuality who are now recognized as having stood above the general run (David Milne, LeMoine FitzGerald, Emily Carr, for example) were mostly submerged in a clutter of paintings that Canadians contentedly and correctly categorized as florals, marines, traditional landscapes and academic portraiture.

Ann Davis has written that "the fundamental nature of a people asserts itself in sly and camouflaged ways." English-speaking Canada, its tone long set by "Scottish Common Sense philosophy … distinguished between the moral faculty and the intellectual one, but insisted that the latter be kept in check [so] that religious tenets remained uncorrupted by 'rationalism.' …The moral faculty, being inspired by God and thus … infallible, should always hold sway over the intellectual." This puritanical moralism, with its emphasis on hard work, frugality and an obsession with sin, at its best created a climate which fostered a defence of citizens against the state, and a concern for religious and mental liberty. Its outward expression was one of personal and public restraint, politeness, respect for privacy, an industriousness conjoined to a talent for making and saving money, and tolerance towards others. At its worst, it graded over into smugness, self-satisfaction, a conviction of superiority, a frozen assurance of rightness, a Pecksniffian hypocrisy,

intolerance, condescension, and an avoidance of anything that smacked of "vulgarity." Whatever the extremes may be, the particulars of the range belie the contention that there is no Canadian identity. For if we can agree that a culture is a culture by definition and that an inauthentic culture is a contradiction in terms, then we know one thing: those

The Triumph of the Egg
Alvin Balkind

Canadians who fret over the Canadian identity are not really concerned about the lack of it, but are dissatisfied with the one they have. It is the kind of dissatisfaction which may have led Wyndham Lewis, trapped in Toronto in 1943–45, to call the town a "sanctimonious icebox."

If Lewis had stayed on after the war, he could have seen the corps of burned-out artists teaching at the Ontario College of Art, producing just enough paintings per year to keep their jobs. He could have witnessed the army of academic sculptors doing war memorials, and observed at the Art Gallery of Toronto, consecrated to propriety and to an elitism based on social class, a parade of white-tie openings of exhibitions for the numerous art societies which were then the mark of the Torontonian as well as the Canadian art world. (And if Lewis had been less intemperate, he might have agreed with the economist Harold Innis, who said that the principal danger in being a social scientist in Canada was that one might die of laughter.)

French Canada was no better off. Perhaps in certain ways it was worse. Anglophone Canadians, guided by their puritanical notions of financial success, had moved into an essentially rural and tribal Québec and

established large and successful industries whose cushy jobs went to their colleagues, leaving the menial tasks to the francophones. Therewith came the Québecois' legacy of secondary citizenship in their own country, and a silent yet boiling acceptance of a marginal existence.

Like Newfoundland with its Irish heritage, French Québec had an abundant culture, nurtured in isolation for several centuries. It was a culture particularly rich in folklore expressed in song, dance, story and craft; it was located within the embrace of the Catholic Church and cultivated in an atmosphere of warm acceptance within the group, as well as cold suspicion of what lay outside it.

Locked in tradition, economic stagnation, conservative religion, and the authoritarian political control of Maurice Duplessis, and educated in church-run schools dedicated to maintaining the status quo, French Canadians in Québec were preserving their identity through a version of *Kinder, Kirche, Küche*. But there were stirrings, and one of the important stirrers was an artist, Paul-Émile Borduas, who in the early years of the war had absorbed the lessons of surrealism, and who preached those lessons in his turn at the École du meuble in Montreal. There in time a coterie formed around him which was to be highly influential.

Surrealism's artistic revolution reflected a social one. Its underlying tenets pressed its followers to beware of the rational, trust the irrational and, in making art, to be inspired by dreams and allow the functioning of the unconscious; not to fear sexuality; vigorously to oppose the compromises and hypocrisies on which settled society thrives. Freud was definitely living at that hour, long before his shrine was built among the hippies.

As a method of making art, surrealism incorporated the spontaneous search for an inner truth by allowing the association of inner thoughts, and sought to facilitate their free revelation by means of "automatic writing." It was a convulsive stance, filled with the fervour of revolt. In Québec, through Borduas and his fellow artists, it came to upset the rigid social balance of that province, and to bring personal grief and artistic renown to Borduas himself.

"Au diable le goupillon et la tuque." To hell with the aspergill (the holy water sprinkler) and the tuque (the woollen cap of the habitant). With these words, Borduas and the fifteen other signatories issued in 1948 the *Refus global*, one of the most remarkable documents in Canadian history. It challenged both church and state in Québec, demanding freedom from their control. It called for "passionate acts," "spontaneity," "magic, love and mysteries," and a "believable utopia." It was a statement sparked by rage, marked by courage, and built on a foundation of frustration and disgust. Its language was brilliant, abusive, poetic, and lit with love and compassion for the Québecois. Its impact, in time, was immeasurable, contributing to the alteration of the political complexion of Québec (and therefore of Canada), and giving rise to a new vitality in the community of young artists, setting off an explosive efflorescence of artistic consciousness which carried Québecois art into the world mainstream for decades afterward.

Life, like art, needs constant revitalization, and it was this which Borduas represented in the art of Québec. Similar, though less convulsive, movements also occurred in other parts of the country, notably Toronto and Vancouver. But before these can be dealt with, we must return to the postwar mood, and stop to look at New York.

The war had wiped out Europe's strength, its empires and – since power is a strong aphrodisiac – much of its sexiness. In contrast, both Canada and the United States, secure behind their Atlantic and Pacific moats, had emerged from the conflict with their real estate intact, and their economies nearly so. The U.S. in particular was especially strong, the focus of world attention, the paradigm for emerging democracies, and the picture of incorrigible

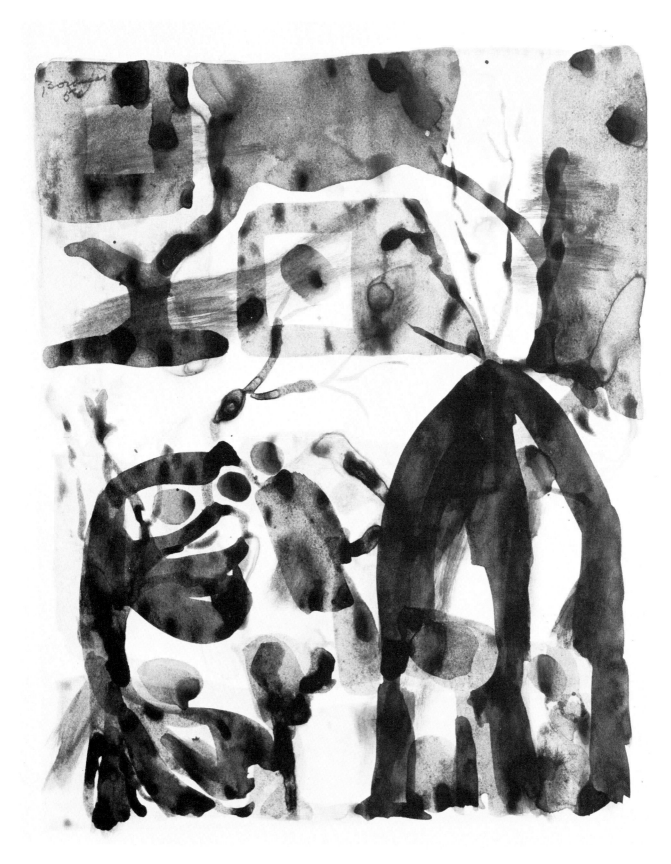

PAUL-ÉMILE BORDUAS, *Les Yeux de cerise d'une nuit d'hiver* (1950)
Ink on paper, 28 × 21 cm, Musée des beaux-arts de Montréal

nopole le règne de la mémoire exploiteuse, de la raison immobile, de l'intention néfaste.

Petit peuple qui malgré tout se multiplie dans la générosité de la chair sinon dans celle de l'esprit, au nord de l'immense Amérique au corps sémillant de la jeunesse au coeur d'or, mais à la morale simiesque, envoûtée par le prestige annihilant du souvenir des chefs-d'oeuvre d'Europe, dédaigneuse des authentiques créations de ses classes opprimées.

Notre destin sembla durement fixé.

Des révolutions, des guerres extérieures brisent cependant l'étanchéité du charme, l'efficacité du blocus spirituel.

Des perles incontrôlables suintent hors les murs.

Les luttes politiques deviennent âprement partisanes. Le clergé contre tout espoir commet des imprudences.

Des révoltes suivent, quelques exécutions capitales succèdent. Passionnément les premières ruptures s'opèrent entre le clergé et quelques fidèles.

Lentement la brèche s'élargit, se rétrécit, s'élargit encore.

Les voyages à l'étranger se multiplient. Paris exerce toute l'attraction. Trop étendu dans le temps et dans l'espace, trop mobile pour nos âmes timorées, il n'est souvent que l'occasion d'une vacance employée à parfaire une éducation sexuelle retardataire et à acquérir, du fait d'un séjour en France, l'autorité facile en vue de l'exploitation améliorée de la foule au retour. A bien peu d'exceptions près, nos médecins, par exemple, (qu'ils aient ou non voyagé)

?

PAUL-ÉMILE BORDUAS *et al,* excerpt from *Refus global* (1948)

14

adoptent une conduite scandaleuse (il-faut-bien-
n'est-ce-pas-payer ces-longues-années-d'études!).

Des oeuvres révolutionnaires, quand par hasard
elles tombent sous la main, paraissent les
fruits amers d'un groupe d'excentriques. L'ac-
tivité académique a un autre prestige à notre
manque de jugement.

Ces voyages sont aussi dans le nombre l'excep-
tionnelle occasion d'un réveil. L'inviable s'in-
filtre partout. Les lectures défendues se répan-
dent. Elles apportent un peu de baume et d'espoir.

Des consciences s'éclairent au contact vivifiant
des poètes maudits: ces hommes qui, sans être
des monstres, osent exprimer haut et net ce que
les plus malheureux d'entre nous étouffent tout
bas dans la honte de soi et la terreur d'être
engloutis vivants. Un peu de lumière se fait
à l'exemple de ces hommes qui acceptent les pre-
miers les inquiétudes présentes, si douloureuses,
si filles perdues. Les réponses qu'ils appor-
tent ont une autre valeur de trouble, de préci-
sion, de fraîcheur que les sempiternelles ren-
gaines proposées au pays du Québec et dans tous
les séminaires du globe.

Les frontières de nos rêves ne sont plus les mêmes.

Des vertiges nous prennent à la tombée des oripeaux
d'horizons naguère surchargés. La honte du servage
sans espoir fait place à la fierté d'une liberté
possible à conquérir de haute lutte.

Au diable le goupillon et la tuque! Mille fois
ils extorquèrent ce qu'ils donnèrent jadis.

Par delà le christianisme nous touchons la bru-
fraternité humaine dont il est devenu la porte
fermée.

3

optimism. It had been a Good War, with clear-cut and evil enemies who had been soundly thrashed. During the war and after, new hope for the world was growing – though with it was born, at Hiroshima and Nagasaki, the growing dread that an even greater disaster, an unthinkable disaster, had become inevitable and awaited us at any turn. The conviction was commonly held that momentous events demanded momentous changes, and that the status quo, with its built-in social inequities, would no longer be tolerated. It was not just mom's apple pie which had been fought for but also international cooperation, justice and a version of the Golden Rule. Declarations concerned with One World and Four Freedoms had been issued to capture and intensify the idealistic common mood; the United Nations was formed.

The war had displaced many Canadians and Americans from the country to the city. Ruralism ceased to be the force it had been for so long. Urbanism was more than a wave of the future; it had become the reality of the present. To this huge internal movement was added the massive immigration into Canada (and mostly to the cities) which, by 1978, had contributed two million people – twenty per cent of Canada's growth over the thirty postwar years.

As Canadians, contemplating the wreckage, turned away from their traditional European "parents," they began to find the United States attractive. In art, that meant New York. American artists, much like many Canadians in our day, had long sought to invent a national art. They wished to escape the regionalism and the half-digested Europeanism of the prewar years. Now the moment had arrived. But it was not to be – as some might have hoped – pure Americanism, undirtied by foreign ideologies; native soil and all that. It was, instead, a powerful intersection of primal American experience, energy, freshness, vigour and ambition, catalyzed by contact with those European artistic expatriates and refugees who settled largely in New York.

Among them were such giants as André Breton, Max Ernst, Piet Mondrian, Fernand Léger, Yves Tanguy, André Masson, Laszlo Moholy-Nagy, Walter Gropius, Marcel Breuer and Herbert Bayer. At the same time, the upheaval in Europe had sent over Albert Einstein, Thomas Mann, Vladimir Nabokov, Igor Stravinsky and a host of others of equal renown.

With the additional help of the Museum of Modern Art (founded in 1929) and the Museum of Non-Objective Painting (which opened in 1936 and later became the Guggenheim Museum), American artists were inspired to review the ferment of twentieth-century artistic ideas in an American context. To the European intellectual search for essences and elementals in abstraction, the Americans brought a physical, energetic response.

The result was what came to be called abstract expressionism, action painting, or gestural painting; and its first-rankers, referred to as the New York school, shook the world: Jackson Pollock, Hans Hofmann, Clyfford Still, David Smith, Franz Kline, Willem de Kooning, Mark Rothko, Barnett Newman, Adolph Gottlieb, Philip Guston, Arshile Gorky. Their paintings, usually large in scale, emphasized brushwork and texture on the surface (in other words, they were painterly) and employed what is called "all-over configuration"; that is to say, they avoided a hierarchy of forms on the canvas by giving, as it were, equal time to all parts of it. As a species of automatist (evolved form of surrealist), the abstract expressionist also welcomed the accidents which occur in the process of painting. But above all, abstract expressionism asserted that in North America too art was a dignified profession, sufficient unto itself. Its forms and philosophies at that particular moment in history appear to have summed up the spirit of the times, and made the world conscious of powerful notions about modern art as a worthy discipline and a heroic expression of the individual. It also placed American art in the vanguard of

world art for the first time, and it pinpointed New York as the new centre.

When we speak of the influences wrought by an art movement, we usually associate them with the aspects of form specific to that art. But there are nonspecific influences as well, and those which emanated from the American art of the 1940s and fifties, and worked on the psyche of America and of all countries with aspirations to participate in a modern world, should not be underestimated. Status quo now meant the evils, dangers and oppressions of the prewar world, and all were touched with an impatience to brush that world aside and embrace the optimistic, experimental, forward-looking world symbolized in the new art. Seen in its cloak of seriousness, dignity and authoritative acceptance, the work of these artists was greeted in the post-World War II period in North America with far more respect than was shown to the work of their predecessors exhibiting in New York in the pre-World War I year of 1913.

Moving gradually, with seriousness of purpose, significant matters were afoot in this country as well, linked to a growing awareness by government that laissez faire in the arts didn't work. After the Conference of Canadian Artists at Kingston, Ontario, in 1941, and the 1951 report of the federally appointed Massey Commission, the Canada Council was formed, and it set quickly about its task of establishing a civilized system of support for the arts, unlike anything then known in the United States. From the Council's foundation in 1957 until the opening ten years later of the Montreal Exposition, art in Canada saw a growth unprecedented in its history. For if the Council made possible an expansion of national purpose within the context of art, Expo was its sophisticated, buoyant, even triumphant confirmation. For the first time in this country, art had become big news, attractive to the media.

At the same time, the number of artists in Canada had so greatly increased, and their economic condition was still so wretched,

that some of them gathered into a kind of union. More was needed than mere dignity and self-respect. What was required was a lobby to demand a fee for artists participating in exhibitions, and to protect them against unfair use of their talents. Thus in 1968, Canadian Artists' Representation (CAR) was formed.

There followed a period of disagreement between CAR and the art galleries, which now and then reached a crescendo. The galleries had long proceeded on the pious assumption that they were doing the artists a favour. It wasn't comfortable for them to be reminded that, in fact, without artists they were dead. Now, however, CAR's system of fees is unquestioned, and in that respect Canada is ahead of much of the rest of the world.

Dealers sprang up everywhere, collectors grew bold, and the corporations, also swept away by the times, saw the public relations value of company collections and dipped into their coffers.

By the early 1980s the entire Canadian art world had been bumped so many notches that it would have astounded those who initiated the process, during the war years and in the first decade after. The civic art galleries in all three of Canada's major cities have undergone considerable expansion; new galleries have been built in cities like Winnipeg, Edmonton, London (Ontario) and Saskatoon, and available cash has enabled centres of all sizes to enrich their programs. Even the universities have established contemporary art galleries. Inspired by the Canada Council, and in response to a moral imperative floating in the air (thicker in some places than others), provincial and local governments have also established arts councils of their own. In Ottawa, the National Museums Corporation has also been established, whose purposes include aid to art galleries, enabling a wider circulation across the country of important exhibitions.

About the same time that the Borduas-inspired blast had incited an art world in

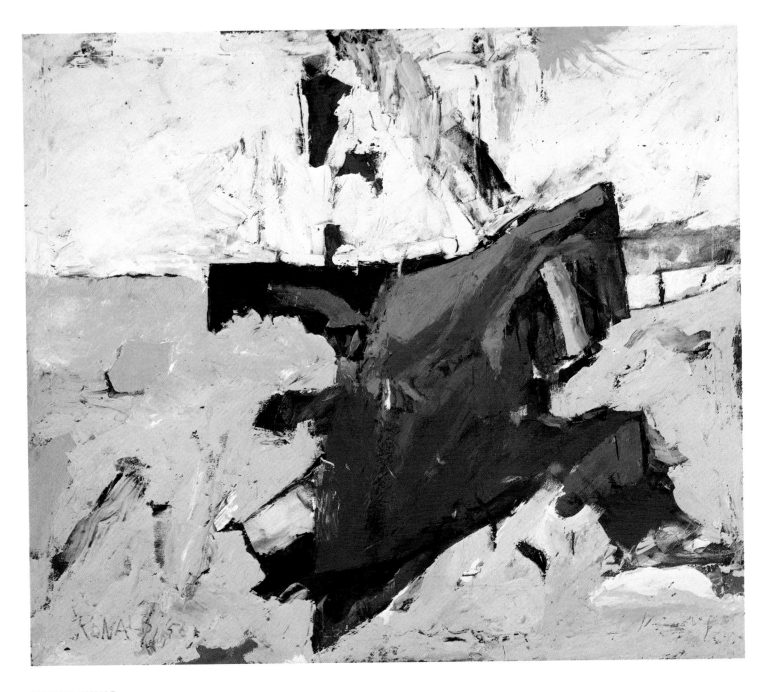

WILLIAM RONALD
J'Accuse (1956)
Oil on canvas, 152 × 176 cm
Robert McLaughlin Gallery, Oshawa, Ontario

Montreal, Toronto moved towards the same realization. In part, it was a reprise of the Europe-New York insemination, though here it was New York-English Canada, in which abstract expressionism was transmitted by the seed of William Ronald to the egg of Toronto. The result was the birth in 1954 of Painters Eleven. Although its artists were far too volatile to continue long as a group, some of them went on to achieve considerable renown. The champagne they poured into the cup of art in Toronto was the beginning of an artistic vitality which continues to flow today in far greater draughts, even if no longer of the same vintage. Their specific accomplishments in artistic terms are dealt with elsewhere in this volume, but not the least of these is a legacy of tough art, vanguardism and high spirits which have placed Toronto at the top of the Canadian heap, a place which until recently it shared only with Montreal.

The big bang which had its epicentre in postwar New York created a universe possessed of momentum, dynamism and aesthetic meanings which far transcended the city of their birth. Even those artists in Canada who worried about the importation of yet another foreign culture substituting for the European one could not avoid participating in this new, compelling galaxy. Sometimes they joined it by engaging it in argument; but it was this very act of contention that helped art to thrive and to prove its new vitality in places that had previously known little more than grey death where art was concerned. It also melded into a resurgence of the traditional Canadian anti-Americanism, set off by the war in Vietnam and a growing concern, which reached a climax in the 1970s, about being swamped by the American media.

In order to follow the course of development in Canada from the 1950s to the present, it will be easier to deal with as many events as possible in a hodgepodge of geography and style rather than strict chronology. Such a treatment is not only convenient but appropriate when we consider the distances between the few centres of art in Canada in the fifties, and the minimal contact they had with each other when Air Canada was still Trans-Canada Airlines, only beginning to shift from propellers to jet propulsion.

First, and briefly, Montreal.

In reaction to the paroxysmic art of Borduas and his Automatistes – in an abrupt pendulum swing, in fact, from romanticism to classicism – there arose a group called the Plasticiens, and with this movement came considerable cooling of the visual heat. To translate from the Plasticiens' manifesto of 1955 (anglophone artists in Canada tend not to write manifestoes), they sought to reveal "perfect forms in a perfect order," by being "totally indifferent…to any possible meanings in their paintings." The Plasticiens were soon eclipsed by two outstanding Montreal artists, Guido Molinari and Claude Tousignant, who pushed beyond the limited explorations of their predecessors to invent an art of extreme purity, subtlety and brilliance of colour-sense, all the while staying within the bounds of strict geometry. They were soon joined by Yves Gaucher, Jacques Hurtubise and Ulysse Comtois who, possessed of strong individual sensibilities, yet pursued similar paths, as did Charles Gagnon, who was, however, much more clearly allied to the New York school.

There then took place another convulsion in politics and art, sympathetic to the Chinese Cultural Revolution. It was summed up in an exhibition in Montreal, documented in the three-volume publication called *Québec Underground,* a massive production by Yves Robillard, Normand Thériault and a long list of others. This was followed in 1975 by the less overtly political exhibition called *Québec 75* at the Musée d'art contemporain in Montreal, which included works by both francophone and anglophone artists. The latter exhibition, together with a series of panel discussions and other manifestations, produced a dramatic confrontation between the dominant artists – largely in the person of

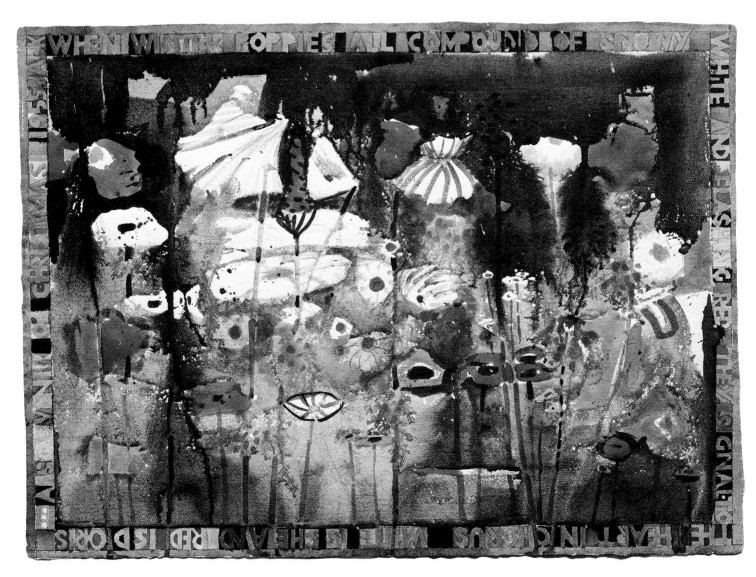

JACK SHADBOLT
Winter Poppies (1955)
Watercolour and ink on paper, 56 × 76 cm
Private collection

Molinari (a powerful man in public debate) – and the revolutionaries who were bent on legitimizing Québecois nationalism and withdrawing from Canada. These occurrences were part of the general turmoil out of which came the rise to power of the Parti Québecois.

The more naive among the politically radical artists in Québec then believed that the election of René Lévesque would lead to a subsidized paradise for advanced art. This was not to be, of course, for no political party which aims to stay in power can stray far from the accepted myths of the electorate. Accordingly, the Parti Québecois hewed close to the line of babies, church and kitchen, not to mention handicraft and maple syrup. Nor would Lévesque swerve from his declared goal of separation from Canada merely to embrace the universal brotherhood of high art.

After a lively period during which Véhicule, an artist-run gallery founded in Montreal in 1972, set the pace for other cooperatives, and after the birth of the magazine *Parachute,* there began a gradual attrition of mood in Montreal art, consistent with the growing political cynicism. There is still much activity to be found there, in the three major small galleries (Yajima, France Morin and Gilles Gheerbrant), in video and performance art, in the arcane investigations of artists such as Rober Racine, and in the evidence of a strong return to painting. Yet it seems at the moment that practically everyone is waiting for Godot.

As we move far west to Vancouver, stepping gingerly to avoid tripping over Winnipeg, we survey a long and vibratory sequence of postwar occurrences. At first drenched in nature, as were artists in Washington and Oregon, and feeling a sympathetic relationship with the entire West Coast of the United States, Vancouver artists like Jack Shadbolt, Gordon Smith, Don Jarvis, and later Toni Onley, among others, expounded the lush plant life, the dark mountain chains and grey ocean and clouds of the region. Although this art may have taken its cue

from Graham Sutherland and the tradition of English landscape, it was shunted through modern sensibilities. (Jack Shadbolt had spent a year in New York in 1948–49, during the earliest beginnings of the New York school, and Jarvis had studied under Hans Hofmann.) B.C. Binning, on the other hand, had combined the abstractions of such European geometricians as Mondrian and the constructivists with a more flowing and playful art reminiscent of Paul Klee.

In 1961, an artist named Roy Kiyooka began teaching at the Vancouver School of Art, stepping into the sensuous world fresh from the inspirations of New York artist Barnett Newman. At the Emma Lake Workshop in Saskatchewan, Kiyooka had imbibed Newman's belief in the supremacy and transcendent mysticism of art as expressed – and expressible – in a solid background of colour intersected by one or several simple, hard-edged lines, painted cleanly with the aid of masking tape in the mode of "colour-field" painting. Certain of Kiyooka's colleagues in Vancouver saw him as the Horned Devil, spouting alien notions. He stayed, however, long enough to charge up a fresh group of painters like Brian Fisher, Gary Lee-Nova, Michael Morris and Claude Breeze, artists radically different from those who incarnated the nature school. Several of these artists (Lee-Nova, Morris and Breeze) gave evidence of being what have been called "tangential pop artists," the only kind that ever really took in Canada, with the possible and offbeat exception of Iain Baxter. Pop art in its purest form was clearly American, and never travelled well north of the border.

At this point, a grand adventure was about to begin. It was made up of disparate bedfellows. Some of these were: a generous dose of Marshall McLuhanism, with its studies of cultural shifts inspired by the impact of the media and technology on the general population and on artists; the revolt of minorities set off by the freedom marches in the Southern States; the assault on puritanism and anti-sexuality begun by the

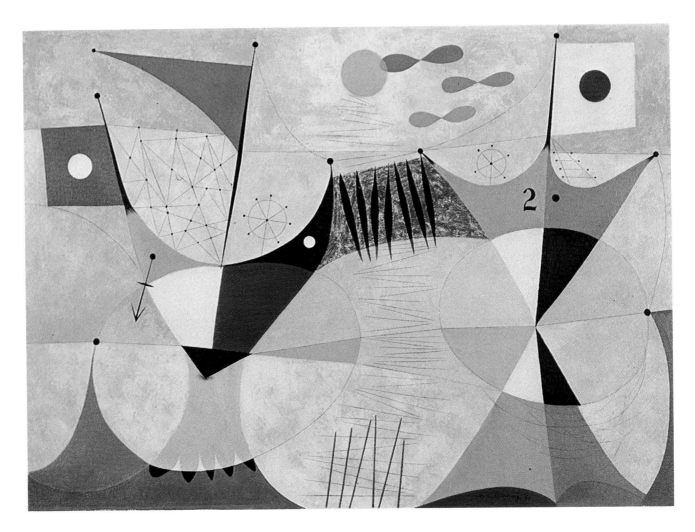

BERTRAM CHARLES BINNING
Fanciful Seascape in Primary Colours (1949)
Oil on canvas, 80 × 111 cm
Sarnia Public Library and Art Gallery, Ontario

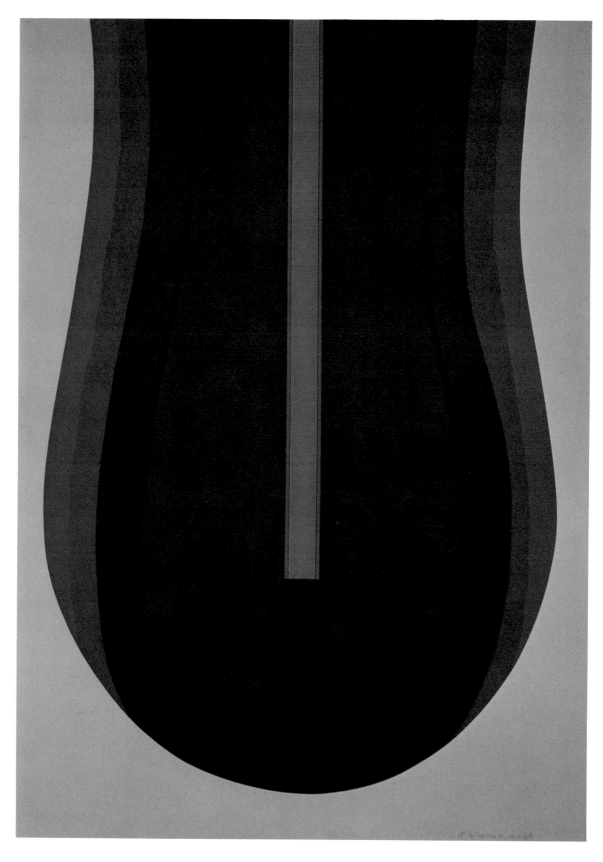

ROY KIYOOKA, *Barometer #2* (1964), polymer on canvas, 247 × 175 cm, Art Gallery of Ontario, Toronto

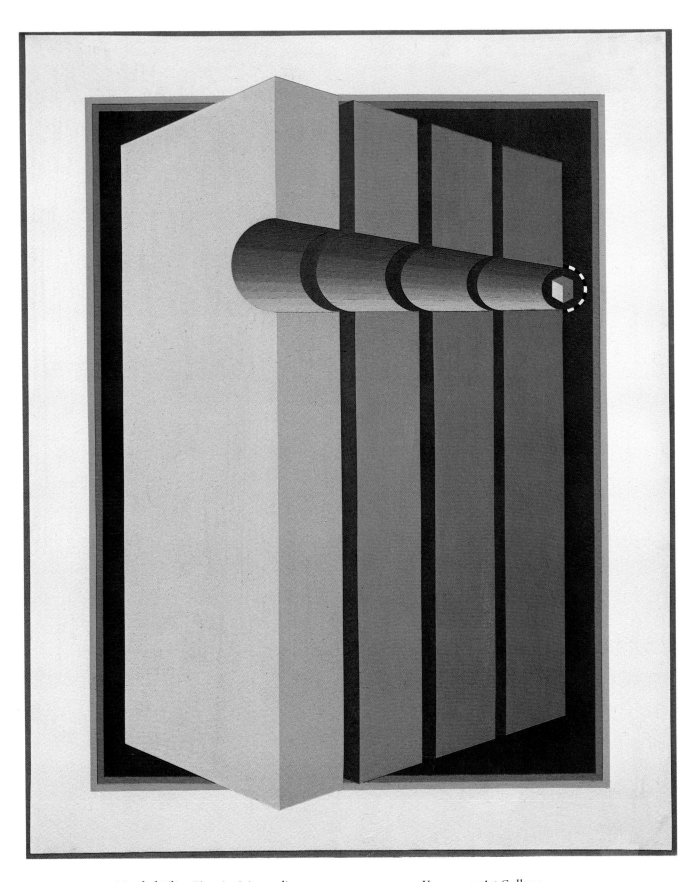

GARY LEE-NOVA, *Menthol Filter Kings* (1967), acrylic on canvas, 153 × 123 cm, Vancouver Art Gallery

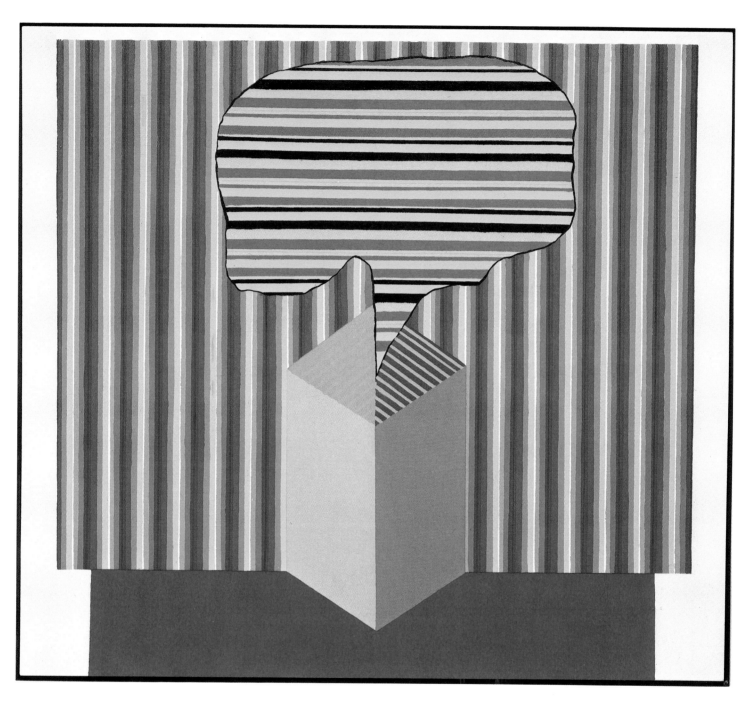

MICHAEL MORRIS
The Problem of Nothing (1966)
Acrylic on canvas, 137 × 152 cm
Vancouver Art Gallery

free-speech movement at Berkeley, California; the increasing interest in consciousness-altering drugs like LSD, which were the object of controlled experiments at the University of Saskatchewan even in the early 1950s (in fact, it was there and then that the word "psychedelic" was coined) and the increasing use of marijuana and hashish by artists and nonartists alike; the social force represented by Elvis Presley, the Beatles and rock music; a popular turn to Zen Buddhism and the meditation mystique of Indian religions; the rise of hippies, flower power, the Love ethic, jeans, headbands and gypsy wanderings; and the intensifying concern about American involvement in Vietnam, with mass, sometimes violent, public demonstrations.

These were accompanied by a preoccupation in art with mandalas, with curvilinear prints reminiscent of art nouveau, and with the slide and light shows associated with rock and mind-bending drugs. Acid rock, acid art. All of this spread quickly throughout North America and to the rest of the world with the help of McLuhan's media.

Vancouver was a natural target to receive this fresh upsurge, permeated with social revolution, not only because it was in a direct line northward from San Francisco but also because it was at the end of the road coming from eastern Canada. Just as the earliest shock waves began to reach Vancouver, in 1967, a short-lived collaboration called Intermedia was born, midwived by a handful of thinkers and doers on the Coast and a generous grant from the Canada Council. It was a group of visual artists, poets, filmmakers, hangers-on and others who set out cooperatively to explore the new technologies and their relevance to art. This they did, and with an artistic force previously unknown among the white communities of that gentled coast. The rare confluence of a sympathetic, supportive public art gallery and several enthusiastic newspaper critics abetted Intermedia from its first steps to its last.

From this period has come much that is taken for granted today: experimental film, video, performance art, the cross-fertilization of poets, musicians and visual artists, correspondence art; photodocumentation as an art form, and the first beginnings of the alternative or artist-run gallery – a phenomenon which has since grown to impressive proportions across the entire country.

Toronto, true to its feisty self, took no back seat in all this action. It, too, had a large hippy population, located in Yorkville (an area now gentrified beyond recognition), and by the time the flower people had discovered political activism, an exotic and raucous population had assembled in the residence (barrack?) at Rochdale, near the heart of the University of Toronto. Whatever else can be said about Rochdale (and everything was, including the misspelling of its first syllable as Roach), in its stew there rose to the surface several artists who are now making important contributions to the arts in Canada.

Well before these events, the nucleus of people who would become the major figures on the Toronto art scene had coalesced at the Isaacs Gallery. By 1962, Avrom Isaacs had drawn to his stable Graham Coughtry, Gordon Rayner, Dennis Burton, Joyce Wieland, Michael Snow, Robert Hedrick, Robert Markle and Nobuo Kubota, some of whom, together with Harold Town, had cut their artistic teeth in Dorothy Cameron's Here and Now Gallery. It was a time of great excitement in art, with its leading figures meeting at Toronto's version of the Café des Deux Magots, the Pilot – as the earlier Painters Eleven had at the Brunswick Tavern – to discuss, with heat and light, the burning aesthetic questions of the day.

A few years later, the dealer Carmen Lamanna appeared on the stage, where he cut a significant and sometimes controversial figure with his artists, among whom were the very best this country has had to offer: Paterson Ewen, Ron Martin, General Idea, David and Royden Rabinowitch.

PATERSON EWEN
Moon over Tobermory (1981)
Acrylic and metal on gouged plywood, 244 × 335 cm
National Gallery of Canada, Ottawa

ROYDEN RABINOWITCH
Seven Left Limits Added to a Piecewise Linear Developed Four Manifold (1976)
Mild steel sandblasted and oiled, 4 × 189 × 88 cm
Art Gallery of Ontario, Toronto

Keeping pace with the commercial galleries (of which there are now dozens), and indicative of a dissatisfaction with conventional exhibition space and its bureaucracies, there arose a number of cooperative galleries. The first of these in Toronto was A Space, committed to the urgent and emergent in art. It was the forerunner, in that city, of a movement which has expanded unimaginably, adding diversity and richness to an already dense art system.

In Toronto, Vancouver and Montreal, there are artist-run galleries in sufficient numbers to permit specialization among them. Some apply themselves particularly to video, for example, or to performance, to film or to art committed to feminism, to a particular political stance or a particular area of sexuality. As the cities diminish in size, the degree of specialization decreases, with one gallery or two serving all functions at once where these are called for, or functioning as cooperative space in ways particular to the community in which it has grown. At the same time, supported by Canada Council grants, vanguard artists travel the circuit of artist-run spaces, alleviating some of the isolation which has so long been an aspect of life for both artist and audience in this country.

If the rest of Canada has seemed to lag behind Montreal, Toronto and Vancouver, it is because art in the modern era became so urban as to preclude much else. It has been next to impossible for the solitary, serious talent to emerge full-blown away from the influence of the larger cities. For the big city continues, as it has in all of history, to provide the information, stimulation and competition which foster the most intense response to the arts. Yet there are in Canada variations on this rule, rooted in the crucial, time-hallowed role of the artist as cultural traveller, who brings advanced thought and a transforming vision to remote and relatively undeveloped places. (Albrecht Dürer, in the early sixteenth century, was a prototypical example: an artist who, like a bee, transferred to northern Europe the pollen of the Italian Renaissance.)

One such cultural traveller, the Toronto performance artist Judith Doyle, said about moving on the parallel gallery circuit across Canada: "Canada gets richer and warmer and more visual as you go toward the West. Toward the East, it becomes more spare, more articulate, more lucid. If you go as far as Halifax, it becomes so lucid it is invisible."

The Nova Scotia College of Art and Design in Halifax, in its brilliant incarnation under Garry Kennedy and Gerald Ferguson, is, of course, far from invisible, having had a considerable reputation internationally as well as in Canada. Although it makes an effort to teach the more conventional artistic disciplines (painting, drawing, sculpture, graphic arts), it has clearly stood for and emphasized an art whose stance is conceptual and critical. This approach to art followed upon the Apollonian stripping-down of painting and sculpture in the latter 1960s, a reduction aimed at discovering the most minimal condition able to bear the load of meaning, and at the elimination from artworks of any reference to matter outside of themselves alone. By logical progression, it became clear to some artists that idea underlies all art, and they chose therefore to bypass all the rest of art to get at the idea in its most naked (though also most abstruse) condition.

Such a radical art being practised in their midst might have puzzled many Haligonians; but in fact, it shares much in the way of the hard scrabble of Nova Scotia itself, with its spare, rocky, North Atlantic harshness. It is to the credit of the school that it resisted the early criticism aimed at its head – one which so brazenly looked to New York and other centres for inspiration. Its success may have been due to the very arrogance of its conviction and to its unashamed sucking at the New York teat. But the college's survival as a force was purchased at a price. In Halifax, to sustain such abbreviated and thin-lipped art called for a cold rigour and ornery fanaticism

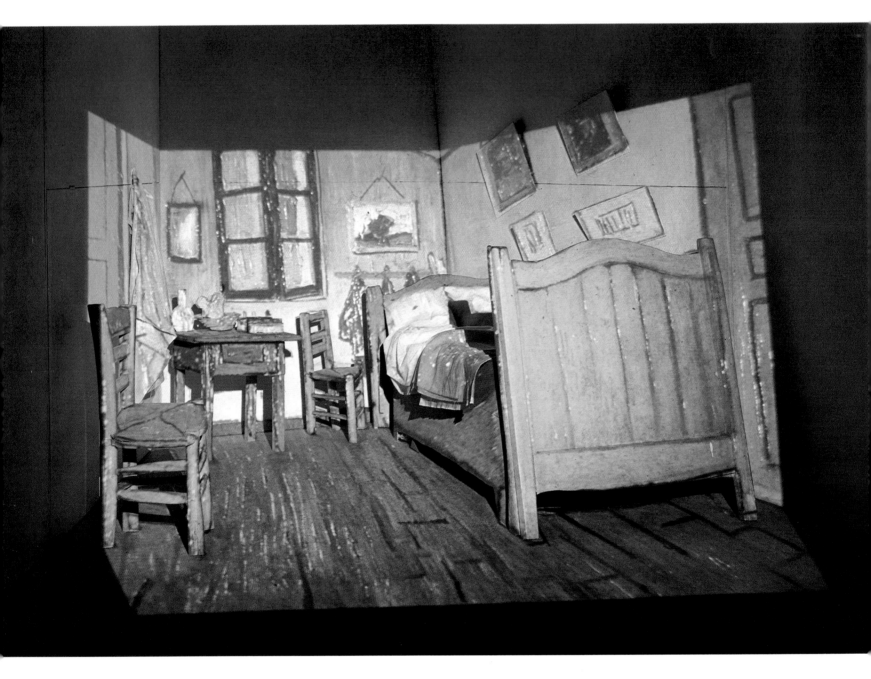

MURRAY FAVRO
Van Gogh's Room (1973–74)
Multimedia construction with photographic projection, 259 × 366 × 366 cm
Art Gallery of Ontario, Toronto

which an outsider might interpret as hostility to everything else.

Although conceptual art as such has lost some of its glamour, its fertility lasted long enough to yield progeny, and it survives therefore in the history of our artistic evolution. It has contributed, for instance, to the rigour and intellectualism of the political, largely Marxist art to be found in some quarters of every Canadian city today. Neither concept art nor its various offspring are "classical" in any classic sense, nor have they anything to do with balance or purity of form, yet this is art which does have its share of restraint and academic emphasis on canons. In that sense it is classical, and in that sense perhaps a little chilling. (Was it Herbert Read who wrote, "Wherever a Doric column rises, the earth is soaked with blood"?)

The surprise of the Haligonians must have been as nothing to that of a quarter million Londoners deep in the conservative farm belt of southwestern Ontario, who have also suffered a flowering of high art in their unlikely city. But where art in London, Ontario, like art in Halifax, tends to be clannish and smug, the London smugness is related to a desire to be provincially London in a cosmopolitan world, while Halifax smugness comes from wanting to be international in a provincial Halifax. Nonetheless, as observers of the Canadian art world are often surprised to discover, London, Ontario, is or has been the home of such formidable artists as Murray Favro, Ron Martin, Royden and David Rabinowitch (turncoats who now live in New York), Paterson Ewen, the late Jack Chambers, and Greg Curnoe. Nor should it be surprising that London, Ontario, was the birthplace of Canadian Artists' Representation, which has from the outset adopted a strongly nationalistic position.

In some other parts of Canada, foreign influences have been more warmly received. New York abstract expressionist painter Barnett Newman, for example, whom I have already mentioned, was invited to conduct a workshop for professional artists at Emma Lake, Saskatchewan, in 1959. More significant even than the colour-field content and philosophical nature of Newman's work, was his forthright transmission to the participants in that workshop that he, Newman, took himself seriously as an artist, that there was a quality and relentlessness to his commitment, and that he possessed as well a true intellectual fervour.

From this intersection of minds stemmed an exhibition at the National Gallery called *Five Painters from Regina,* a title given it by Richard Simmins, former Director of the Norman Mackenzie Art Gallery at the University of Saskatchewan. Its artists (Ronald Bloore, Ted Godwin, Kenneth Lochhead, Arthur McKay and Douglas Morton) like those of Painters Eleven, the Automatistes and the Plasticiens, or any group burdened with a sobriquet, were by no means of a kind. They did, however, share enough similarities in intention to allow cohabitation, at least for a while, as a recognizable community which elicited notice across the country.

Saskatchewan also miraculously conceived a small school of figurative ceramic sculptors who worked in colours and forms ranging from semirealistic to wild. The inspiration which sent them over the top came from a long visit among them of that funkily bewitched Californian, David Gilhooly, who brought to bear whatever influence he could muster upon what was already a "native" movement. These artists (among them Victor Cicansky, Joe Fafard, Russell Yuristy, and Marilyn Levine – the last now living in the U.S.A.) soon achieved and have since retained national status.

Going back for a moment to other parts of the country, and to the 1960s, installation art began to make frequent appearances in art galleries. It was sired by the neo-dada happenings of Allan Kaprow in the United States in the late fifties, which were a choreography of theatre, game and art, with the complicity of such pop artists as Claes

Oldenburg. Installations (for a while also called "environments") often had much the same character, though they were static, in that they occupied, and remained in, a given space in which were juxtaposed objects, frequently bizarre in nature, capable of giving off supercharged, haunting and sometimes humorous reverberations. Among those which caused a stir in Vancouver were two presented at the Fine Arts Gallery of the University of British Columbia: Iain Baxter's *Bagged Place* (1966), and Gary Lee-Nova and Robert Arnold's *Chainy* (1970). Canadian artists are still making installations, though what these works express has on the whole changed. A number of artists use the medium to extraordinary effect, producing work that is fundamentally conceptual in nature and embraces a variety of means, effects and technical devices.

As the sixties dwindled away, a number of new and hybrid genres arose – process art, earth art, video and performance. Process art concerns itself with something in between the generation of an idea and its end result, with the stress on how it got that way. Earth art or land art, on the other hand, is a means of moving out into nature and away from galleries, thus allowing for limitless expansion, an acceptance of the inevitability of destruction (which might be recorded as "process"), and a documentation of the whole by film, videotape, drawings, or photography. Reinhard Reitzenstein's *Quartz Dig* (1975), for example, documents the temporary excavation of three quartz rocks, which were afterward safely returned to their burrows.

Performance as art rose to prominence during the mid-1970s. Like video, and like other approaches to art today, performance has been able to sponge up issues which have long been part of twentieth-century art, and express them in a new guise. Better in this case to say newish guise, for futurism and dada had already invented performance in the early years of this century. Some of its latter-day proponents have lately turned to

other media, but it remains a lively art, the object of festivals and special cabarets, and certainly performance works still appear on the lists of circuit art which travel the cooperative galleries.

Among these success stories, one came so quickly as to surprise many of us, though it shouldn't have, for the medium has been around for 150 years. It is photography. These days everybody has a camera, just as cultivated ladies in the nineteenth century were expected to have paper and watercolour sets. As in other media, relatively few photographers have possessed enough talent to be known as artists, but in this case even relatively few means comparatively many, and there is such a production of them in art schools today that it is clear photography has tapped some deep human need in the past decade. It is as though a great-great-grandfather had suddenly appeared with all the vigour of youth. There is simply no end to the ways in which photography is being applied in art now, from the straight job of recording with sensitivity, to its adoption as a political, social and conceptual tool.

Sculpture in Canada was hardly worth a mention before the war. Not so today, though little attention was paid to it until Dorothy Cameron mounted an outdoor exhibition of sculpture at the Toronto City Hall Plaza in 1967. Since that time, sculpture has come into its own in art galleries, public spaces, and special parks set aside for it. Its practitioners include, or have included, among many others, Ulysse Comtois, John Massey, Al McWilliams, Geoffrey Smedley and George Trakas.

Abstract, or modernist, painting, often mentioned in the same breath with the name of the critic Clement Greenberg, cannot yet be counted out, though there are those who would like to do so. It lives and is particularly well at the Edmonton Art Gallery; and its proponents everywhere, though embattled, hold on to the dream.

Certain more recent developments in Canadian art have already been pinned to

IAIN BAXTER
Bagged Place (1966)
Installation at the Fine Arts Gallery, University of British Columbia, Vancouver

JOE FAFARD, *Don* (1982), ceramic, 53 × 41 × 11 cm, Melnychenko Gallery, Winnipeg

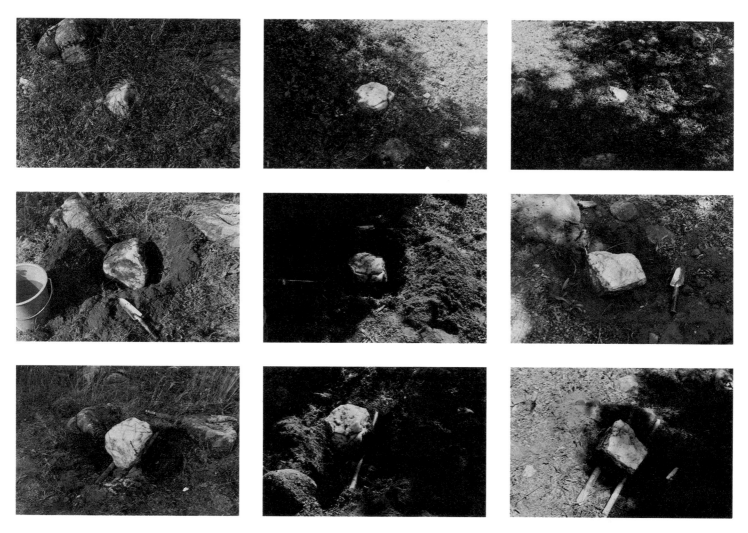

REINHARD REITZENSTEIN
Quartz Dig (1975)
9 colour photographs, each 51 × 76 cm
Carmen Lamanna Gallery, Toronto

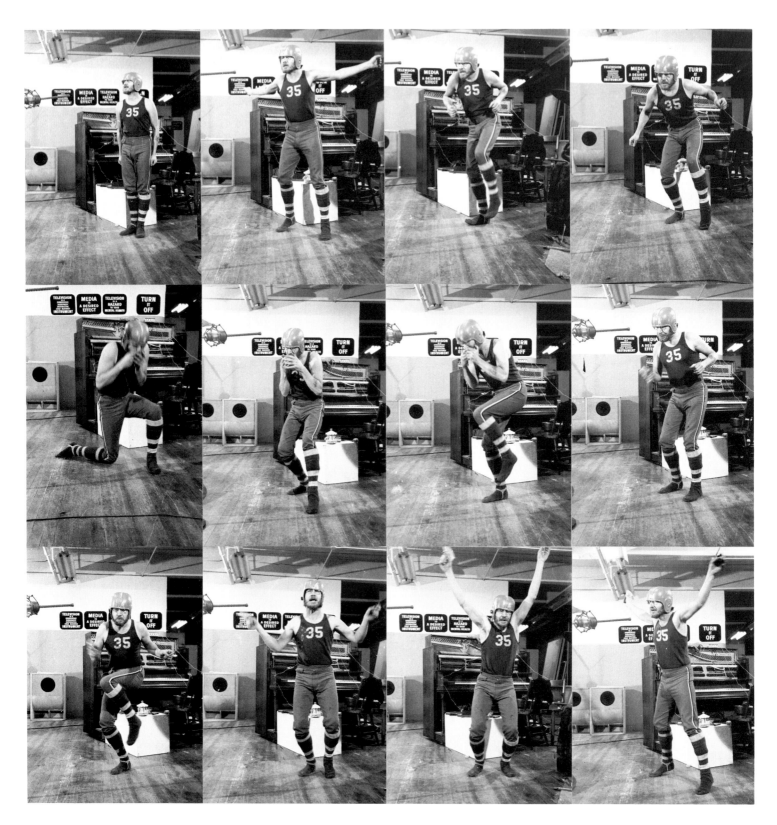

AL NEIL
Untitled (1968)
Performance at Intermedia, Vancouver

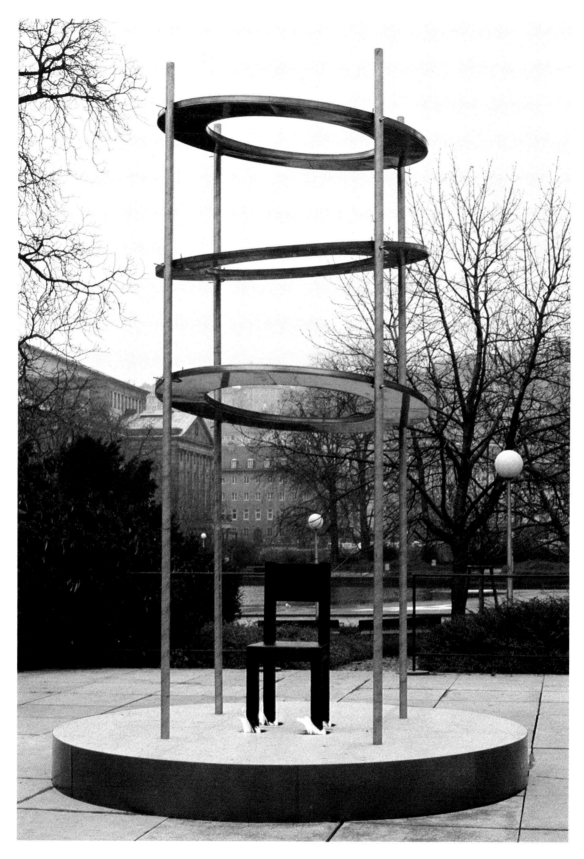

AL MCWILLIAMS, *Rumination on a Set of Circumstances* (1983)
Mixed media, 427 × 335 × 335 cm, installation at the Kunstverein, Stuttgart, West Germany

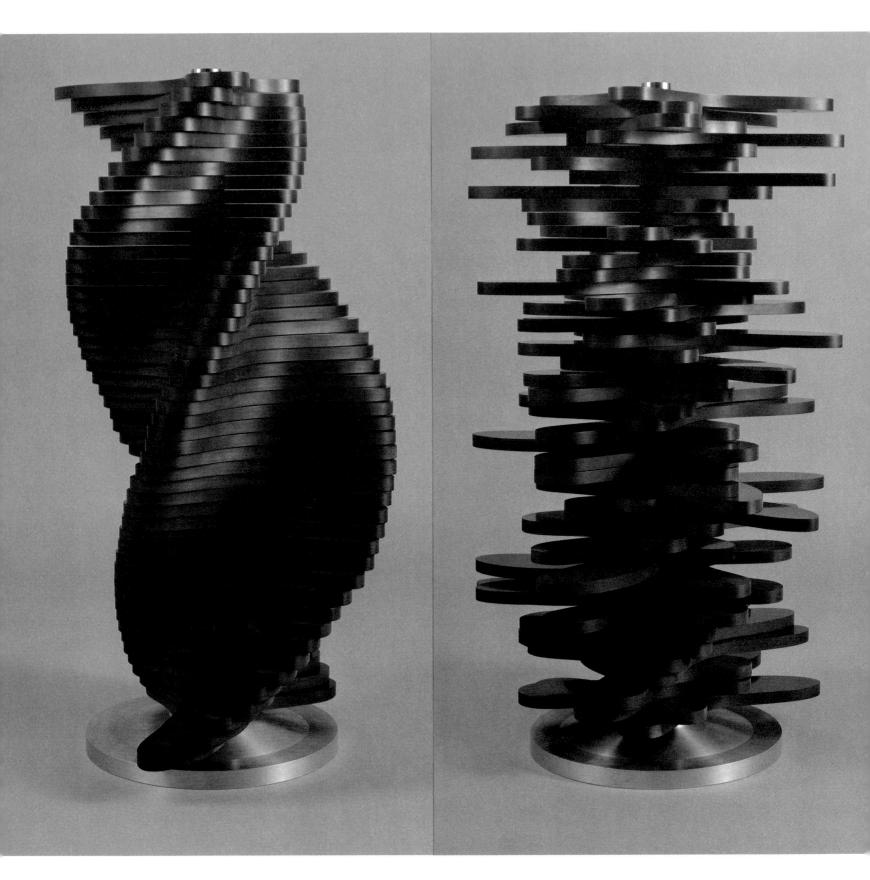

ULYSSE COMTOIS, *Colonne* (1968), phenolic laminate and aluminum plate, 70 cm high, Mira Godard Gallery, Toronto

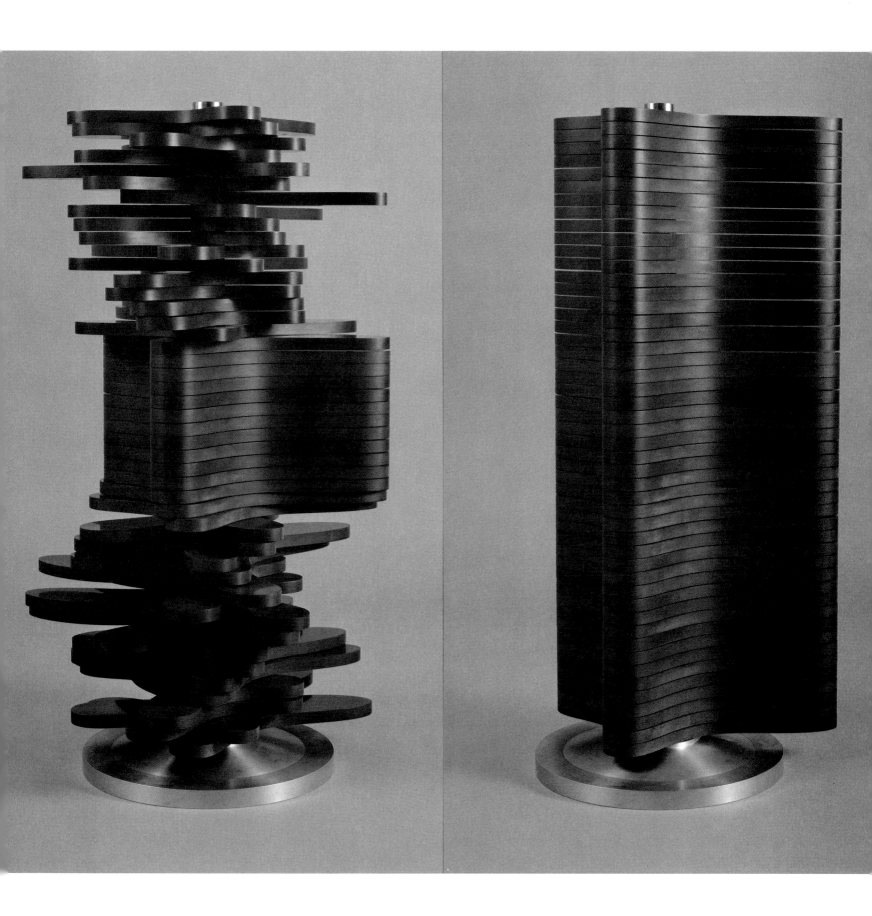

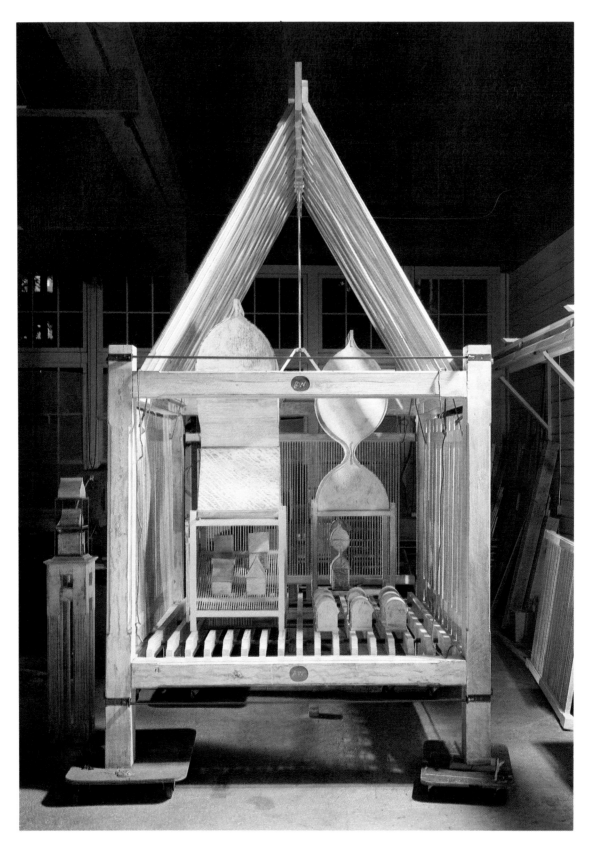

GEOFFREY SMEDLEY, *White Pleasure* (1979–80)
Wood and mixed media, 417 × 227 × 227 cm, collection of the artist

the critical wall with such labels as neo-expressionist, postmodern, and New Figure. Even apart from our weariness at hearing the prefixes "new" and "neo" once more, we might do well to disregard such names. The artists – such as John Scott, Nancy Johnson and Oliver Girling – who are herded by critics into this single corral are, like all corralled artists everywhere, completely individual, and unhappy about being so placed. Each is concerned in her or his own way with matters of social and political concern and moral seriousness, each is directly and passionately responsive to the dangerous world they see around them, and each has found a unique way to express these concerns in strong, sometimes jarring, large-scale works. Another way has been graffiti art, which has in the past several years been appearing spray-painted on city streets, walls, abandoned doorways, and construction hoardings. Like punk, to which it owes some debt, graffiti art frequently expresses a jerky, emaciated, robotic, catatonic anger. It is a forceful reminder of a comment by the late Anna Freud: "Young people now are not interested in man's struggle against himself, but in man's struggle against society. They see that what psychoanalysis may lead to is adaptation to society, and that is the last thing they have in mind."

Similarly opposed to adaptation, at least in their more radical groupings, are the members of the gay and lesbian movement, who, as a growing social force, have made themselves a presence in art, and who, together with other defiers of historic repression (blacks, women, native societies), are determined to reveal themselves to be deserving of respect as members of a distinct branch of the human race.

At present the art of the gay movement cannot divorce itself from societal issues, but there are numbers of gay and lesbian artists who have begun to make a mark for themselves outside of the closet. (This was brought to public attention during the fall

of 1982 in an exhibition called *Extended Sensibilities: Homosexual Presence in Contemporary Art,* at the New Museum in New York.) Some of the best (and worst) art emanating from the area of Queen Street West in Toronto, and from the little-gallery scene in Vancouver, has for some time reflected the Canadian version of this movement. It would be safe to say that the same force has begun to operate with equal importance elsewhere in the country.

The "gay sensibility" in art does not lend itself easily to characterization, but what it shares with much twentieth-century art is the need to cut through established art, test it, function as a catalyst and, more latterly, to adopt a politically radical stance. Because this seems little different from art that doesn't call itself gay, it leads one to postulate that many non-gay artists don't hesitate to act upon the gender contradictions biologically common to all human beings in order to investigate metaphorically the deeper significance of the human condition.

Finally, art remains subject more to biological than to political rules. It requires to be invaded frequently in order to be productive; and in this it exhibits the utterly primal, animal and vegetable need to reproduce or die. Genetics tell us that cross-fertilization strengthens a species, and that inbreeding leads to the Jukes and Kallikaks. To me, it seems the same in art. It all depends, as always, upon who is cross-fertilizing with what, and how. Which may have been what Picasso had in mind when he said that bad artists borrow, good artists steal.

Quite apart from form and content, there are messages in great art which come through to the best of artists. Those messages are intangible in character and capable of great effect. They never have to go through Customs and Immigration, and are not subject to regional, national or international barriers. And they are powerful despatches, able to provide

immeasurable sustenance to those who pursue the lonely profession of artist in Canada.

Here is what they say: Be optimistic in your work; give it your best shot. Seek your most sublime essence, and if you find it, you may yet walk among the geniuses of history, and even among the gods. You must take risks, and you must ignore the contumely sure to be heaped on your head when you do. The making of art is ridden with joy and with anxiety; there is no other way.

Vera Frenkel, whose work is discussed elsewhere in this book, has said, in effect:

Canada has a role in refreshing jaded palettes, but not if her artists remain derivative. Yet she can't stop being derivative through national orthodoxies. That would result in art done for external motives: thin art. There is still a chance for us to make art from our own deep experience and from a more immediate sensory apprehension of the world. What is difficult is to do this in a way which recognizes our inner alienation and the forces which sever us from our own experience. Important and renewing art is so rare and so difficult to do because it has to bridge the extremes of alienation on the one hand and direct personal response to the world on the other.

The truth is that much is at stake. Who and what are to dominate? In which direction should I – and therefore Art – go? Where the hell is that Zeitgeist, anyway? How much, if at all, should I allow outside influence to permeate my Pure Soul? Am I or am I not as brilliant and far-seeing as I am utterly convinced I am? Is there such a thing as the Pathetic Fallacy, and am I tainted by it?

Knowing as we do that John Knox and Savonarola are always lurking somewhere in the Canadian (the human?) psyche (sometimes with good reason), it might be worth reminding ourselves, as the air fills with the odour of sanctity and the fascinating stench of decay, that all of life began in a cosmic compost heap.

The Sausage Principle of Murphy's Law says that people who love sausages and respect the law should never watch either being made. The same goes for history, though we haven't the option of choosing whether or not to watch: we are in it up to our clavicles. The muck and the chaos, the anarchy and the conflicts, the revelation of truth in the scent of lilacs, the dire record of human duplicity, all have a way of glomming together after a time to suggest the faint possibility of discernible order, even if not of meaning. It is this adhesiveness which comes, later, to be called a movement, a decade, an era, or an epoch, even a civilization. A stamp is put upon it, a name is applied, and the Demon of History, having devoured its prey, is then satisfied – for the moment.

It is a bromide to say that history repeats itself. Surely it doesn't, at least not to the letter. In its broad outlines, however, the cliché holds; for the repetitions have always depended upon the unchanging character of our *verdammte* species, upon the institutions which we create, and on their consequences for good or evil. To my mind, the swing of the human psyche from

depressed to confident and optimistic, the built-in need to excel in something above the apes, and the squid-like velocity with which we try to jet ourselves out of boredom and loneliness, had as much to do with the invention of the Italian Renaissance as did the rediscovery of classical manuscripts, castrated sculptures of the human figure, and the birth of banking in Medici Florence.

The trick is to find what triggers confidence and to embrace it, barring overwhelming external blows, and to cast a wary eye on pessimism – a difficult task given the myriad constrictions of life as we know it. What we seem to need, to keep us on a fairly even track, is some idea of utopia which respects the rights and dignities of our lot. Postwar Canada had generous doses of that, and the outcome has astonished us all, even if it has saddened some. If we are economically, politically and emotionally in the dumps at the moment, there is little reason to believe that, as in James Bond, zircons are forever. What we might do is to count our chickens after they are hatched, and be certain of the ultimate triumph of the egg. For the latest weather forecasts, keep your eye cocked on art, but be sure to wear your boots.

And let the poet of Ecclesiastes have the last word:

The thing that hath been,
it is that which shall be;
and that which is done
is that which shall be done:
and there is no new thing
under the sun.

Overleaf:
JOHN SCOTT
Detail from *Jobless* (1983)
Ink on blue paper, 61 × 244 cm
Carmen Lamanna Gallery, Toronto

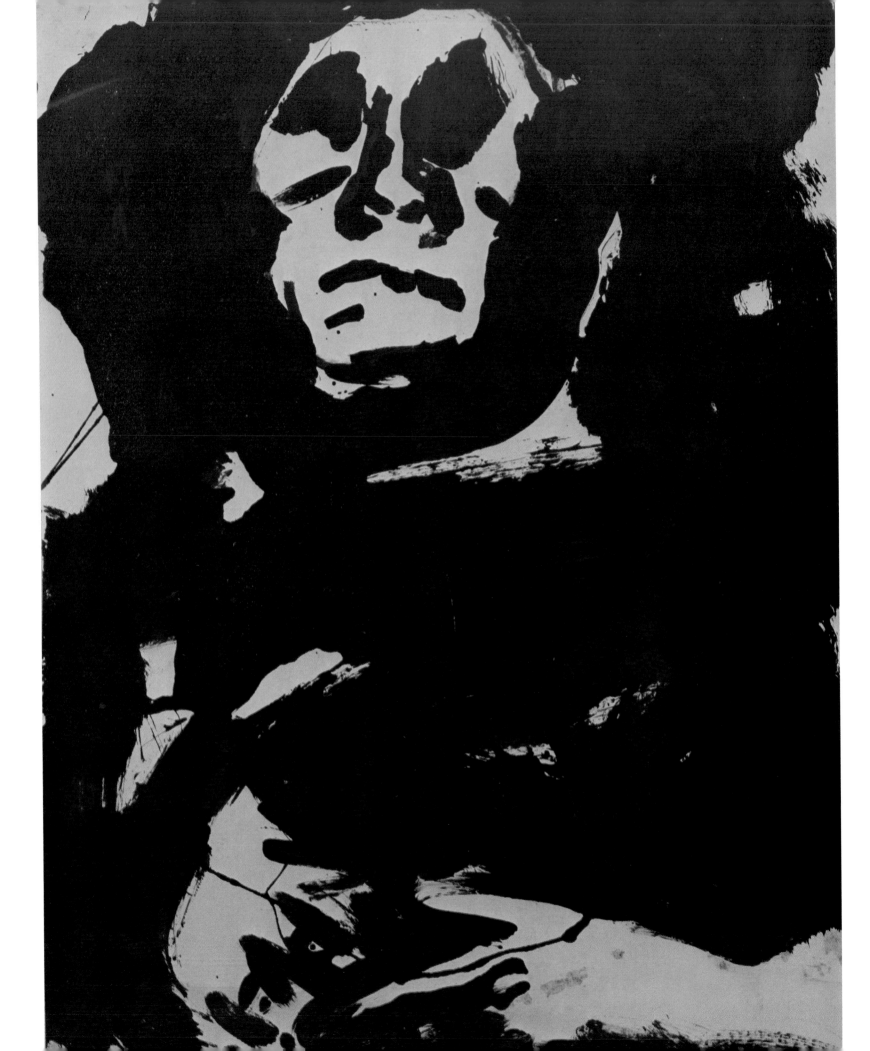

The artist with his easel set up in the countryside, painting the scene before his eyes, is one of our stock cultural stereotypes. Most people would be surprised to learn how recently this conception has developed – the major movement to outdoor painting having come only with the impressionists at the end of the nineteenth century. Behind this stereotype of the painter sitting behind his or her easel *en plein air* is a more general assumption that the artist's role is to respond in some direct visual manner to the perceived external environment. It is nowhere better exemplified than in Cézanne's much-quoted description of Claude Monet, that he was "only an eye – but what an eye!" By contrast, the idea of a visual artist rejecting the perceived external world as the basis for his art, rolling paint on with a roller, using masking tape to get a sharp edge, using his or her own body as the art piece, or even welding, spray painting, or carrying out other industrial activities, is still resisted by many people who otherwise feel attracted to a world in which art plays an important role. Since Monet's day the role of the artist has undergone both technical and conceptual changes, but even where the artist continues to depict landscape, the range and nature of the depictions have varied radically from decade to decade.

By and large, the history of Canadian art is an integral part of the history of the western industrialized nations. At certain times, however, it has developed in ways particular to this northern country. The tradition of landscape painting in Canada has reflected these particularities most clearly.

When the Canadian Group of Painters was founded in 1933, it pointedly embraced a membership that represented all of Canada (in contrast to the Ontario-focussed Group of Seven) and a cautious creed of nationalistic purpose. Its members espoused modernism in art, although they argued that "modernism in Canada has almost no relation to modernism in Europe," and

opened the door to figure and portrait work in addition to the mainstream landscape interest of the Group of Seven.

In fact, however, little changed. Canadian artists continued to paint mainly landscapes and to believe that this in itself would somehow create a national art. The young artists followed the generation before them in their basic attitudes and assumptions,

A Sense of Place

Terrence Heath

even if some, such as Bertram Brooker, began to break new ground and to turn away from the earlier landscape work. In the background, A.Y. Jackson and Lawren Harris still asserted their leadership and their particular brands of nationalist thinking. Nature, for them, played an organizing role whether in a documentary or spiritualistic sense.

If we look beyond the individual contributions of members of the Canadian Group of Painters, the group's most important contribution to Canadian art was the staging of annual exhibitions which invited and showed works from artists across the country. André Biéler in southern Ontario, Jack Humphrey in the Maritimes, Fred Varley and Emily Carr on the West Coast, and many others were included in them. By and large, these exhibitions showed central Canadians the landscapes of Canada.

During periods of nationalistic fervour it is not unusual for artists to seek out unique aspects of their country for representation: the landscape, the history, the people. Of these, landscape (and seascape) has been particularly important in Canada, but here the nationalistic representation of the land has had a distinct feature setting it apart from European landscape painting. Until

very recently, Canada was largely wilderness. Colonial settlements clung to the shores of southern waterways and railroads. Beyond the settlements lay a land which was in great part uncharted and which the non-native could think of as uninhabited. It was also a northern wilderness. These two concepts, Wilderness and North, inform much of our artwork, both in the visual and literary arts, of the century from 1850 to 1950.

A vocabulary for talking about the organizing principles and concerns of Canadian art was created some years ago by our most learned critic of literature, Northrop Frye. The basic human question, *Who am I?*, has, according to Frye, a unique Canadian twist. For the Canadian artist and writer it has been not *Who am I?* but *Where is here?* Even a quick look at Canadian art and literature up to the end of the Second World War yields the strong impression that the Canadian artist has searched, analyzed, feared and rejoiced in the natural world of this northern country as the organizing principle of his or her sense of being an artist. *Where is here?* has been a basic question in Canadian art communities and in defining *les deux nations* of Canada.

For a colonial people, the wilderness is not only a defining fact, it is part of a whole other problem: How do we live here? The creed of the Group of Seven summed it up in artistic terms in 1919: "The great purpose of landscape art is to make us at home in our own country." And yet there is in much of Canada's literature, and in some of its visual art, a strong suggestion that this process is caught in mid-stride: that while the land has been inhabited, it has not been domesticated, not made into a home. Northrop Frye summarizes this predicament as "the conquest of nature by an intelligence that does not love it." Few of the Group of Seven felt at home in a wilderness that lay beyond easy reach of the city, and those who ventured farther, such as Lawren Harris into the Arctic, portrayed an awesome landscape which was anything but homelike.

It is interesting to think of many of the wilderness paintings of our outstanding pre-World War II artists as trophies. As Tony Urquhart has pointed out, much landscape painting of the wilderness or of natural settings is trophy-hunting, in which the artist as hunter goes into the wilds, finds the prize specimen, and returns with it mounted for exhibition in a safe, urban gallery. The most nationalistic member of the Group of Seven, A.Y. Jackson, hunted across Canada from coast to coast in search of paintable game to bring back to Toronto. He also often had to admit defeat, as he did to Emily Carr when he lamented to her that it was "too bad that West of yours is so overgrown, lush – unpaintable." Surprisingly enough, he found many places in Canada unpaintable. There is a prairie story of his visit to Regina, where he had to be taken across the typical, flat prairie land to the Qu'Appelle Valley in order to find subject matter suitable to his personal sensibility.

Not all artists shared this rugged, outdoor landscape enthusiasm with its nationalistic overtones. John Lyman of Montreal, for example, was opposed to identifying Canada with its landscape and to concentrating so exclusively on subject matter as a guiding criterion for art. He said flatly, "The real Canadian scene is in the consciousness of Canadian painters, whatever the object of their thoughts."

Since the Second World War, the tide of opinion in the visual arts has often swung against the landscape tradition. The decade of dominance of nonrepresentational art from the late 1950s to the late 1960s moved artists' concerns away not only from representation of the northern landscape but also from the nationalism and concern with a unique identity which informed the Group of Seven and their successors. The Automatistes, the Plasticiens, Painters Eleven, the Regina Five, whatever the differences among them, were united in their nonrepresentational art and international stance.

In 1974, critic and curator Barry Lord spoke against the prevalence in Canadian

galleries of "unoccupied landscape" and questioned its use in the search for national identification. He raised his voice for a socially committed art depicting the everyday world of Canadians. Landscape painting was, he said, often an escape – a non-statement about the country and as noncommitted in its way as abstract art.

Rejected by nonrepresentational artists and sometimes proscribed by art critics, the concept of place has survived and broadened over the last forty years. Regionalism, nationalism, intensive urbanization, social dislocation and new international art movements and concerns have radically altered both the concept of *Where is here?* and the range of artistic experimentation and conceptualization. North, Nature and Nationalism have been joined, and sometimes replaced, by a range of concerns, including economic exploitation, ecology, mythology, urbanization and anti-Americanism. Yet, despite all the changes, despite growing internationalism and sophistication, the "here" of the question has, for surprisingly many people, remained tied to a sense of place. And for many artists, that sense of place remains tied to the land, whether place is construed as something accessible to the eye or is understood as process, as personal space or communally shared territory, as place objectively observed or charged with emotional attachment. At the same time, while place has persisted as an animating idea, it has assumed a less straightforward and less obvious role in the artist's total vision. The artist might be an ironic eye, a camera lens, or an aerial spectator, but rarely is he the innocent eye. In this new world, the artist concerned with place has moved outside the role of depictor of place into a ritualistic function as mediator of place. Here I have separated these functions – depiction and mediation – in order to attempt to gain some perspective on the art of the last thirty years. The movement and flow of the making of art cannot be captured in such categories for long; they can, however, like stop-action

photography, give us time to observe the movement more closely before it continues.

The full impact of abstract or nonrepresentational art was long in coming to Canada. The dogged national resistance to it can be traced through the careers of many Canadian painters. Bertram Brooker moved into abstract work at an early stage in his career, in the 1920s, but soon left it for something very reminiscent of later high realism. Similar starts and stops, flirtations and brief affairs with abstract art can be seen in the work of artists as diverse as Jacques de Tonnancour, Ernest Lindner, Jack Shadbolt and Claude Breeze. The recent return to landscape painting of almost all of the Regina Five, who so ardently espoused the tenets of abstract expressionism in the 1950s, can be seen as a prime example of what is almost an artistic reflex in the history of Canadian art. Not until abstract work was fully sanctioned and commercially supported by the American art market did it gain a good foothold in both the schools and studios of Canadian artists. Even then, most major Canadian painters went only part way in espousing the abstract mode, or perhaps it could be said, they clung to the well-established Canadian landscape tradition even while adopting some of the tenets of the predominantly American-influenced nonrepresentational art of the 1950s and sixties. Gershon Iskowitz of Toronto and Gordon Smith of Vancouver are two examples.

Iskowitz has always stood a bit apart from the Canadian art scene. By nature a loner, who for years reversed day and night in order to have the undisturbed periods of time needed to paint, Iskowitz came to Canada in 1949. He had spent the Second World War in the prison camps of Nazi Germany, and after the war he was briefly associated with Oskar Kokoschka in Munich. The landscape and freedom of Canada impressed him and he took air trips over the northern part of the country to see its extent. These aerial views became the basis for his large canvases of daubed-on

GERSHON ISKOWITZ, *Uplands B* (1970), oil on canvas, diptych, 213 × 355 cm, Gallery Moos, Toronto

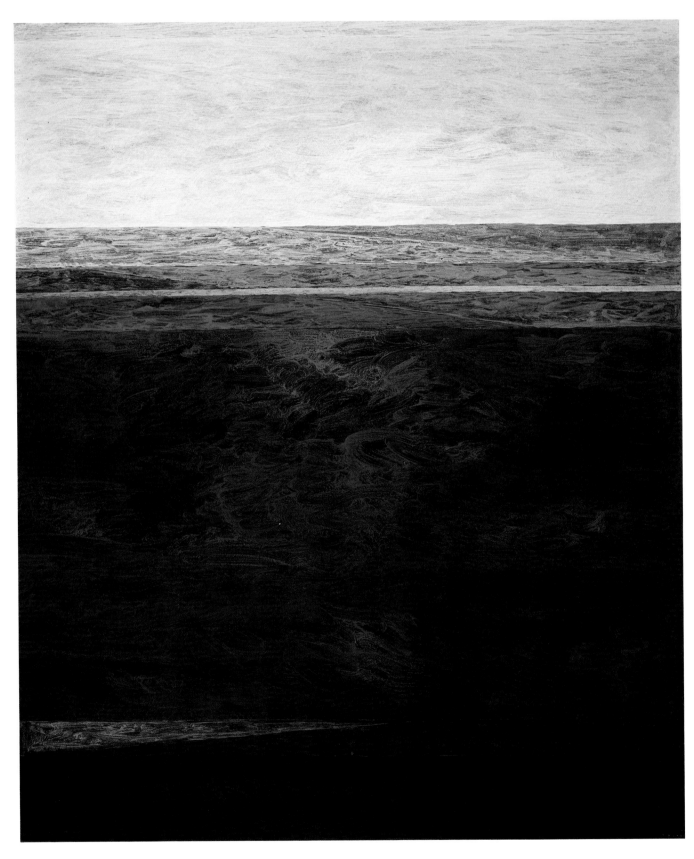

GORDON SMITH, *West Coast M-5* (1974)
Acrylic on canvas, 183 × 152 cm, Toronto Dominion Bank collection, Toronto

paint. Many on seeing his paintings are surprised to be told that the artist is depicting any landscape at all, much less a Canadian one. The landscape motif, the place depicted, has been subjugated to Iskowitz's primary concerns of surface treatment and colour.

On the West Coast, Gordon Smith, with his feet planted firmly on the ground, or at least on the shore, has also dealt with landscape as a referential basis for abstraction. Smith retains the strong horizon line that is so much the primary visual experience of sea and prairie vistas, but his striated division of canvas into subdued bands of colour allows him to use colour freely within a determined range. The seascapes become the occasion for abstract paintings belonging to the larger North American genre of colour-field painting, which developed from American abstract expressionism of the 1950s. Smith's work can also be seen, however, as a direct attempt to make the most basic statement about the visual experience of the ocean, where the elements of nature seem to be reduced to their simplest visual forms: sea and sky. Similarly, Smith's concern for interpretation and fidelity to the experience of seascape can be seen in his use of colour. In this, Smith's reference to nature is much less ambiguous than that of Gershon Iskowitz, whose colours and forms seem to be arrived at more by subjective decision than by visual reference to his environment.

In fact, this use of landscape as the visual structure for abstract painting appears as a major preoccupation of Canadian artists everywhere. The work of Jack Humphrey, for example, remained steeped in the visual world of the New Brunswick forests, but until his death in 1967 it became progressively more abstract. Humphrey called this reference to landscape an "authentication" of his work – an indicative attitude for the Canadian artist. In central Canada one could point to many artists in addition to Iskowitz who have abstracted landscape. The work of Jacques de

Tonnancour in the 1950s and some of Gordon Rayner's works, such as *Magnetawan* (1965), would be examples. On the prairies, Otto Rogers has invested his abstracted landscapes with spiritual inspiration. Takao Tanabe, from the West Coast, has also, by a process of simplification and stylization, found in the prairie landscape the same basic structures as Gordon Smith has found in seascapes. Toni Onley's collage-like abstractions of landscape, particularly of the North, are also in this tradition.

Barry Lord labels this abstract landscape painting "a minor colonial school of abstract expressionism," and undoubtedly there is some truth in his assessment. It is, however, equally true that these painters belong to the Canadian tradition of identifying Canadianness with place – or, said differently, they address Northrop Frye's question *Where is here?* As the Group of Seven appropriated to their own use international styles of postimpressionism and art nouveau, so the Canadian abstract landscape painters have adopted and adapted the international style of abstract expressionism in order to deal with their natural northern subject matter. If there is a clear difference between the earlier and later Canadian manifestations of "foreign" styles, it is the decline of nationalistic concerns in abstract landscape paintings.

Outside of the tradition of abstract landscape art, yet still related to it, are a number of artists who find their source material in nature but have developed unusual ways of approaching it. Richard Prince's work in the early and mid-1970s is a case in point. Prince's small sculptures of these years dealt with forces or processes in nature that usually elude visual presentation – gravity, wind or even quasi-geological stratigraphic classifications of landscape components – sometimes symbolically represented. Because such aspects cannot be depicted by any ordinary visual means, Prince moves into diminutive but visually participatory work – that is, the viewer cannot simply look at the pieces; she or he

must participate by following through a sequence of causes and effects to arrive at the basic "abstraction." Sometimes, as in *Landscape File,* this has been a physical process, but most often it has consisted of a visual sequence of imagined involvements.

Another artist who depicts place through a particular reference system is Tim Zuck. Zuck's small paintings of ships and houses seem to derive from children's art or naive painting but are upon examination carefully laid out patterns which nevertheless give a strong sense of place. During his years in Nova Scotia, the influence of his immediate surroundings and the folk art traditions of that area gave a strong Maritime aspect to his work.

It is instructive to consider by way of contrast the work of the prairie artist Dorothy Knowles. Her landscapes are readily identifiable, but they do not evoke place. They are quite deliberately worked over in an open, wash and drawing technique which tends to bring the background to a visual level with the foreground. The painting rather than the depiction is of primary concern, even though the subject matter would suggest a more traditional landscape approach. The treatment of landscape is far less abstract than one sees in the works Gordon Smith or Gershon Iskowitz, but the references are just as secondary to the method of painting. Knowles's paintings thereby become not depictions of place at all. Instead, her art contains an internal, almost circular reference system of its own. Seen from the perspective of the landscape tradition, her work reminds us that certain types of abstraction may in fact contain more of a sense of place than faithful rendering does. The search for the basic forms of landscape, no matter how geometric in their delineation, and a concern with the primary colours of natural phenomena, may present more visual information about place than the spatially undifferentiated surface detail and tonal patterns, however representational, of paintings such as Knowles's.

The resurgence of major realist painting in the 1960s came as a surprise to many people in the art world who had assumed that the mainstream of painting would continue in the exploration of abstract or nonrepresentational forms. In part, the return to visual representation threw into sharp question the assumption that there was a progressive, straight-line art history which led from the colour and surface concerns of the impressionists and the basic geometric structuring of the cubists in the late nineteenth and early twentieth centuries through to the American exponents of abstract expressionism and colour-field painting of the 1950s and sixties. The history of art proved to be more complex and less sequential than that view allowed. The questions of content and message were again raised, and these in turn unleashed a torrent of further questions about the social and political responsibilities of artists, the nature of painting and the supporting world of galleries, curators and critics (for which much of the huge abstract work had been created), and about the role of art in the lives of ordinary, image-oriented people. With these questions came others posed by the use of photography, media reproduction of art images, the problem of permanence versus impermanence in art, and the relationships of one art form to another.

Superficially, the realist work of the 1960s might seem closely related to the earlier depiction of North, Nature and Nationalistic concerns by the Group of Seven, but on closer examination it turns out to be a profoundly new direction and an integral part of the reorientation in art which has taken place in the 1970s, throwing into question many earlier assumptions about what art is and how it should function in society. It is difficult to define high realism, but the name is loosely attached to painters who work with representational imagery that is rendered in sharp, focussed detail. Some concentrate particularly on the rendering of textures; others focus on event

or narrative moment. Whatever differentiates them, there is in their work a strong visual relationship to photography. With many, this comes of working from photographs, even to reproducing the colour balance of Kodak or Agfa film; with others it is the handling of the foreshortened planes and perspective "distortions" of the camera; but all have that nonselective detail of the photographic image.

Given this representational accuracy, one would assume that the high realists would provide the best example of contemporary artists who give us a sense of place. Strangely enough, this is not usually true. The very focussed particularity – seemingly for its own sake – of high realist painting removes the works from the field of interpretation. The clarity of the image and its nonselective detail, as in photography, forces upon us the sense of a particular fleeting moment rather than the more slowly building sense of place. Frequently when the imagery deals with urban life or landscape, a sense of anonymity is added to that of transience, for urban places in North America are full of scenes interchangeable across the continent. An instructive example of this lack of a sense of place seems to me to be the work of Ken Danby. In his series of paintings of rural Ontario, with its immobilized old mills and other buildings, there is a lack of identification which raises in me not a sense of place but a sense of displacement. The media imagery of magazine illustrations, nostalgic advertisements and sharply focussed billboard art further remove his work from the sense of individuality which a sense of place requires.

The most formal and least photographic of the high realists is Christopher Pratt. No doubt, both in the washed colours and in the references to sea- and wind-weathered buildings, he evokes a great deal of the Newfoundland in which he lives and works. His central concern and the strength of his paintings, however, rest firmly on his superb placement of architectural forms and planes. As he himself has said: "The last place I want to see when I am doing a painting is the place that inspired it." His paintings do not refer to a place nor re-present a place; they are basically as self-contained as the most abstract of compositions.

So many strong realist painters make their home in Canada that it is difficult to select a few for discussion here, but three painters who have been variously called high realists, realists, magic realists and one of them even abstract realist, give us new perspectives on place. These three are Jack Chambers, who made his home in Ontario; Ernest Lindner, long-time resident of Saskatchewan; and E.J. Hughes on the West Coast.

Chambers, who became a leading spokesman for realist and nationalist concerns in Canadian art, moved from a realism influenced by the traditions of Spanish painting and the impulse of surrealism, to a representational realism centred in his immediate surroundings of London, Ontario. He came to be regarded as a painter who brought to art his region, his specific place, and a new sense of a country that is finally inhabited. Although his images can be located around London, both his landscapes and his neighbourhood and household depictions have a universal or at least national dimension. The scenes Chambers chose to paint are repeated throughout the country and often beyond.

Ernest Lindner, who is now one of the most senior of Canadian artists, developed an early stage of realist style which combined something of the older tradition of the Academy and its rigorous draftsmanship standards with the colour preoccupations of post-World War II abstract work. In surveying his long life of painting and drawing, one is struck by the consistency of his style and sensibility. Apart from a brief flirtation with nonrepresentational work in the late 1930s and early forties, he has stubbornly clung to and deepened his interpretation of the northern forests and the minutiae of their multifarious forms and transformations. His large, detailed

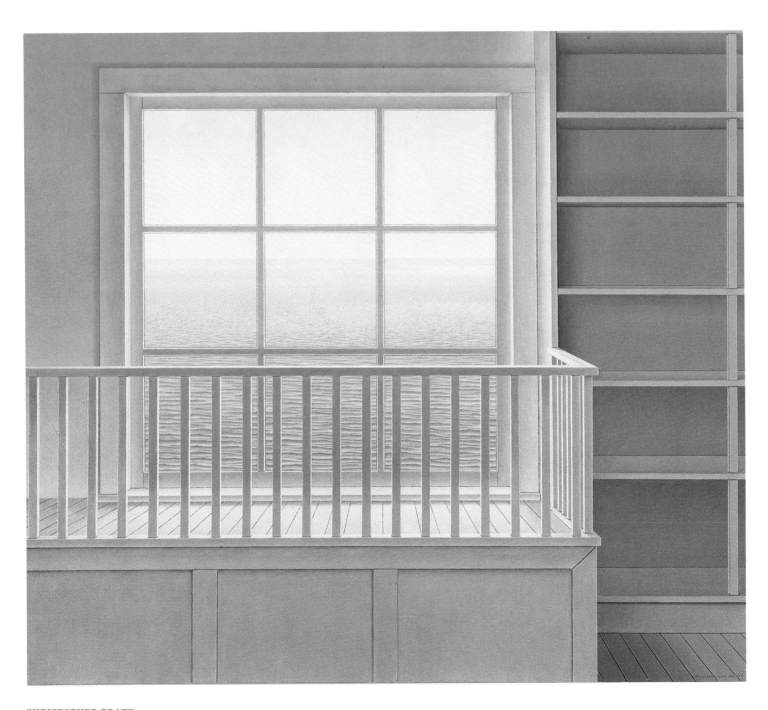

CHRISTOPHER PRATT
Shop on an Island (1969)
Oil on masonite, 83 × 92 cm
London Regional Art Gallery, Ontario

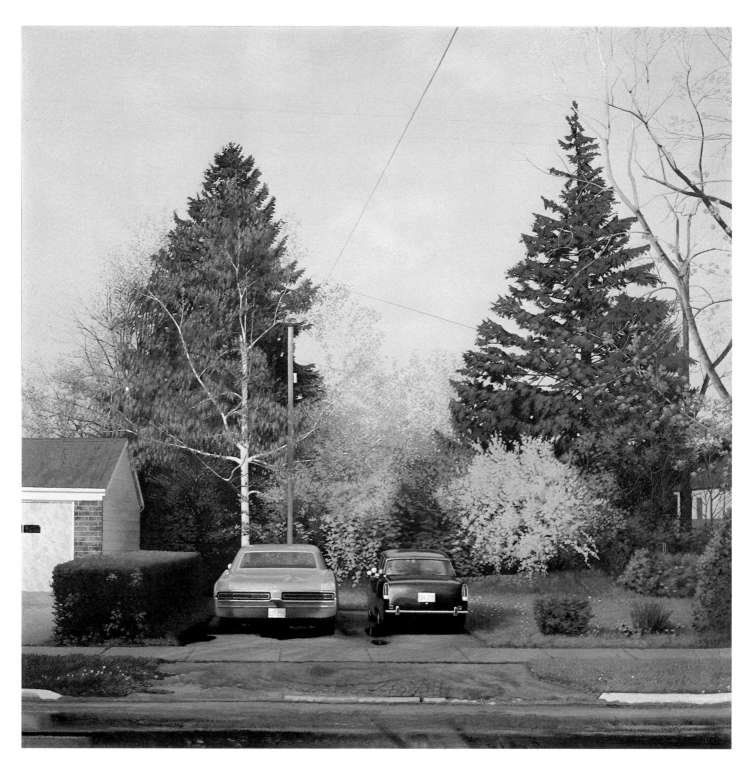

JACK CHAMBERS
Lombardo Avenue (1972–73)
Oil on canvas, 92 × 92 cm
Canada Council Art Bank

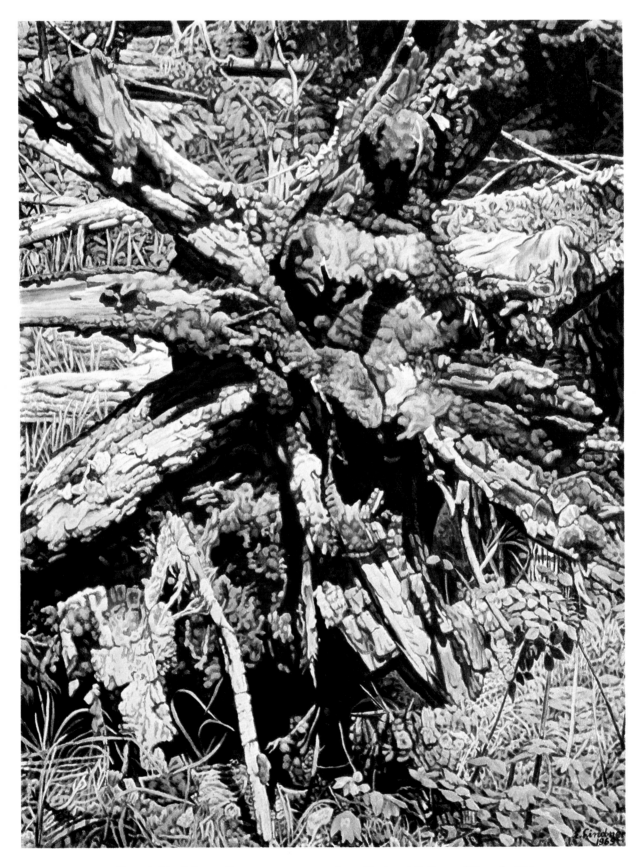

ERNEST LINDNER, *Uprooted* (1969), acrylic on canvas, 102 × 76 cm, National Gallery of Canada, Ottawa

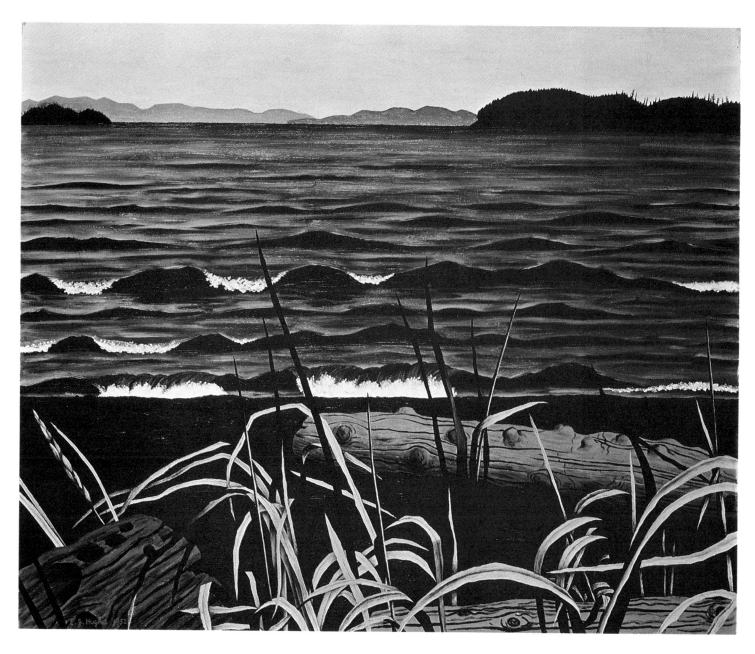

E.J. HUGHES
Beach at Savary Island, British Columbia (1952)
Oil on canvas, 51 × 61 cm
National Gallery of Canada, Ottawa

TERRENCE HEATH

paintings of forest flora are rendered neither with the focussed accuracy of high realism nor with the impasto of the Group of Seven. Lindner says that living on the prairies has trained his eye and his sensibilities to seek the close and detailed, and at the same time, he has developed an awareness that the great elements of the natural world are broad and simple. To me, there seems to be in his paintings both something of the late Viennese eclecticism and melodrama and also the visual elementalism of the prairies which he has adopted as his own.

The work of E.J. Hughes over the past forty years has developed into a distinctive style which, if further examined, might prove basic to much Canadian work. At first glance, his works look like the paintings of a naive artist. There is about them a directness of vision, often a narrative line and an unadorned, innocent-seeming use of form and colour–properties which much naive work attains. Later artists such as Greg Curnoe, Joe Fafard and David Thauberger have deliberately used related styles as they sought to come closer to an indigenous expressive form for their art–and they are, of course, like Hughes, strong regionalists.

The history of Canadian art is unusually difficult to reconstruct because it tends to be constantly ricocheting off the art of other peoples. Who are the successors of the Group of Seven, the Canadian Group of Painters and the Contemporary Art Society? What Canadian predecessors do Jack Shadbolt on the West Coast and Lindner on the prairies have? Often, our art has not only been enriched by the art of other countries; it has been overwhelmed. It is difficult to point to a stylistic uniqueness even among the most nationalistic and regionalist of our artists. But as the genre painting of the seventeenth-century Dutch artists is readily distinguished by their choice of subject matter, so Canadian artists seem to return constantly to the subject matter of this country which is so dominated by its natural surroundings. Whatever the prevailing international style, the depiction

of landscape remains a major activity for Canadian artists. But whereas the intense nationalist drives of the major landscape painters before the Second World War were aimed at giving a definite answer to the question *Where is here?,* the painters of the past thirty years seem to take the landscape more for granted as a sort of touchstone or talisman of national life. It is a fascinating and slightly bizarre thought to picture the major abstract painters of Canada and the United States isolated, as certain of them were each summer in the late 1950s and throughout the 1960s, in the art camp at Emma Lake in northern Saskatchewan. Here we have almost a symbol of the contradictions and paradoxes facing the Canadian artist. But behind the paradox is the Canadian awareness of the elemental forces of the natural world of this northern country. As the Maritime poet Alden Nowlan has written in *Shaped By This Land,* a book he produced in collaboration with painter Tom Forrestall:

If I am sentimental
curse me, it is my inheritance,
what I bequeath
is laughter for the young lovers
of this country where summer
is tense always, a lull between storms,
where even in August
I can sense the snow clouds.

If we pursue the question of depiction far enough, it will lead us to a significant discovery about the relationship between living beings and the land. All artists who depict a place also create that place. Depiction is never mere reproduction of the visual experience, not even if the photographic medium is used as a basis for painting. Depiction always involves interpretation, and that modification or filtering of the visual experience is a new place.

Some artists, however, go beyond interpretation of place to a more explicit creation of place. These artists are posing a new question: Northrop Frye's question,

Where is here?, has been modified into *How is here?* The new question has new answers which are by no means unrelated to the old, but which require a different set of mind regarding some of the traditional concepts of art.

Some artists create a place or sense of place by highly personal involvement in a landscape or way of life. They do not re-present a landscape or way of life directly, but they create highly personalized images of their involvement in their surroundings or community which amount to a creation of what at one time would have been called the *genius loci,* the spirit of the place. To borrow a term from literary criticism, they create a mythopoeic place, a place where myths are made.

In Canadian art over the past few decades, many artists from all parts of the country have been creating these mythopoeic places. An obvious example is the Winnipeg artist Ivan Eyre, whose artistic life has been so deeply involved in the place where he was born and educated. In his biography of Eyre, George Woodcock quotes the artist as saying:

In life, particular situations evoke persistent feelings – clear spaces, air rich with dreaming, the sensuality of a shaded dark prairie grove, a black bank of exposed roots in an empty stream bed, a windless summer evening sky luminous with pink light, or dim cloudy mornings in the fall when leaves and grasses are withered. An object couples with another, and the ensuing relationship emits something that seems to be "truthfulness."

All the elements of the mythopoeic are present in this reflection: the intense sensual involvement in place, the receptivity of the artist, and an assurance of truth in the necessary coming together of experience in what is basically the beginnings of mythology. The artist is explicitly emphasizing that he is not "only an eye."

For many years, from the mid-1960s to the late seventies, the work of Ivan Eyre was among the most distinctive but least known in Canada. One of the reasons for his

relative lack of recognition at that time is that he persistently worked outside of the major art movements of the continent. He was neither nonrepresentational nor realist. Although sporadic attempts have been made to trace his influence back to German expressionism or late medieval painting, he developed a style and a vision that were his own. What is of relevance here, however, is that his vision belongs to a particular place. An unrelenting atmosphere of impending disaster and unavoidable doom pervades his imagery. Figures struggle across the prairie landscape, horses on wheels move through strewn debris, dark figures rise on the horizon, men and women pursue their dreams and pleasures in the midst of an alienated landscape. These are not paintings that eulogize either the people or the land. Nor are they paintings that depict the people or the land. Yet they create the place they are.

In the late 1970s, Eyre began to paint what became a series of large and detailed landscapes. Most of them are based on what in the prairie context would be called parkland settings – that rough country between the prairies and the northern coniferous forests. But these landscapes too are not depictions; they are constructs based on experience and memory, painted into a new place. They are something akin to the evocations of place which painters of classical themes created as settings for the great events of ancient mythology. The artist depicts a recognizable landscape, but paints it as the setting for an event which is heavily charged with a significance not present in the landscape itself. This can happen even when, as in Eyre's work, we may be unable to say just what that event is. It may be an event which we sense has yet to take place, or which we have already half-forgotten, or which we feel to be present yet cannot see.

Alex Colville too can be seen more comprehensively as a creator of mythopoeic space than as a high realist (his usual designation). There is a difference in kind

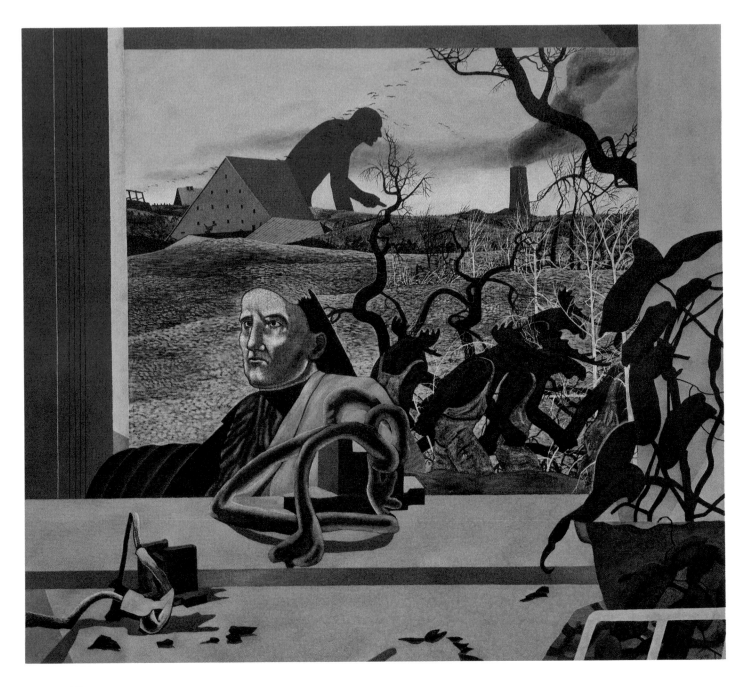

IVAN EYRE
Moos-O-Men (1975)
Acrylic on canvas, 142 × 163 cm
Collection of the artist

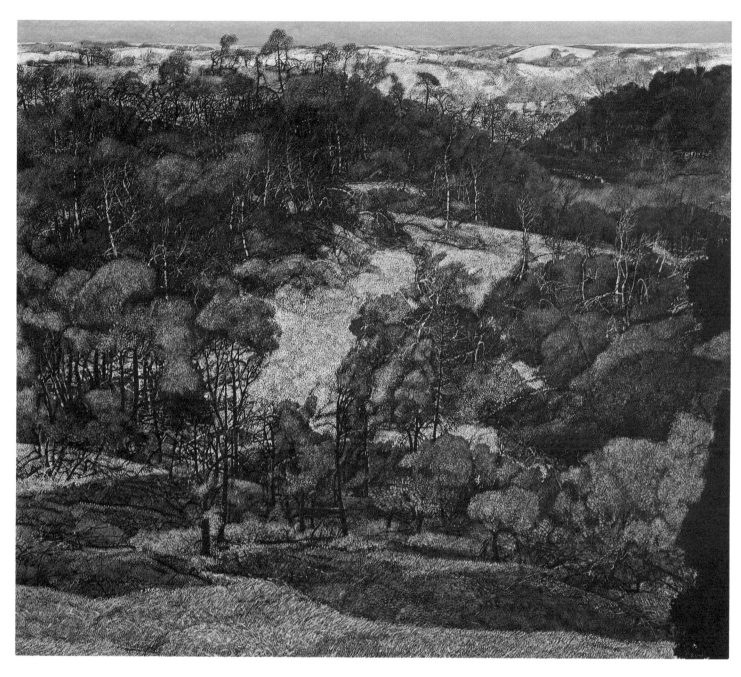

IVAN EYRE
Valleyridge (1974)
Acrylic on canvas, 142 × 167 cm
Private collection

between his work and the work of painters such as Tom Forrestall. Colville is not depicting a place; he creates a place in which the viewer can live out a basic "truthfulness" (to use Eyre's term), related both to the emotional insight of the artist and to a world that is rich in meanings. The painting *Church and Horse* is an example of such a place. Only the most literal commentator would proclaim it Canadian because it portrays the United Church, a Canadian institution. It is rather a place of its own, created by the artist out of his experience and his perception of how one "object couples with another."

Similarly, the paintings of Jean-Paul Lemieux and the prints of David Blackwood create mythopoeic space. The figures exist in a real world but it is a world created for them, or, better stated, not separable from them. And there is a sense in which these places seem to be indigenous. One thinks again of John Lyman's assertion that "the real Canadian scene is in the consciousness of Canadian painters."

Another artist who seems to create place rather than depict it is Paterson Ewen in Ontario. The sense of place in Ewen's work moves from the locality and community to more intangible places of meteorological and cosmological events. His paintings, partly gouged out of plywood and using the material base as an integral part of the rendering of the image, are exuberant attempts to deal with those aspects of place which are ephemeral but so important in one's experience of them. Because the subjects are temporary – a storm, a fork of lightning, the wind – they cannot be presented unless the viewer can be made to step out of his or her life and enter the suspended world of the meteorological happening. The work points to the place where the viewer must go; it verifies the actuality of the event, and therefore, of the place, and gives assurance that the place is not the one the viewer is normally in.

The boundaries in all discussions of art are very flexible because the experiences

are not verbal. Categories in discussions of art, however, are most useful when they furnish new ways of experiencing the art and not new ways of containing it. Even while we see the category beginning to merge with other, as yet undefined ones, we may still be able to see how creation of place marks an important change in the traditional concept of the art object – a change which in stronger or weaker ways is affecting all the visual arts today.

There is also a change in the stance of the artist in Canada over the past forty years. The visual and the aesthetic have never defined the limits of artistic activity, and increasingly over the past decades artists have explored roles which move them very far from the stereotype of the easel artist recording what is perceived. One of the roles artists have explored, especially in the last fifteen years, is that of the "primitive" artist.

In Canada "primitive" art has meant the traditionally based art of the Indian and Inuit peoples – a tribal, shamanistic art surely very different from the self-expressive art of western industrial civilization. But the two traditions come together in this country, and their exchanges have been rich and varied. Major changes have ensued in both traditions.

In 1978, in an essay on Lawren Harris, poet Eli Mandel wrote as follows:

Paradoxically, the romantic answer to the question posed by the tension between culture and nature ends with primitivism: with the abrupt transitions of mythic narrative, with the movement of the romantic lyric toward pleasures secret and austere, with the figure of the Indian out of myth, a tragic and violent mask confronting civilized man.

Mandel is following the argument of Northrop Frye in regard to the "progress" of Canadian literary history from romantic landscape poetry to the interior landscape of modern myth, and drawing parallels in the development of the work of the Group of Seven. In the visual arts the persistent association of nature with deeper spiritual

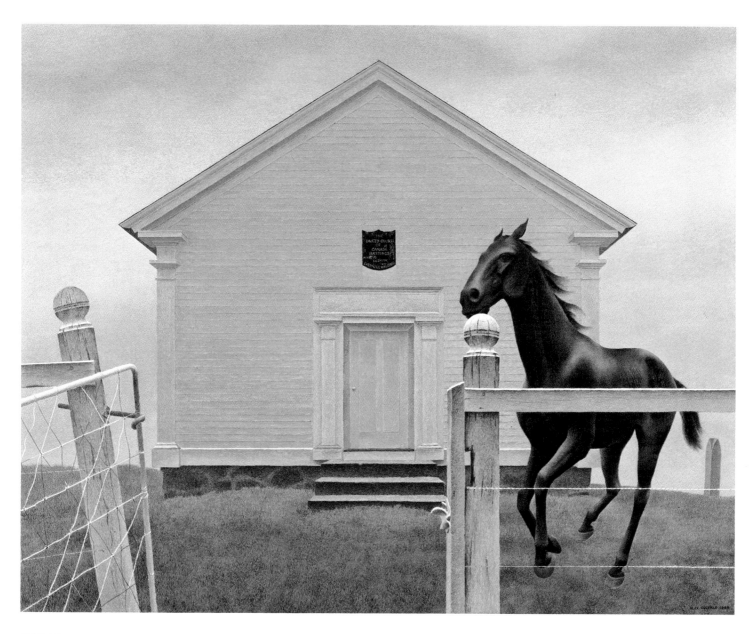

ALEX COLVILLE
Church and Horse (1974)
Acrylic on masonite, 56 × 69 cm
Musée des beaux-arts de Montréal

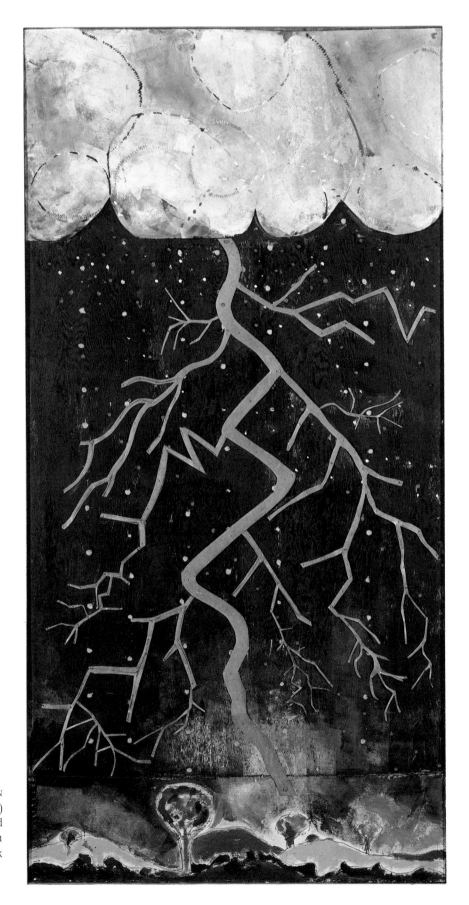

PATERSON EWEN
Forked Lightning (1971)
Acrylic, canvas, metal and
engraved plywood, 244 × 122 cm
Canada Council Art Bank

meanings and moral values is one of the many bridges by which the non-native artist is able to find reverberations of his own sensibilities in the art of Indian and Inuit.

Many Canadian artists have in one way or another turned for sustenance to the cultures of the indigenous peoples of this northern country. (Of course, the farther west and north one goes, the more of those great cultures has survived into the present day–even if the remains are only a small part of what was originally there.) Many have also responded to the external "primitivism" and dwelt, for their own reasons, on the violence and the elementalism of the indigenous mythopoeic world.

The contact with the "primitive," however, is also basic to modern European art. Pablo Picasso, for example, remembered as a revolutionary moment in his development as an artist the impact of his first encounter with African masks:

Painting isn't an aesthetic operation; it's a form of magic designed as a mediator between this strange, hostile world and us, a way of seizing the power by giving form to our terrors as well as our desires. When I came to this realization, I knew I had found my way.

But the personal meaning of African art for Picasso was not experienced by all artists, and eventually the impact of this contact with primitivism seems to have become in Europe primarily a question of form. In Canada, where the same land is inhabited by the Indian artist and his non-Indian contemporary, there has been a different and more extensive development, not concerned so much with form or content as with artistic stance or attitude.

Traditionally, neither Indian nor Inuit artists have depicted place, yet their work often expresses place very strongly. In part, the use of local materials–cedar, buffalo hide, whalebone, argillite, soapstone, feathers–and in part the use of local cultural imagery–animals, hunting or fishing techniques, stylized family emblems,

mythologies linked to particular features of landscape–give their works a distinctive "location." I have come to call this act of re-presenting a place through materials and cultural images an act of mediation. In mediating place, the artist deals with the external environment not as an object to be rendered in a visual medium but rather as another subject for whom the artist "speaks." Philosophically this attitude is animistic: the world is subject as the artist is subject.

A second attitude of the artist as mediator is the belief in the transformational power of art. In the Indian or Inuit world this power is the power of the shaman who can not only transform himself but can also change the forms of other things.

A third identifying attitude of the mediating artist is concern for the holistic dimension of all things; that is, the act of art is not to isolate or distinguish the art object, but rather to integrate it with all things, including the artist and the viewer/participant.

The relationship between the actual Indian or Inuit society and the contemporary artist may not be explicit or even direct. The attitude of mediation has become a major artistic stance in many contemporary aesthetic expressions. The artists discussed here are as varied as artists can be in the products of their labours, but they all in one way or another have chosen to act as mediators in some or all of their works. At the most obvious level, these artists may work with objects which have direct references to animistic art, such as totems, masks and sacred space; at a more remote level, they may handle materials that have no references to "primitive" art, but to which they give a sacral dimension.

Emily Carr's early, deep interest in the native cultures of the Northwest Coast has been taken up by many artists since, but no one has pursued the shamanistic transformation of materials and forms as persistently as Jack Shadbolt.

Shadbolt is on the one hand a major contemporary Canadian artist whose work

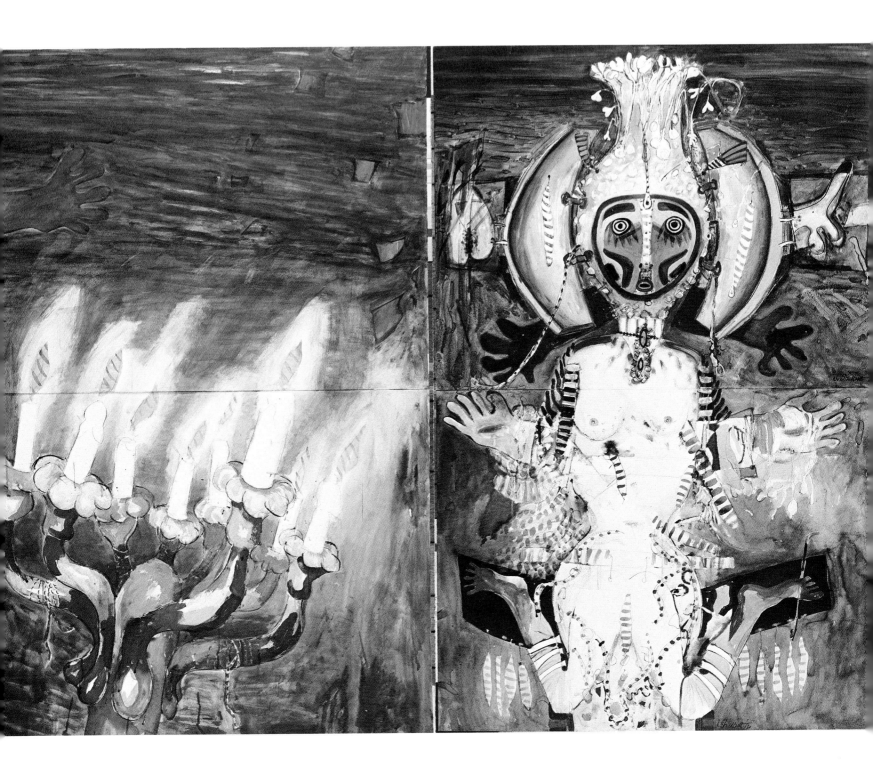

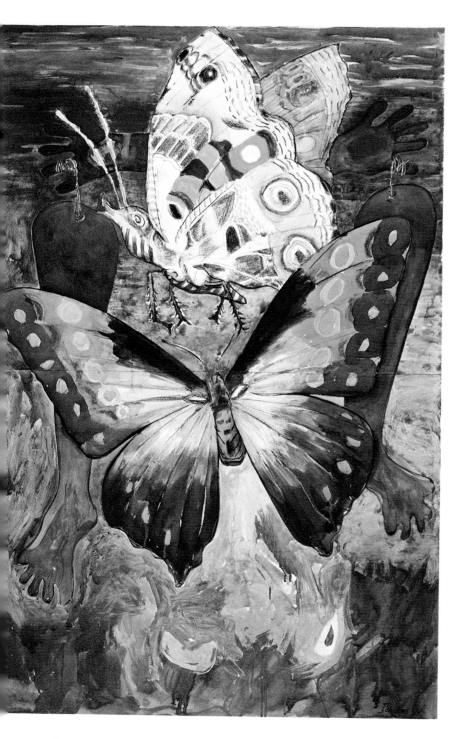

JACK SHADBOLT
Bride (1960–74)
Ink, latex, crayon and acrylic on board:
three panels each 152 × 102 cm
Private collection

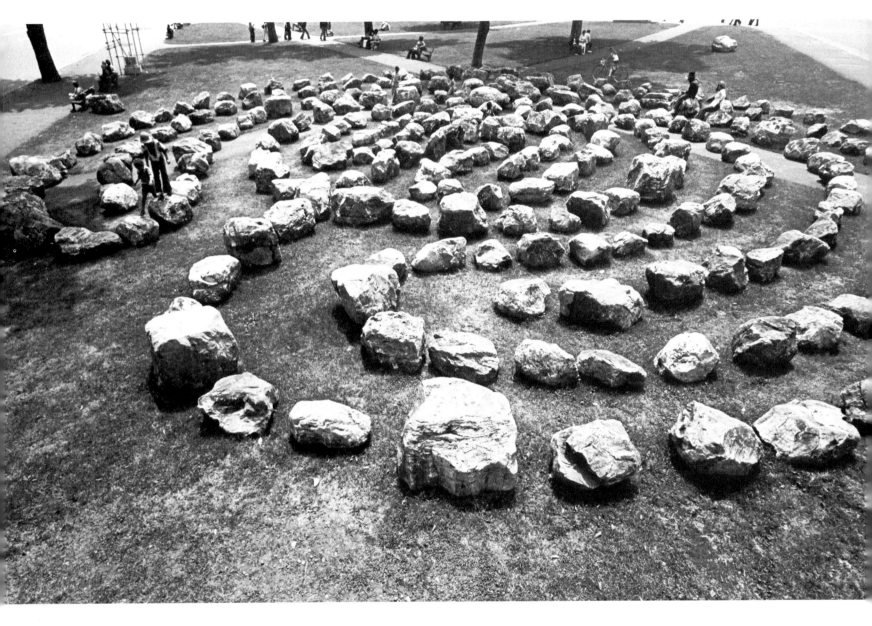

BILL VAZAN
Stone Maze (1975–76)
250 tons of boulders, 37 × 55 m
Installation for Corridart, Montreal

has reflected his continuous involvement in the major art movements of North America. It was Shadbolt who introduced the ideas of the American/German painter Hans Hofmann at the first Emma Lake Workshop organized by Ken Lochhead in 1955. Since the mid-1930s, Hofmann had taught a new formalism which emphasized that the act of painting was forming with colour, and that composition was a balancing of position and negative shapes – his famous push-pull harmonizing of pictorial tensions. Shadbolt absorbed these teachings and passed them on. His own work can be seen as a part of the excitement generated in Canada largely by New York art in the late 1950s and early sixties.

The other side of Shadbolt is the artist fascinated by both the forms and the transformations of the Indian spirit world. Although Shadbolt uses totem-like and mask-like figures in many of his works, these are more visual clues than central transformations. His 1974 triptych *Bride*, for example, exhibits the abrupt transitions familiar in mythic narrative – transitions which require that the work be read symbolically, not sequentially. Yet this is not imitative of West Coast Indian art. Its references to European art, such as that of Chagall, or to Shadbolt's own earlier work, are as strong as its links with Indian art. It seems to me it can be seen most clearly only if we understand that the artist is not acting or expressing or even alluding, but rather that he is trying to transform both an inner, personal experience and a set of external learnings into another reality.

Another artist deeply indebted to an indigenous culture is Jack Butler of Winnipeg, who has worked extensively with Inuit artists and has incorporated something of their attitude into his own work. In the early 1970s, Butler went through a period of direct allusion to shamanistic art, creating a long series of works dealing with physical and skeletal transformations. Recently his work has moved away from these explicit references to a broader concern with

transformations in the composition of forms, in the development of the human body and in materials that absorb light to take on new or previously undiscovered forms. His most recent works, a series of hanging paper arches, are close to installation pieces, yet each piece remains a distinct entity, which only becomes completely meaningful when the viewer is initiated into its mystery and transformations. They are visual objects of some strength, but they also have both material and formal depth in relation to the artist and his past experience. The paper, for example, is made from old drawings felted into new sheets – that is, old art is transformed into the material of new art, an old sensibility into a new. The skeletal structures in the paper are revealed, or come into visual being, only when illuminated, and they refer both to the old drawings and, beyond them, to their Inuit origins.

Totemic references too have appeared in the work of many artists. One thinks of Irene Whittome's *White Museum*, the leather-covered stones of Tim Whiten, the bone and bronze "artifacts" of Richard Prince, the *Caucasian Totems* of Walter Redinger and, more whimsically, the hieratic spoons of Ronald Bloore. But perhaps the major preoccupation with "primitive" objects can be found in the work of the so-called land or earth artists. Although earth art in itself does not necessarily allude directly to the site art of earlier societies, some of the most astonishing works of man have been huge land constructions, such as Stonehenge, the medicine wheels of the Plains Indians, megalithic animal forms and pyramids. These huge, prehistoric structures have inevitably influenced many contemporary artists who may be interested for other reasons in large works built directly out of the soil.

Montreal artist Bill Vazan, for example, has developed his stone circles and calligraphic hillside art – which continually returns to the basic questions of the natural and the cultural – to the point where the relation of self and earth has become for

him the basis of art. The circulating of time, art as artifact in an archaeological sense, the orientation of the human being to the planet – these concerns align Vazan's work with the landworks of past civilizations and give his concepts a significance that relates to our most basic awareness of the cycles and rhythms of life on this earth. He has created stone labyrinths, land designs that cover entire hillsides, and extensive snow patterns. But he is not a romantic longing for the old sense of the sacred place; he never drops his hold on the contemporary situation. He sees the planet both past and future as if it were in part an art object, and sees himself, therefore, as an artist who is very close to the basic nature of the world as a series of systems, both natural and artificial. He transforms this world through physical displacements and groupings of natural objects, and he emphasizes the anthropomorphic centre of all perception of the meaning of these transformations.

The mask motif has been a central interest for Winnipeg artist Don Proch over the past decade. His masks, some of them wearable, are fibreglass heads which have very detailed drawings on their surfaces. The drawings are a part of the topography of the masks and also of the landscape, which in turn becomes face or clouds or body. In addition, other objects with their own reference systems are used to complete the masks – a rifle barrel coming out of the eye, a set of chicken bones appearing as smoke from a chimney. A mask is, of course, a mysterious object in itself, concealing the face, projecting in place of the face a new set of impressions. The drawings and accessory items of Proch's masks deepen the mystery and multiply the references and impressions. His interest in shape-changing extends to his two-dimensional work as well, but it is the mask that affords him the greatest opportunities. Philosophically, Proch has espoused the communty of Assessippi, Manitoba, which he comes from, and he involves a number of people in his art production. Often he will incorporate objects from that community into his

sculpture, modifying them, transforming them to a point where they retain their original meaning but take on a new significance as a part of the art object. Proch mediates the transformation of the community place – via a hay rake, a bicycle, a carved bird – into an aesthetic place.

Greg Snider on the West Coast, working with industrial materials and more abstract forms, performs the same kinds of transformations. He would undoubtedly be taken aback by the suggestion that his work is related to shamanistic art, but he is much concerned with the re-using of "culturally predetermined" (in his words) materials, and with the rediscovery of inherent reference systems which are basic to the place in which he lives. He is a formalist in his mode of expression, but his sensibilities seem to me to be ritualistic. That is, he creates forms which accumulate meaning by transforming culturally predetermined materials into significant symbols.

There are other ways in which the contemporary artist may mediate place. Henry Saxe's 1974 piece *Sight/Site*, which is a ritualistic act more than an installation piece or an art object, and George Trakas's hierarchy of materials and sense of the relation of the material to place, both come to mind.

On a more personal level, Liz Magor has used objects associated with a place or a person and transformed them into totems of a contemporary kind. Her 1979 work *Four Boys and a Girl* consists of clothes compressed into vaguely coffin-like blocks that are set out on the gallery floor along with the press used to make them. These forms were, but no longer are, inhabited – and thereby, they become fundamentally places. Magor's art is a redeeming of forms which people or animals have left apparently empty – discarded forms which were intimately connected with what they were. She transforms these forms in such a way as to reactivate their old meanings and at the same time point to a new significance.

As non-native artists have begun to

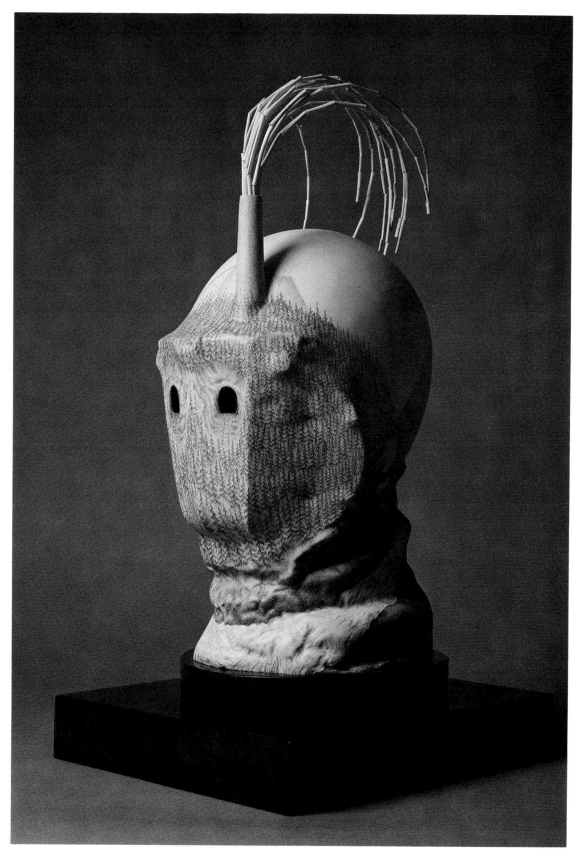

DON PROCH, *Manitoba Mining Mask* (1976), silverpoint and graphite on fibreglass and bone construction, 58 cm high, University of Saskatchewan, Saskatoon

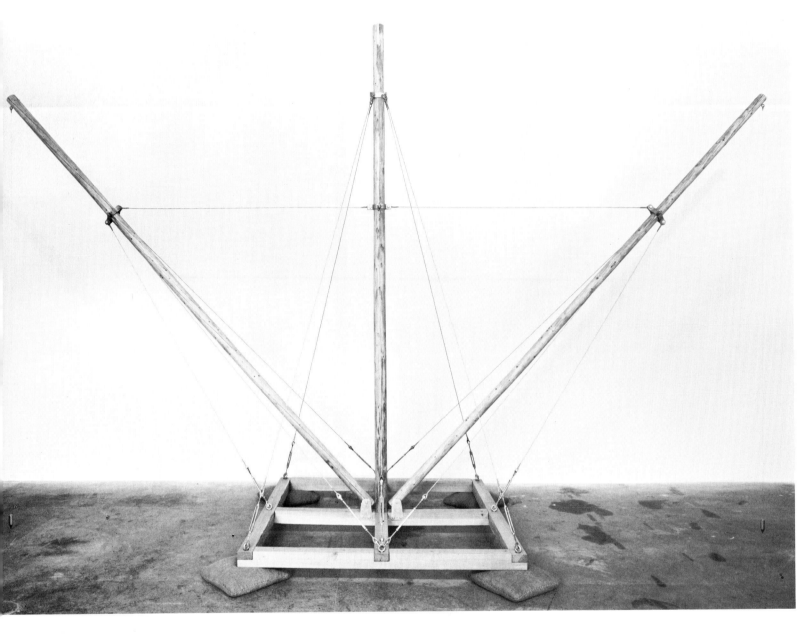

GREG SNIDER
Spar (1980)
Wood and galvanized metal, 383 × 589 × 232 cm
Collection of the artist

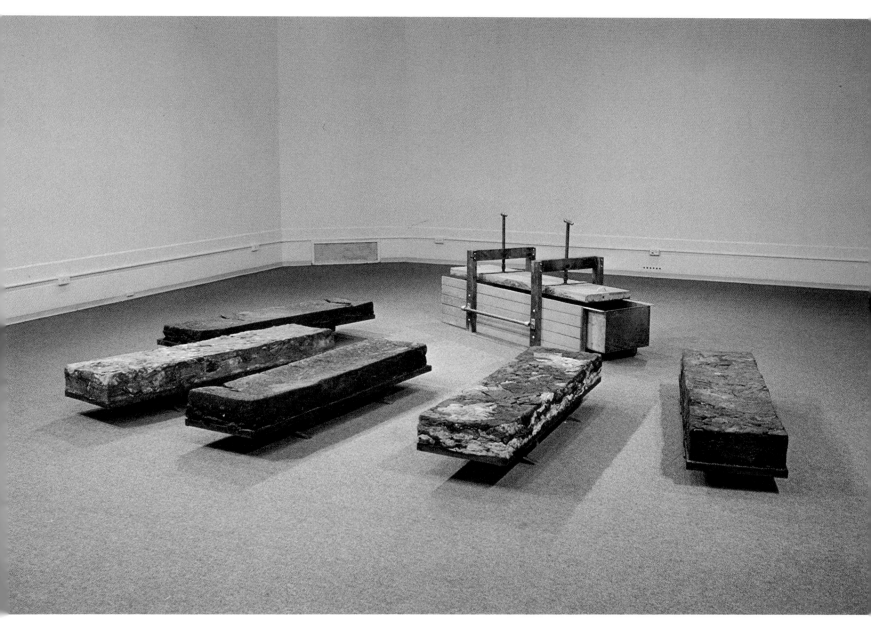

LIZ MAGOR
Four Boys and a Girl (1979)
Fabric, grass clippings, white glue, wood and steel:
five slabs each 178 × 45 × 30 cm; machine 183 × 68 × 68 cm
Collection of the artist

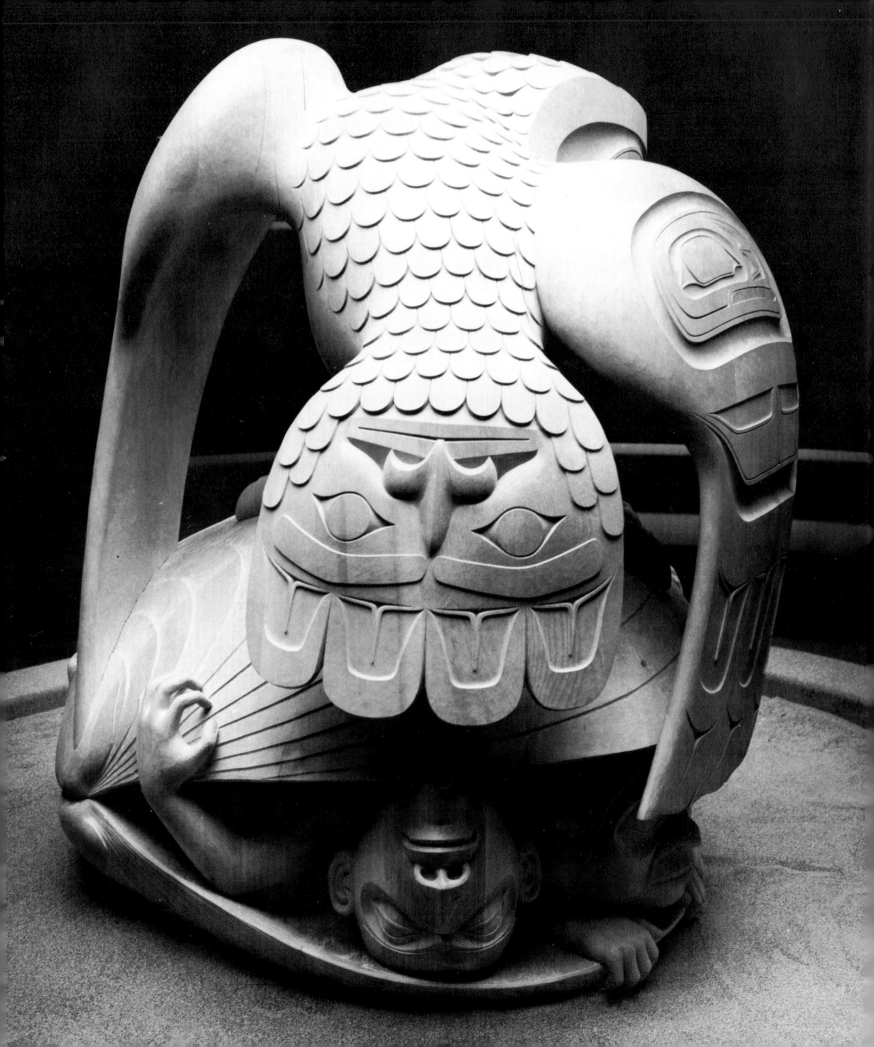

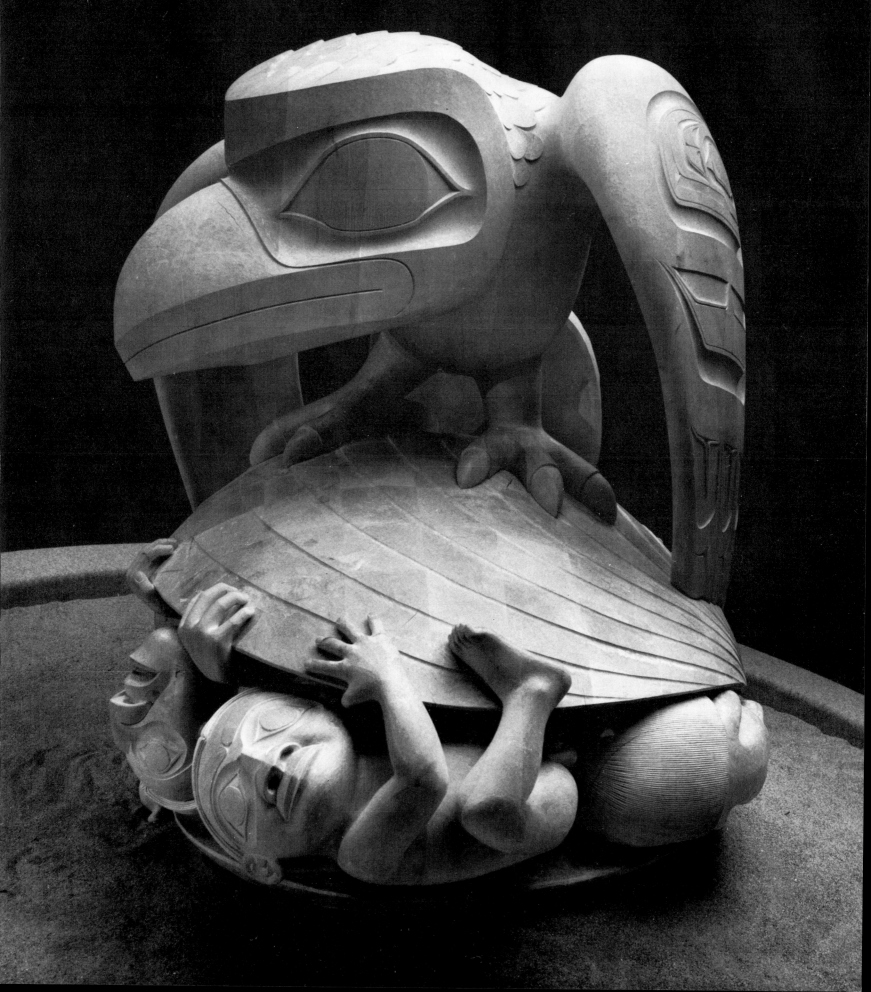

TERRENCE HEATH

appreciate the attitude and concerns of native artists, a number of native artists have adopted artistic modes of expression from the dominant, industrial society which surrounds them – but without, in some cases, removing themselves from the basic mediating role of their traditional society. In 1980, Bill Reid, Haida artist of the West Coast, created what is one of the singularly most impressive pieces of sculpture in Canada: *Raven and the First Men.* Although this free-standing sculpture is immediately recognizable as West Coast Indian art, it has no exact parallel in the traditional coastal art. The work depicts Raven prying open a giant clam, from which the first people then emerge. It is clearly a piece of gallery sculpture, nonfunctional in an architectural sense and meant to be viewed from all sides (unlike the earlier Haida poles).

As the late anthropologist Wilson Duff said of Reid's work, the artist "has been using his eyes and his intuition to jump the seeming chasm between Picasso and Edenshaw."

In a totally different manner, the Inuit carver Karoo Ashevak, who died prematurely at the age of thirty-four, created sculpture which, while recognizably Inuit, openly embraced the self-expressive tenets of contemporary western art. Nevertheless, the sense of place is strong in his carvings even though he does not in fact depict any place.

The two modes of addressing a sense of place in contemporary Canadian art – depiction and mediation – are parallel both in space and in time. There is, nevertheless, a certain chronological change in emphasis over the last thirty years. In the 1950s and early sixties, depiction was by far the most common indication of a sense of place. By the mid-1960s, what I have called mediation could be seen in the work of an increasing number of artists.

There seems to be little evidence that a sense of place is in any way abating as a central concern of Canadian artists. It is, however, undergoing some radical changes. On the one level, there has been strong assertion of regional concerns across the country which has enriched the art being produced. On another level, nationalistic concerns have changed from their former ubiquitous presence and become more focussed in certain art activities. If a strong regional art is the basis for a strong national art, as Northrop Frye argues, then this new sense of place should emerge as a more effective embodiment of the country's aspirations than the more obviously nationalistic art of the past.

Preceding pages:
BILL REID
Raven and the First Men (1980)
Laminated yellowcedar, 210 × 180 × 180 cm
Museum of Anthropology, University of British Columbia

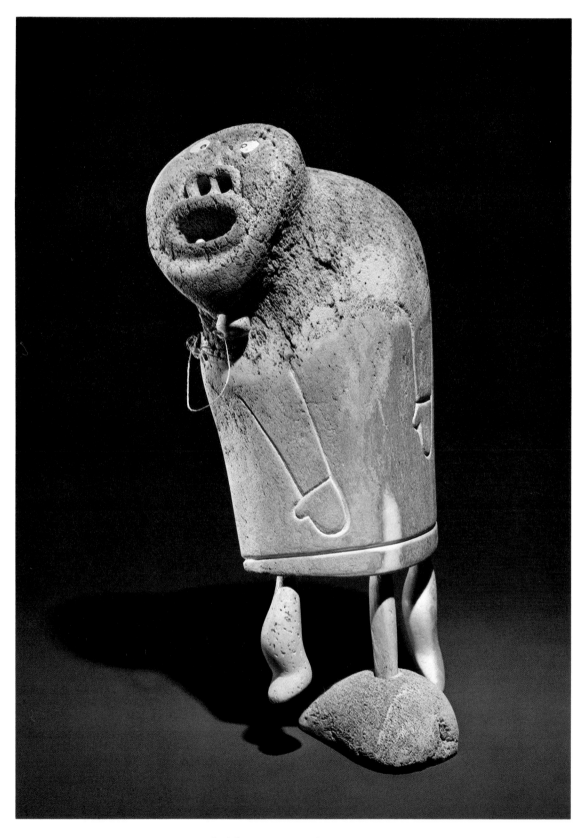

KAROO ASHEVAK, *Spirit* (circa 1971), whalebone, stone and sinew, 50 × 27 × 16 cm, Winnipeg Art Gallery

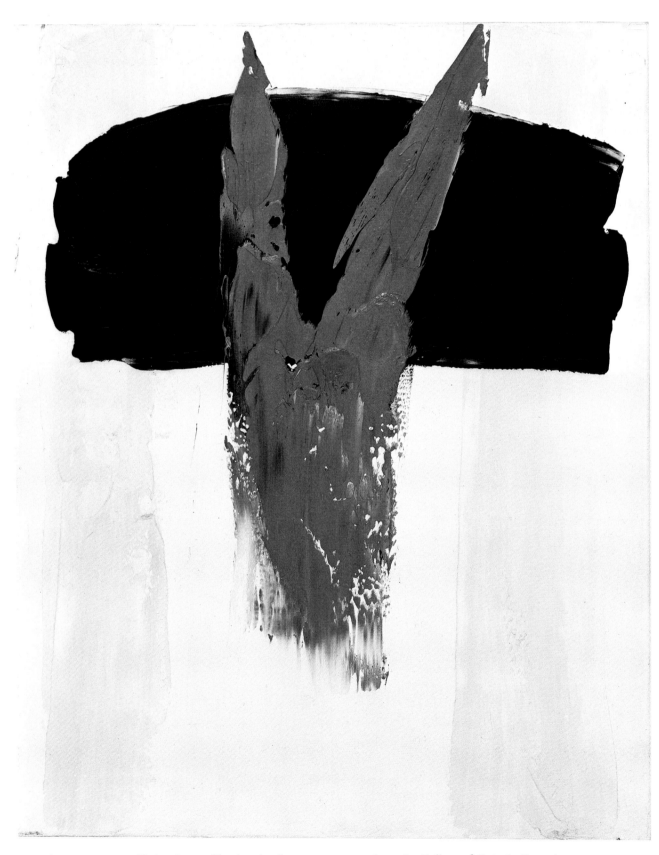

PAUL-ÉMILE BORDUAS, *Abstraction en bleu* (1959), oil on canvas, 92×76 cm, Art Gallery of Ontario, Toronto

As an ongoing gloss on the appearance of much Canadian art during the past thirty years, this essay is more a kind of limited mythology than an art history. And because it is not a history of art in Canada during those years, I have made little attempt to discuss every painter deserving mention, or to order works of art into their proper chronological places, or even to gather the works together with any rigour into discrete collections of related pictures. Instead, I have attempted to provide an inventory of the artist's means, a marshalling of the artist's expressive constants, that will, I hope, demonstrate by accumulation the existence of an adjacent alphabet out of which a genuine and meaningful visual language continually evolves. It is this Ur-language of forms and colours, visual signs and signals, that we read when we look at works of abstract art.

Behind the development of this visual language lies the fact that, throughout the history of his art, man has always been his own abstraction. Alive and conscious, we move as perambulating verticals, living at right angles to what must always be, for us, the horizontal face of the earth. In sleep or death, when we lose consciousness, we fall, recline, stretch out onto this hospitable surface that supports us always. As a result of this raw set of biological imperatives, we assign great presymbolic importance to the two directions, the vertical and the horizontal. The vertical, as a direction, is always seen to be lively and energetic, while the horizontal is regarded by all of us as quiescent and serene.

Our abstract art, which profoundly mirrors what we are and how we order reality, seems to me resolutely structured upon these axes, the vertical and the horizontal, to which we assign energetic and even moral values. The horizontal in art is quiet, peaceful, everlasting, and readable as infinite in both directions. The vertical is, by contrast, questing, ambitious, ethereal, transcendental – and also readable as infinite in both directions. Oblique lines, diagonals, we tend to read as lines or thrusts of energy in the process of rising to become verticals or falling to become horizontals. Because they are neither resolved verticals nor horizontals, we tend to feel oblique lines

The Alternate Eden

A Primer of Canadian Abstraction

Gary Michael Dault

as *local disturbances,* terminal lengths of energy adjusting themselves for the moment against the eternal length and breadth of horizontal and vertical, x and y. Obliques, therefore, are temporary, detachable, highly energetic, articulate, maybe frivolous. And poignant in a sense, because in their state of constant adjustment to the infinite, they are handy graphic compressions of our own mortality.

Right here, in the marshalling of vertical and horizontal coordinates and an adjustment against them of obliques, lies much of the essential business of two-dimensional abstract composition – especially as it first appeared in the rather late arrival of abstract painting in Canada.

It was 1910 when the Russian painter Wassily Kandinsky discovered that one of his nearly abstract landscapes, which had somehow been placed on its side in his studio, no longer looked like anything recognizable at all. It had shaken itself free of all mimetic content, to become in his sight a rhapsodic swarm of free-floating coloured shapes. Despite this gloriously liberating introduction (not given to Kandinsky alone) into the world of pure form and pure colour in intellectual suspension, it took years for the idea of

nonrepresentational art – what is usually (if perplexingly) called abstract art – to settle easily and naturally into the consciousness of artists around the world.

Certainly it took a while to get to Canadians. It was only with painful caution that Lawren Harris worked his way through what Emily Carr called his "serene and uplifted planes," feeling his way along the thread of theosophy (a sometime mystic philosophy earlier embraced by Kandinsky himself) from the radical clarifying of nature in his famous paintings of sharpened and polished mountain tops, to totally abstract pictures. A similar kind of tentativeness can be seen in Ontario's precursor to abstraction, Bertram Brooker. At the most adventurous stage of his career, with the pictures he made in 1929 (like *Ascending Forms* and *Evolution* – both in the National Gallery of Canada), carefully modelled rod and cone structures lift and fasten themselves to already established constructions of vertical and horizontal beams and shafts of light. Today these pictures look hesitant and nervous – though touching in their earnest desire to affect the viewer and induce in him spontaneous emotional atmospheres by means of clarified structures alone, a species of aesthetic Platonism carried out with great and sometimes (as in the case of Harris) noble seriousness.

The next step in the fleshing out of the abstract *x/y* picture (with its arsenal of attendant obliques for structural fervour) was taken by artists who came to understand how these raw building blocks for spare structural truths could be usefully de-Platonized and made more telling and personally expressive. The available space of the structurally defined picture plane could be looked upon as a sort of metaphysical mirror in which the artist's manoeuvrings with colour and line could reflect what he himself was thinking, feeling, dreaming – as a painterly reflection which would end by somehow becoming an equivalent to the sum of the artist's parts.

"How can I know what I think until I see what I say?" asks E.M. Forster's nameless but wise old woman. It was this kind of search for personal meaning – after the fact of expression, as it were – that brought together a number of Canadian artists who wanted more vitality and freedom in painting than the mere streamlining of nature could provide. Their quest was fueled to a large extent by the researches of the European surrealists and automatists of the 1920s and thirties, and the American abstract expressionists of the forties and fifties.

In Montreal, the search resulted in a rapid transformation of the entrenched rules of picture-making. This reinventing of painterly procedures was spearheaded both by Alfred Pellan, who had returned to his native Québec in 1940 after fourteen years in Paris assimilating cubism and surrealism, and by the brilliant Montreal painter Paul-Émile Borduas, who had produced, by 1943, a series of astonishingly tough and fluid little pictures like *Viol aux confins de la matière* and *Signes cabalistiques*. Here, against a deep and velvety dark background (a space as endless and uninflected as possible) Borduas floated and writhed dots and dashes and signs of pigment – direct promptings of his unconscious expressed as the tangible trackings of spontaneous movements of mind. It's as if the hard geometries of the objective world had been dragged inside the psyche where they had melted into something gamier, more visceral. Basically, the crystalline had become the organic. Somehow it was a great deal more personal and revelatory that way.

Borduas and a number of other Montreal painters of similar aesthetic and philosophical conviction began to refer to themselves quite deliberately as Automatistes. The name alone was a proclamation of painterly freedom. They held their first exhibition as a group under that name in a residential district of Montreal in April 1946. (Others in the group were Marcel Barbeau, Roger Fauteux, Pierre

Gauvreau, Fernand Leduc, Jean-Paul Mousseau and Jean-Paul Riopelle – who was then producing a gloomy kind of automatic writing but who would, in 1947, depart for Paris to make the chunky, sanguine pictures in red and green and black and white that would make him famous.) In the incendiary manifesto *Refus global,* 400 copies of which were published on 9 August 1948, Borduas shook the dust of Québec traditionalism and conservatism from his feet and set out to clarify once and for all some of the ambiguities hovering about the concept of automatism. He identified as its three distinguishable procedural modes the mechanical, the psychic, and the surrational. Mechanical automatism proceeded, he wrote, "by physical means – folding, scraping, rubbing, dropping, smudging, gravitation, rotation....Objects produced in this manner [have] universal plastic qualities ...[but] these objects," he added, "tell very little about the personality of their author." Psychic automatism he defined as "free and uncensored movement of thought... surrealism," which was useful mostly, he decided, for an understanding of the nature of the creative process. Surrational automatism he labelled "nonpreconceived writing in paint."

"One form," he explained, "calls up another until there is a feeling of unity or until it is impossible to proceed without destruction. No attention is paid to content while the work is going on. This freedom is justified by the assurance that content is inextricably linked with form." Such a procedure was to be a route to self-discovery, rather than a method for getting pictures made. For Borduas, the ultimate reward of surrational automatism was "a sharpened awareness of the psychological content of any form, the human universe created from the simply universal."

A patient and painstaking searcher after the metaphysical truths to be unlocked from colour and form in nonrational suspension, Borduas worked diligently and with great lucidity during the next fourteen years towards the making of a pictorial unity, towards a new integration of the painterly "objects" that floated on his pictures' surfaces with the surface plane itself. Despite having moved to New York in 1953, in the heyday of Tenth Street abstract expressionism, he remained curiously untouched by the rainbow slatherings of Willem de Kooning or the savage whorls and drips of Jackson Pollock. He laboured instead to thicken and encumber both the painted objects suspended high over his pictures' surfaces and the surfaces themselves, until the twoness implicit in object dancing over surface began to break down into a great, slow-moving unity of thick painted object melded to thick painted background.

After he moved to Paris in 1955, Borduas's paint got even heavier and more recalcitrant, deep and creamy like cake icing, his colour reduced to a majestic white, black, sometimes brown, with only a very infrequent swatch of bright colour for use as a heavy and dignified moment of bravado. In the late and highly theatrical *Abstraction en bleu* (1959), the heavy, smeared V of blue still reads as a distant and disturbing echo of the yearning vertical axis, and is still convincingly figurative in the very temporariness of the blue against the infinite and generalized neutralities of the painting's heavy and solid darks and lights. In what is considered to be his last painting, the work called *Composition 69* (1960), heavy brown-blacks threaten to fill the picture plane entirely, gradually blocking out the yellowish-white light that still gleams from behind the coagulating and intensely suffocating applied darkness.

Despite his long absences from Canada (he was away from this country from 1953 until his death in 1960), Borduas was a central and impressive force in Québec art all through the 1940s, fifties and sixties – mostly, I think, because of the monastic rigour of his standards and because of the heady example of his vigilant policing of his own aims and motives as an artist. He was, in large measure, a paradigm of that

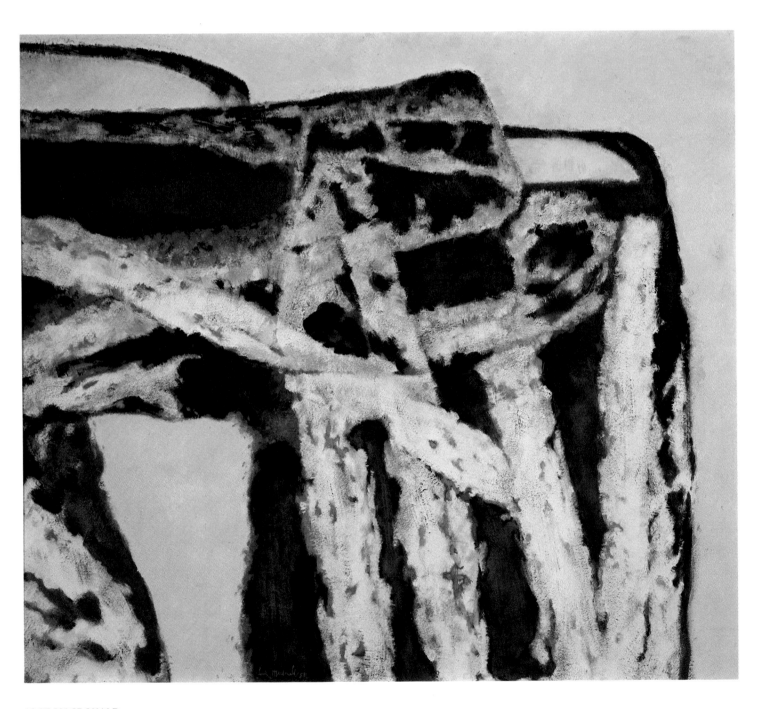

JOCK MACDONALD
Rust of Antiquity (1958)
Oil and lucite on masonite, 107 × 220 cm
Robert McLaughlin Gallery, Oshawa, Ontario

curiously Québec-engendered tension between extreme sensuousness and extreme rationality that so frequently results in a rejection of an outward theatricality and decorativeness for the often private and inaccessible orderings of the theoretical. It occurs again, for example, in painters like Guido Molinari and Claude Tousignant, in their carefully and even scholastically organized flight from Borduas's automatism to their equally demanding and codified plasticism.

It is a touching contrast to the inexorable and sinewy progress of Borduas's Automatistes that advanced abstract painting broke so suddenly upon Toronto during the early 1950s. It was a moment presided over to some significant degree by painter Albert Franck, who was one of the first to encourage (and collect works by) a number of artists who would shortly come together as Painters Eleven.

The group originated in William Ronald's offer to organize an exhibition for Simpsons' Department Store, called Abstracts at Home. The idea was to show abstract paintings happily enlivening a number of rooms of modern furniture. Simpsons' agreed and left the details to Ronald – who promptly called upon Oscar Cahen, Jack Bush, Alexandra Luke, Kazuo Nakamura, Ray Mead and Tom Hodgson to join him in this enterprise. After the display had been mounted, in October 1953, the painters solidified into a group. Ronald asked his friend and sometime teacher Jock Macdonald to join. Oscar Cahen invited Harold Town and Walter Yarwood. Ray Mead asked Hamilton, Ontario, painter Hortense Gordon. And together, they became Painters Eleven, holding their first meeting at Alexandra Luke's studio-cottage in Whitby, Ontario. The Eleven were by no means a group of passionately philosophical and like-minded manifesto-makers like the Automatistes. "We were terribly innocent," Town has said. "I don't think that any of us had a sense that this was a revolution …. We just finally put on a show because we were sick of being told where to hang, how to hang, and when to hang."

During the five years they showed together as a group, the members tended to work their way from a lot of relentless and accumulated dabbing with thick pigment towards a number of painterly methods which resulted in flatter, less modelled, less illusionistic pictures, many approaching the all-overness of design so important to the tacit modernist assumption that paintings are two-dimensional and ought to look it.

Central to the appearance of many of the paintings by members of Painters Eleven during the early 1950s is the presence in their pictures of a reassuring set of x/y horizontals and verticals and the setting up against them of structural and calligraphic hooks, loops, and other oblique-derived disturbances in paint. Of special interest is the presence of the painted hook. A product of both the abstraction of natural forms and a sort of liberated handwriting as the energetic trace of pure personality objectified, the hook occurs frequently in the early work of Cahen, Town, Ronald, Nakamura, Mead and Hodgson. It lends a sense of feral urgency to Cahen's *Animal Structure* (1953), where a central vertical thrust made up of coloured biomorphic loops of paint is enlivened by the inclusion within the structure of a rapidly sketched beak and a couple of beautifully drawn claws. These biological moments surfacing in the welter of Cahen's abstract colour structure act as very specifically readable vectors which break through the surfaces of the stylishly applied paint and return us to the exotic unknowableness of the animal. In Jock Macdonald's *White Bark* (1954), the painted hooks are quite obviously derivations of thorn or springy young leaf. In William Ronald's *Slow Movement* (1953), however, the big brownish hooks of oil paint are detachable enough from the rest of the structures in the painting to act as free-rolling spatial delineators, tumbleweeds of pure directionality, urging the eye to roll slowly along the painting from left to right, up and over a thickly painted and rather stolid red-orange horizon-structure. The painting could be a score, a chart, a

shorthand for the orchestration of slowly looping movement. Basically, then, the hook is an attention-getter and a gnarled vector.

Loops are less imperative, less demanding, but they work on the same principle: that the viewer will recognize in a loop of paint a shorthand for his own organicism. Loops are organs. Loops are discrete, bounded volumes (implied volumes, since we are speaking, after all, of paint) with edges and surfaces, and with interiors that might leak through a puncture. Harold Town's *Essence of Rex* (1953) is a system of loops organized around a central spine. His *The Dixon Passing Muggs* (1956) presents, against a deep vertical ground, visible to the left and to the lower right of the central structure, a complex amalgam of painted biomorphic forms, as least one of which seems correctly located for a stomach, while another, near the top of the picture, takes its place as a persuasive set of breasts – or lips, or other sexually charged organs. All this may of course be quite distant from the meaning of the picture as the artist saw it – or sees it still. But it follows nevertheless that the provocative organic shapes in the painting do trade on their power to meet us at our narcissistically urgent pressure points – and set up what is, at least initially, a compelling response, a kind of analytical disarmament, however temporary.

After a time, the hooks and loops either dissipated or they coagulated into great, heraldic central presences – emblems of consciousness hovering in the centre of a vast performance space. The way Jock Macdonald, for example, unclenched his hook and loop paintings and opened them out into the strange, floating, meditative colour swarms of *Primordial Fire* (1957) and *Rust of Antiquity* (1958) is a joyful study in the progress of Canadian modernism.

Ronald and Town were, in these years, masters of the central image. Ronald's central-image paintings were made, he has pointed out, as his imagistic contribution to the arsenal of painterly effects being mounted by the New York abstract expressionists. His *J'accuse* of 1956 (see page 18) is one of the first of them. Here, against a very landscapish grey-olive ground surmounted by a yellow-white "sky," is a shirt-like or flag-like sheet of bright scarlet edged in black and digging down into the central body of the painting. Its force is ameliorated somewhat by the presence of a couple of smaller and pictorially secondary patches of pink farther over to the left. The picture is fine and savage in the requisite abstract expressionist way. Its link to naturalism is still evident, however, in the theatrical intrusiveness of this red patch into the cold landscape-ness all around.

By 1959, Ronald had reduced his dependence on landscape to the point where, in a picture like *Gypsy,* the central, brain-like image – a great vortex of blue and pink and hot orange, with one "eye" or axle in bright blue right in the middle – floats authoritatively (like a coalescing of consciousness) against a system of white horizontal slats. The landscape reference is thus reduced, in the rhythmic repetitions of the slats (like rough Venetian window blinds), to a kind of staff upon which the big heft of central images plays itself out. *Kiyo,* also from 1959, presents the central image as a noble and celebrational presence with radiating spokes and bright lines of white and yellow paint squeezed from the tube directly onto the canvas where they snap and eddy around the central presence like little bolts of electrical homage. In 1960, the central image was codified into a slightly unruly central square in a banner of black and white checkerboard patches (*Scotch,* 1960). By 1964, it was a thin, battered membrane of sandy and rather fleshy pigment stretched over a watery beige ground, its indeterminacy pointed up even more by the solid band of red and yellow stripes running vertically behind it like a spine through the painting (*Mystique,* 1964).

Ronald's brief but showy foray into hard-edge painting, with its neat, ruled-off passages of even, uninflected colour,

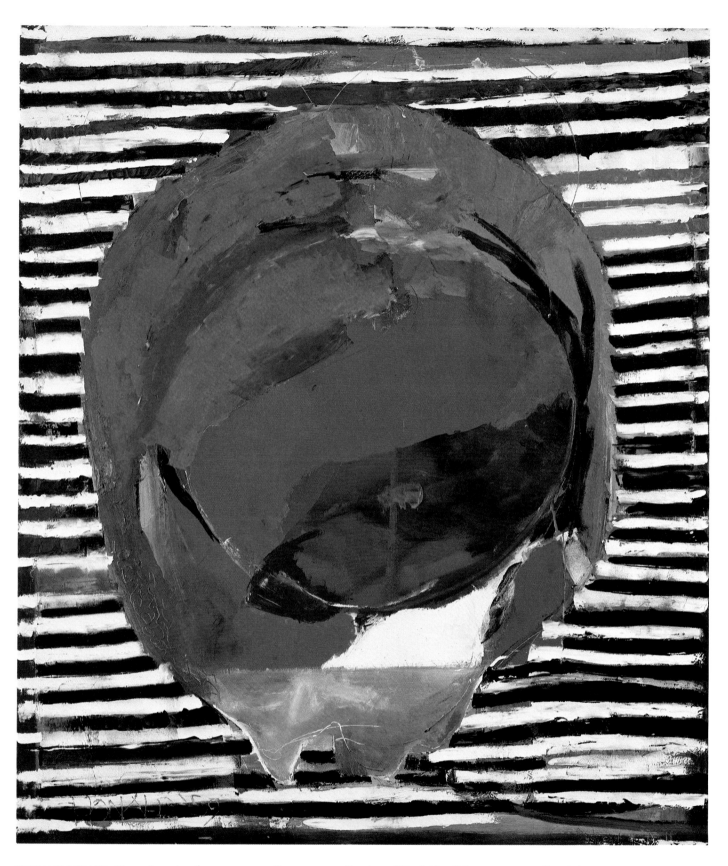

WILLIAM RONALD, *Gypsy* (1959), oil on canvas, 178 × 152 cm, collection of Dr & Mrs Sidney L. Wax, Willowdale, Ontario

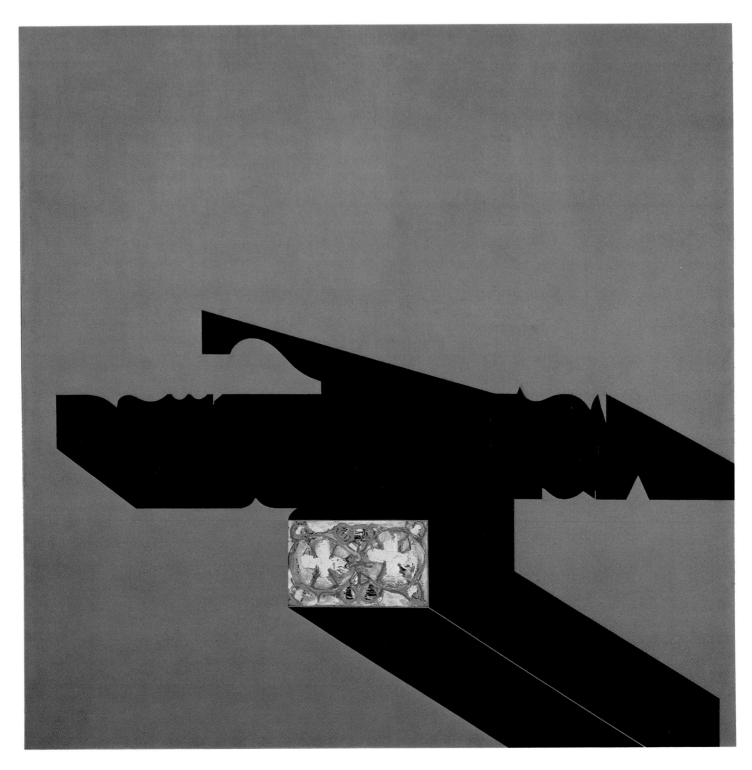

HAROLD TOWN
Park #1 (1970)
Oil and lucite on canvas, 188 × 188 cm
Canada Council Art Bank

resulted in works like *Barbara's First Tantrick* (1969) and the enormous and, in my estimation, rather weak-kneed mural in Ottawa's National Arts Centre. Thereafter, he returned to the kind of painting he could do best: the generous, miasmic kind. By 1973, he was labouring to achieve a sort of painterly plenitude, loading up his canvases with pounds of freshly squeezed pigment – hot writhing twists of it – like a crowded beach seen from the air. Only in a painting like *Sumiko* (1974) is it really clear that here again is the Ronald central image, this time loose and unhemmed and exploding out from the middle in a molecular swarm of coloured bits all coming at you from what is still perceivable as a support-structure of rawly painted verticals and horizontal braces.

Harold Town's use of the central image was very different from Ronald's, and different in a way that points up Town's love of painterly paradox and his progress through a synthesis of procedural discontinuities. He often erected totemic presences in the central spaces of his pictures, such as the muscular twist of paint thrusting up through the great, diamond-shaped playing field of *Pitch Out* (1960). He has also acknowledged the pictorial authority of the central image by taking it on in compositional combat, as in the majestic *Tyranny of the Corner* series (1962–63) where the attention paid to the corners of the painting is paid just for the slightly perverse pleasure of discomfiting the normally dominant centre.

After the optical experimentation of the *Dot* pictures and the *Silent Light* series of 1968–69, Town started into the impressive *Park* series. Here, he could take what he knew about hard-edge effects and combine that with passages of abstract expressionist turmoil, coming up, as a result, with a series of paintings that were unsettling in the friction they generated when their radically polarized styles rubbed together on the same plane. *Park #1* (1970), one of the best of the series, is a vast, flat and mostly open canvas with a handsome hard-edge construction which builds up into the emptiness from the lower right. This construction, a streamlined visual metaphor for the man-made environment, the sibilant song of urban man, holds a small, neatly defined rectangle of decorative expressionist painting, a postage stamp of pigment possibly representative of park or garden-spot, perhaps an outpost of individualism in a machine-honed and mass-produced world.

The *Parks* are an absorbing study, too, for the way they take the usual structure of the *x/y,* horizontal/vertical support and fold it back upon the surface of the earth, as it were, and view it from above. In many of Town's paintings, the work is seen as if the artist – and then the spectator – were hovering above the earth, the *x* and *y* horizontals and verticals becoming coordinates of an imaginary latitude and longitude. It happened in the artist's 1958 St. Lawrence Seaway mural, where compositional elements were suggested by the plan of the Seaway's system of locks and canals, and again in the Toronto International Airport mural, where the thrusts and reaches of the painting derive from the appearance of the airport's runways as seen from the air. With the *Parks,* the spectator looks down upon a map-derived set of natural and man-made passages in uneasy juxtaposition, spread out below him at a distance (a fictional distance, controlled to some extent by the relations between the usually small patches of hot, heavy painting and the supporting passages of cool, uninflected design).

In the paintings that followed the *Parks* – the extraordinary and inexplicably ignored *Snap* paintings of 1972–78 – Town combines the flatness of the support structure of the *Parks* with the urgent bite of their tiny passages of tension and turmoil. The two modes become one within the making of these sometimes eccentric but always invigorating paintings. The paintings were called *Snaps* because Town painted them by

HAROLD TOWN
Snap #101 (1975)
Oil on canvas, 188 × 254 cm
Collection of the artist

loading a taut, horizontal string with pigment and snapping it at the canvas. Some of them are unruly and garish, gloriously baroque and sometimes deliberately gauche and tasteless, much given to grape-purple and scarlet and a particularly indecent acidic yellow. Some are slow and warm and pastoral, independent planes of gentle, muted colour, reluctant to give themselves up to inspection. One of the best of them is *Snap # 101,* a part of the so-called Envelope Series—in this case a postmodern meditation on Monet's haystacks. "The painting is about those shimmering fields," Town says, "and about keeping everything flat."

One of the most original and indeed visionary of the Painters Eleven was and is Kazuo Nakamura, whose work, unhappily, is not much seen or discussed these days. Nakamura's early work consisted of spiky renderings of tree and sky, full of painted hooks and arcs and thorns and the whole cliché-ridden vocabulary of tentative abstraction from nature. Soon, however, Nakamura was making eerie pictures of strange navy-blue architectural structures erected on bright, endless plains against evacuated navy-blue skies. Other tiny structures sat at lonely distances, remote, aloof. Nakamura's atmospheres were so empty, his shadows so dark, his sidelighting so hard and unrelenting, his pictures looked as if they'd been painted on the moon.

The critics have paid much more attention to Jack Bush and his progress from the clotted abstract expressionist oils of his Painters Eleven days to the radiant colour-field banners that made him an international reputation. Part of the fascination of the Bush story is traceable to the clarity of his decisions about what constituted modernist art and the relentlessness with which he set about to "knock the ball out of the park." ("I thought, well, what have I got to lose, let's try go and beat Matisse; he won't mind at all….") Another part of the fascination lies in the art-politics of Bush's friendship with the influential American art critic Clement Greenberg.

As early as 1955, Greenberg had worked out his restiveness with the inability or unwillingness of many important painters of the New York school (Willem de Kooning, Arshile Gorky and Franz Kline especially) to break out of the shallow spatial theatres erected by the cubists and thus create with a greater spatial freedom "in the absence of a sufficient illusion of depth." Given the creation of large, flat performance-fields of colour, Greenberg felt, the pictures' surfaces might be spared the jars or shocks resulting from "complicatedness of contour," leading to works that would stand or fall "by their unity as taken in at a single glance."

Greenberg's role in the making of Canadian modernism has been trumpeted, excoriated (Ronald Bloore called him "the greatest disaster that ever struck Canadian art"), and, I think, exaggerated. Greenberg himself apparently feels his influence was a lot less profound than has been widely thought. The fact remains, however, that when Greenberg came to Toronto in 1957 (at William Ronald's suggestion) to spend half a day looking at the work of each of the members of Painters Eleven, he gave Bush a number of ideas that Bush took to heart.

Not everybody wanted Greenberg's advice, but Bush welcomed it. He and Greenberg seemed to have hit it off right away, becoming friends as well as participants in a dialogue about the route to important art. Greenberg admonished Bush for his uncritical annexation of the "hot licks" of the New York action painters. He told him his oils were gummy and tentative. He liked Bush's watercolours better. He liked their openness, the fact that they were unencumbered by elaborate effects. "Try painting simpler and thinner, as you have done in your watercolours," he told Bush. "If it scares you—good—you'll know you are on to something that is your true self." Bush tried and came up with large-scale oils like *Breakthrough* (1958) which, while they were still murky and scumbled, were composed of formally discrete elements riding on an empty, uninflected, more or less monotonal

KAZUO NAKAMURA
Infinite Waves (1957)
Acrylic on canvas, 94 × 102 cm
Robert McLaughlin Gallery, Oshawa, Ontario

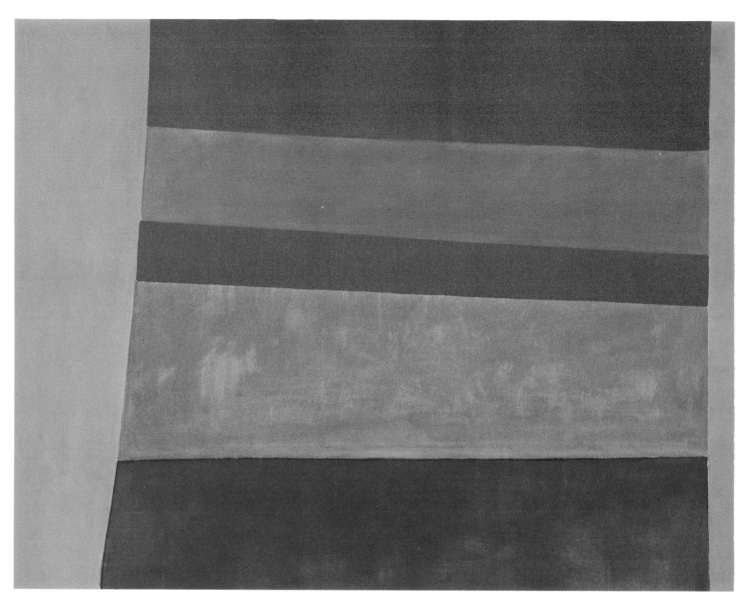

JACK BUSH
Dazzle Red (1965)
Oil on canvas, 206 × 264 cm
Art Gallery of Ontario, Toronto

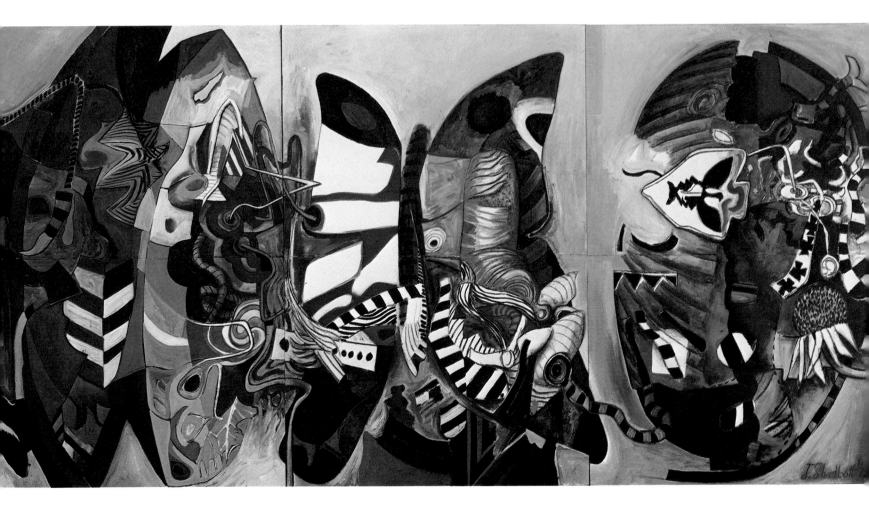

JACK SHADBOLT
Transformations II (1974)
Mixed media on board: three panels each 152 × 102 cm
Private collection

ground. From then on, he was a man in pursuit of painting as fully declared colour.

In *On a Green Ground* (1960), Bush produced a central image painting, but he reversed the Ronald/Town procedure by brushing in a loose, watery, green-brown ground all around a raw canvas disc in the centre, flanking it with a pair of thinly washed, floating verticals in red and blue. The raw canvas centre acts as a corrective to the conventional reading of illusory (i.e., cubist) depth in the picture, and reminds the viewer that what he sees is in fact simply colour on the honest materiality of raw canvas. After a couple of directly considered homages to Matisse (*Bonnet* and *Top Spin,* both from 1961), Bush began his famous funnel or sash paintings, in which a central vertical, made up of thinly painted bands of pure colour soaked into raw canvas, is cinched in at the middle by the force of the surrounding billows of painted ground (or in which, contrariwise, a central vertical of stacked bands of colour exerts enough force within the picture to suck the large fields of ground into its commanding core). The sash pictures are very beautiful in their lambent and uninflected colour. Because the colour was soaked into the canvas itself, each picture could be perceived as a painted object rather than the support for a bright skin. Each was as anti-compositional as Bush could make it. All in all, the sash paintings were very assured, very much the successful product of what Bush has described as "policed intuition." Today they seem among the finest examples of postpainterly abstraction or colour-field painting.

So too are the *Step* paintings like *Dazzle Red* (1965) in the Art Gallery of Ontario and *Tall Spread* (1966) in the National Gallery – where, against a controlling spine or vertical axle at one side of the picture, a series of horizontal bands of saturated colour mounts up the canvas. An exhilarating bringing-together of lyric hues, of pinks and yellows, hot reds, sky blues, ochres, and light grass greens, the *Steps* are among the most successful of Bush's explorations into

the expressive power of free, untrammeled colour. They are also as close as Bush gets to integrating an entire surface of colour blocks in a way that precludes having them unlock and retreat to the position of structural supports in shallow cubist space.

It is, in fact, only during these years, say 1963 to 1970, that the pictures work this way. After the *Steps,* beginning with the so-called Fringe paintings, Bush adopts a mottled organic ground upon which he dispatches smaller swatches of colour to disport themselves. Because the colours are fresh and bright and often inventively positioned, the pictures have an infectious playfulness. But that's all. No longer have they the power to present themselves (as the *Steps* did) as a collection of pure volumes of colour in space, free of the traditional dramaturgy of figure against ground. Even less can be allowed the "musical" paintings of Bush's last years. Here, the mottled grounds turn into pretty, sponged-on surfaces of swirling, romantic, tinged clouds over which Bush has laid rhythmically gathered strokes of colour. These paintings, most of which have prescriptive musical titles and which appear to set up some highly sentimental equivalences for the beating of music through time and the stroking of colour through space, are extraordinarily disappointing and, at the end of a career like Bush's, bathetic in their ingenuousness.

Vanguard painting came to the West Coast almost entirely through the energetic explorations of one man – Jack Shadbolt. While Painters Eleven were teaching themselves modernism in Ontario, Shadbolt was careering around Italy and Greece, having already studied in London and New York. His base of operations was then, as it is now, Vancouver, and he constantly brought to his art a stimulating amalgam of ideas from Emily Carr, from European surrealists like Miró and Ernst, and from American abstract expressionists like Kline and de Kooning. He employed everything from the washed Mediterranean palette of Nicolas de Staël to the heavy oil embroglios of

GARY MICHAEL DAULT

Kokoschka. Shadbolt wound his pictures on an armature of nearly Wordsworthian pantheism cranked up by a Nietzschean absorption in the epic satisfactions of triumphant god-forms, totems and talismans that have come through the selection processes of nature and history. His drawing from 1953, *Presences after Fire* (in the collection of the National Gallery), for example, is a depiction of a number of rather personable – indeed, almost cocky – vertical forms that seem to be neither flora nor fauna but instead partake of the generalized qualities of both – and seem, too, to be mighty pleased about their withstanding the destructive but clarifying fire that has apparently preceded them.

Widely read and quick to internalize ideas, Shadbolt had always been extraordinarily prolific. From 1947 to 1959, he sluiced out from what was clearly a fecund imagination a whole career's worth of accomplished watercolours. From about 1959 on, he painted in oils and then in acrylics, making bigger and more intellectually ambitious paintings, all the while engaged in the self-imposed search for what he speaks of frequently and reverently as form. "A bristling form can suggest aggressiveness," he has written. "A self-enclosed form, sealed firmly within its own contours, can suggest solitude. Intertwining forms can evoke eroticism. A dancing, rhythmic sequence may evoke a sense of lyric joy...." The expressive power of forms – which Shadbolt seems convinced are archetypal, and which together constitute a sort of image bank, a *spiritus mundi* – is released only within the artist's imagination, where, in a state of what he has called "palpitant reverie" or what he once referred to, with equal felicity, as "an orgy of recall," events in his life are "legendized." "My paintings," he says, "seem to me to be imprints of this inchoate flow [of legendized events] passing through me into configuration."

During the last fifteen years Shadbolt's pictures have grown cleaner and more highly organized than before, though with no loss

of richness or detail. A late work like *Bride* – a triptych whose centre panel was painted in 1960 and whose symbolically enriching wings were added in 1974 – is incandescent with the raw stuff of mythology and surrealist sexuality (a fetish doll, the menorah, a moth, and a butterfly), all of it saved by the artist's powerful sense of compositional rightness from turning into a passage of pop anthropology. His long series of "butterfly triptychs," like the stirring *Transformations II* (1974), is even more abstract than shamanic dreams like *Bride* (pages 66–67), more generative of the idea of symbolically assisted transformation itself, and generalized enough to accommodate readings which include metaphors about the nature of the creative process at large. By 1977, in paintings like *Mountain Summer (End Flight)*, the butterflies have been absorbed into the tao of formal energy that runs all through the painting, so that their former precise, kite-like outlines devolve into one overall matrix of buoyant, vivacious colour. Shadbolt's career has been a long steady advance – careful, painstaking even, and sure.

About the time of the Painters Eleven activity in Ontario, and at the height of Jack Shadbolt's solitary journey from naturalism to abstraction, a number of isolated but ambitious painters in Saskatchewan also began to make their presence felt.

It was Ottawa-born painter Ken Lochhead who, as head of the Regina Art School, persuaded the University of Saskatchewan to allow its outpost at Emma Lake in the northern part of the province to be used as an art camp for his summer classes. This was in 1955. From that year on, the Emma Lake Artists' Workshop and Critics' Symposium – organized, as painter Art McKay once put it, "to inject a spark into this culturally arid area" – became a stage on which was acted out the complex and invigorating progress of western Canadian abstraction.

Jack Shadbolt led the first Emma Lake seminar in 1955. Beginning in 1957, the workshop was conducted by a series of

Americans, including Barnett Newman, Clement Greenberg, Kenneth Noland, Jules Olitski and others. This weight of American modernist thought fell heavily upon Canadian prairie painters (especially in the pivotal summers conducted by Newman and Greenberg), with results that are still being debated. It is inescapably true, however, that Barnett Newman's huge fields of colour, his "new kind of flatness, one that breathes and pulsates," came as a shock of recognition to Saskatchewan painters. So did Greenberg's critical shoring-up of Newman's spatial radicalism.

Ken Lochhead, for example, had begun with a number of small pictures in which groups of heraldic figures, modelled like chessmen, arranged themselves in theatres of cubist space. These were followed by pictures like *Collective Farming* (1953), where the figures became merely chunky vertical presences leaning back upon a flattened space that slanted off towards an unmistakeably prairie horizon. The implications of such a collapsed space led Lochhead to complete (shortly before Greenberg's 1962 seminar but after a certain amount of exposure to Newman) an entirely different kind of picture. His *Left of Centre* (1962) was a four-foot square of masonite on which he had painted four simple, interlocking shapes in enamel – with a vertical axis of raw masonite down the middle of the picture and a narrow band of raw masonite running all around like a sort of frame, gathering in the painting's emphatic right- and left-handedness. *Left of Centre* was flat, anti-illusionistic, fully declared, irreducible.

By 1963, Lochhead was painting works like the well-known *Dark Green Centre*, with its simple, emblematic arrangement of bars of lucid, open colour soaked into the middle of a vast field of unsized and unprimed canvas. *Dark Green Centre* was icon-like in its overall appearance, and was at the same time a philosophically orthodox emblem of Greenbergian postpainterly abstraction. During the 1970s, Lochhead produced a long series of huge, ethereal paintings made by spraying cloudy, amorphous grounds and then floating upon them wispy arabesques of candy-coloured acrylic, organic vectors aflutter on deep, spongy vistas of ground. Not nearly as intellectually rigorous as his stained, Greenbergian works of the 1960s, these cosmeticized spray-paintings are little more than collections of inconsequential painterly events being enacted against deep, resonant grounds – rather similar in effect (and in their cloying prettiness) to the paintings of Bush's late "musical" period.

Lochhead was a member of a resolute group of painters who congregated around the Emma Lake seminars and the Norman Mackenzie Gallery in Regina (where another of their number, Ronald Bloore, was made director in 1952). They referred to themselves, after the National Gallery's *Five Painters from Regina* exhibition in 1961, as the Regina Five. Others in the group were Douglas Morton, Ted Godwin and Art McKay. McKay has remained, with Bloore, one of the toughest, most uncompromising of the group, keeping the rigour of the paintings that first brought him attention: his homely but taut enamel mandalas on masonite, such as *Effulgent Image* (1961) and *Flux* (1964).

Bloore was and still is the most compelling and the most provocative of the Regina Five. An art historian and university lecturer as well as a painter, he has always brought to his painting a highly developed sense of the intellectual continuity of visual ideas. Bloore has submitted to a number of self-imposed painterly disciplines, the most obvious being his long sojourn in the realms of white. In Bloore's hands, white became as reflexive as a full palette; indeed, Bloore must surely have employed as many whites as the Inuit have different words for snow. (I own a Bloore drawing, a study for his mural in the Confederation Centre, Charlottetown, on which there is a scribbled checklist of a dozen kinds of white to be used for that one work alone.)

His characteristic forms – those simplified

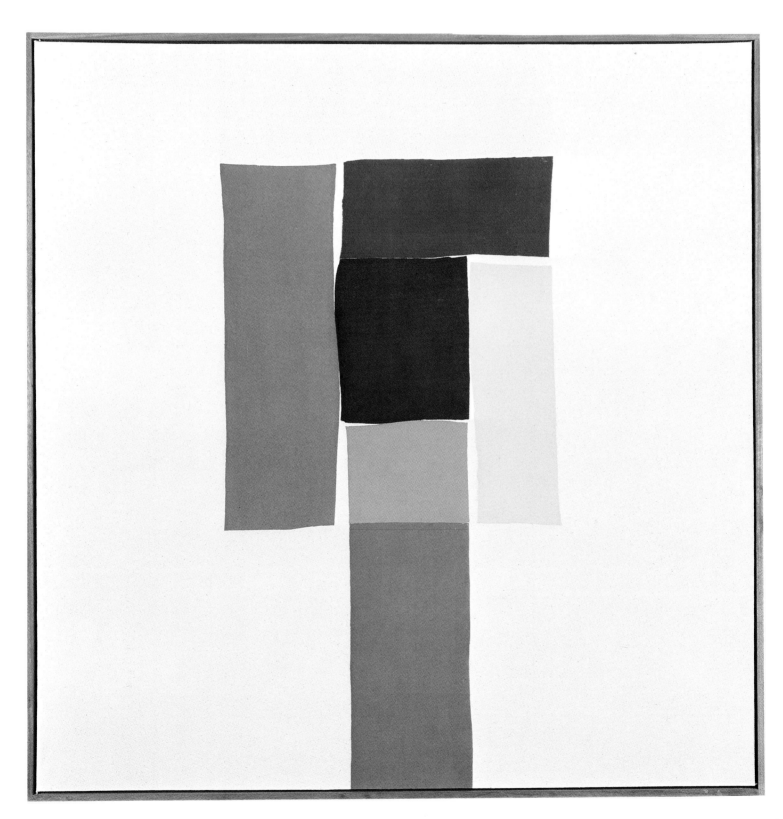

KENNETH LOCHHEAD
Dark Green Centre (1963)
Acrylic on canvas, 208 × 203 cm
Art Gallery of Ontario, Toronto

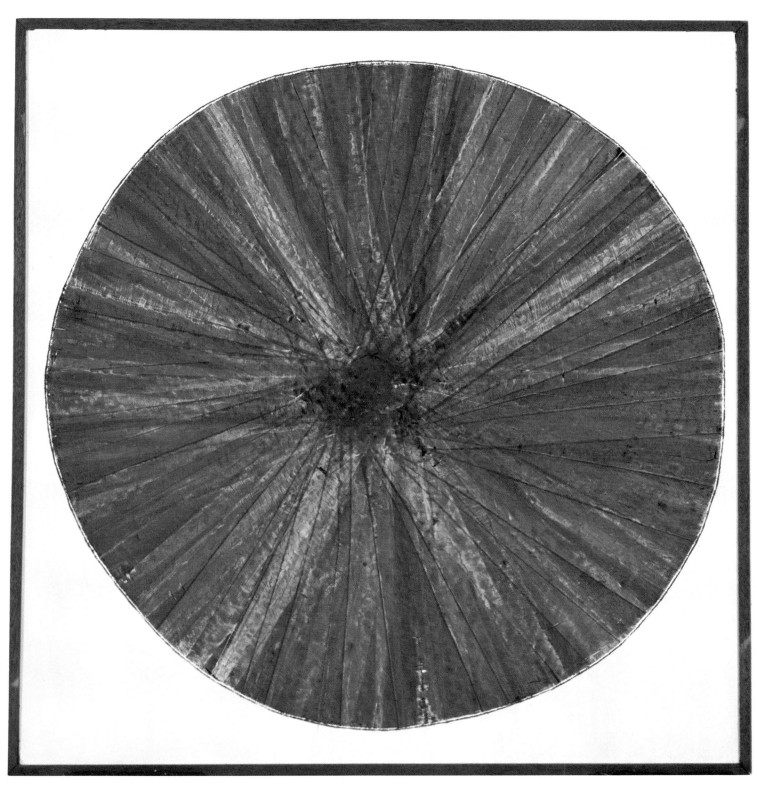

ART MCKAY
Flux (1964)
Enamel on masonite, 122 × 122 cm
Edmonton Art Gallery

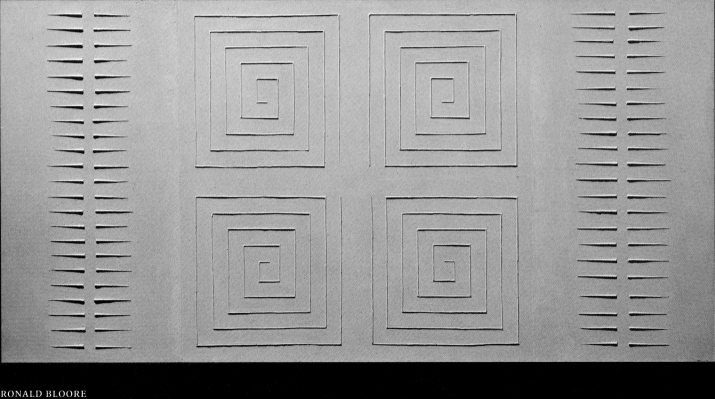

RONALD BLOORE
Painting #11 (1965)
Oil on board, 122 × 244 cm
National Gallery of Canada, Ottawa

and indeed codified arrangements of white welded by the almost sculptural force with which he applies paint to the masonite panels on which he works – are often mandalic discs, like McKay's. Often, too, there are cellular nets stretched across his wide horizontal or tall vertical surfaces. Sometimes he employs delicate, incised ribs of pigment, striations, lines of hardened paint cut into dots and dashes. These articulations of paint are laboriously built up out of the masonite by Bloore's monastic and tireless way of applying his medium: letting it dry, sanding it down, applying more, drying, sanding, and so on until the paint that remains when the work is finished looks somehow as if it had always been there – a system of mysterious but inevitable runic marks that seem to rise out of the board on which they occur.

"The prairie makes mystics of us all," wrote a Saskatchewan curator, and it is tempting to see Bloore's mandalas and his endless, white horizontals and yearning, white verticals as responses both to the big-sky country where many of the paintings were made, and as responses to a searching mysticism in the artist himself. But equally potent as the organizing force behind the paintings is the anthropological ground swell that animates Bloore's images and links them to the charged and timeless symbols of the past.

Bloore's latest pictures seem, unfortunately, to lack the satisfying metaphysical rightness of the great white-on-whites. Never comfortable with abrupt colour shifts, Bloore has nonetheless undertaken a long series of black and white compositions (many of them in sumi ink on paper) in which arbitrarily chosen shapes interreact in ways that appear to be offhand and even (however alien to Bloore's behaviour as a painter) spontaneous. The cumulative effect of this straining after buoyancy is a certain formal inauthenticity.

Prairie painting after the Regina Five was a spirited and fertile amalgam of the toughness and vigour and dogged privacy of vision of the best of McKay, Lochhead and

Bloore, the Newman-Noland-Olitsky-fueled flatness of colour-field painting supported by Greenberg's pronouncements about the integrity of the two-dimensional painted object, and the grandeur of prairie flatness itself. It was out of this heady mixture of influences that such painters as Otto Rogers and William Perehudoff came to maturity. Perehudoff was to run the entire gamut of postpainterly abstraction's modes and means, sometimes with genuflections to Bush. Rogers would modify the rigorous orthodoxies of prairie abstraction both through the natural delicacy of his sensibility and through his deep commitment to the Baha'i faith – which he seeks to make palpable in the measured equilibrium of his canvases.

Rogers's absorption in what he calls his "continuing pursuit of synthesis and atmosphere" has led him, as he wrote in 1978, "to stand silently in awe of the two great factors in creation – unity and light." He goes on to ask himself, "What is the balance between the head and the heart and what is their conversation? Is it possible that the language of exchange between knowing and loving is a construction of light and a unity of diverse elements?" There is something of Bush's childlikeness in Rogers's collapsing and transforming of the various modalities of sensuous experience, but his stylistic wistfulness is shored up by his mysticism. He finds, for example, "a mysterious connection between the senses … how a certain surface can seem melodic, can seem to have sound in it, or a certain surface can seem to be able to be breathed in, be very atmospheric … and yet it's just texture." This delicacy of sensuous crossover has resulted in some exceedingly rarified paintings, most of them built formally upon the solid horizontal of the prairie, over which dance and billow vibrant clouds of painted matter – punctuated, usually with the little convex buttons of pigment that turn up all the time in Rogers's paintings, as if they were indices of the artist's control over his own ephemerality.

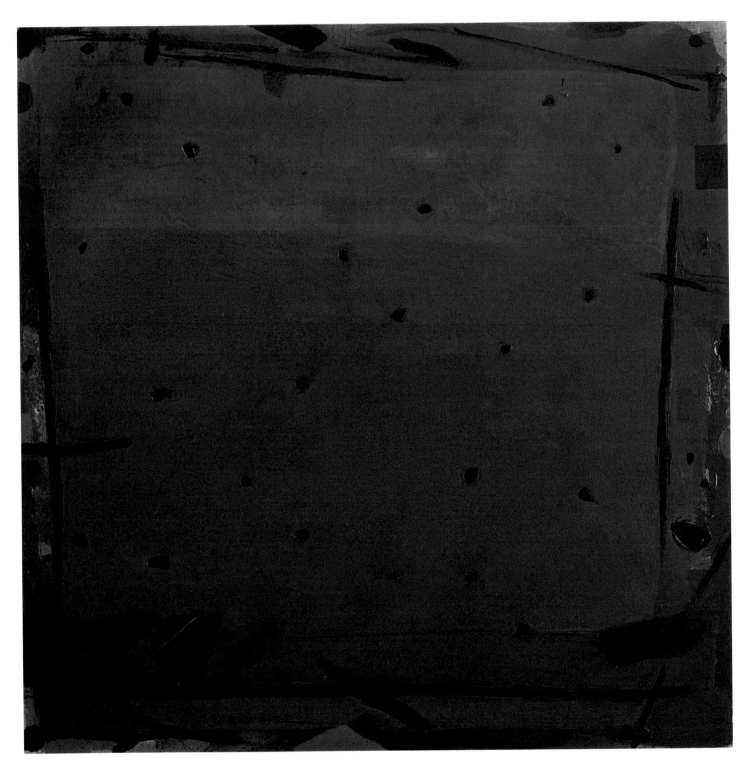

OTTO ROGERS
Mondrian and the Prairie Landscape (1978)
Acrylic on canvas, 152 × 152 cm
Mendel Art Gallery, University of Saskatchewan, Saskatoon

Sometimes, Rogers's landscape-derived abstractions make asymptotic approaches to the reality of nature. His *Silver Field* (1976) is a cold, severely horizontal arrangement of bluish-black marks (fences? shards of frozen vegetation?) distributed poetically over the surface of a convincing evocation of the prairie in winter. By contrast, his *Structured Atmosphere* from the same year is merely a heavy field of dark green-purple, lowering over a low-set horizontal axis which may or may not be read as a horizon line. His splendid *Mondrian and the Prairie Landscape* (1978) is a highly formal painting, very much a "unity of diverse elements" in which an art-historical reverie about (I suppose) the nature of the imperious rectangle and its fate at the hands of a transforming prairie spirituality is carried on the painterly shorthand of a brownish-green lozenge (the greenness of natural life forms, nature *green* in tooth and claw?) surmounted by a generalized reddishness (the fate of a primary colour reborn in the mind of the mystic?). The prairie may indeed make mystics of us all; for Otto Rogers, at least, the prairie is a wide, infinitely receptive golden bowl into which he is able to pour the promptings of his own, sometimes too intangible, free-floating spirituality. (Younger prairie painters have tended to keep their eyes focussed more on the immanence of New York than on the omnipresence of heaven.)

Greenberg, Newman and the other theorists and practitioners of colour-field painting had opened to the painters in Saskatchewan a sense of heroic scale and a sense of the simplified lyricism extractable from colour on its own. They had quite a different influence upon painting in Montreal (and the influence there of Greenberg himself seems to have been nil). In the West, free colour had become intertwined with nature and nature-mysticism (probably because of the overwhelming spatial fact of the prairie), but in Montreal, New York colour-field painting was seen as a way to denaturalize colour,

setting it up as a neoplasticized matrix from which could be cut demonstrable facts about the nature of perception and spatial reality. The Québec painter who has done most to invest colour with this hard physical presence and an internal set of unsentimental behaviours is Guido Molinari.

"Language in general," Molinari once wrote, "is a vehicle for thought; painting isn't. It accomplishes thought by itself…." This heady freeing-up of painting from the multitude of functions that are literary, political, and generally adjacent to the unspeakable confrontation between colour and consciousness has occupied Molinari since the mid-1950s. As a precocious and somewhat dandified young intellectual, Molinari had successfully posed his way, with considerable juvenile panache, through everything from painting in the dark and painting blindfolded to declaiming volleys of surrealist poetry from a baby's highchair. His early immersion in tachiste experimentation led him rapidly through so many phases of modernism that by age twenty-two he was already scribbling animadversions upon the automatism of Borduas and his followers and throwing in his lot with the anti-Automatiste Plasticiens. (He was, however, never officially a member of the group, which consisted of Louis Belzile, Rodolphe de Repentigny, Jean-Paul Jérôme, and Fernand Toupin.)

Molinari, like the Plasticiens, felt that the Automatistes brought too much that smacked of "taste" to their intellectually fired derangements of painterly attack. They were also, he decided, continuing to construct their abstract formal discoveries within the illusionistic, implied three-dimensional space which had long been abandoned by Piet Mondrian, and more recently by Jackson Pollock. "Whatever the literary or *plasticien* vocabulary an art form uses to define itself, it will be valid only in terms of the spatial structure it creates," Molinari claimed in an article published in 1955. "And it is the solution to the problem of colour-light that will condition this space. In short,

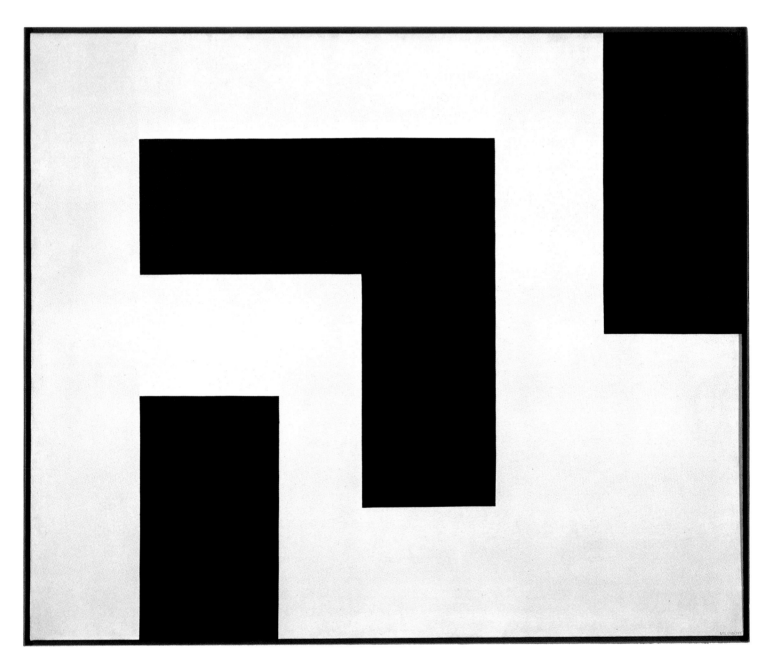

GUIDO MOLINARI
Angle noir (1956)
Duco on canvas, 152 × 189 cm
National Gallery of Canada, Ottawa

we must stop redoing the painting which has already been overly redone."

Molinari came early to an understanding of the essential two-dimensionality of the picture-plane and, at the same time, of the reversibility of the figure-ground elements within a painting. The three black geometric shapes in his *Angle noir* (1956) are so thoroughly interlocked both with the edges of the canvas and with the white areas remaining that they no longer seem to float within the painting's space as a whole but seem, rather, an equal and integral part of the work's structure. Rodolphe de Repentigny, writing about *Angle noir* and Molinari's other pictures of the time, pointed out that anything in them that might contribute to what he termed "localized tensions" had been wiped out. "There remain," he wrote, "only powerful balances, heightened by extreme contrasts: light and the absence of light."

Colour-light, as Molinari had put it, was too often used by artists as a wrapper for some other kind of pictorial concern and not examined for its own perceptual display. For him, colour was a way of creating a "vibratory space" that had its own weight, density and presence. He chose the vertical stripe as the most convenient and rigorous embodiment of uninflected, saturated colour, and began testing its meaning as a performing quality by abutting it with stripes of different colours, freeing each one – in the autonomy such juxtapositions bestowed – to become as fully itself as possible. What Molinari sought was a pictorial space which would correspond to what he called "the emotional reality of the internal world" without reproducing the structures of the external world. Molinari's serialized stripes, apprehended by the viewer as a sort of vital metaphysical chord, set up "a constantly renewed time-space continuum," which, because of its complexity, defeats memory and, as a result, appears as "essential newness at each moment of perception by the viewer." *Bi-sériel orange-vert* (1967) is an example. The ongoing perceptual renewability of the paintings themselves quickens in the patient and attentive viewer a rewardingly unencumbering feeling whereby he is encouraged to become the second polarity in a mute but urgent dialogue between the painting's painted space and his own accelerating spatial understanding. Molinari's colours-out-of-space behave with remarkable exactness and subtlety. The colour of a stripe is understood for a moment in the full clarity of its own properties and is then modified, perfumed almost, by the alternate qualities of the next one. A colour previously experienced is experienced differently when it is discovered again flanked by colours different from before. Molinari's colours ripple and breathe. They are reflexive and demanding, responsive, resistant, alive.

In the late 1960s, in paintings like the triptych *Dyade brun-bleu, Dyade orange-vert, Dyade vert-rouge* (1968–69), which summarized his work up to that time, Molinari widened the stripes, reduced their number, and reduced the optical dazzle by quieting the colours into harmonic rather than chromatic contrast. Such reductions, paradoxically, make the performance of such works even more demanding and complex. Molinari has pointed out that within any large surface of a given colour (as, for example, within each of the wide stripes of paintings like the triptych), that colour will have both a peripheral quality and a central quality, which are always different from one another. "You cannot," he asserts, "get an equilibrated mass [of colour]. Mass always more or less organizes itself in an opposition between nucleus and periphery." All this is perceivable only over time. As Molinari puts it, "the painting can have a symbolic function by which you can say that the percipient comes from the periphery [of the painting] *and that he actually enters* [my italics], just by the enumeration of the colours, the serial aspect of the work; he gets involved in the core and he makes the colours alive and real. All this happens in real time, anthropomorphic time."

Molinari's paintings of the past three or

four years, paintings within the *Quantificateur* series, are virtuoso engineerings of extremely dark colours, rich browns and greys and purple-blacks, presented as wide vertical stripes which, because they are so subtly close in chromatic value and in the warmth or coolness of their toning, are extremely slow to reveal, first, their underlying structural principles and, second, the nature of their colour performance.

Like Molinari, Claude Tousignant has been painstakingly self-conscious in his patient uncovering of the formats for his researches into the nature of colour-in-space. Beginning, the way Molinari did, with paintings of an all-over, tachiste surface that short-circuited the Automatiste figure-ground deliberations, Tousignant rapidly worked his way through the theoretical shopping-list so important to vanguard art in Montreal during the 1950s (the ideas of Piet Mondrian, Mark Rothko, Barnett Newman) and came out the other side with simple "uncomposed" panels split evenly into two uninflected enameled rectangles (like *Oscillation,* 1956) or, even more radically, with panels enameled a single colour, clean and hard as refrigerator doors (such as *Monochrome orange,* 1956). "What I wish to do," Tousignant wrote at the time, "is to make painting objective, to bring it back to its source – where only painting remains, emptied of all extraneous matter – to the point at which painting is pure sensation."

This pursuit of hard, unyielding irreducible space eventually turned into a long exploration of the nature of light in painting – an exploration which led to the targets or bull's-eye paintings for which Tousignant is probably best known. In 1965, he painted twenty works to which he gave the generic name *Transformateur chromatique:* immense circular paintings made up entirely of sets of bright, concentric bands of colour which flicker and pulsate outward towards the edges of the disc, centrifugally, and back in again, centripetally, towards the centre. The

opposing systems both cancel and reinforce one another. It is a wild optical confrontation that heightens the curious self-absorption of the paintings, making them objectified, self-sufficient presences.

These were followed, in 1966, by the *Gongs* (a smaller number of colour bands, each of them equal in width) and the *Accélérateurs chromatiques* (1967), where Tousignant sets up a circular system of serialized colour bands, not unlike the serial verticals of Molinari, but which here are iconically solipsistic, a system of colours in conference – in camera, almost. Indeed, it is Tousignant's use of the localizing disc (his colour bands partaking neither of infinite horizontals nor verticals but becoming instead an ongoing warping of both into circles) that gives his work its autonomy, its stubborn and eternal immediacy.

Like Molinari and Tousignant, Yves Gaucher was impressed by the spatial discoveries of the American abstract expressionists, particularly Newman and Rothko. When Gaucher saw the Museum of Modern Art's Rothko exhibition in 1961, he experienced what he subsequently described as shock – at the size of the paintings and at their ability to absorb him in spatial meditation. It was Rothko, as Roald Nasgaard of the Art Gallery of Ontario has pointed out, who clarified for Gaucher what painting meant: "It's not what you see…it's not what you analyze…but the state of trance that you can be put into by the work…."

Great fields of enterable colour, like Rothko's vast and cloudy solitudes, were one route to the state of trance. Rhythm was another. It is usual to think of music as rhythmic and painting as spatial. It is perhaps more stimulating, however, and more useful, to think of music as gatherings of spatial densities first perceived by the ear, and paintings as the product of pulsations and punctuations read first by the eye – and after that by the entire embodied imagination. Certainly for Gaucher, rhythm was the dependable given of existence itself;

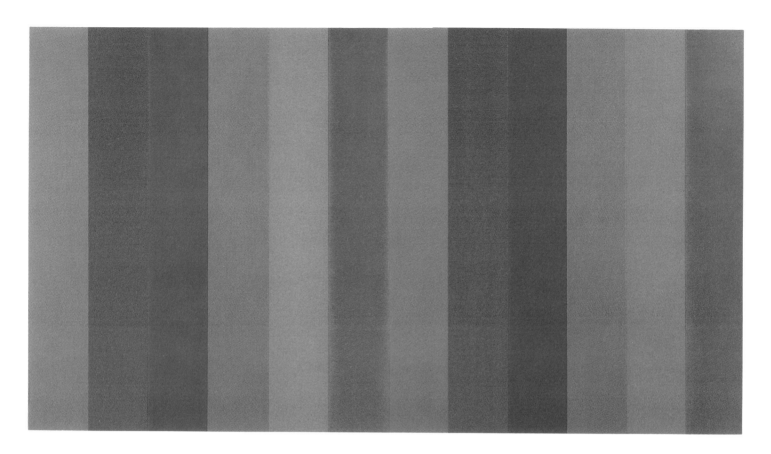

GUIDO MOLINARI
Bi-sériel orange-vert (1967)
Acrylic on canvas, 203 × 363 cm
National Gallery of Canada, Ottawa

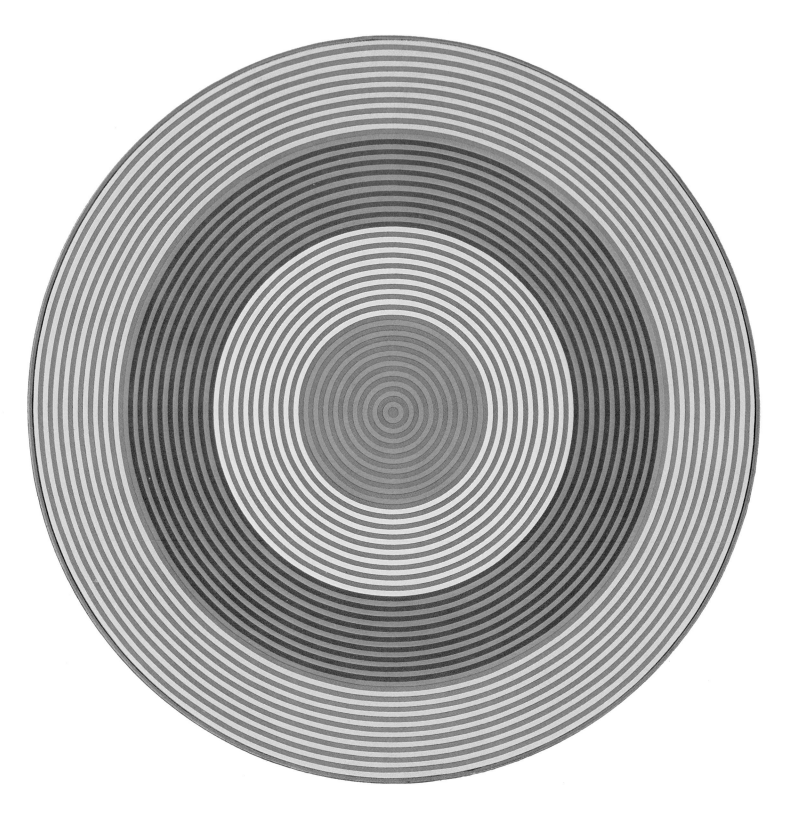

CLAUDE TOUSIGNANT
Gong #36 (1966)
Acrylic on canvas, 92 cm diameter
Canada Council Art Bank

it was heartbeat, night and day, the seasons, the whole round of dancing life. And it was the creative informing of this sense of continual recurrence with which he ultimately infused his paintings.

It began in the early 1960s with the fine *En hommage à Webern* prints, in which tiny squares and short embossed lines pushed up out of the heavy white paper that supported them. The prints looked like scores for an unknowable music, and they were slowly readable in time, from side to side and up and down across their soft, absorbent surfaces. After this came the *Danses Carrées,* square paintings hung from one corner (into a diamond or lozenge shape) with groupings of short lines and squares arranged symmetrically upon their surfaces.

In 1966, Gaucher began the series he called *Signals,* wide horizontal paintings supporting groups of lines of equal length (the "signals" that give the series their name). These short, coloured lines (sometimes they're grey and are "coloured" by the pressure of the coloured ground around them) set up both an intriguing sense of the nearly detachable massiness of the blocks of colour they almost succeed in defining, and at the same time, a strangely convincing horizontal skittering of light conducted from side to side. This visual beeping (it's almost aural) is carried on in the *Ragas* of 1967, where the signals are no longer arranged symmetrically, and in the great *Grey on Grey* paintings of 1967 to 1969. Tranquillity and energy, limitation and transcendence, emptiness and plenitude; these works are gentle, almost invisible paintings that hum with their silent, lateral piercings of grey signal through grey ground. They move and do not move, sound and remain silent.

The *Colour Band* paintings that followed investigate with great authority (if not always with the keening drama of the *Grey on Greys*) the relative weights and measures of pure colour in space, colours lying heavily or lightly, in modifiable relation one upon the other, lying in wide horizontal bands where they take on the landscape's slow, diurnal pace in their luxurious evolvings into positions of pictorial prominence and withdrawal.

Jean McEwen's use of the fundamental spatial coordinates is strikingly different from Molinari's, Tousignant's, or Gaucher's. Like Molinari, McEwen has for the most part chosen the vertical upon which to base his paintings. With McEwen, however, the vertical is no longer a planar, anti-compositional colour area, but rather a spine running up through the body of the painting, holding it together and providing an axle on which hinges the palpable right- and left-handedness of McEwen's surfaces of sparkling colour. His paintings are not about structure but about entrapped light; light caught in thick, silky glazes, light in bright shards, like bits of bottle glass on the beach. In the latest paintings, works like the beautiful *Espace minuté de jaune et mauve #3* (1982), the central spine has been reduced to a vertical rent in the canvas, through which show dabbed highlights of blue, pink, purple. The rest of the canvas is a rippling white-gold scumbled over the bright diamonds of colour that lie buried just underneath.

Equally committed to a certain untrammelled gorgeousness in painting is Charles Gagnon of Montreal. Gagnon is especially interesting in the ways he has interiorized the "hot licks" of the New York abstract expressionists (of which Clement Greenberg spoke so disparagingly to Jack Bush). He has contained their effects by constructing exquisitely proportioned fields and optically precise containers. Within the very inventive boundaries of these framing devices, his dashing brushwork is free to enact the rituals of abstract expressionism's convulsive painterliness.

Gagnon first saw the work of de Kooning, Motherwell, Pollock and the rest (so the story goes) in the pages of *Time* magazine in 1954. A year later, he was on a bus to New York. He spent his time there in a devoted

YVES GAUCHER
Vert 1 (1968)
Acrylic on canvas, 204 × 305 cm
Canada Council Art Bank

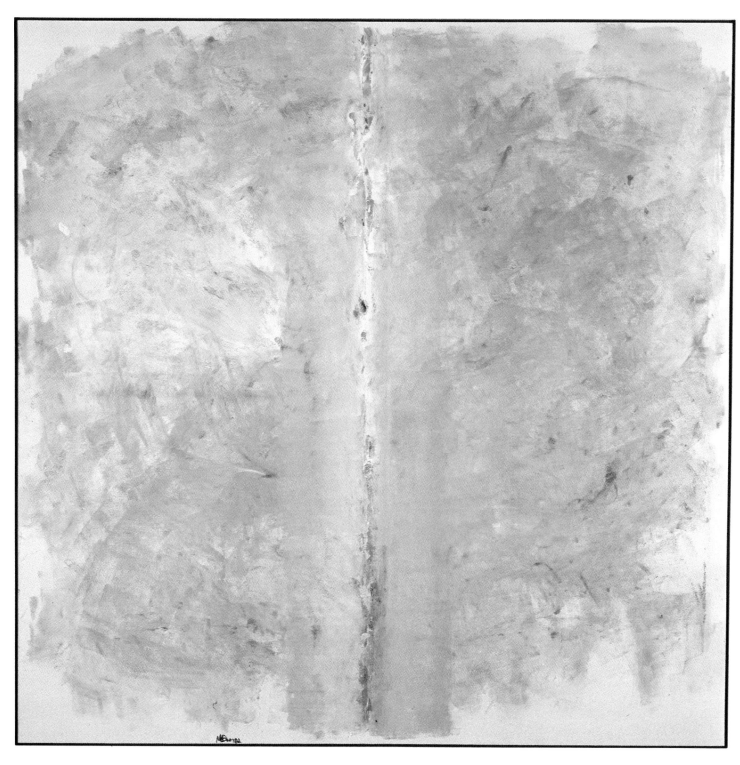

JEAN MC EWEN
Espace minuté de jaune et mauve #3 (1982)
Oil on canvas, 183 × 183 cm
Mira Godard Gallery, Toronto

CHARLES GAGNON
Inquisition FMRR (1980–81)
Oil on canvas, 213 × 285 cm
Yajima/Galerie, Montreal

apprenticeship to abstract expressionism, with the result that nobody else in the country can apply paint with precisely that speedy, de Kooningesque whip and slather which Gagnon can achieve. It could have been a problem. Nobody, after all – including Gagnon – wants to be a pocket de Kooning. Fortunately, Gagnon had formal ambitions for his paint-handling ability. They had to do, as Philip Fry argues, with Gagnon's abilities as a photographer and, in particular, with his intuitive understanding of the idea of the viewfinder, the picture frame, cropping and boundary: of inside and outside, and of what Fry persuasively describes as the creative tension between the condition of being here and the condition of desiring something out there, "between the realities of daily life and an ideal state of affairs." Paintings like the *Marker* series of 1973, for example, are constructed so that a wide horizontal field of sumptuous, fleshy, abstract expressionist paint handling (drips, wipes, stroke engulfing stroke in a cloudy buildup of deep space) is contained between two black (or white) bands running along the top and bottom of the painting, compressing what is in between, testing the difference between the plane of the canvas itself and the illusory depth of the paint in the middle. The *Screenspace* and *Splitscreenspace* paintings (1975–76) are similar to the *Markers,* with the important difference that the loosely painted central area is itself split into horizontal bands, but with each one clearly a discrete space – possibly at a different imaginary distance from the plane of the canvas itself.

The handsome *Cassation* paintings, begun in 1976, work like the others except that the horizontal banding is gone; now one large rectangle of loosely brushed paint is imposed on another – like a door of paint cut into a wall of paint. Because both areas are handled in the same loose, open manner, the smaller, centred rectangle initially seems nearer, more enterable than the larger rectangle that makes up the rest of the painting: a figure on a ground. This

impression is immediately countered, however, by the fact that both figure-plane and ground-plane *are composed equally* of drips, splashes, and swipes of the same kind, of the same frequency and density, of the same hues. The pictures, then, are *two kinds of deep, painted space compared:* two illusory planes, one no more nor less real than the other. Yet they are obviously different – or why compare them? A luscious, painterly conundrum. What tends to happen is that when the viewer's understanding of the painting's space starts to break down, he is disarmed into a pleasant sort of spatial guilelessness whereby the painting can finally begin to mean something. "I don't believe that art has anything to do with communication," Gagnon has said. "Art really deals with communion. You're making a passive statement instead of an active statement; you're there, and you're letting the people associate themselves with what is there…."

In 1955, the year Gagnon got on a bus for New York, there was a Painters Eleven exhibition at the Hart House Gallery in the University of Toronto. For a handful of ambitious young artists – Graham Coughtry, Michael Snow, Dennis Burton, Richard Gorman, Robert Markle, John Meredith, all of whom were still or had recently been students at the Ontario College of Art – and for their friend Gordon Rayner, who was already working as a commercial artist, the exhibition had revelatory impact. Like Gagnon, these young painters knew the work of the New York school only through the photographs in magazines. The works by the Painters Eleven, by contrast, were raw and real and theirs to inspect at close range. "We just couldn't conceive of painting with such strength and power," Dennis Burton has said. "All purely abstract but not like Mondrian, or Picasso, or Kandinsky. Such surfaces! Gord [Rayner] and I went back to our studio…and painted our first nonobjective, nonfigurative abstract paintings that same day, and vowed over some Hudson's Bay rum never to paint

representationally again!" Subsequent visits to the Albright-Knox Gallery in Buffalo, New York, to see their first real de Koonings, Gorkys, Rothkos, Motherwells and Stills accelerated, for most of them, what Painters Eleven had begun.

Most of these young, post-Eleven abstractionists came eventually to exhibit at the Greenwich Gallery, a shoestring showplace for the new art, begun by Avrom Isaacs in Toronto's Gerrard Street Village in 1955. Isaacs had opened to the trumpeting of a manifesto in which he championed to a skeptical art establishment the force of his artists' burgeoning sense of aesthetic integrity, and pledged his willingness to "grow with it as it grows, rather than trying to adjust to any mythical 'level of public taste'." He was as good as his word – to such a degree that when the Greenwich Gallery modulated a few years later into the Isaacs Gallery, it was already home to what came to be thought of as the Toronto Look in abstract art – and the centre of a new establishment of its own.

Graham Coughtry was only twenty-four years old in 1955 when the Greenwich Gallery opened. He not only had paintings in its inaugural exhibition, he had a two-man show at Hart House (hard on the heels of Painters Eleven) that same year, with Michael Snow. Both showed figure paintings. Coughtry – who has always thought of himself, he says, as a realistic painter – belongs in this discussion of abstract art nonetheless, I think, because of the way he paints. Never an inventor of painterly spaces (his figures inhabit the shallow, tipped-up, illusory volumes of cubist rooms), Coughtry nevertheless brought to Canadian painting a pauseless lavishness of paint application, an expansive, unstinting, brutishly hedonistic wallowing in the expressive possibilities of pigment for pigment's sake that was, and continues to be, influential.

Coughtry's images have been for the most part figures emerging separately or together from the welter of oil paint which defines them, and which coalesces around them,

giving them substance and context. Often looked upon as highly erotic images, the figures of Coughtry's famous *Two-Figure Series* of the early 1960s are shown in an ongoing, flowery combat that is mostly a function of the act of painting itself: texture and hue in violent juxtaposition. One of the most accomplished presentations of his famous roiling twosome is his *Afternoon Lovers (for Pablo Neruda),* dated 1979. Here, in this vast hotbed of golden oil paint, the mythic couple strive, their limbs as fluid as syrup and everywhere merging with the painting's lava-like ground. The only directional cue remaining in this all-at-once picture is the sudden, cool blue right angle of the bed and the green diagonals that form its side – where, like all diagonals, they keep the picture's energies local and immediate and urgent.

Michael Snow must also be mentioned briefly here, because of the power and accomplishment of the nonrepresentational paintings he made in the late 1950s and early sixties, between his time as a figure painter and the time of the famous *Walking Woman* works. Paintings like *Secret Shout* and *Blues in Place,* both from 1959, are very spare, open and inventive pictures – loose, drippy slaps of paint organized against casually pencilled grids. In 1960, Snow made paintings that were even more spare – outrageously so for their time: pictures like *Red Square* and the brilliant *Lac clair.* The latter is a square of deep lake-blue with four strips of adhesive tape affixed at each of its corners, arranged into a sort of geometricized pinwheel so that the entire picture has a slugglish torque, an undertow. *Lac clair* is remarkable, too, in the way its vertical and horizontal strips of tape not only act as indices to the painting's deep calm but, at the same time, begin the slow spinning movement which ultimately turns the painting's blue field into a central image.

Gordon Rayner has also been an unfailingly exciting, if frequently erratic, painter. At his worst, he is too given to gimmicks (usually in the form of vagrant

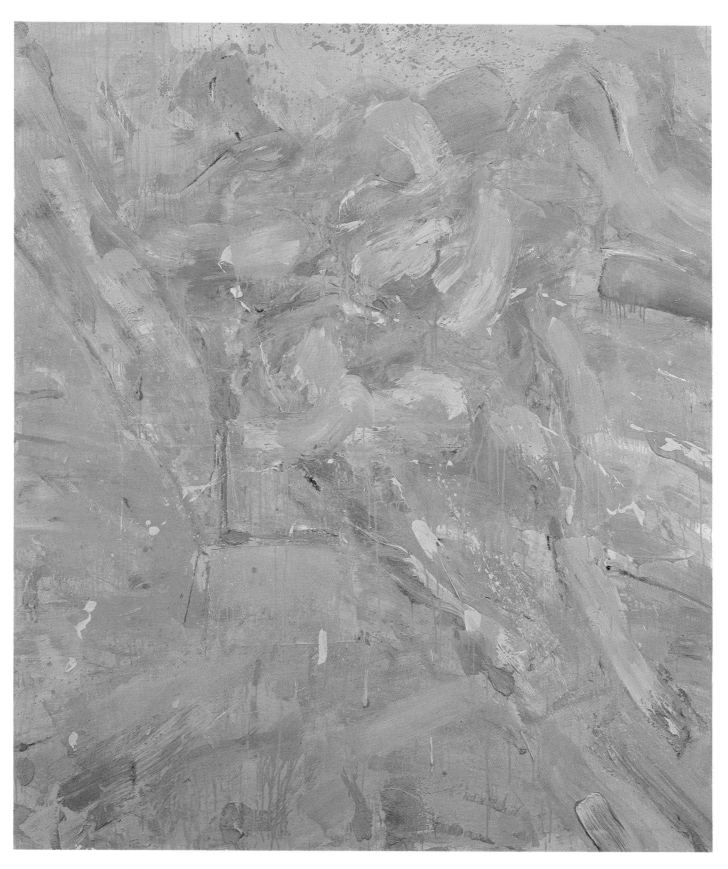

GRAHAM COUGHTRY, *Afternoon Lovers (for Pablo Neruda)* (1979), oil on canvas, 213 × 183 cm, Isaacs Gallery, Toronto

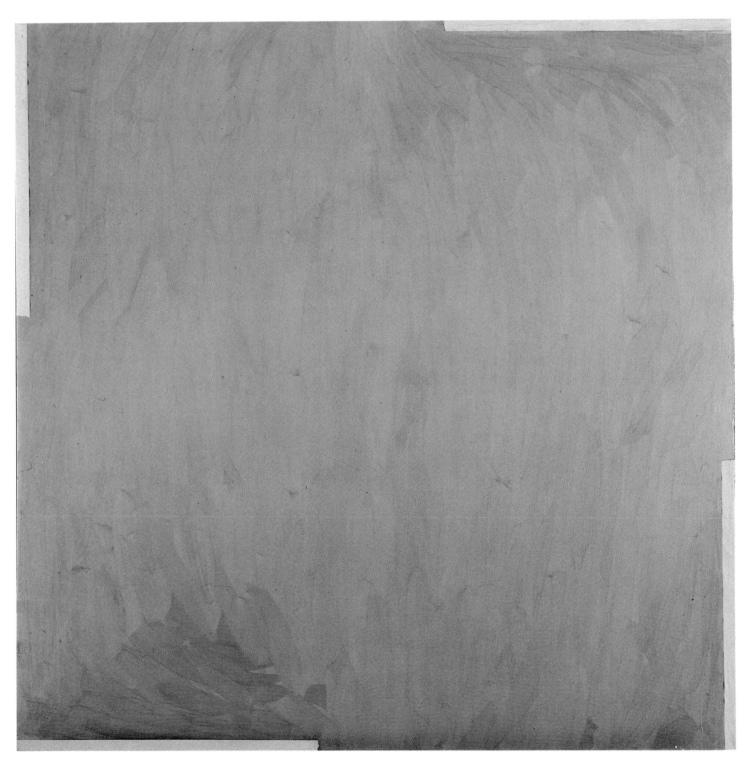

MICHAEL SNOW
Lac clair (1960)
Oil and paper on canvas, 178 × 178 cm
National Gallery of Canada, Ottawa

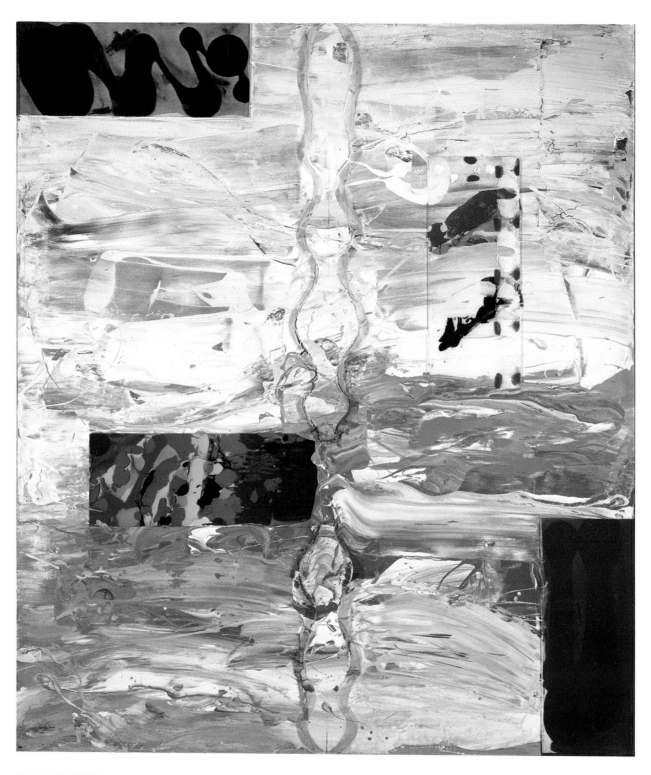

GORDON RAYNER
Persian Book (1974)
Acrylic, wood and plexiglass on canvas, 214 × 183 cm
Canada Council Art Bank

GARY MICHAEL DAULT

collage, as with the real rocks tied onto the canvas in his *Rockslide Rapids,* 1972). At his best, however, Rayner is capable of genuine formal inventiveness, a hot theatrical colour sense, and a fervent feel for the natural world – from the endless, velvety darks of the Magnetawan country of northern Ontario, where he has a cabin, to the richness and exoticism of India and Persia. Rayner's well-known *Magnetawan #2* (1965), for example, is a brilliant evocation in entirely abstract terms of a savage lightning storm in the North, with two surprisingly placed pourings of thick, white acrylic as the crackle of the lightning and a wide band of lambent orange soaked into the canvas as the coming, storm-free dawn. His *Persian Book* (1974), on the other hand, is equally successful as a recreation and condensing – in purely abstract terms – of an illuminated page. Its ornate wooden spine and plates of plexiglass sunken into the sumptuous fields of paint are altogether convincing both as an emblem of distant cultural opulence and as what Rayner himself has called "the joy of painterly painting."

Many of his new pictures are odd mixtures of landscape references and raw formal inventiveness in paint. The best of them, the enormous *Grand Span* (1982), is an immense white froth of acrylic, like a tumbling river, fringed at one side by tall green plant forms which have been incised into the thick white paint – as if they were there first, before the whiteness. Rayner's painting continues to be risky and exciting. The stylistic catholicism of which he has always been accused has mellowed, apparently, into a rather more coherent vision of a garden of earthly delights and the questionable shapes that it contains.

Among the most original of the Toronto painters of the post-Eleven generation is John Meredith. He may have been less influenced by American abstract expressionism than the others. His early painted verticals (like *The Real 13* of 1959 and *Proscenium,* 1960) may have owed something to Barnett Newman, but their upward thrustings of raw, worked-up pigment seem to have more to do with organic growth and personal assertion than with the delineation of space.

The curious, smeared, feathery edges of Meredith's lines soon grew into a sort of trademark, their nervousness and delicacy sometimes lending them a frayed and weary look and, at other times, giving them energy and movement. Meredith began to use these distinctive painted lines to draw heraldic shapes and peculiarly private, runic configurations, like his fine *Bengal 1* (1962). These grew in richness and complexity into the overwhelmingly beautiful and mysterious altar-like triptych of 1966, *Seeker* (owned by the Art Gallery of Ontario), and into the rich, densely patterned, mandalic pictures of the late 1960s, like *Atlantis* (1966) and *Karma* (1967). These, in turn, were followed by such paintings as *Japan* (1972) and *Toshiro* (1973) – huge, convulsive paintings carefully scaled-up from drawings. There is something absolutely typical of Meredith, a sometimes painfully shy and private man, in this odd, intuitive wildness which exists freely enough in miniature, but which can be made public only with great and exacting labour. Lately, his work has gained in simplicity. His *Blue and Yellow* (1980), for example, is a spare and exquisite arrangement of blues on a yellow ground, made Meredithian, as it were, only by the presence of the black drawings with their characteristic wiped lines.

Of the Toronto artists who were just students at the time of the Rayner-Burton-Coughtry ascendancy, David Bolduc is probably one of the best. He makes paintings of startling beauty, saved, usually, from mere decorativeness by the authority of his painterly touch and by the self-consciousness of the allusions to cubist collage and to abstract expressionist paint handling. Typical Bolducs have soft, brushy grounds in resourceful colours, surmounted by what is usually a single image – often a vertical bar or stroke, or a rectangle, fan or grid – most often drawn onto the canvas

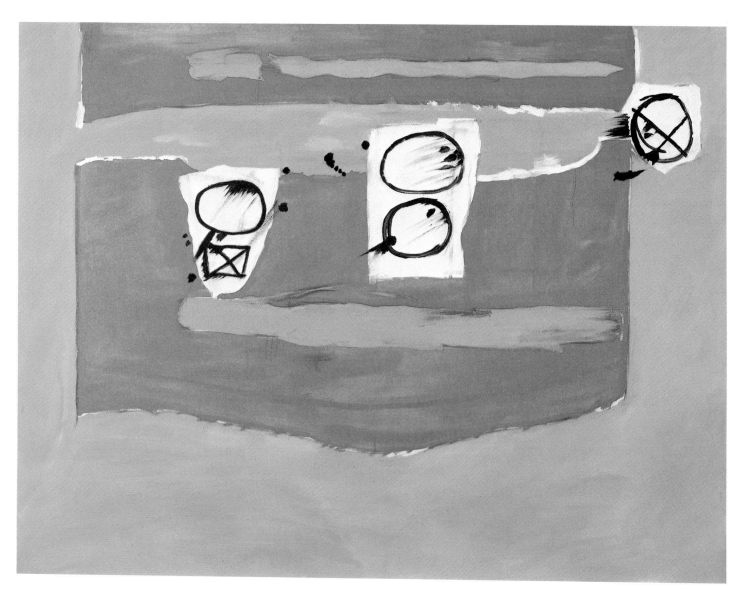

JOHN MEREDITH
Blue and Yellow (1980)
Oil on canvas, 152 × 198 cm
Isaacs Gallery, Toronto

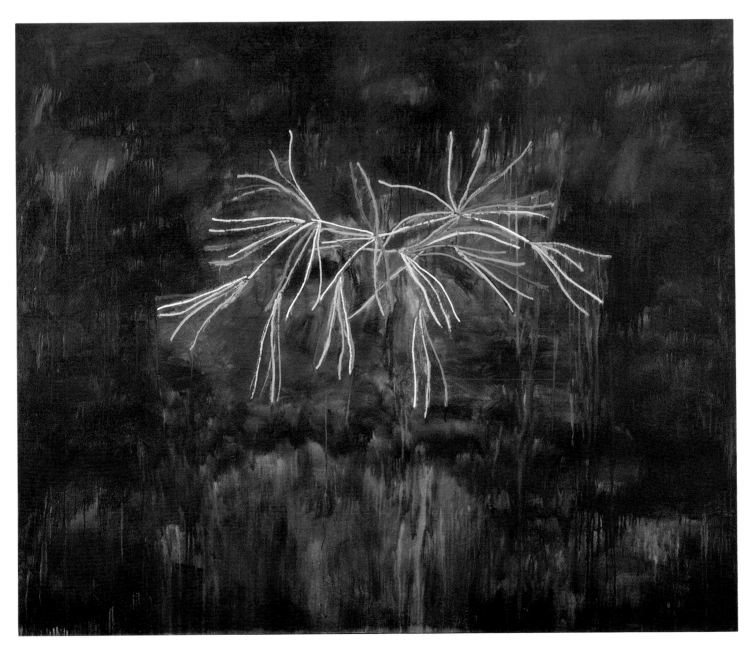

DAVID BOLDUC
Tamil (1982)
Acrylic on canvas, 254 × 305 cm
Klonaridis Gallery, Toronto

straight from the tube. Considering that these single central images are almost always verticals hanging in the middle of the picture, it is remarkable how various and expressive Bolduc has been able to make them. In his *Four Is Polaris* (1978), a tightly clenched fan of coloured lines hovers urgently against a dotted celestial ground, as if it were bound to pictorial secrecy and condemned to remain enigmatic. In the expansive *Tamil* (1982), however, the central gathering of thick painted lines is an engaging starburst of colour, an open configuration that suggests everything from antlers or candelabra to fireworks in the dark.

Bolduc is an extremely formal painter (one of his ongoing problems, for example, is keeping the central image from detaching itself too completely from his ground), yet he possesses a sensibility fine enough to keep his paintings from going cold and mechanical. Not a great original, Bolduc takes his place as the inheritor and transmitter of a highly developed and subtly articulate painting vocabulary which he is skilful enough to use with care, with modesty, and at his best, with genuine élan.

A number of other painters of Bolduc's generation have discovered alternative ways of controlling the rich magmas of paint they inherited from the New York school and about which they feel both affectionate and ironic. Ron Martin of London, Ontario, for instance, uses pigment – and now colour alone – as a way of registering his existential presence in the world. "I think," he says, "that a painting can only be understood in terms of a symbol, an analogy of the reality you or I exist in." His very long series of one-colour paintings (red in 1972, white in 1973, black from 1974 to 1979) were enacted rather than painted, the artist fully engaged in pigment, pulling and swiping and clawing his thick, gelatinous acrylics over the canvas in an orgy of personal affirmation. We come to know our independence, and the illusions we construct to keep us from it, Martin feels, only by breaking those illusions down. How? "We can only do that," he has said,

"by throwing ourselves into a set of circumstances that we provide for ourselves, a framework within which we act sincerely through our own independent responses. We come to know as [a] result of acting…." It's as if Jackson Pollock had never lived. The newest works, like *Tinted Chromatic Sequence Repeated Three Times with a Bocur Rose Red as Constant* (1982), are laboratories for the comparisons of colour. They are about the way colours work in juxtaposition and the way you remember them (or fail to) across the space of other colours and through time. As such, they are the fortunate benefactors of the earlier researches of Guido Molinari.

As a coda to this entire mythology of horizontal/vertical infinities as the basis of pictorial power, and the idea of the oblique as a localizer of energy, I want to look briefly at a recent series of paintings by Vancouver artist Gathie Falk.

The paintings, with the overall title *Pieces of Water,* are large, rather impressionistic sheets of mainly watery blue and blue-green that look as if Falk "took a long sharp knife and cut down into the ocean to lift out a piece … and painted the top surface of this piece of water." The "current" of the water is from the "top left to the bottom right" of the picture plane (or the reverse) – that is to say, on the diagonal. Each of the paintings in the series has a subtitle – a homely and everyday phrase which seems inexplicable in relation to the painting. There are, for example, paintings subtitled *President Sadat, Calgary Olympics, Constitutional Agreement* and *Surplus Cheese.* According to Falk, the subtitles come from radio broadcasts she heard while she was painting. At least one critic has taken great exception to this unheroic titling, however, indignantly suggesting that generalized titles like Images I, II and III would have been more appropriate.

It must be remembered, however, that these paintings are made of obliques. They are not horizontals of brimming sea stretching off into the archetypal. They are, rather, momentary and localized

experiences, albeit cut from a matrix (of water) that runs through us all and under everything we do. Great, still oceans are horizontal. Prairies stretch off on either side till we must take their endlessness on faith. But *Pieces of Water* are angular shards of experience that enter our lives like facts, taking up local habitation–and given names.

It is not so great a leap through time and stylistic evolution from Lawren Harris's "serene and uplifted planes" through Gathie Falk's *Pieces of Water* as it would first appear. The atmospheres and intellectual textures of paintings change dramatically, but as each artist infuses his work with the essence of his own personality and the impress of his mind, the underlying structures of abstract painting continue to bear an absorbing resemblance one to another. As music dances extravagantly upon a neutral and imperative staff, so do the artists' shapes, colours and textures yield their varieties of sensuous experience within an arena of flatness and light that is the same in the beginning for every painter. Abstraction is a language made of optical signs and signals instead of utterances. But like a language that is spoken, the language of the painter is a quick, sinewy, reflexive tool that decorates and makes meaningful the great archetypal ideas from which it has sprung: ideas about man's place in the world and his understanding of the joy and majesty and irony and anxiety of that place. Abstract painting is about seeing. Seeing is about understanding. Understanding rolls onward towards wisdom. And wisdom is honoured all over again by the graceful shorthands of abstraction. Painting is an eternal return.

GARY MICHAEL DAULT

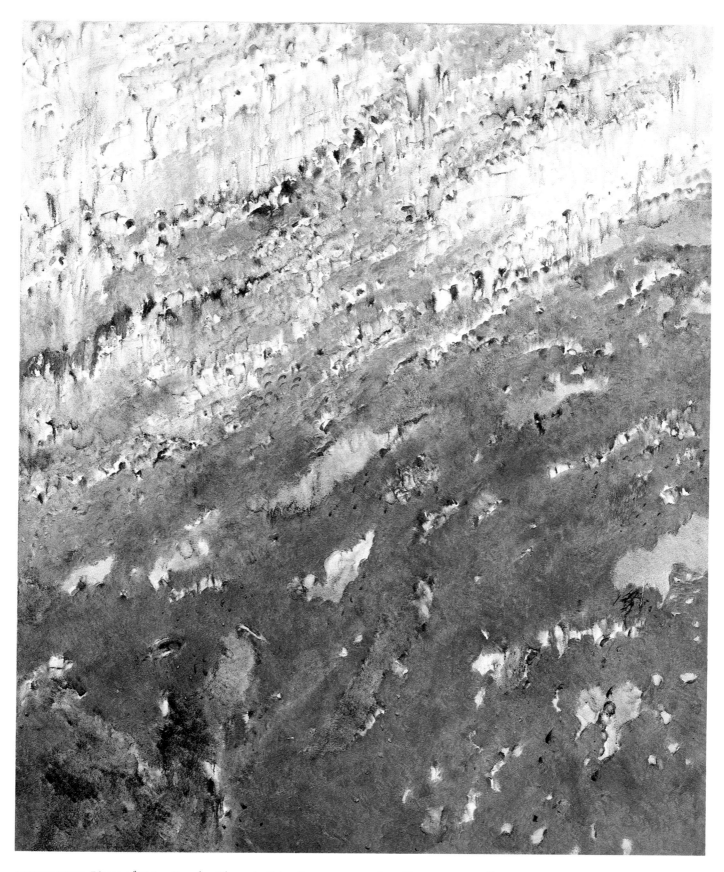

GATHIE FALK, *Pieces of Water: Surplus Cheese* (1982), oil on canvas, 198 × 168 cm, Isaacs Gallery, Toronto

JOYCE WIELAND
The Water Quilt (1970)
64 embroidered kapok pillows, 122 × 122 cm
Art Gallery of Ontario, Toronto

Art does not mirror society in any simple way, nor do burning social issues of themselves make great art; indeed, they may not make any art at all. The way in which artists respond to their society is, moreover, sometimes difficult to perceive in their work. To read even the most deliberate social and political messages which that work may contain, it is often necessary to know something of the social context in which the work was made.

Canadian political and social history since the Second World War has been much coloured by debate about Canadian identity, focussed from time to time through the fluctuating tensions of Canada-U.S. and anglophone-francophone relations. There are constant questions, too, concerning how much regional and ethnic culture can be accommodated within a federal system and, conversely, how much direction from a centralized authority can be tolerated in a pluralist society. Within the art world, this anxiety has been partially alleviated by a number of forces – the Canada Council (founded in 1957), the artists' lobby group known as CAR (Canadian Artists' Representation, founded in 1968), increasing public awareness of art in Canada and abroad, and, not least, just more good art – yet an impulse towards self-questioning remains.

On a personal and a national level, the trials of self-definition have been of the essence of Canadian art since the Second World War, for it has been a time in which there seemed to be no safe assumptions, few agreed-upon definitions, no dependable consensus even on the simplest of human and aesthetic issues. In order to survive, artists have always had to deal with definitions of art, but in the twentieth century they have mostly had to define it for themselves. Art over the last thirty years in particular has been a long process of interrogation: which of the old conventions can still be used, how are new ones to be created and given meaning, to whom will they be meaningful, and what new media

are available to make them so? Artists must make their case for themselves, and therein lies the interest of much recent art.

There is often no clear distinction between the social context and the context for art. For the artists with whom we are concerned, self-definition – what it means to be an artist – is itself a critical social issue. They are part of the modern debate over

Redefining the Role

Charlotte Townsend-Gault

what artists can and cannot, should or should not do about the society in which they find themselves. To acknowledge their questioning is to realize the seriousness with which many artists have taken their social responsibilities and the extent to which they are making their own an enduring tradition of the artist as social commentator and critic.

"We refuse to be ghettoed in an ivory tower, well-fortified but too easy to ignore," proclaimed Paul-Émile Borduas's *Refus global* of 1948. In the Québec of that era, it was a radical manifesto about the separation of art and politics, a bitter attack on the socioeconomic bondage which Borduas and his fifteen cosignatories saw as the legacy of their society, and a bold demand for artistic freedom. The message of the *Refus* is that art should be engaged in a revolutionary struggle – but with its own weapons. Many Canadian artists still hold to this view, but not all are so certain what their weapons are and how they might be used.

Borduas himself left Canada in 1951, for reasons having to do more with the sources of his inspiration than with politics, but still he left. And the issue of staying or leaving, or of coming back (like the issue, for immigrants, of arriving) has always had

special importance in Canadian cultural life. It has been seen less as normal flux within an artistic community than as a reflection on the domestic culture left behind, or joined or revisited.

When he had settled in Paris, Borduas wrote about his Canadianness: "I belonged to my village first, then to my province; I considered myself a French-Canadian, and after my first trip to Europe, more Canadian than French, Canadian (merely Canadian, just like my compatriots) in New York, and lately North American. From now on I hope to 'possess' the whole world..."

Many artists working in Canada today also share Borduas's view that "art has no boundaries." They insist that Canadian art, along with the art of other technologically advanced societies, is part of an international movement, speaking a mutually comprehensible language, addressing the same issues and plugged into the same global village of communications technology and the international movement of artists, critics and curators. There is plenty of evidence that Canadian art and artists can hold their own in this context, so the argument goes, and that they are no longer, in Borduas's scornful words, "spellbound by the annihilating prestige of remembered European masterpieces."

Working within or through outside influences has long been an important, and conscious, part of the Canadian experience, and the social impact of the Group of Seven has been particularly important in this respect. They had helped to make it possible to be taken seriously as an artist in Canada, establishing at least a somewhat innovative role in a country hitherto notable mainly for its caution, and for its adherence to the culture of the colonizing countries. It was they who announced the possibility of a distinctively Canadian form of artistic expression. Their work has now become so widely known that the Group of Seven can be said to have provided Canada with a cluster of images – icons almost – synthesizing for many Canadians who otherwise know little of art, how they feel, or

think they ought to feel, about their country. That amalgam of cloud, rock, glancing sun and windswept tree stands for an idea about the country, and it is an idea which extends far beyond appearances.

One of the social values of art may be that it serves as a focus for the collective memory, bringing the past into the present. But artists since the Group of Seven – those of them, at least, who have been attentive to the social realities of their time – have found themselves living in a different world, which must be answered with different art: art made in a different context, though sometimes within it we find the Group of Seven's familiar nationalist ideals.

Joyce Wieland's attitude, for instance, has been that the cure for Canada's cultural identity crisis is to concentrate on those attributes, natural and cultural, that are peculiarly Canadian: its northernness, its winter, its multicultural culture. She brought her own rendition of these attributes together in 1971 for a major exhibition at the National Gallery, *True Patriot Love*.

Here was an attempt to revive or refresh the most banal symbols of national identity – the maple leaf, the beaver, the national anthem, Laura Secord. Expressed through a great array of materials and handiwork, Wieland's deeply felt sentiments came across sensuously and with charm and wit. There were four versions of the Canadian flag – because craft, like content, is important, and if knitted to different patterns, the maple leaf takes on very different dimensions. In a piece entitled *O Canada*, a mouthing of each syllable was embroidered in lipstick red, giving a succinct reading, or rather a singing, of the national anthem which is at once loving, feminine and patriotic: medium and message satisfyingly at one.

Wieland's *Water Quilt* (1970–71) was made up of sixty-four arctic flowers and grasses embroidered on muslin flaps. Lifted up, the flaps revealed passages from James Laxer's book *The Energy Poker Game*, printed on sixty-four little cotton pillows lashed

together to make up the quilt. Laxer's book dealt with the uses and abuses of Canada's natural resources. Water is one of them, and, like the arctic flora, too humble to be overlooked.

Wieland said of her work of this period that it is "not so much a vision of Canada; it's making things about what we have in common in Canada." And the making of it was a collective effort. Wieland enlisted the knitting, quilting and embroidery skills of many women in the Maritime Provinces and Québec, for she is convinced that some of the most valuable cultural efforts in Canada's past have been collective, made by women and made anonymously.

Particularly since her return to Toronto in 1969, after a number of years in New York, Wieland has interpreted very literally the idea that an artist has social responsibilities, and has felt that her own should be directed towards strengthening the idea of Canada against the encroachment of American hegemony and homogenization.

The proposition that Canadian art can and should find sufficient sustenance in Canada alone is, not incidentally, also shared by two of the most ambitious histories of that art yet written. In *The History of Painting in Canada: Toward a People's Art,* published in 1974, the Marxist critic and theorist Barry Lord identified a strong current of political commitment running through Canadian art history, and in this respect at least his work administered a useful corrective to the prevalent view that art is produced in a sociopolitical vacuum. Dennis Reid, in his less evangelical *Concise History of Painting in Canada* (1973), also affirms that something can be done, that art is not determined by the processes of art history alone. From their differing perspectives, both these works remind us that what happens in the eye of the beholder, let alone the artist's eye, depends largely on her or his political consciousness—which, like the flag, can be lowered, raised or changed.

While Wieland has been evoking a national consciousness, other artists have sought similar ends by evoking a local or regional consciousness. Art of this kind now flourishes in certain towns in southern Ontario and on the prairies, for the simple but sufficient reason that these places are the artists' homes.

Greg Curnoe resents the economic and cultural dependency of his country on the United States, he disliked the internationalist assumptions implicit in his education at the Ontario College of Art, and he is angry at what he regards as Canada's cultural amnesia. Curnoe's personal solution has been to root himself and his art in a specific place: London, Ontario. In part, his response to that place has been to celebrate the details of his daily life with family and friends, and the ordinary things he sees from his studio window. But he is doing more than sharing the view. Curnoe is giving advice about the need to belong, about knowing where you are. It is his means of defence against contemporary social alienation—a problem much aggravated, in Curnoe's view, by the threat which American imperialism poses to Canadian society.

It is not surprising that Curnoe's 1978 mural for Dorval Airport was removed as soon as it was installed, since it failed utterly to deliver the Canadian anodyne thought suitable for tired travellers. Using the uncompromising ironies of history, Curnoe suggests that Canada has put herself at risk by conniving with the U.S. war machine. The mural, which was made in several sections, resembles a large cut-out of the R-34, the dirigible which, in 1919, made the first crossing of the Atlantic by air. While this might seem a fit subject for celebration in an international airport, Curnoe was also keen to show that flying machines have their destructive uses. In addition to the dirigible, the mural portrays the German air raid of 2 July 1917 on London, England. Included is an extract from the diary kept by the pilot of one of the Gotha G.IV aircraft used in the raid: "Suddenly there stand as if by magic here and there in our course little clouds of cotton, the greeting of enemy

CHARLOTTE TOWNSEND-GAULT

guns. They multiply with astonishing rapidity. We fly through them and leave the suburbs behind. It is the heart of London that must be hit!!!"

This is no remote protest. Painted during the Vietnam War, the mural includes images from its own present as well – the face of U.S. President Lyndon Johnson, for one, while Curnoe's own wife and son, his friends and his friends' children are to be seen in the dirigible. Clearly it is not just somewhere distant in time and space, but his own London, and everyone's London, which Curnoe believes is at risk.

His feeling that Canadians, and some of their leaders, have themselves been responsible for the ease with which the Americans have been able to realize their ambitions is clearly demonstrated in Curnoe's 1965 portrait of Mackenzie King, which shows him reaching out in a gesture of passive response to the ministrations of an electric vibrator. At the same time sinister and flippant in mood, it carries a sardonic legend: "Canadian $ accepted at par for this object. The Liberals sold us to the U.S.A.! The PCs destroyed Parliament! The NDP betrayed the CCF!" Entitled *For Ben Bella,* this work is not dedicated to any Canadian politician, but to the Algerian revolutionary leader Ahmed ben Bella, who is one of Curnoe's heroes.

Another of Curnoe's political responses has been to found the Nihilist party and to play every week with his friends in the Nihilist Spasm Band. With the late Jack Chambers and other London artists he has also done a great deal of work for Canadian Artists' Representation, believing that one way of protecting the culture is to protect the rights of those who make it. But Curnoe has a wide definition of what culture is, which follows naturally from his attempt to make no distinctions between his life with family and friends, his politics, bicycle racing, music and his visual art.

Such an inclusive definition of culture can afford artists an enriched yet immediate ambience within which to site their own work. The approach is typical of a number of other artists who, like Curnoe, have committed themselves to a particular geographic and social milieu and whose work grows from that commitment. These artists share the apparent need to establish some firm ground against the encroachments of internationalism and what are seen as the attendant swings of art fashion. They also share a conscious decision to find, or if need be to make, their own mythologies and to borrow none; and a determination – inherited from the Group of Seven – to deal with their own backyard in their own way.

That Canadian national and cultural consciousness is not high, that Canadians know more about American culture than about their own (courtesy of Colonel Sanders and McDonald's), and that we are subtly and inextricably implicated in the doings of the multinational corporations – all these are propositions held not only by Greg Curnoe but also by John Boyle. From his base in southern Ontario (formerly St. Catharines, more recently in Elsinore), Boyle has been resurrecting Canada's culture-heroes and re-establishing them in the context of present values. He has produced some of the most uncomfortable statements about Canada ever made. The title of one of his boldest series, *Yankee Go Home* (1974), expresses succinctly Canada's discomfiture with its own identity. If this is shocking to some, so it should be. Complacency, as Boyle reminds us, is one of our worst enemies.

Boyle's *Midnight Oil* (1969) addresses the matter of being an artist in Canada by addressing the figure of Tom Thomson. Portraits of Thomson, taken from photographs, are set in landscapes well known to Boyle, including the view from his own studio. Canoe Lake, where Thomson died, and the canoe used by a CBC research team filming a documentary about his death, are also included. So are several portraits of women, whose role in the piece may be known to Boyle alone. With its multiple angles and facets, the work recalls the form of a Byzantine icon or a Gothic

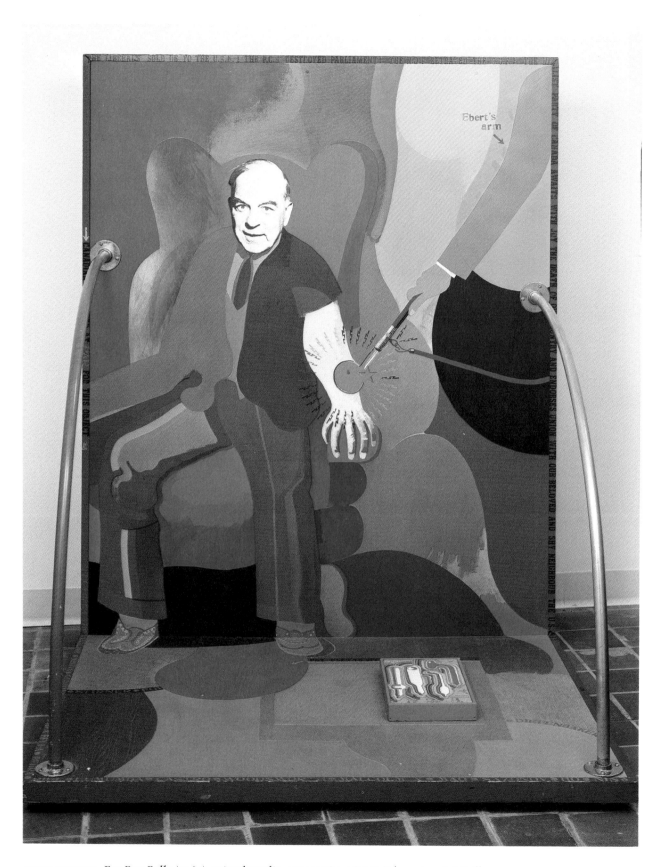

GREG CURNOE, *For Ben Bella* (1964), mixed media, 157 × 126 × 98 cm, Edmonton Art Gallery

CHARLOTTE TOWNSEND-GAULT

reredos, and the religious connotations are appropriate. Thomson is a hero, a saint, and this is devotion, though with a modern and Canadian aura. Thomson is shown, for instance, fishing and tying tackle. In an ironic gesture towards those two comfortable genres of Canadian art history, landscape and the figure therein, the artist himself becomes the figure in the landscape, its sensitive and solitary recorder. Boyle thus ties his artistic heritage to the landscape of his particular place and time.

Even more (for some of us, at least) than southwestern Ontario, the Canadian prairie seems to draw a particular kind of allegiance which takes for granted Canadian content, and preserves it through the rather broad definition of culture, the anti-internationalism, the homegrown mythology, and the not so much rugged as dogged individualism known in many Canadian regions. While argument as to whether or not there is a peculiarly Canadian perception seems likely to go on forever, it is apparent that a number of artists living on the prairies respond to their situation by concentrating on how it looks and feels to live in Canada.

Ceramic sculptor Joe Fafard, born in Ste. Marthe, Saskatchewan, lives now in the small town of Pense, between Moose Jaw and Regina. He has in the past turned his shrewd eye on the art world and his artist colleagues, but in the Pense portraits of 1976–79 he pays profound tribute to the dignity of the extraordinary, ordinary people of his town. In these clay sculptures, some 35 cm high, he recognizes, like Jonathan Swift and Lewis Carroll, the potency of altered scale. But his world is the real world, and his people the people of Pense, warts and all, including the social nuances to be read from the choice of clothes, the set of the head, the way a chair is sat in or a cigarette held. There is no obvious relationship between the pieces, but taken together they form a powerful picture of this small community and its concerns. Patriarch and gossip, solitary and joker – such people could be found anywhere, were it not for the crucial fact that they belong absolutely to Pense.

Victor Cicansky, another ceramic sculptor, delights in reproducing in clay the social history and natural abundance of the prairies. In works like the bas-relief *The Old Working Class* (1978), installed in the Provincial Building in Saskatoon, he celebrates a way of life which is roughly equal parts struggle and bounty. His neighbour, painter David Thauberger, records prairie architecture – the community halls, churches and agricultural dealerships, the farming roots and the aspirations that they betray – with a commitment to place that recalls Curnoe and Boyle.

In 1976, Fafard, Cicansky, Thauberger and Russ Yuristy collaborated on a work which effectively sums up their devotion to the prairies and to their culture. Commissioned as part of Saskatchewan's contribution to the Olympics, it incorporated the work of these and other professional artists, and of a number of so-called folk artists as well.

The Grain Bin, as it was called, turned a genuine specimen of that most common and essential prairie object into the repository for fifteen artists' responses to the farms and settlements, story and history of the prairie. The contributions ranged from panoramic views to small studies of gophers. The interior is a superior sort of diorama, comprising the artists' versions of prairie farming in the 1920s: farm animals by Fred Moulding, a house and barn by Frank Cicansky (Victor Cicansky's folk-artist father), a church by Russ Yuristy, prairie flowers in ceramic by Linda Olafson and cows by Joe Fafard. *The Grain Bin* stands as an eloquent witness to the proposition that your culture is what you perceive it to be, and since a culture is made up of many individuals, that perception is bound to be polymorphous.

Widespread immigrant quilt that it is, Canada is particularly rich in a certain group of artists who remind us not only how polymorphous Canada is, but how polymorphous art is. We have no better name for them than folk artists, for one of

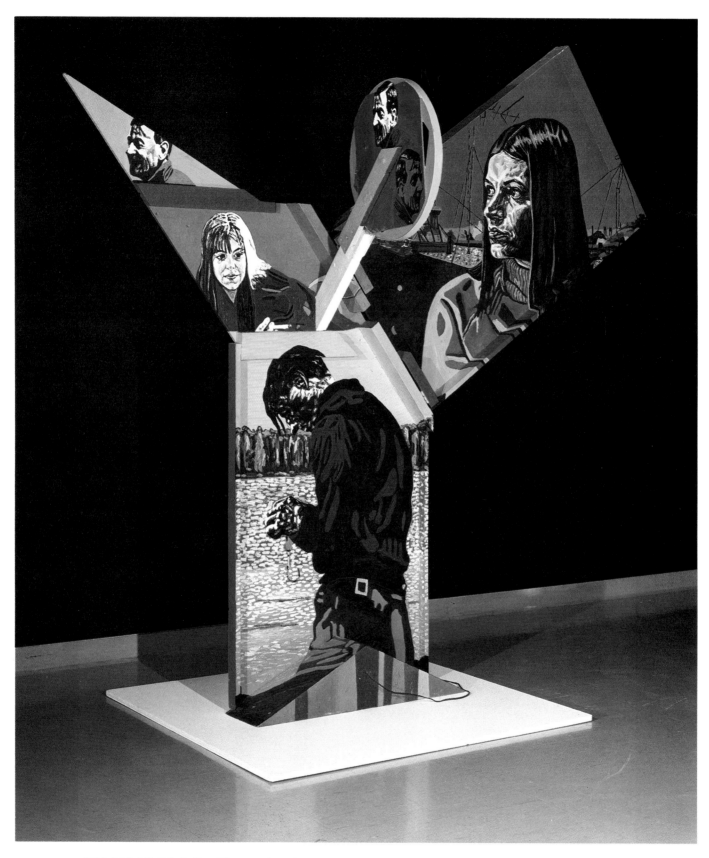

JOHN BOYLE, *Midnight Oil: Ode to Tom Thomson* (1969)
Oil on wood construction with light fixture, 244 × 249 × 84 cm, London Regional Art Gallery, Ontario

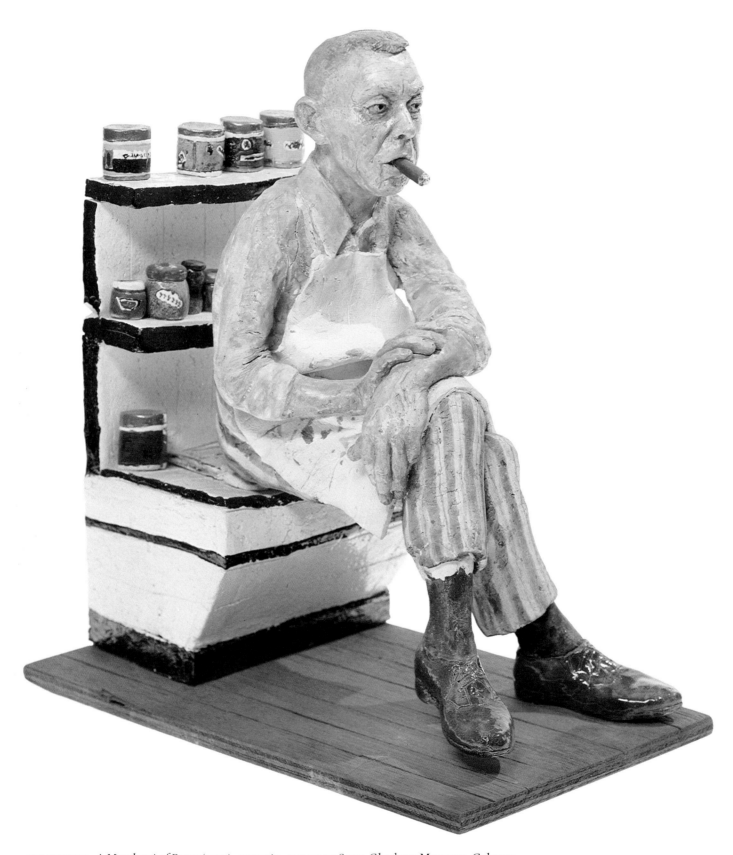

JOE FAFARD, *A Merchant of Pense* (1973), ceramic, 41 × 25 × 38 cm, Glenbow Museum, Calgary

VICTOR CICANSKY *et al*
The Grain Bin (1976)
Mixed media installation, 321 × 541 × 310 cm
Western Development Museums, North Battleford, Saskatchewan

JAN WYERS
These Good Old Thrashing Days (circa 1957)
Oil on fabric, 71 × 99 cm
Norman Mackenzie Art Gallery, University of Regina

the ways to recognize them is that they fit into none of the categories by means of which the mainstream art world keeps track of itself from year to year. But their work too is rich in social content and sometimes speaks eloquently, in locally rooted voices, of issues of nationwide concern. We can look briefly at the work of four of them.

William Kurelek was born in a small Ukrainian immigrant farm community near Edmonton and grew up on the prairies, where he painted the settler's experience of Canada in the settler's terms. He understood that the land works the farmer as much as the farmer works the land, and for him, when he sat down to paint it, it was never mere "landscape." Kurelek's charming but tough illustrations of his remembered prairie childhood provide some of the few images of ordinary life and collaborative work in Canada with which many people are able, or willing, to identify. For his own people he painted *The Ukrainian Pioneer* (1971–76), a six-part mural, beginning with the crowded poverty of the Ukraine and showing the daunting emptiness of the new land side by side with the immigrants' efforts to tame it.

Kurelek presents an awkward challenge to the contemporary art historian's habitual categories; the only point of agreement might be that he cannot be ignored. Jan Wyers in Saskatchewan, George Sawchuk on the West Coast and Arthur Villeneuve in Québec are others who, for all their profound differences, have this in common with Kurelek: they do not belong to the mainstream of art by any definition, yet each has been discovered (initially by other, more mainstream artists) and has then been given institutionalized recognition – exhibitions, reviews and a serious, art-literate audience. The question will always be: at what risk? It is one thing for the artist to play with the context of his work, quite another to have it altered for him.

Dutch-born Jan Wyers, who immigrated to Canada in 1916 and farmed for many years near Windthorst, Saskatchewan, also left a vividly felt response to life on the prairies.

He painted as he remembered – the work hard but good and shared – and he did so with a guileless confidence in his own vision and his own methods.

The reactions that greeted him, once he had been discovered by the art community, were much the same as those awaiting Arthur Villeneuve, the barber/painter of Chicoutimi. Many came to marvel at the inventiveness and freshness of each artist's vision, while bemoaning the fact that just by being "discovered," this freshness was forever sullied. Other observers have doubted aloud whether art that springs up thus untutored, with scant reference to the problems and solutions of art as the historically minded art world knows it, can be art in any meaningful sense at all. But Villeneuve's stated desire is "to move the people," and he undeniably succeeds, moving them through both the matter and the manner of his work. His hundreds of paintings on topics from Québec's history include, for instance, depictions of the shameful battles between the Indians and the white usurpers, in which the latter look like anything but noble forebears, and he has made one of the very few records in Canadian art of General de Gaulle's incendiary visit to Québec in 1969.

Villeneuve's most remarkable feat was to paint the ceilings and walls, the doors and some of the windows, inside and out, of his own house in Chicoutimi. In 1959, after three years of work, he opened what he called Le Musée de l'artiste to the public. Animals, people in town and country settings, history, geography, fantasy, painted in bright colours with no regard for perspective or foreshortening, brought the structure vibrantly to life.

Many people in Chicoutimi objected strenuously that this could not and should not be art, but it was not long before the museum was being visited by thousands each year. Now Villeneuve is well known, but the artists who supported him from the first recognized that he had, on his own, solved a perennial and still contemporary problem: how to make art public and

WILLIAM KURELEK, *The Ukrainian Pioneer #3* (1971)
Mixed media on plywood, 152 × 122 cm, collection of the House of Commons, Ottawa

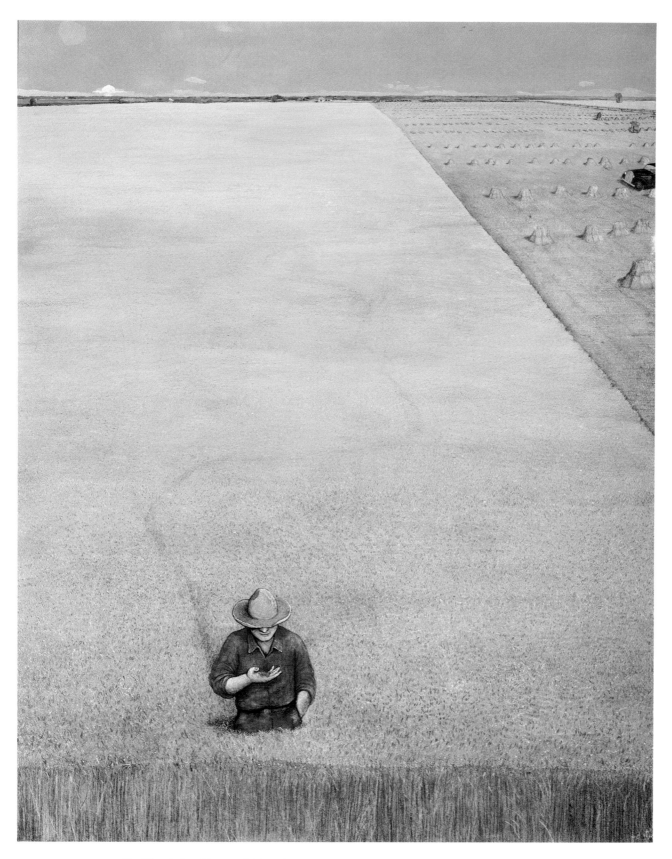

WILLIAM KURELEK, *The Ukrainian Pioneer* #6 (1971)
Mixed media on plywood, 152 × 122 cm, collection of the House of Commons, Ottawa

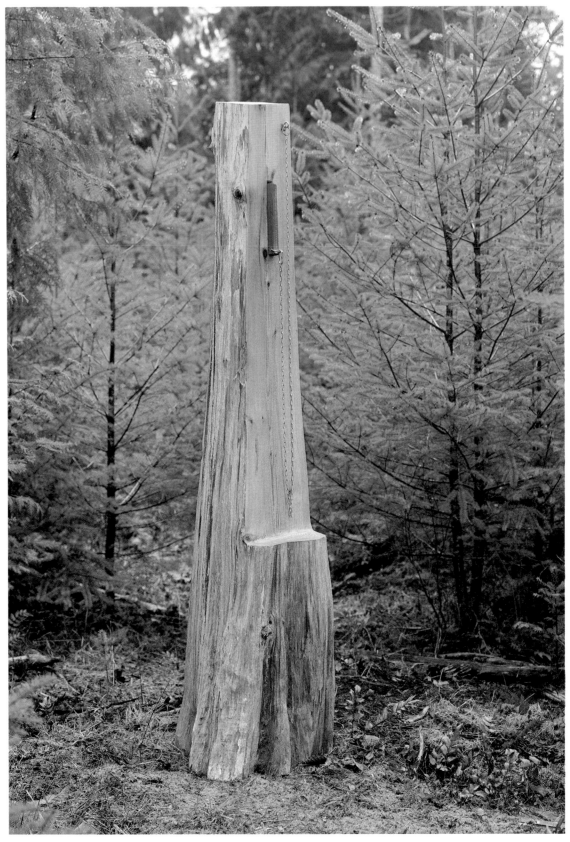

GEORGE SAWCHUK, *New New Testament* (1980)
Western redcedar, chain and book, 191 × 48 × 38 cm, collection of the artist

publicly meaningful. As far as Villeneuve was concerned, the reason for his success was simple: "Leonardo da Vinci paints only what he sees, but I create."

Until the perceptions of the art world caught up with him, George Sawchuk's work had been rooted in two ideologies, Communism and Catholicism – which came together, combined with an earthy pragmatism, in the woods behind his house in North Vancouver. Born in 1927 or 1929 (he is not sure which) Sawchuk had been a manual labourer until he lost a leg in an accident. This was when his ideas began to take shape through the imaginative juxtaposition of tree and found object: tap, telephone, wheel. The trees maintained their dignity as free-growing things, thus providing a living frame of reference which often gave a special twist to some wry or didactic point. (Alas, the trees had to be cut when Sawchuk started to show in art galleries.)

A characteristic later Sawchuk work is *New New Testament* (1980), in which a copy of Lenin's *Alliance of the Working Class and Peasantry* is nestled in a free-standing tree trunk and fixed to its base by a chain. The substance of the book is returned to the tree from which it came, while its ideological contents are bound to nature, as is any human enterprise. This, Sawchuk has long been saying, is a fact we overlook at our peril. But the high irony that the root should have to be severed so that the work can be seen in a gallery is one more instance – and a disturbing one – of the medium as message, though the medium is as unelectronic as a tree.

Commitment to a locale, such as we see in the work of Curnoe or Kurelek or Fafard, or in Sawchuk's characteristic use of local materials, is not exclusively a rural or small-town concern. Melvin Charney is a Montreal artist and architect whose work is devoted to demonstrating the relationship between the physical reality of a city, as determined by its political and economic history, and its inhabitants' perception of that reality.

Charney's strongly felt compulsion to reveal the history of thought and of usage behind architectural façades has led him to create quasi-architectural constructions or adaptations of gallery space, architectural drawings and plans, photodocuments, texts – whatever he finds necessary to demonstrate that the identity of a city's inhabitants is directly related to the identity of the city itself. His work amounts to a perceptual history of urban politics, and he shows that history to be one of destruction, abuse and ignorance of the urban environment.

One of his photodocumentary works, *Une histoire…Le trésor de Trois-Rivières* (1975), records the impact upon him of the formal presence of a meagre house in the working quarter of Trois-Rivières. Charney saw in it the geometry of a classic Doric temple. In the Musée d'art contemporain in Montreal, Charney built a wooden replica to emphasize the formal essentials of this house and its latent references to the temple's heroic dignity. At the same time, its mean proportions and materials stood as vivid witnesses to the marginal existence of its builders and inhabitants. In these Charney saw references also to a tomb. Photographs, coloured and retouched by the artist, furthered the point.

In drawing our attention to this building, Charney shows us that it exists in a cultural limbo, a domain where conventional architectural and cultural history have failed at their task. He wants to rescue it, and thousands of other humble edifices in Québec, to give them the local and topical and vital references they deserve. "And if this building is refused its place in the consciousness of a culture," Charney asks, "is it not because this culture denies the consciousness of its people?"

Charney is best known for Corridart, the collaborative effort of a number of Montreal artists in response to the 1976 Olympics in their city. Corridart has become a cause célèbre because of the high-handed act of censorship which destroyed it barely a week after its installation – a paramilitary, nighttime operation, with floodlights and

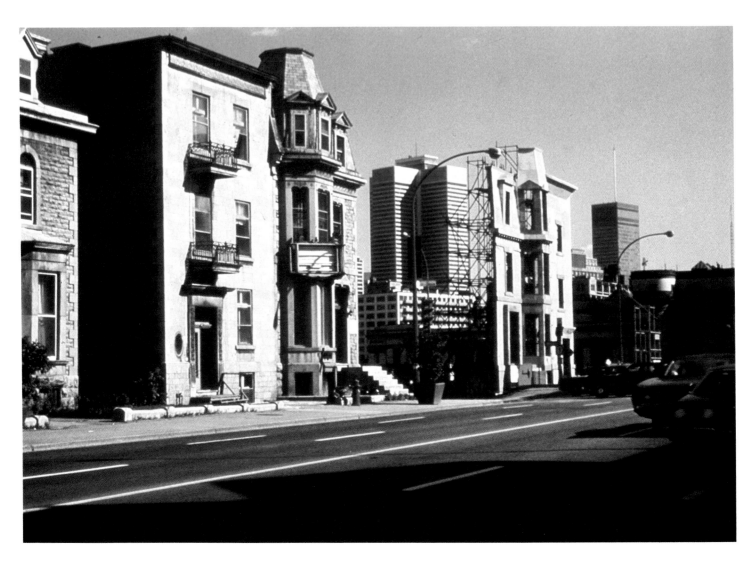

MELVIN CHARNEY
Les Maisons de la rue Sherbrooke (1976)
Wood, steel and concrete construction, 16.4 × 15.8 × 12 m
Commissioned by the Arts & Culture Program of the XXI Olympiad
and installed at the corner of Sherbrooke and St. Urbain streets, Montreal, June–July 1976

bulldozers, mounted at the command of Mayor Jean Drapeau before the Olympic visitors arrived. The artists lacked the means of legal defence, but Drapeau's reaction was an extraordinary tribute to art's effectiveness, and a demonstration of the fear it can inspire.

Charney chose Sherbrooke Street, the city's main processional axis and architectural witness to Montreal's history and fluctuating fortunes, as the natural avenue for the Corridart scheme. He wanted to show, in public, how art could respond to the history, life and function of a street. In retrospect, Corridart is best judged by its degree of engagement with social, historical and environmental issues rather than for the quality of individual works, though several of them have endured well in memory.

For his own contribution to Corridart, Charney used a vacant lot on a corner site that had been razed for a building project that never materialized. There he constructed, in plywood on scaffolding, two full-size façades of nineteenth-century greystone townhouses similar to those still standing across the intersection and typical of the street. The facades, *Les Maisons de la rue Sherbrooke* – more than a drawing, less than a reconstruction – recalled the dignity of the street, created an architectural configuration more proper to an earlier urban vista, and pointed up the indignities to which that vista is subject today. It was street art, which is to say public art: not only in the street but about it.

Calgary artist Rita McKeough also makes art out of houses – and out of their destruction, in an allegory of the continuous destruction of the social environment which has become a condition of our lives. Disgusted at the overnight disappearance of old, but perfectly good, houses in the districts of Calgary where she has lived, McKeough responded not to the politics of it all, which she regards as a long lost cause, but to the destruction of helpless objects. Their plight is indeed very like that felt by many human beings when confronted by

forces the magnitude, complexity and nature of which they dimly comprehend and which they feel unable to contest.

Defunct, a 1981 installation which filled a large gallery at the Alberta College of Art, consisted of detailed replicas of four typical houses and the sites where others had been. McKeough had seen houses like these torn down, and every night for the duration of the show, she came into the gallery to destroy, bit by bit, in unpredictable increments, the very structures she had built with her own hands. The houses had a lot to say about it, too, in accordance with McKeough's expressed belief that they are alive.

One house wept, another cursed, one offered a disquisition on it all while the fourth maintained a meditative resignation. Their reactions were almost drowned out, however, by the overwhelming syncopated rhythms of hammers, saws and pile drivers mixed with heavily percussive music. When the exhibit closed, all four houses were gone, reduced to heaps of lumber fit for the dump. But there is a sequel. The allegory is carried a stage further in a new work, *Destruck (sic,* 1983), in which the houses have evolved arms to defend themselves against their antagonists. A fight is staged with the bulldozers – but who wins is a foregone conclusion.

More contemporary artists could be named who view social issues through the lens of a specific Canadian location. There are others, of course, who address social questions brought to focus elsewhere in the world, often leaving the viewer to work out the implications these issues have for us in Canada. And there are those who address, in direct thematic terms, issues ubiquitous in the contemporary world.

Through the work of Gershon Iskowitz, for instance, a personal encounter with the horrors of the Second World War in Europe has entered into the record of postwar Canadian art.

Iskowitz was born in Kielce, Poland, and was living there at the time of what the Nazis euphemistically referred to as the

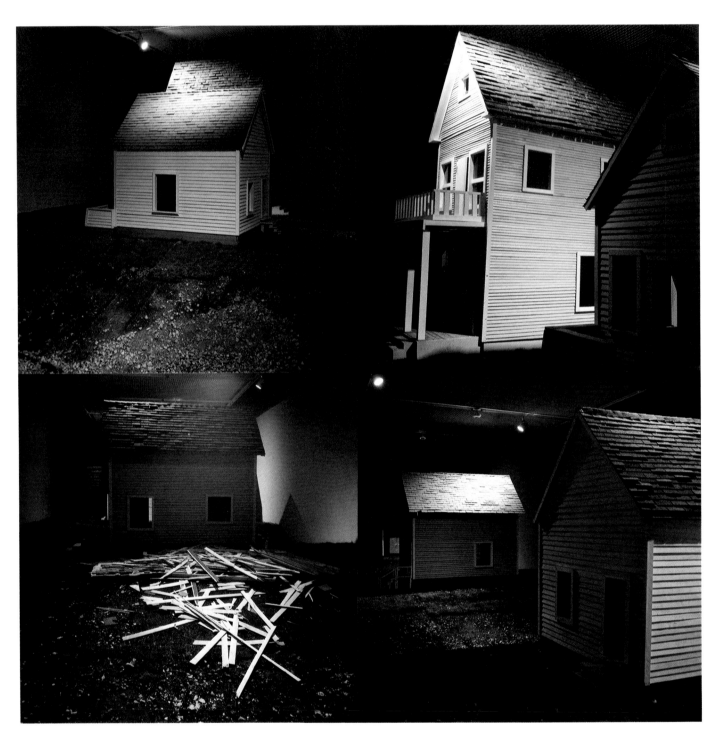

RITA MCKEOUGH
Defunct (1981)
Mixed media installation and performance
Alberta College of Art Gallery, Calgary

"resettlement" of the Polish Jews. He was the only member of his family to survive the internment, and one of the few individuals to survive Buchenwald. Somehow he found ways to draw and paint, even while there, using watercolour paints he had discovered while on a work detail, clearing the wreckage after an Allied bomb raid. Lacking fresh water, he sometimes dissolved the colours in coffee. After the liberation he came to Canada, bringing with him a few of the terrifying works he had made and kept hidden under the floorboards of his barracks. He continued to work on these harrowing testimonials to human cruelty and suffering, until their intensity was transmuted into the large, vibrant canvases for which he is better known.

Yet his early work became a part of Canada's history, part of the memories that he shares with others now living here, and most distressingly, not far removed from the present-day experiences of the oppressed and exploited in many other parts of the world.

Many of Ontario artist John Scott's works contemplate not the horrors of past wars but the horrifying weaponry in readiness for those of the future. In a drawing entitled *Feral* (1981), he points out how close Canada is to Detroit, and how Windsor, his birthplace, falls well within any "kill vector" over the American city. Moreover, by scrawling those words casually across the drawing, he points out the nonchalance with which the obscenely depersonalized, placeless and faceless terminology of the war planners is often used.

Another Ontario artist, Jamelie Hassan, has much to tell us about our tenuous place in the world by looking at events in Argentina. There the grandmothers of the *desaparecidos* or "disappeared ones"—the missing persons whose numbers have continued to mount under the rule of the military junta—used to wear on their headscarves the names of the grandchildren for whom they were searching and the dates of their disappearance. Hassan transformed the scarves into triangles of porcelain in a

work of the same name, *Desaparecidos* (1981). The frozen scarves lay seemingly at random across the gallery floor in mute testimonial–like the originals, before the grandmothers of Argentina were forbidden to continue their silent demonstration. Hassan's work also included a dossier containing copies of some of the documents which had been filed with Argentine authorities, describing those who had disappeared. By thus personalizing the crime, through the heartbreak of these particular old women, Hassan brings into focus for us the heinous nature of tyranny wherever it occurs. Argentina, as we know, has no monopoly on disappearance.

Indeed, the human creatures who tentatively populate the wastes and urban distortions of Montreal artist Carol Wainio's latest paintings seem to be both victims and perpetrators of the Kafkaesque nightmare in which inexplicable disappearance, senseless struggle and bewilderment are normal. Each of her pictures sets up a particular situation; together, they outline a general predicament. In *Human Rights Movement* (1981) a few individuals are set free, or set loose, from the architectural monolith which dominates a number of the works and stands perhaps for the mass itself, as well as for more obvious agents of oppression. In *The Age of Enlightenment* (1982), two people have scaled what could be a mountain only to find that the object of their efforts–a rather dubious light fixture, which is not the source of much light–is still beyond their reach.

Bruce Barber, an artist now living in Nova Scotia, is, like John Scott, concerned about our neighbouring superpowers and their continuous preparations for war. Barber, however, has devoted his attention not to the weaponry but to the propaganda which surrounds us–and which, as he likes to point out, we ignore at our peril. In a recent performance, *Vital Speech/Agit Lecture* (1982), Barber gave a factual demonstration of the sort of advertising propaganda that can be found in the pages of the *Atlantic,* an American journal of conservative opinion.

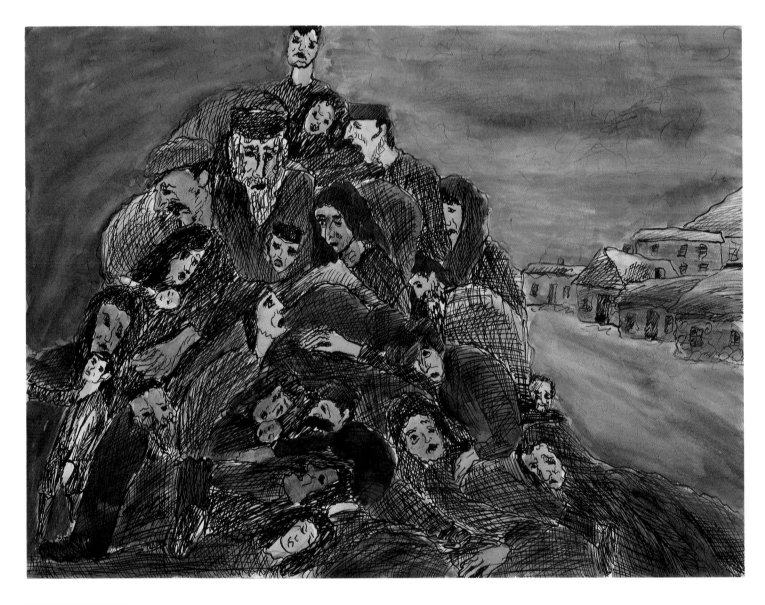

GERSHON ISKOWITZ
Yzkor (1952)
Watercolour and ink on paper, 31 × 41 cm
Gallery Moos, Toronto

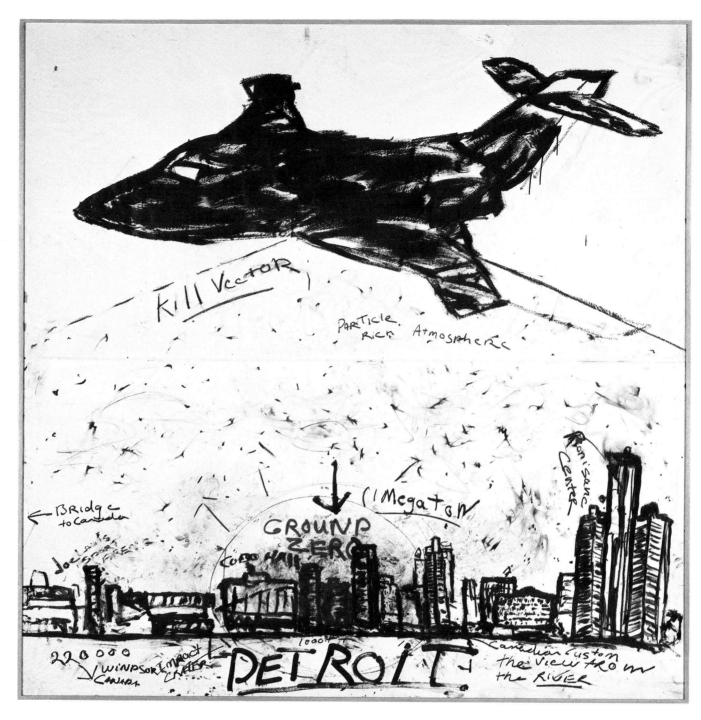

JOHN SCOTT
Feral (1981)
Oil on paper, 244 × 244 cm
Canada Council Art Bank

He showed slides of full-page advertisements with headings like "The Wrong Route to Peace," and read them aloud with his own gloss. The "wrong route" turned out to be peace marches, which the advertiser equated with a suicidal bid for unilateral disarmament. What is needed, said the ad, is bilateral disarmament – only feasible with arms parity, though exactly how that should be achieved was not made clear. The signatory of this advertisement was United Technologies of Hartford, Connecticut, one of the world's largest manufacturers of electronic components for strategic weapons systems, and Barber leaves no doubt that, in his view, the company's scarcely disguised aim is to speed up the arms race.

The interpretations turned up by this close and didactic reading of a text are unlikely to have surprised many members of Barber's audience, but his performance gave the issues an undoubted presence. Throughout the performance, assistants were rolling enlargements of the annotated advertisements and putting them into mailing tubes. Members of the audience were then invited to pay a dollar and mail one to the president of United Technologies.

Like a number of the works we have been looking at, Bruce Barber's performance piece raises a series of important questions – not only about the propriety of a major manufacturer of weapons components advising us on the right road to world peace, and not only about the role of the artist as a social critic. By inviting the audience to become directly involved as counter-propagandists, it raises questions also about the relationship of artist and audience, and about the boundaries (if any) between art and life. On a more general social level, it questions the role of the communications media in our lives, and the difference between truth and information.

The necessity of questioning not just the content but also the shape in which information reaches us has now become, for a number of artists, an important theme and an important social issue, replacing the fascination with which any and all forms of information were frequently received before the information explosion had been exposed.

Claude Breeze, an artist from British Columbia who has worked for the last several years in Toronto, is a maker of vivid and compulsive paintings, and it is not surprising that he has been fascinated by the addictive nature of television viewing and the apparent casualness with which images appear on the screen. In his 1967 series *The Home Viewer,* he combines the pictorial conventions of painting with the framing device of the television screen to administer a twofold shock. There is a horrifying image, and the image is stilled, painted deliberately into an icon for our contemplation. Until we turn away – if we are able to do so without carrying the image with us – there is no escape. Is the television really more merciful, or only more insidious, for the fact that, while we sit there, its images move on?

The emotional insensitivity wrought upon us by the media is also one of the themes of Paul Wong and Kenneth Fletcher's photographic work *Murder Report* (1980). When a body was found lying in the alley outside their studio window in Vancouver, the two took up their cameras and followed through what happens after a violent crime – the police activity, the morgue, the coroner, the suspect, the sociologists. The body becomes an object, a statistic, and is at every stage misunderstood. The artists clearly felt that something crucial was being missed in the official routine they recorded. Their accompanying text tries to remedy this, and thus to bring violent crime out of the limbo to which those of us not professionally involved prefer, with the connivance of the media, to consign it once the first, quick, voyeuristic thrill has passed.

Edited Messages, a 1982 videotape by Calgary artist Marcella Bienvenue, is another work which compels us to think about the role of our officials as they see themselves, and as the media present them

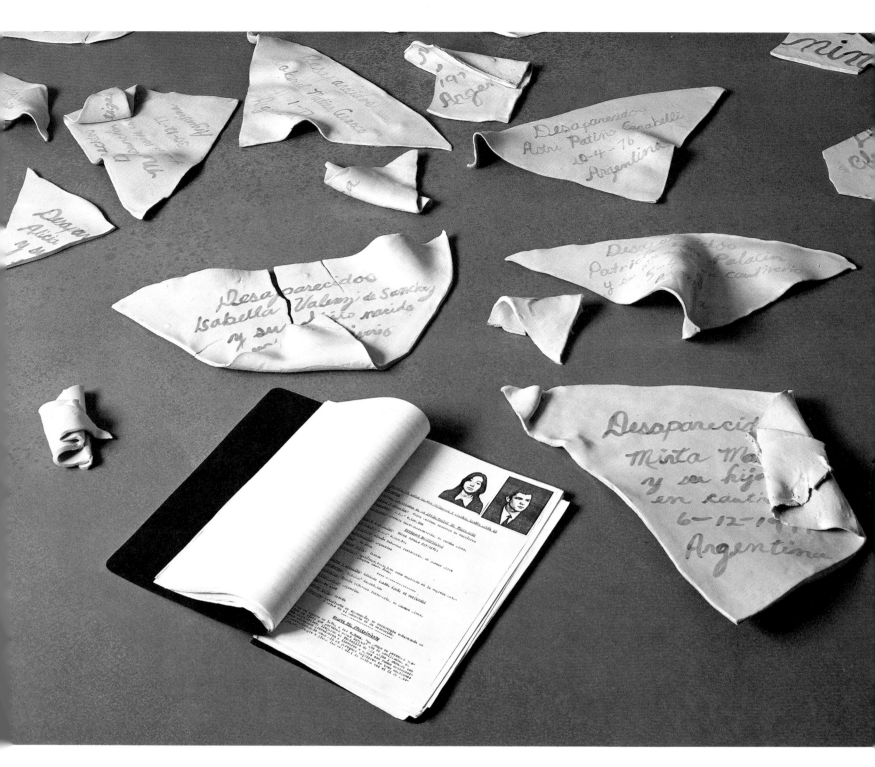

JAMELIE HASSAN
Desaparecidos (1981)
Approximately 60 pieces of porcelain with photocopied dossier
Collection of the artist

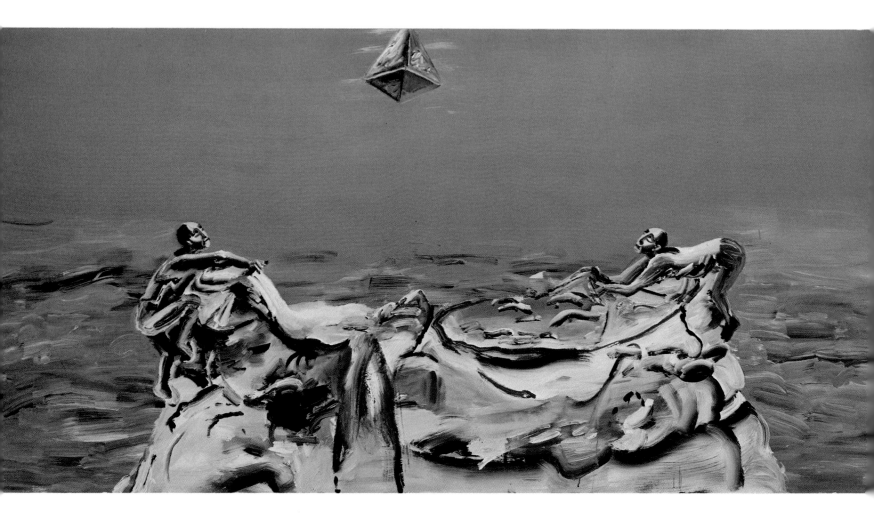

CAROL WAINIO
The Age of Enlightenment (1982)
Acrylic on masonite, 122 × 244 cm
Yarlow Salzman Gallery, Toronto

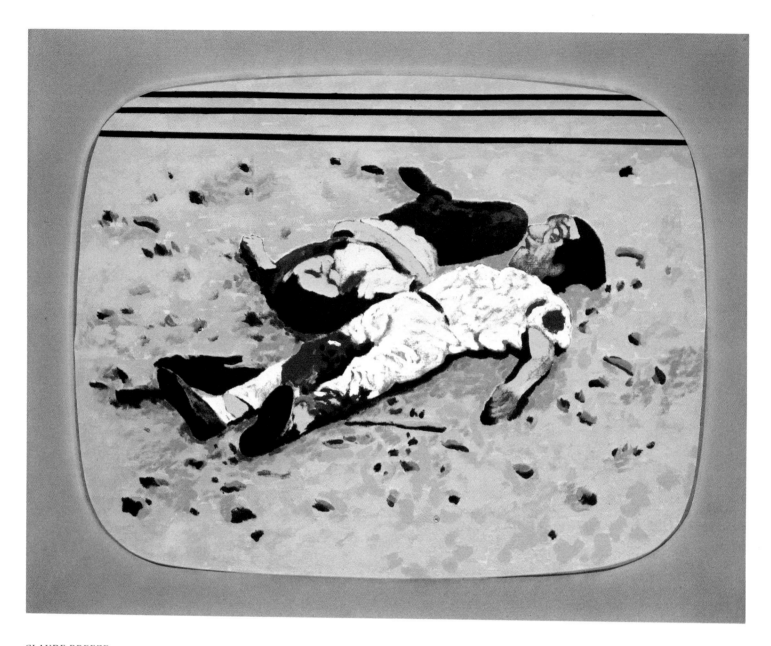

CLAUDE BREEZE
The Home Viewer #4: The Riot Victims (1967)
Oil on canvas with plastic frame, 70 × 87 cm
Collection of the artist

to us – though its method is closer to parody than to photodocumentation.

We might want to laugh, but the encounter in Bienvenue's videotape between a charismatic figure who is presumed to have all the answers (though she will only volunteer "no comment") and those who, urgently, for whatever reason, need to know the answers, is no more a ludicrous frame-up than what can be seen any day on TV. The questions – "Will you be willing to endorse the banishment of objectivism?" and "Are you capable of diagnosing disorder?" and "How are you defining reality at the present time?" – are, significantly, of the unanswerable kind. The tape is something of a parable about the search for a personal sense of reality, for truth in a world of manipulated media, where the stereotype is taken for the archetype with unthinking ease.

From this very brief look at some of the recent Canadian art which turns the tools of the media against themselves in order to interrogate the media's effects upon us, we may move to the wider issue: the use of the visual arts in interrogating the roles we build for ourselves and others in our public and private lives.

Perhaps the most pervasive, and ultimately the most important exercise in self-redefinition in Canada in recent years has been the redefinition of the roles of women, and in this task, too, Canadian artists have played a part. While not all art on the subject is made by women, that which is often seems to speak to the issue "from inside." That is to say, there is nothing reportorial about it, and in this it is related to such various works as William Kurelek's *Ukrainian Pioneer,* John Scott's antiwar drawings, and Rita McKeough's demolition installations.

The images of women now being presented to us by Canadian women themselves are exceedingly various, and largely concerned with personal identities, but they do have a declamatory, public side, very conscious of their reception. There is

Joyce Wieland's *Venus of Scarborough* (1982), a blooming, luxuriating nude flowerbed, in marked contrast to Rae Johnson's *Temptation of the Virgin* (1981) and *The Annunciation* (1982), paintings too urgent for finesse, with a taunting frustration that flings an art history book in the art lover's face. There is Kate Craig's video analysis of a woman encased in an exquisitely made, pink satin straitjacket (*Strait Jacket,* 1980), and there is Lisa Steele's *Birthday Suit* (1974) in which the video camera traces the scars and defects of the artist's body, raising as it does so a host of questions about how women are more usually presented to the public gaze.

A constant theme of feminism has been the imposition of a social image on the personal one. Implicitly or explicitly, the art speaks of the need to recognize this social image and peel it off, and of the need to understand the power and the politics of personal relationships in our public and private lives. Lisa Steele's work in video has for a number of years involved the scrutiny of biographical and autobiographical detail for clues as to why women's concerns are what they are and why society treats them as it has. In two series of tapes (made in 1978–80) she tells of the fortunes of Gloria, a single mother on welfare, and Mrs Pauly, who, bewildered and bound by the complexities of life, can only misapply the adage, "It's a free country, right?" Steele examines that blurred area where personal predicament and social persona meet and collide.

Redefinition, like charity, begins at home, and if there is a common theme implicit in most of the works discussed in this essay, it is that, in recent years, the artist's own social identity and function in society has been a critical social issue, often central to the work.

The strategy adopted by the Group of Seven, and later the Automatistes, of grouping together to find strength and stimulus in numbers, and for mutual defence against public indifference, even hostility, towards art, has become something

of a Canadian institution – one of the alternatives, quite simply, to leaving. The strategy has a practical function when it comes to organizing exhibitions, but recently it has been something more. New ideals, for which group cooperation is essential, lie close to the roots of artistic motivation, and concerns about the means and methods of exhibition and promotion have often been inseparable from the works themselves.

Fusion des Arts in Montreal and Intermedia in Vancouver were early examples of cooperative effort, soon followed by A Space, the Western Front and many others. From these collective bases, artists discovered that they could very well serve their own promotional and distribution needs, and so a network of artist-run, nonprofit organizations grew up across the country to parallel the existing institutions.

A large part of the feminist movement in the arts has also been directed towards the establishment of women's cultural cooperatives, such as the Women's Cultural Building in Toronto; Womanspirit in London, Ontario; Manitoba Women in the Arts; Powerhouse in Montreal; and Women in Focus, located in Vancouver. They have given women increased confidence in their own work, in the face of what is interpreted as an inhospitable, patriarchal environment.

Canada's parallel galleries are the envy of other countries, but it is already apparent that alternatives too become institutionalized and that they can become distorted through time by the familiar institutional problem of the fixed but limited audience, with fixed and limited expectations. The only remaining logical strategy may be to stop calling oneself an artist altogether. It has been adopted by certain erstwhile video artists, among others, who now elect to work for, and show their work to, community groups or political organizations.

Brian Dyson, though he still regards himself as an artist, has pronounced himself dissatisfied with making art in a society where it is inevitably interpreted as self-expression and turned into a marketable commodity. This sort of reception renders art socially useless, according to Dyson, where it should be useful, for society needs something that artists can and should provide. With other members of his local community in Calgary, Dyson therefore founded in 1980 an organization called Syntax – a grass-roots cultural movement which nevertheless maintains international connections. Its activities have included publishing the radical monthly newspaper *City Limits* and mounting a poster campaign to oppose the expansion of the light rail transit system through the local residential area. Through such means, Dyson is demonstrating that, for him, direct social action is the only defensible way to realize his aspirations for art as a widely relevant and accessible endeavour.

The question of whether the artist stands in some special relationship to the rest of the world is interpreted by Carol Condé and Karl Beveridge as a question of privilege. Both had been showing successfully as formalist artists, but they broke from this in 1976 with a show at the Art Gallery of Ontario entitled *It's Still Privileged Art,* publishing a booklet with the same title. It takes us through a typical day in which they deal with curators and collectors, visit galleries and plan a show for a major art institution, as well as working out the shared responsibilities of family life, all in a simple, mock-heroic style. The pictures are accompanied by a commentary in which the two deliberate over the conflicts between their private lives and their dependence on and disapproval of the institutions which enable them to maintain both the style of their private lives and their public roles as artists. By the end of the day, they have seen that art as they have known it can change nothing; one might as well give it up "and become a worker, an activist, play chess…." This piece of art concludes with the resolution, which Beveridge and Condé

ALEX JANVIER
Nobody Understands Me (1972)
Acrylic on canvas, 92 × 122 cm
Department of Indian and Northern Affairs, Ottawa

have also made in their lives, to "start by demystifying art practice, by exposing its spurious claims to 'special' knowledge, its 'privileged' status." Only then, they say, can we "enter into the reconstruction of communities and human relations."

Canadian native artists have had the question of what artists actually do forced upon them by the collision of cultures that has shaken their own definitions to the core. For them, the question has been and continues to be an overtly social and political issue, though one does not necessarily see this in the work. Since the late 1960s, when displays such as the Native People's Pavilion at Expo '67 forced the Indians' own version of their cultural plight on a wider audience, there has been a tremendous surge of activity by native artists. They are seeking, through their art, a redefinition of the role of their people in the most general sense and of their role as artists in particular.

The history, circumstances and current beliefs of Indian bands across the country vary widely, and with them current ideas about what their artists should be doing. Consequently the role of the native artist in Canada today extends from the preservation of traditional culture – bringing artists' talents to bear on traditional forms for traditional purposes – to the task of identifying new images relevant to their people in a changing world.

The situation is further complicated by market pressures both on the artists and on those who would promote their work, and by the embarrassed nature of the relationship between native and so-called mainstream art.

White society, as a destroyer as well as importer of traditions, has proved itself in many respects unworthy of emulation. Many of white society's values are suspect after all, even to itself. But within this context of values in turmoil, many native artists have chosen to accept at least one of the white man's modern traditions: that of the artist as isolated individual, expressing

personal rather than collective values and beliefs, and suffering the alienation that accompanies such a position. It follows that the work must be able to stand and be judged on its own, free of ethnic labels. This has already happened in the case of many native artists who have gained renown and a wide market. The achievement of artists such as Alex Janvier, Norval Morrisseau and Daphne Odjig has been a great encouragement to others. Although they have appropriated some of the forms and techniques of Euramerican art, these particular artists have used them to represent something their own culture provides, and which the white man's culture conspicuously does not – namely a vocabulary of symbols, still more or less meaningful, linking human and nonhuman culture, defining the human place in a nonhuman world.

Through the work of these artists, the beings and ideas of the cosmology that is shared, albeit with significant variations, by most native groups, have reached and enriched a much wider audience. The Underwater Panther of the Ojibwa, the Raven of the Haida, the Thunderbird of the Kwakiutl, the notion of manitou and some of the ideas behind the spirit quest and shamanism are now well known to many non-Indians, largely through the medium of the visual arts. That wider audience can hardly evade the anger, frustration and despair which often gives these symbols a new poignancy. Jackson Beardy's *The Conflict* (1971) and Morrisseau's *We Are Gods Within Ourselves* (1981) are fine examples. Sarain Stump's *The Pain of the Indian* (1973) is a devastating image – a mask in agony, centred on a hide, presented in the hieratic manner of traditional Plains art.

The impetus of the renaissance of Northwest Coast art came from the urgent need to preserve the forms and images of its once great cultures, for some of them, like the Haida, had been near to extinction while the treasures of their history filled galleries in the world's great museums. The new work

DAPHNE ODJIG
The Indian in Transition (1978)
Acrylic on canvas, 240 × 810 cm
National Museum of Man, Ottawa

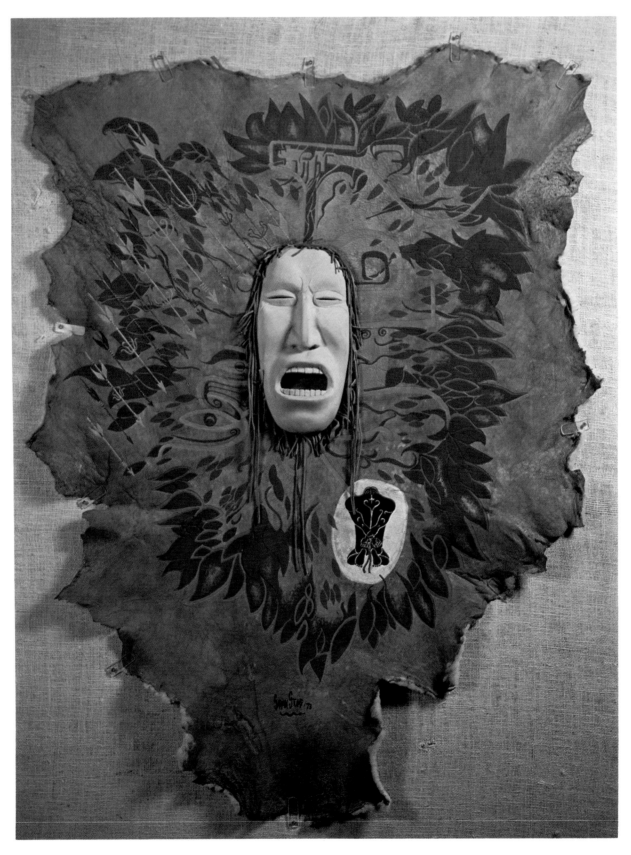

SARAIN STUMP, *The Pain of the Indian* (1973)
Acrylic on split sheepskin with mounted wooden mask, 117 × 87 cm, National Museum of Man, Ottawa

154

ranges from painstaking replicas of the old forms to adaptations of the old idioms into new media, most notably serigraphy. The idea behind the best of this work has been that there could be no rejuvenation of the culture, no new creativity, without a mastery of the old. The idea is given a further twist (one not unfamiliar in the European tradition) in a statement by Robert Davidson, himself a contemporary Haida artist with a superb command of the old forms. "The only way tradition can be carried on," he says, "is to keep inventing new things."

Distinctions are not always easy to make; works are sometimes expected to play double roles. Joe David's print *Memorial Canoe* (1977), made on the death of his father, is one of several that have been published in two editions. Single-colour versions of the print were made to be given away in the traditional manner at the memorial potlatch, while the three-colour version was sold on the open market to raise funds for the event.

Lyle Wilson's *When Worlds Collide* (1979), in a terrifying but inarguable metaphor, shows the elements of traditional Northwest Coast style – the form lines encasing ovoids and U-shapes – pulled out of context, shifting and fragmenting into meaningless debris. In 1980, Wilson made a powerful and still more eclectic work, an etching which is addressed to some of the non-Indians or non-Northwest Coast Indians who have played some role in the revival of Northwest Coast Indian art. Called *Ode to Billy Holm… Lelooska…Duane Pasco…& Jonathan Livingston Seagull,* it incorporates both sides of an Indian Status ID card, part of the cover design of Bill Holm's book on Northwest Coast art, a silhouette figure with a shaman's rattle and eagle mask, and is printed on a Japanese paper that included flower petals and leaves in the pulp. This prettiness only adds to the impact of the piece, which is complicated, menaced and menacing.

As Indians are wrestling with definitions of their role in contemporary society, and coming to terms with the contemporary art of the colonial culture, they are relying on the traditional potency of art and its symbols within their own cultures, fighting with these against the injustices and falsifications of recent history. It is highly debatable whether art has any such potency in the society in which their work must now make its own way.

As a number of Canadian artists have been reminding us, we live in a world in which nothing, least of all art, retains its sanctity very long, and in which the system that thrives on this planned obsolescence of value somehow keeps coming out on top. Consider for instance a work by Nova Scotia artist Gerald Ferguson, mounted at the Glenbow Museum in Calgary in 1980. In a literally brilliant statement about art and money, Ferguson arranged for one million newly minted pennies to be heaped on the gallery floor. With so much emphasis on the cash value of art, we might as well be looking at money, and as it turned out, money actually looks rather good. The heap was for sale, of course, and was a great hit with the news media. It also effectively demonstrated that the art system is a closed, or at least a continuously closeable system, which assimilates with ease even the wittiest gestures designed to expose or subvert it.

Within that system and outside it, the belief that artistic freedom and political commitment cannot coexist dies hard. We have looked at a number of works which confront social issues and express a will, and sometimes a way, towards social change. But the fact remains that most people working in the visual arts in Canada since the Second World War cannot be characterized as politically aware. The change we are now seeing in Canadian artists' understanding of their roles is not so much the beginning of overtly political art as the dawning awareness of the impossibility of being neutral in a deeply troubled world.

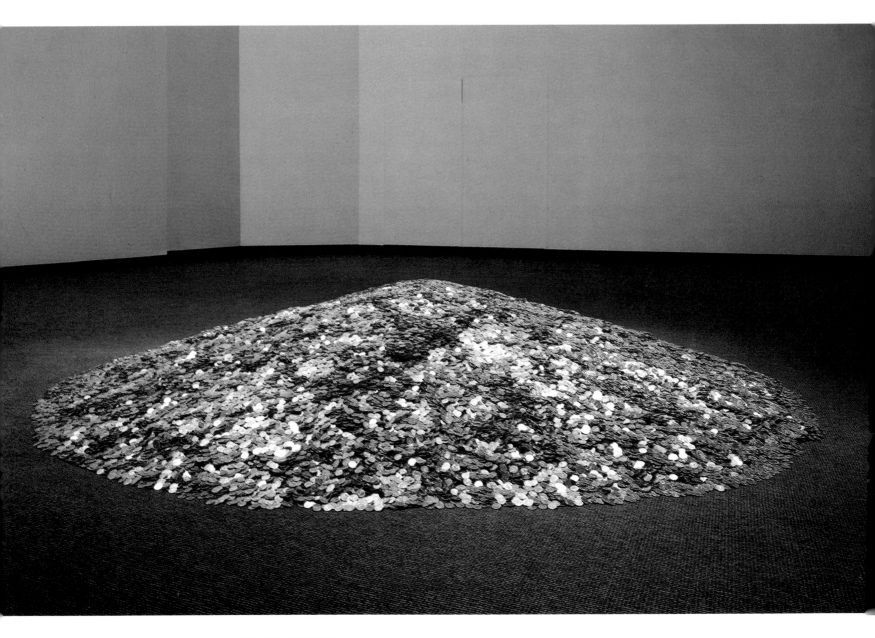

GERALD FERGUSON
One Million Pennies (1979)
3 tons of Canadian pennies
Installation at Glenbow Museum, Calgary

As the twentieth century began drawing to a close, we again saw human and nonhuman faces and figures in the serious art of urban Canadians, expressing the private desires and figuring forth the personal visions which lie hidden beneath our clothes and masks, the everyday habits of our lives and the received conventions of our history.

Some of the makers of these works reached no farther than their own life stories for their images of suburban banalities, childhood memories of enchanted gardens or long days growing up in Calgary as a kid who didn't like cowboy boots – images which seemed to them to summarize boredom endured, violence witnessed, moments of pleasure enjoyed.

Others went deeper within themselves and into the human past, and brought back lost languages and mythic vocabularies for talking about contemporary psychological realities – old allegorical figures such as wolves, fish drawn up from the oceans of dream, recoveries from the ruins of Pompeii, and the archetypal, shadowy corridors and brilliant costumes of sexual perversity, the dark at the top of the stairs and the dark in the cellar of the soul.

Still others, artists perhaps of a more contented sort and sanguine humour, went to work like archaeologists into the kitchen midden of mass media and pop-culture refuse spewed out of the vast communications industries and networks created in the wake of the Second World War. These excavators of culture discovered new sources for new statements about the contemporary self in history. Old copies of *Life* were hauled down from the attic and used as catalogues of glamorous images and popular allure; radio plays, TV commercials, vaudeville, advertising and other old or démodé formats were put to work as scaffolding for fantastic masques about sex, self and society now; bagfuls of souvenirs from holiday trips were recycled into art. Romantic novels from the thirties, bold love songs, and stories from Canada's popular

history – all these and other bits and traces of cultural evidence were making appearances everywhere in the fabrications and fictions of some of Canada's most thoughtful beholders of the city.

The most obvious questions raised by this proliferation of impurity, eclecticism, eccentricity and nostalgia for the past in

The Snakes in the Garden

The Self and the City in Contemporary Canadian Art

John Bentley Mays

Canadian art are, quite simply, *Why?* and *Why now?* and *Why here?*

When the seeds of abstraction did finally arrive on the winds of popular media and the art press from New York after the Second World War, they found especially fecund, welcoming ground in Montreal and Toronto. Artists in those urban centres were enthralled by this gospel of secular celebration in pure form and colour, the movement of paint and metal and stone released from the need to mimic or represent existing forms. It promised (and it fulfilled this promise) to liberate painting and sculpture from the bondage of sentimental portraiture and the cozy, conservative, decorative styles into which landscape art had fallen during the 1930s. New York modernism also encouraged the belief that, at last, an Esperanto of the imagination was possible: a theoretical visual language freed from the divisions, tensions and hatreds of the real world and set free to be, like music, a purely abstract, universal expression of the soul, the body and the natural man.

By the early 1960s, however, even as abstractionism was beginning to take root in

the Canadian West, the grand certainties and proud ambitions of the abstractionist movement had begun to wobble in the United States, under the assault of pop and camp, the new fascination with quick-print, mass communications and the flotsam of mass culture.

The Canadian apostasy from modernism's values, and the founding in this country of a distinctly heterodox church of new possibilities, did not take place all at once, nor was it a universal reverse. Indeed, a number of artists beginning to work on modernism's agenda, dismayed by the faltering of modernist standards, decided to keep the faith forever, whatever the changing fashion. But other artists, especially those coming of age in the Diefenbaker years and unpledged to the heroics of American abstractionism, felt what so often comes with the doubting of old certainties: a fresh sense of liberty, and the awareness that, with the breakdown of an authoritative centre (in this case, New York), a new set of permissions is always given. Thus art continually sustains itself as worthy of our affection, attention and work, by this renewed grace of permission in every generation.

In Canada, from the early 1960s onward, artists began to feel free to work again in the old visual dialects provided by representation and recognizable form, using art to describe and comprehend the world outside the self, the nearer environment of the body and personal history, and the deep structures of our fears, desires and the larger longings of hope.

At least some of them glimpsed a new understanding of what such art-making can be: not merely an intellectual procedure or material manipulation, not just an initiation rite into this or that fashionable art-world movement, but a process of self-revelation and inquiry, expressing personal mythologies, states of mind, dreams, evocations of mystery, the surreal or transcendent experience. Working in the ruins of high-church modernism, these heretics created a place to stand and a body

of eccentric, engaging work in materials acquired from the factory, the souvenir shop, the electronics supply store and other unlikely sources, as well as the more traditional suppliers of paint and chisel.

My purpose here is to provide a map and natural history of this exotically disparate, miscellaneous, difficult, sometimes fever-ridden zone in the Canadian artistic imagination.

Like the charts made by Canada's first explorers, this map of the first part of the territory (which has Vancouver, circa 1960, at its centre) will likely have bulges and narrows where there aren't any, and large blank stretches right next to closely described clearings in the forest. This is true simply because few writers have gone in before me to claim and survey the terrain. Several useful, partial accounts do exist, however, and what has been available to me I have used: the critical writings of Alvin Balkind, Jo-Anne Birnie Danzker and Frank Davey about the 1960s in Vancouver, and the recollections of artists, legends, folktales and scraps of gossip gathered up over the past decade. Laid down side by side, these fragments fit loosely together, yet tightly enough to create a remarkable picture of some of the most interesting artistic work in Canada in the years after 1959.

The year is a good one with which to begin, for it was in 1959 that Marshall McLuhan, on a visit to the University of British Columbia, set the tone and program for much of what was to follow. His was hardly an unfamiliar name. Already, the Toronto communications theorist was heralding the imminent collapse of the old distinctions between high art and popular culture, and among the various media themselves; and he was foretelling the rise of a new culture of perverse, punning, genre-blurring media consciousness from those ruins.

Even at that early date, it was possible to make out in McLuhan's thought the main lines of what was to become known as (for want of a better term) the postmodern mode of art and consciousness – the rejection of

JOHN BENTLEY MAYS

masterpiece-making as the goal of art, the exchanging of the macho-heroic image of the artist for a more polymorphous, sociable one, and the transformation of the studio from a monkish scientific laboratory for the working out of the modernist program of streamlining and rationalizing (the heritage of the Bauhaus, via New York) into a rec room of personal expression and dialogue with technology and the hitherto taboo imagery of the mass media. Artists began to see in McLuhan's utterances a role for themselves as something other than suppliers of objects for consumers; they caught sight of new roles, as communicators, celebrants and hierophants of the new electronic and media mysteries.

But these prophetic thunderings against art's most cherished dogmas would perhaps merely have echoed in the silence of some university lecture hall, and all things in Vancouver might have gone on unchanged, had it not been for an historic Canadian susceptibility, and for the enthusiasm of a few people. The susceptibility was that old preoccupation (going back to Champlain and extending through the Group of Seven and Emily Carr) with documentation, map-making and comprehension of what it is to be in Canada: communication with the barely understood self and with the native ground. Chief among the enthusiasts was B.C. Binning, artist and head of the University of British Columbia's Department of Fine Arts during the 1960s.

Committed to the notion that local artists needed to see, touch and be touched by the current American fulfilments of McLuhan's prophecies, Binning, along with literary missionary Warren Tallman, saw to it that just about everybody who was anybody in the interdisciplinary, autobiographical, documentary and media-conscious American art business came to Vancouver during that time – such as Zen musical revolutionary John Cage, pop artist Robert Rauschenberg, and beat poets Robert Duncan, Allen Ginsberg and Jack Spicer.

Along with McLuhan and the Americans also came the 1960s – including all that we

mean by The Sixties: the rebellions against everything that modernist American humanism had given the world, from Cold War foreign policy to the suburban tract house. Suddenly, permission existed to exceed humanism, to plumb the depths of consciousness with drugs and trances, to uncorset the repressed and forbidden in one's self, and to delight in the music, fantastic clothes and mayhem of the movement and the moment. One of the first places in Canada where these countercultural forces met and collided was the Vancouver home of artist Jack Shadbolt, who in 1966 began hosting and galvanizing a sort of McLuhanite seminar for interested artists and onlookers. The group included, among others, conceptual artist Iain Baxter and architect Arthur Erickson.

In the talk-hungry environment of mid-sixties Vancouver, it didn't take long for the sessions to attract the most radical experimental artists in the local scene – among them composer Don Druick, artist Glenn Lewis, poet Gerry Gilbert and painter Gary Lee-Nova. Not long after that, some of the group decided to pass beyond intellectual chitchat into concrete incarnation, whereupon they christened themselves Intermedia, acquired public money and an inventory of media hardware, and moved into a space on Beatty Street.

Communication was, from the outset, the focus of Intermedia's imaginative work. Poetry, music, posters and ideas proliferated and spread like a new syncretic gospel and cult from Intermedia's audiovisual underground, reaching far beyond the boundaries of the art world, into the general drift of Vancouver's countercultural life. Nor was the Vancouver Art Gallery unaffected by the goings-on. Between 1968 and 1970, the Gallery sponsored a series of landmark festivals of the new, transmedia, tribal and sociable Vancouver art.

"Intermedia offered a place where there could be a fusion of energies," wrote Brad Robinson at the time of the 1970 festival, "where the meeting of artist and audience

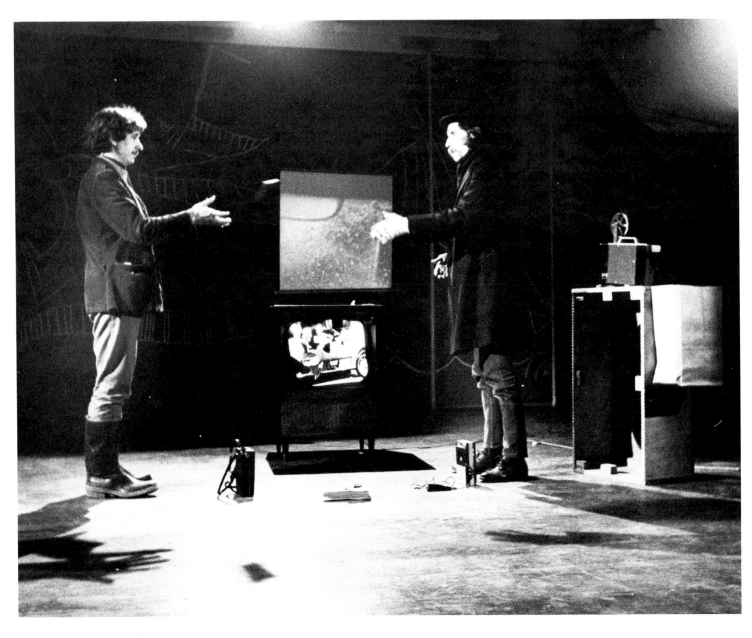

GERRY GILBERT & GLENN LEWIS
The Look (1968)
Performance with portable radio and simultaneous film, at Intermedia, Vancouver

could occur on grounds lacking pretense and where the two could work together…as tangibilities that would shove around the boundaries of convention…the day as wave sweeping in at the shoreline of predicates, urging new definitions of activity, new verbs…." In concrete poet and publisher Bill Bissett's (bill bissett's, to use his preferred form) psychedelic rituals, Ed and Bonnie Varney's real kitchen set up in the gallery, Michael deCourcy and Dennis Vance's talking photographs of Intermedia personalities, in the city-wide feast that concluded the 1970 event, one found, or was supposed to find (in Brad Robinson's words again) "a benevolent explosion in which the entire exultancy of spirit established the event as a work of art – a living organism alive and mutually harmonious."

Here was the happy version – a darker one would emerge in Vancouver a bit later – of the new body conceived as social metaphor: a joyful, youthful vision of a future when new green things could grow in the dry soil of art galleries, when electronic and mechanical means would carry us all beyond the solemn banquet of art history, long presided over by the venerable arts of painting and sculpture, into a scrumptious cream-puff land of untrammeled desire and eternal desserts of amusement.

By 1970, at the time of the last Intermedia Week at the Vancouver Art Gallery, personal performances, actions and divinations were sprouting like magic mushrooms everywhere on the Vancouver scene – but like the larger hippy-rock cultural melodrama in which it flourished, this dancing on the grave of high art was soon to slow down. The dancers tired of looking at and celebrating their beautiful selves, and the spectators got tired too. Repeating the *sic transit* syndrome that seems to be embedded in the very genes of twentieth-century art, some artists went back to traditional media formats such as painting and sculpture, while others hived off from the general scene to work on their own studious projects in traditional isolation

from the herd, and still others turned in their art-scene membership cards and headed for the forests and islands to seek visions too large and transcendent, perhaps, for art to probe or express.

Intermedia officially folded in 1971, but at the same time another remarkable coalescence of energies – perhaps the final remarkable development of that brief, florid epoch in Vancouver – was entering suddenly into its own. It began in the Point Grey digs of painter Michael Morris, who was to serve as its *genius natalis* and, for several years, as its guardian angel.

In 1960, when Morris was only nineteen, he was being hailed by West Coast critics as a painter whose progress would bear close watching. And in fact in the last few years, Morris, who now lives in Berlin, has returned to drawing and painting. But in the mid-sixties in Vancouver, he had begun to celebrate the then-popular iconography of the death of high art. One of his early works was a film documentary of the public, ritual destruction of a piano. His subsequent posters and other artworks were frequently prophecies of the rather sternly avant-garde, mixed-media New Jerusalem which would rise after the pianos and other symbols of the gracious high-art past were dispatched. In his icons, Jean Genet and Hieronymus Bosch, pure form and phallic bullets, and the assassinations of presidents and pianos all met in a general, postmoralistic promiscuity – a melding which, like many outcomes of the hedonistic 1960s, was stern in its own codes of passionate antimoralism.

The social circle which formed in Morris's apartment was largely composed of former Intermedia participants with a distinctly post-hippy, hard-edged outlook – graduates, one might say, of that flowery haven, now ready to face the colder air and meaner streets of the 1970s. Like Intermedia before them, they needed a base camp from which to launch their operations, and a physical stage on which to perform their masques of doctrine. So it was that in 1973 they incorporated themselves as the Western

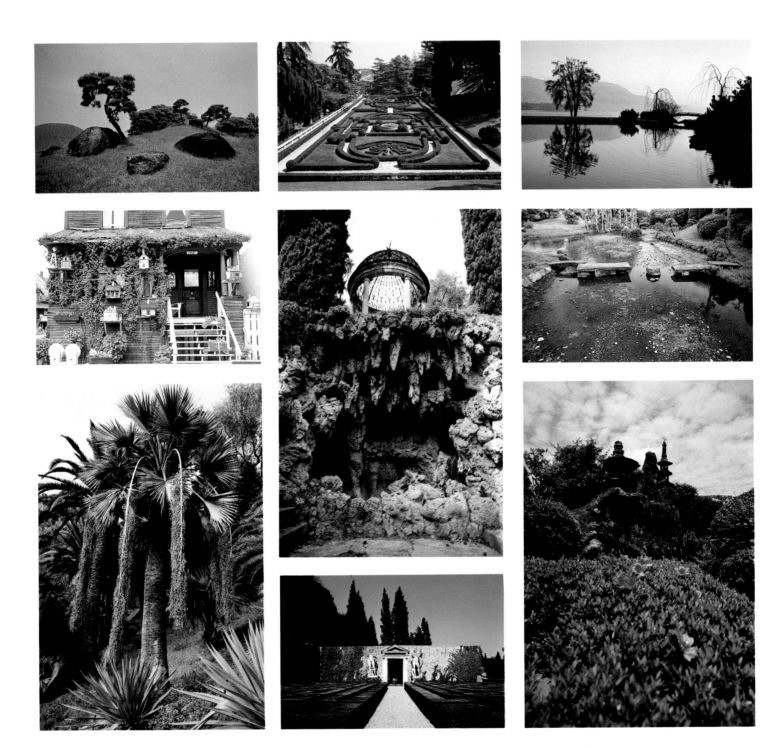

GLENN LEWIS
Excerpts from *Nine Mythological Steps in the Universal Garden* (1977 & continuing)
Upwards of 1000 photographs, both colour and black & white, in nine categories:
*Bewilderness, The Gateway, Utopiary, The Troddenway, Field and Cloister,
Waterway, Metaphorest, The Mount, Hollowland;* format varies
Collection of the artist

Front Society and bought a spacious wooden labyrinth of theatres, apartments, studios and stairwells which had once served as a Knights of Pythias hall.

But unlike Intermedia, the Western Front Society and its member artists (especially Morris himself, as well as Eric Metcalfe and Kate Craig, Glenn Lewis and Vincent Trasov) were enchanted less by the sizzle and glow of the new communications technology than by the obsessions, persistent clichés, fables and fashions merchandised by middlebrow media such as television, radio and the movies. Like explorers, these artists were to go into the jungle to observe, catalogue and analyze the bizarre images and acts of the natives there. Yet they themselves, of course, were part of the tribe they were describing, consumers of the same cultural fantasies. The work of the Western Front in its early days, as acted out in videotapes, publications, performances and installations, was to incorporate those popular dreams, creating fantastic versions of them so large and so striking they could scarcely be understood by the Front actors themselves and could only with difficulty be ignored by others. That work involved holding up to popular culture an odd kind of fun-house mirror which showed not a loony distortion of the conventions and fables of urban life, but a reflection of those realities just as strange and intense and often unhappy as they really are.

Each of the Western Front artists chose a different object for this common task of reflection and revelation. Glenn Lewis, for example, took ornamental gardens and topiary of the sort abounding in Vancouver, and engagingly wondered why people made them. In the early 1970s, when many of the love children thought they were getting back to the garden by leaving the suburbs and heading for the forests, Lewis was going into the suburbs, taking pictures of the artificial fantasy gardens which ordinary, nonhippy people built for themselves. Following the mythographers and sounders of the preconscious such as Frazer, Jung and

Eliade, Lewis eventually glimpsed in garden-making a deep hope for paradisical, infantile states of joy – repressed, perhaps, but apparent there in a sublimated state, if one took the time to see them. So it was that he persevered in his decade-long meditation on what he has called "the green world of human origins – the mythology of paradise."

In 1976 and 1977, he and photographer Taki Bluesinger travelled through India, Iran, Sri Lanka, Pakistan and Italy, documenting the most famous gardens ever created, seeing in them expressions of this universal will to tame and curate nature – and, by mythic extension, the nature in ourselves. His photographic studies of gardens, his writings, and his humorous pygmy-dance performances were all explorations of the universal nostalgia for paradise. And like so many performative, documentary works of the period, they were not merely records; from each of Lewis's works came a call for a return to innocence, and the reintroduction of innocence into the midst of life – revelations of the river of longing which surges beneath the carefully laid-out streets and conventions of our rational civilization.

It was precisely this quality of rational obsession, boredom and repetition in mass urban culture – the conspiracy of total disorder against every discrete individual and every other anomaly – which fascinated artists Eric Metcalfe and Kate Craig. Accordingly, they turned themselves from middle-class Vancouverites into Dr and Lady Brute, the first citizens of Brutopia, a fictional anti-Oz intended to show up Western culture's pseudo-Ozes for what they are. (For most Front artists, the adoption of exotic stage names went along with the donning of fictional identities – a further elaboration of the masking and unmasking play that was important in these early days of the Front's development.)

In their performances, videotapes, photographic works and installations, the Brutes were telling us that Brutopia wasn't somewhere over the rainbow. It had arrived,

ERIC METCALFE *et al*
Pacific Vibrations (1973)
Paint on gallery front
Installation at Vancouver Art Gallery

164

in a brutal glory of immanent eschatology, if we opened our eyes to look at it. To help us see this onslaught of uniformity and kitsch, Dr and Lady Brute covered the façade of the Vancouver Art Gallery with leopard spots, the trademark of sleazy skin magazines and porn; and they fabricated portraits of Vancouver itself being covered in the stuff. Pornography, they seemed to be saying, was the high art of Brutopia – a not very subtle gibe at the relentlessly sexy allure of regular gallery art. Slicked-down nightclub acts, they seemed also to be saying, are its only liturgies and solemn meditations.

But the real life of Brutopia – the real life, that is, of North America – wasn't a boozy evening in a black leatherette cocktail lounge. As anyone who lived in the era of Vietnam knew, the lifeblood of the modern Brutopian state was violence, bondage and the aggressive expropriation of the authentic self by mass-produced banalities and complicities. In one of his performances allegorizing this fact of culture, Dr Brute bound himself to a pillar of the sort designed for a radically simplified, formalist house in Vienna by the philosopher and architect Ludwig Wittgenstein. The chaining of the brute in us to the rationality of modern culture, the victory of Brutopia over our unruly, nonconformist selves – these were some of the messages relayed by Dr Brute's melodramatic but profound piece of living sculpture.

The most conspicuous piece of anthropological spadework undertaken by any Western Front artist, however, was conceived by John Mitchell and performed by Vincent Trasov in the fall of 1974. As television news watchers across Canada, and readers of *Esquire,* the *Village Voice* and Andy Warhol's *Interview* will recall, that was the autumn Trasov dressed up as a Planters Mr Peanut and officially ran for mayor of Vancouver.

For Trasov and his Front comrades, the mayoralty bid was not just another case of a nut running for public office, but a complex performance work meant to explore and expose the workings of mass media, and specifically the process by which a natural object (such as a man, or a peanut) is transmuted into a mute commodity for mass consumption.

Interviewed on television, always in his Mr Peanut uniform, Trasov never spoke except through his press officer, John Mitchell. The Peanut's silence and the fixed stare of his monocled eye spoke more loudly than words about the entrapment of politicians and celebrities inside their shells of image. Such persons exist to be consumed by the mass audience, yet their official shell is also their protection against proximity with their potential devourers. Mr Peanut and the Peanut campaign took all of these ideas and translated them into visible, palpable form: words made flesh, myths made fact, and – with the flair and audacity characteristic of the best Vancouver performance art of this period – thrust into the faces of the consuming public which creates both myths and fact.

Looking back at the event, in words that could as easily be describing Brutopia or even Lewis's Paradise, Toronto artist A.A. Bronson observed of the Peanut: "It is the very emptiness of the image, the very lack of content, that creates its desirability…. This lack of substance combined with its familiarity leaves it an open receptacle, a mirror on which the media can project anything they want. And they do…."

The Peanut campaign, the travels of Glenn Lewis, the performances of the Brutes and the antics of other Vancouver artists who drifted in and out of the Western Front – such events had for a long time (since the jazz-age Europe of the futurists and dadaists, anyway), been part and parcel of the avant-garde tradition of cultural unmasking, mayhem-making and more subtle research into the structures of public meaning and private desire. But the vigorous, heterosexual, Promethean artists of the twentieth century were only the remote, superegoizing godfathers of the

JOHN BENTLEY MAYS

Western Front; its presiding goddess was the permissive, erotically exotic, many-breasted earth mother of the counterculture.

The Western Front was not the only sophisticated, perverse love child of Prometheus and Cybele. Throughout the 1960s, in cities across North America and Europe, artists like those at the Front were creating arch, camp, role-playing lives to live – becoming artworks themselves, with all the artificiality, narcissism and impertinence towards traditional social and artistic values involved in such self-creation. It marked the first successful invasion of the North American art world by the aesthetic and psychological rebellion against the normal expressed by drag-queen pomp, and the rites for eye and flesh which had been performed in history's gay bars and steam baths since the days of Sodom.

Andy Warhol's superstars, and Warhol himself, had been perhaps the most conspicuous exemplars of this stance, but by the early 1970s, the stance, or elaborations of it, had been taken up by groups of urban artists everywhere. Because they shared a common, camp faith, they entered quickly into communion with each other – naturally enough (if anything could be natural in this world of studied unnaturalness) by the use of the mails.

Had artists at the Western Front been merely exchanging press releases or newsy letters with their counterparts in New York or Berlin, the fact would hardly be worth mentioning here. But, once again in topsy-turvy fashion, the artists took an ordinary cultural fact (what could be more prosaic than the mails?) and turned it into an elaborate metaphor of the cheap, throwaway culture they celebrated. It was also a studied fulfilment of the communication experts' prophecies about the decentralizing and demotion of traditional artistic priorities and hierarchies.

Artists at the Front, scores more in the cities and towns of Canada, and hundreds around the world, devoted themselves to the making and mailing of elaborate postcards, love notes and ephemeral art-scene arcana, as well as fragments of leopard skin and other bits of ritual memorabilia. The content tended to be insider stuff – funny, enigmatic, evidently faked, nakedly prurient – but the content of the act was not as important as the fact and the eloquent flair of it.

Correspondence art (as it came to be called) was an art of pure information and disposable images, inexpensive (to undermine the art market), easy and nearly instant (to make a rude gesture in the direction of The Masterpiece). Like most products of these artists, correspondence art also came with a metaphysical (or metacultural) rationale. The correspondence-art scene, it was said, was the first art scene which had, like Pascal's universe, a centre that was everywhere and a perimeter that was nowhere. It was an invisible, polymorphous-perverse body of information lying across the geography of the world, with entries and exits at every point, and no hierarchy imposed by location (New York, for instance, or any other big city), nor by access to big grants or big private patronage.

This was an art to match and symbolize a mode of sexuality – as all art probably is in some final, psychoanalytical sense. If the modernist exemplar was the isolated, heterosexual eminence furiously working, always alone in his studio, the exemplar of correspondence art would be the sensualist relaxing after his mainly anonymous and sociable pleasures and obsessions, constructing palaces of nostalgia in the air. Is it any wonder correspondence art looked odd when curators began taking it seriously enough to put it on display in museums? Can anyone wonder why the guardians of high-art values think it's a matter best left out of accounts of the art of Canada, which isn't supposed to be about such things?

But some Canadian art was very much about such sexuality and a throwaway attitude towards it in the early 1970s. If one wonders today how pervasive it was, one can go to the archives of Art Metropole in

VINCENT TRASOV *et al*
Mr Peanut with Art Rat and Candy Man and *Mr Peanut with the Brute Saxes*
(excerpts from the Mr Peanut mayoralty campaign, 1974), Vancouver

Toronto and of the Western Front in Vancouver, or visit Glenn Lewis's *Great Wall of 1984*, permanently installed in Ottawa's National Science Library. The Wall is a museum of transparent plastic boxes, stacked up and sealed, a beehive of time capsules, each one conserving (as though it were trapped in amber) a memento, fabrication or ephemeron selected from all that then flowed so freely and copiously through the mails.

Or, had you known such things were going on in Canada and the U.S.A., you could have dressed yourself up appropriately (that is, in extremis) and flown down to Hollywood on 2 February 1974, for something called the Deccadance.

Nearly a thousand people, from all over the westernized world, showed up that night and crowded into the Egyptian-style Elks Hall – artist-creators of the postcard and throwaway, "metaphysical sculptures" decked out in their trademark costumes, and practising nonartists whose main nonartform was themselves, their lives and bodies.

Patterned after (what else?) the Academy Awards, and organized largely by the Canadian contingents from Vancouver and Toronto, the Deccadance was a Woodstock of the perverse, anti-art imagination, and a show of strength for the international cult of the flimsy, the gesture, the outré. There were prizes, called, rather naughtily, the Sphinx d'Or Awards: Art's Dead But Gossip's Still Alive, to Toronto's Noah Dakota; Best Major Work, to Glenn Lewis for the *Great Wall of 1984;* Ms Congeniality to Anna Banana of Victoria, and so on. But the device of the Academy Awards was also meant by its designers to signify deeper concerns. The conceptual art of the 1960s had turned imaginative and critical attention from the static art object to the responding, changing consciousness standing in front of the object. Thus was born in intellectual austerity the art-historical child which was to grow up as such luxuriating flamboyance.

In fact, the whole program of psychological modernity since Freud had been the expression of the repressed and forbidden, the making of unconscious conscious. The Deccadance, where everything came out of the closet, and everybody came out to appreciate each other's self-creation as art, was a fulfilment of all modernism's prophecies (though one might yet understand the classical modernists' contempt for this sort of dramatic leave-taking, and one might wonder whether Freud would have felt quite comfortable among the studs-and-leather outfits, the banana costumes and the shark-fin bathing caps worn during one of the gala theatrical production numbers).

In order to function successfully both as image and as identity with its peculiar cycle of images, the Deccadance really did have to happen in Hollywood – birthplace of deluxe decadence, the mythology of the moth of beauty and the flame of career, the casting couch, and the land of archetypal, monumental self-fictionalizing. For the purpose of our story, however, the Deccadance had an additional importance – the strong presence, among both its organizers and its participants, of Canadians (who, incidentally, walked off with most of the Sphinx d'Or), and of three Canadian metaphysical sculptures in particular: the Toronto artists known as General Idea.

Michael Tims, Jorge Saia and Ron Gabe were artists and architects who had early become involved in throwaway art-making, postcards, performance and other fascinations of the era of communications art. In 1968 they traded in their individual names for new ones – A.A. Bronson, Jorge Zontal and Felix Partz, respectively – and assumed a corporate identity as General Idea. GI was created as "an artists' partnership working collaboratively in a variety of media," according to one resumé, "a framing device within which we inhabit the role of the artist as we see the living legend," in the words of a more lyrical one.

They changed location, from Winnipeg to Toronto, along with the changes of name,

installing their operational headquarters first in the bohemian Gerrard Street neighbourhood, then later in a walkup at the foot of Yonge Street. There they began to turn out the artworks, events, installations and publications that made them, by the end of the 1970s, among the best-known Canadian artists in the international circuits made visible and viable by correspondence and communications art.

From the outset, General Idea was the manufacturer of a varied line of artistic products. As artists making standard gallery objects, they created paintings embodying their interest in American conceptual art, installations resembling museum giftshops (another comment on the commercial hard sell of art) or more sentimental tableaux, and more recently, fictional "artifacts" from the ruins of Pompeii—meaning, as one might guess, the ruins of our own hedonistic civilization itself, paralyzed and dismembered beneath the ashes of its frantic self-promotion.

As impresarios of camp, and metacritics of the fevered camp mode which urban society had adopted, as publicists and analysts of publicity itself, General Idea deployed the instant-fame format of the beauty contest in a series of resonant acts and performances—each of them proclaimed as a rehearsal for the biggest one of all, which they called *The 1984 Miss General Idea Beauty Pageant.* And as promoters of cult and myth, they provided a cultural focus for the ambitions of the post-hippy (but very hip) glittering young proletarians and entrepreneurs of Toronto—the boutique and restaurant owners, fashion-conscious artists in love (as always in Toronto) with New York, scene-queens emerging from the shadow of the drag world in the newfound freedom of the time, all the streetwise smudgers of distinctions between high and low, and the more sophisticated investigators of the lands along the borderline.

That cultural focus was *File Megazine* (*sic*, not Magazine). In those days, it was sold on

the stands, where it would have fit in comfortably with *Look* and *Life*. But *File* (an anagram, of course, for *Life*) looked like both and neither. *Life*-sized and lavishly illustrated, *File* functioned as a portable art gallery of images, a local gossip rag, a Yellow Pages and newsmagazine of the correspondence-art network, and a repository of General Idea's arch, trenchant musings on culture, history, nature and the plays among all these presences.

The central subject for these thoughtful forays into the anthropology of art was called the 1984 Miss General Idea Pavilion—General Idea's architectural answer to Brutopia, and perhaps an even more useful framing and focussing device for the criticisms of contemporary culture. General Idea believed that 1984, like Brutopia, was not on its way. It had arrived ahead of schedule, and was embodied as fact and performance in the impersonal, robotic bureaucracies of business and government, in our mindless entertainments (such as beauty pageants, and all the image-merchandising they involve), and in the stereotypes and conformities of urban capitalist culture, all being endlessly reinforced by advertising, television, workplace discipline and the mass standardization of personal expectations, aversions and sympathies.

All of this was summarized in General Idea's Pavilion, which turns out to be an imaginary Tower of Babel set in the middle of the landscape of 1984—an architectonic, dynamic image of a society compelled by its fear of disintegration and disorientation to undertake increasingly elaborate, exhausting projects of will. As the embodiment of nature's final conquest by unnature—the central cultural project of will which General Idea has always addressed—the Pavilion was throughout the 1970s the scaffolding, and imaginary architecture, to which each of their events and artworks contributed. Its construction was a matter of gradual accumulation rather than preconceived plan—composition as

GLENN LEWIS
Great Wall of 1984 (1973–74)
Plexiglass boxes containing invited contributions
(365.25 boxes, each 23 cm on a side)
National Science Library, Ottawa

GENERAL IDEA
The Unveiling of the Cornucopia:
A Mural Fragment from the Room with the Unknown Function
in the Villa dei Misteri of the 1984 Miss General Idea Pavilion (1982)
Enamel on plasterboard and plywood, five panels each 224 × 122 cm
Carmen Lamanna Gallery, Toronto

explanation, Gertrude Stein had called the process – with each new performance, each exhibit, and each new issue of *File* adding its bit to our understanding of the total metaphor.

But about halfway between the Deccadance and 1984 – in the last years of the 1970s – the building of the Pavilion began to undergo serious setbacks. The ground plans went up in flames (deliberately) in one well-known outdoor performance work. Later, in a particularly spectacular outdoor work, General Idea showed us that the whole exuberant project was prone to the same catastrophes as Babel and Pompeii. The piece was entitled *Toronto's Fault: The First Tremors (The Ruins of the Silver Bar from the 1984 Miss General Idea Pavilion)*. Working with tons of landfill piled beside a downtown Toronto building then undergoing demolition, and using hundreds of silver-painted bricks, columns, wires and other items found in and around the site, General Idea fabricated a vast earthquake site, complete with artifacts and general ruin. It was a dadaist construction, spread over an acre of real estate, but it transmitted a powerful series of cultural and psychological meanings. At one level, *Toronto's Fault* sounded a prophetic warning against the chauvinism and boundless self-promotion that Toronto had adopted as its artistic, architectural and more broadly cultural style during the 1970s. At another, it proclaimed the vulnerability of General Idea itself and its principal work of imagination, and the end of a phase of the group's creative career.

Furthermore, the piece announced the end of a long passage of work by these survivors of the Collapse of 1984, as further construction of the Pavilion was given up in favour of a prolonged archaeological dig on the site, carried out, as usual, in exhibits, performances and in *File* photo-essays. Some of the work was real recovery from the past. In 1982, for example, General Idea showed system paintings done fourteen years before. And some of it was a task of

imaginary excavation at Pompeii, now appropriated as frame and context for the continuing exploration. Fabricated fragments of fresco and other recovered art began to appear in museum shows, often self-consciously detained in museologically respectable cases and frames. The work of picking up the pieces had begun.

Long before General Idea came on the scene, Freud had been intrigued by the excavations at Pompeii, and for much the same reasons as these Toronto artists. The excavations were useful as metaphors for the project of unearthing all that had been suppressed, the bringing to light of the smothered forces and realities buried deeply, forcibly within the unconscious mind, and revealing the results of the disastrous process of repression. The utopian, self-gratifying enthusiasms of the lovebead era, the frustrations of the stingier 1970s, the ominous prospects of the next decade, and, despite all that, the continuing work of the contemporary artist as gatherer, creator of meaning and metaphor, and critic of society's delusions and fantasies, all were present in the work General Idea undertook among the ruins in its archaeological projects of the early 1980s.

When General Idea began working in Toronto, not even the most uncritical chauvinist would have been inclined to view the home town as the vivid centre of anything. By and large, especially in matters of art and culture, it was still a provincial backwater with pretensions. But against a general background of rather timid postwar artistic modernism, changes were already taking place, as urban young people began to be aware of, and then to appropriate, the dress codes, tribal mores and more substantial ideas of the late sixties' counterculture in North America.

The youth culture of rebellion, centred in Rochdale College and the Yorkville area of Toronto, was, as elsewhere in North America, an intoxicating cocktail of anarchy, kinkiness, dreamy pills, New Age pieties and old-fashioned hedonism. But in Toronto as

JOHN BENTLEY MAYS

elsewhere, it was also spawning some things that would endure the passing away of lovebeads and bell-bottoms: the tumultuous new Toronto theatre scene, for example; music studios and dance workshops; publishing ventures such as Coach House Press; and a whole generation of new fiction writers and poets.

There was also a new art scene, and the artists originally faced the same obstacles as their colleagues in other disciplines. Young artists tumbling out of the counterculture had virtually nowhere to go, if Avrom Isaacs, Carmen Lamanna, Dorothy Cameron and a few other perceptive and risk-taking dealers would not take them. And unlike the Vancouver Art Gallery, the Art Gallery of Ontario (except during the brief tenure there of curator Alvin Balkind) remained by and large aloof from the new developments in Toronto art, and willing to give only token acknowledgement to the changes overtaking art elsewhere in the world.

So it happened that the artists did what the dancers, writers and musicians also did, with equal and often surpassing success: they took matters into their own hands. In the fall of 1970, artists Marien Lewis, Stephen Cruise, Robert Bowers and John McEwen took an old, empty building on a Toronto back street and turned it into an answer to the world of the museum and of ordinary commercial galleries.

That answer came to be known as A Space, which is exactly what it was – a space to fill, a gallery where new work could be shown and seen, a clubhouse for the art-scene socializing valued in those days, a studio and workshop where things could be seen as they were being fabricated, a theatre and laboratory. Under the leadership of Victor Coleman in the mid-1970s, A Space forged strong links with the Western Front and other artist-run centres springing up in all regions of the country, and with artists, musicians, poets and other creative workers across Canada, in the United States and around the world.

It also became the Toronto home of the sort of collaborative performance work (radio plays, Brutopian theatricals, postmodern masques of innocence and fall) that were being fashioned at the Western Front and elsewhere on the international network. But perhaps more important, A Space became the scene of some pioneering efforts in the fields of camera art, video and sound technology as put to work in artistic applications. Together with General Idea, the Coach House Press, the new underground theatre and cinema, and the steadily growing community of writers and critics, the artists of A Space were becoming ingredients in the most active, outward-looking art scene in Toronto's history.

The art which emerged at A Space, especially during its earliest period, displayed little of the exuberance and outlandishness being flaunted at the Western Front, or even in the beauty pageants and fashion fêtes of General Idea. A Space and General Idea were to have a productive relationship – but that came later, at the end of the decade, when General Idea (as well as A Space) had seasoned and matured a bit. Due in part to important visits by New Yorkers Vito Acconci and Dennis Oppenheim – artists who were then preoccupied with self-analysis and behaviour – but due also to the grey earnestness that never quite seems to lift from Toronto art, however playful it wants to be – and, of course, for other reasons – the artists around A Space then seemed bent on the hard work of anxious, personal analysis and discovery, and of trying to make contact with the world over the prison walls of individuation and language.

The most important tool for performing these early acts of witness, research and surveillance was video. Introduced into the United States during the mid-1960s and already important in Vancouver and at the media-conscious Nova Scotia College of Art and Design, portable and affordable television technology came to A Space on its foundation in 1970. A few attempts were made to use it as a way to document the

outré and personally assertive. In Marien Lewis's *Dance Soap* (1973), the artist married herself off to art in a gala ceremony staged in a sleazy West End Toronto hotel, and had it all recorded, à la home movies, on videotape – a statement parodying modernism's prim, bride's-eye-view ideals of artistic fidelity, and making the new pledges of loyalty which feminist artists were willing to offer to their art and to their lives as artists. But a sampling of titles of other early Toronto tapes indicates video's more characteristic uses: *Confessions*, by Jill Bellos; *Contact Piece: A Nude Model*, by Eric Cameron; *This Is the Way I Really Am*, by Colin Campbell; *Sleep/Dream Vigil*, by Lisa Steele. There were bodies everywhere, as though taking off one's clothes could really make one accessible and vulnerable. These were not bodies glamorized by Western Front or General Idea mythology, nor interpreted by elaborate costumes and masks, but flesh being scrutinized and researched. The videotapes that resulted were an electronic analogue to correspondence art – ephemeral, instant, cheap, intimate, and liberated from the demands of high and historic museological seriousness. What Jill Bellos once wrote about her own video work could have been written by any number of young artists at that time in Toronto:

Video in the beginning was everything film could never have been for me, direct instant feedback, which was more suited to my way of working than the laborious nature of film. But more important than that, video offered social interaction within the world out there. Going out on the street with a Portapak, talking to people, was maybe an effort to heal that guilt I always felt as a painter, of my esoteric isolation....

Despite a rapid proliferation of styles and interests and dimensions of irony, the interrogation and explication of intimacy remained perhaps the central concern of video during the years immediately after its Canadian debut. Had it stayed with such self-absorbed, sentimental subject matter, video art would probably have had a very short life, but it was soon put out to work in a wide variety of artistic applications: as a means of documenting artistic events, as a sophisticated tool for probing and registering more complex states of mind and behaviour, and as a way to refresh (and, in a way, to re-invent) narrative in art.

A list of outstanding Canadian video artists of the 1970s would be long, and would include the names of artists from every region of the country. But the careers of Rodney Werden and Lisa Steele, both of whom have worked principally in Toronto, are not untypical of the process many video artists have gone through while learning their medium.

Both Werden and Steele began with the personal, documentary, notebook phases of work characteristic of early video production in Toronto. But both soon found themselves working with ideas similar to those in vogue with the artists of General Idea and the Western Front, though generally greyer and more subtle in Toronto's prevailing climate of sobriety and moral seriousness. They were concerned, in other words, with the ways raw data (such as people) are transformed into fabricated personalities by the insistent kneading of all the media in the environment, both high-art and popular – television, music, fashion, photography, advertising and narratives of all sorts.

In the mid-1970s, Werden's awareness of these issues took the form of still photographic studies of sexual bondage and sensual extremity, and striking portraits of writers and artists (Dr Brute, for example) who had been asked to act out for the camera the roles in which they found themselves, or would like to find themselves one day. The results were icons of appropriation, as each artist took a pose from the cultural or sensual environment and performed it for the camera. But Werden's investigations in video were perhaps of more lasting importance.

RODNEY WERDEN
Portrait of Eric Metcalfe as Dr Brute (1974)
Photograph
Collection of Sandy Stagg

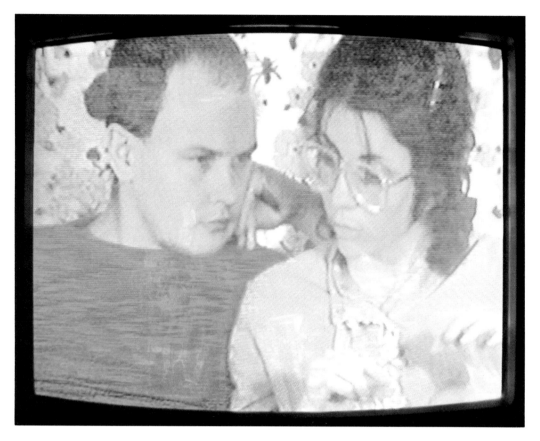

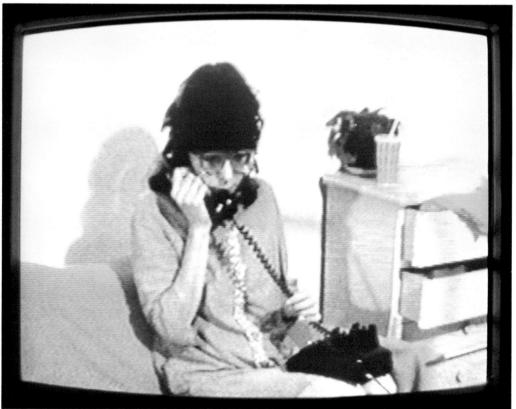

LISA STEELE, excerpts from *The Gloria Tapes* (1980), videotape in four parts, 53 minutes long

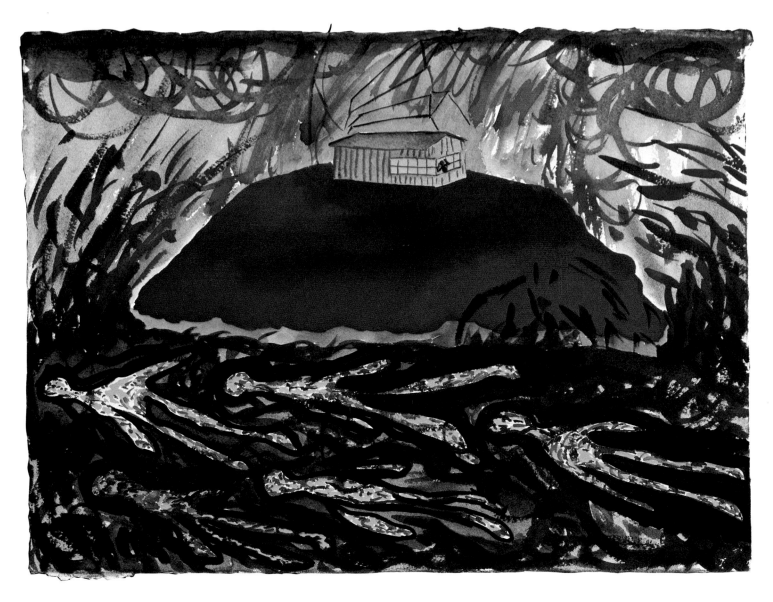

SANDRA MEIGS
Burning Island: study for *The Maelstrom* (1980)
Watercolour on paper, 29 × 39 cm
Ydessa Gallery, Toronto

Throughout the 1970s, he performed a series of videotaped investigations of extreme sexual styles, adopted by his subjects as rebellions against what was considered the prevailing, conformist dullness of urban mass culture.

Most of his works in this vein did not turn out to be pornographic. They demonstrated instead that he could use the video camera much like a pin in a butterfly cabinet, holding the devotee of what Werden called "unsanctioned desire" in alert mid-flight for our examination. His best videotapes were troubling, difficult penetrations into certain inner desolations known to denizens of the city. They were revelations of the conflict between desire and realization, and of the difficulties faced by those whose desires contradict the broad cultural craving of Canadians to view themselves as a self-possessed tribe in a picture postcard of the North. Rodney Werden's videotapes stood perhaps first among works by Toronto artists disclosing the hitherto unspoken, the previously repressed dimensions of Toronto's inner life.

In her tapes of the late 1970s, Lisa Steele investigated those who had not rebelled but had submitted to the regimenting delusions of mass culture – battered wives and welfare mothers, victimized by poverty, sexism and their failure of access to the new currencies of information and clerical skill. Steele acted the parts herself and spoke the lines, worked up from the actual words of the women involved. In these tapes, Lisa Steele gave speech to the speechless – or, more correctly, to those who had been given an absurd, crippled language of desire and description, and had been made to live and work and suffer inside it. Thereby, she created poignant disclosures of the difficulties women especially, but all of us, experience in framing our sexual and social identity within the cant and jargon of freedom dealt out to us by a society which is basically, of course, unfree.

Some Canadian artists involved in the newfound technologies of art discovered a

single, unmixed medium, such as video or film or photography or holography, to be a quite serviceable formal tool for researching these problems of identity and personal meaning. But a number of gifted artists – the Hummer Sisters, Tony Brown, Sandra Meigs, Betty Goodwin, David Buchan, Noel Harding, John Massey, Vera Frenkel, Vincent Tangredi, Tom Graff, among others – working outside the General Idea and Western Front orbits during the mid- to late 1970s, picked and chose as they would among the technological equipment and cultural artifacts available, using what seemed good for the telling of their stories and the stating of their minds.

Sandra Meigs combined film, drawings and phonotape in such works as *The Maelstrom,* and in her installations about boxing, to produce essays for all senses on the anxiety churning at the very heart of our human existence. In her sombre statements in three dimensions, the conflicts of the human heart (allegorized eloquently for her, as for a number of other artists, by boxing matches) are placed inexorably centre-stage, as though the ritualized, permanent vexations she treats are at the same time irremediable injuries in the deepest tissue of human desire.

At quite the opposite end of the philosophical and production scale stands the Vancouver performance artist Tom Graff, who used only soft presentational technology – tall women elegantly dressed in Edwardian finery, live piano music to accompany his own fine voice, fanciful settings of fabric and paper – to tell his ironic, humorous stories about Canada, what it was to be in a country so saturated with self-congratulatory, but also self-deprecatory, mythology. He was concerned not about the darker ontology which compelled Sandra Meigs, but with the personal meaning of his own immigration from the United States in 1960 – a concern expressed as staged music-theatre celebrations and clever sendups of Canada's fables about all its national treasures, from

handsome Mounties to the Group of Seven. Though utterly different from the work of General Idea or the Western Front in terms of its encounter with the social and sexual meanings of existence, Graff's art was also an art of the borderline. He addressed the question of what it means to be in a place where the border is everywhere in one's life, and where ironic, observing distance from a larger social identity therefore becomes the central and enduring fact of that life.

At the end of the 1970s, the twenty-year period in Canadian art which had begun with the epiphanies of Marshall McLuhan was at last coming to a pause, levelling off, and consolidating. Canadian video had long since left behind its behaviouristic, introspective aesthetic, and had developed distinctive narrative, fictional voices well known wherever video art was viewed in Canada, the United States and abroad. Though serious scholarship lagged far behind international interest, even the public art galleries of eastern Canada had acknowledged installation, performance and video art to be significant (if still somewhat suspect) ingredients in the Canadian mix, and some of these artworks had even been sent abroad as the culture approved and supported by the Canadian state. The projects, dreams and art of General Idea and other adventurers in media formats and recently appropriated artistic technologies were also being spread abroad by periodicals such as *File* and Eldon Garnet's *Impulse* magazine. New public interest, and these new informational vehicles for art-making, and for making art seen and understood, provided Canadian artists with an unprecedented number and variety of ways to express their visions, mythologies and discontents.

No matter how various these opportunities of communication may have been, however, they shared certain characteristics – a broadly perverse sense of humour and style; a casual disrespect for established artistic means, from easel painting to modern sculpture; and a

handyman, eclectic attitude towards the new media. Yet it was clear as early as 1975 that a younger generation of artists, working in both English and French Canada, was becoming aware of still newer (and simultaneously older) permissions and motives.

The permissions came, in large measure, from Europe, where expressive, densely figurative painting in Germany and Italy (with its roots in the bitter expressionism of the early twentieth century) was enjoying a remarkable and much publicized revival. The North American pattern and ground of motives was more complex. A generation of artists had arrived on the international scene who knew little or nothing of the happy media-consciousness of the 1970s – for all that they eagerly enjoyed the liberty which media art gave them to appropriate the fabrications of mass culture and entertainment, from New Wave, through punk and beyond. The newer mood was grim, confronting a retrenched conservatism and a failing international economy. The newer stance of the young tended towards passivity and despair, in the face of impending nuclear war and the lesser afflictions of persons by states and classes. Sisyphus was elected to replace Narcissus as the sexual and artistic archetype for this newer generation.

It was in this context of revived (or imposed) bohemian conservatism in Toronto, Montreal, New York and elsewhere in North America that a revised notion of what painting could be took root and pushed up its hard, thorny stalk. A sense of how quickly this happened can be gathered from a single example in Toronto's recent art history.

In the fall of 1981, a group show of ten young people opened in a tiny apartment one floor above Spadina Avenue. It was a painting and sculpture show intended to inaugurate a new artist-run centre, soon known as ChromaZone – but there was nothing very odd about that. A new generation of artists emerging on the

Toronto scene was reappropriating easel painting, with all painting's kit of stuff and clutter, and its total strategy of concern with the traditional matters of composition in two dimensions and the problems of drawing. The studio work of painting was being devoted again to expressing the fantasies, narratives and fictions which hitherto–throughout the 1970s, in any case–had been almost the exclusive domain of electronic, photographic, publications and performance media.

Nor was the appearance of one more artist-run centre much of a surprise. By 1981, the self-help social and artistic experiment begun at A Space a decade before had become a network of more than forty artist-run cooperatives across the country, a dozen of which were located in Toronto.

What was remarkable about the ChromaZone opening was the fierce commitment of the gallery's five founders– Andy Fabo, Oliver Girling, Rae Johnson, Steven Niblock and Hans-Peter Marti – to painting and drawing as the artist's most useful formats for authoritatively communicating visual information about the world and the self.

The show seemed to galvanize the local scene, bringing artists and art students quickly into the new project of figurative, roughly expressionistic painting and drawing, and out of their studios with products ranging widely in quality, but urgent in style. Only a year later, the directors of YYZ, another artist-run centre, were able to organize the *Monumenta* group show, which included the work of nearly seventy artists from Toronto alone, most of them painters, many of them dedicated to the same goals as the ChromaZone artists: the development of a vividly psychological, aggressive, yet nostalgically allegorical, even neoclassical, style of art-making, which would render visible, tangible and perhaps manageable the tensions and vexations of life on earth.

While the *Monumenta* show gave ample evidence of old artistic media being pressed back into use as vehicles of new concerns, more often than not the paintings and drawings of these figurative artists showed their makers' continuing interest in the imagery of television, video art and photography, and the received images generated by mass media. Some, notably ChromaZone artists Rae Johnson and Andy Fabo, were working with the lurid, excited colours peculiar to television, and composing their tableaux using the odd distortions and perspectival shifts peculiar to the photographic image. As sources for his combative paintings and multipanel constructions (which again featured boxers as emblems of urban conflict), Fabo has used pictures lifted directly out of the *Village Voice*, bus-station boxing magazines and pornographic plastic-wraps. One of Rae Johnson's recent projects involved small, vivid paintings done up from Polaroids taken at a particularly raunchy Halloween party in a Queen Street West hotel, then installed in the hotel itself–art returning to, and becoming part of, its motif, like a guilty person returning to the scene of the crime.

Other artists, usually outside Toronto and in a different dialogue with contemporary art (one thinks, for instance, of Calgary artists John Hall and Christopher Hurst) have gone back to the older, historical ideas of composed easel painting: the still life and picturesque tableau in the case of Hall, and the romantic story-picture (though employed with a wicked twist) in the case of Hurst. But whatever the quality and extent of the artist's dialogue with the history of art–which varies widely, often taking on a hostile edge–and wherever in the country that dialogue is being carried on, the complex, ambivalent experience of urban alienation and freedom is a constant theme. It includes both alienation from the past as a source of continuity, and alienation from the present as a source of power and integrity–which, however, is also freedom from the publicity of urban life and bondage to its customs.

The traditionally reassuring topic of the

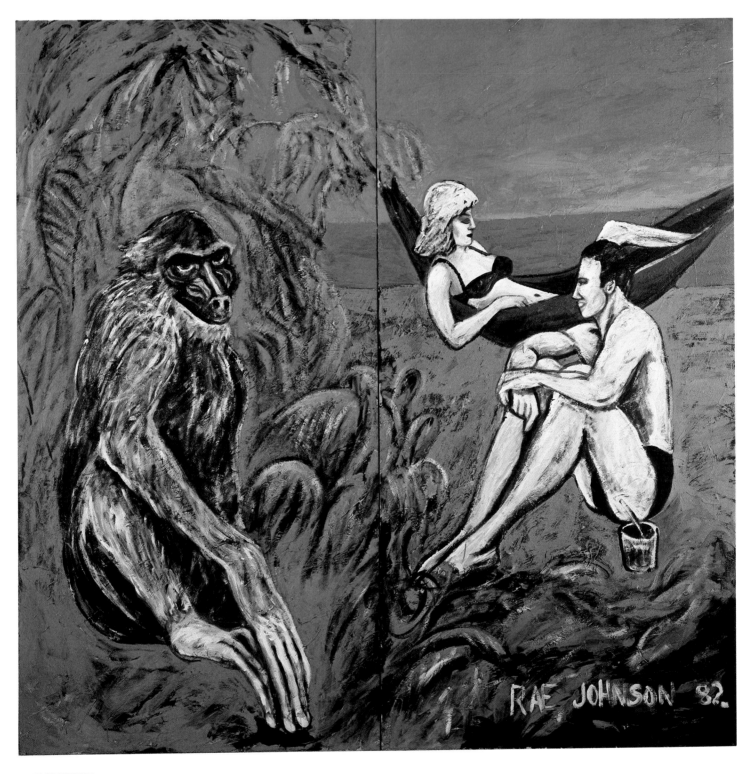

RAE JOHNSON
Vacation #1 (1982)
Acrylic and marble dust on particle board, diptych, 244 × 244 cm
Collection of the artist

landscape has lately been ignored in much of the work of both urban and rural Canadian artists. The streets and highrises of anxiety have walled in the self from the traditionally comforting Canada beyond. Leaving behind the cultural ironies of General Idea and the psychological ambiguities of Rodney Werden – and leaving behind the technological variety and eclecticism of these artists and others – the new painters, draftsmen and sculptors have set out their flat statements blatantly, often with contempt for customary painterly beauty, as accusatory descriptions of the alienated state. The new Canadian city they have lived in is not even allowed the slick, honky-tonk charm of Brutopia; nothing that fetching or theatrical would be admitted. The most ambitious of these artists have attempted to strip their work of poetic ambiguity and replace it with a blunt, utilitarian and unmistakeable iconography of personal discontent.

Take tourism, for example. What could be more useful as a symbol of such discontent, especially for the white, middle-class suburban artists of Canada trying to distance themselves from their roots? Since the earliest days of European industrialization, artists have been fleeing the dark satanic mills and searching for Edens to depict and celebrate. But the tourist pictures of Montreal artist Lynn Hughes are anything but exotic. They are inventories of the cheap watches, cheap radios and cheap sex tourists find and buy in banana-republic paradises. Similarly, Rae Johnson has in one work depicted a background tableau of white, plaster-cast people, with some kind of long-fingered simian closer to us, and it's not hard to figure out whose side we are asked to be on.

A more wistful, lost stance is struck in Calgary painter John Hall's *Tourist Series* (1981–82). Little tableaux of sentimental kitsch and tourist souvenirs, from California and New York, have been blown up on canvases of almost monumental scale. They are memorials, writ large, to good times enjoyed anywhere but in Calgary, but those happy moments really could be captured nowhere else but in art and in memory – as Hall reminds us by writing across one picture the words, "Things didn't work out." They didn't work out in paradise for mankind, and it appears certain that they never will – which is why we always go back where we came from, in the Canadian cities that lie forever east of Eden.

At the bottom of this revival of bitter tourist imagery are, of course, the realities that make tourism necessary, urgent, even imperative: the philistine stinginess of life in most of Canada's cities; the poverty of strong support within them for free and innovative creative work; and the general, studied greyness of them all – especially the ones whose downtowns have been gutted by the rational, modernist city planners to make way for the glass boxes of Brutopia.

The charge against the cities has been laid during the early 1980s with remarkable force by Toronto painter Shirley Wiitasalo. She has not parodied or hectored in her remarkable paintings, but she has provided visualizations of urban life as it is lived by those who feel it as something other than liberation. Her works are difficult meditations on a world schematized and dressed out as figures and places are on television, stripped of ambiguous richness, dematerialized into pure structural imagery set free to float in space as so many electronic impulses drawn into visibility by invisible magnetic fields. These radically simplified, extreme figurative paintings reveal men and women fast-frozen in the rational city, paralyzed in happy poses inside the unfreedom of industrialized urban life. They disclose, as few contemporary paintings have been able to do, the simple, rude metaphysics with which every city dweller must deal, even in the most peaceful places.

But on this side of the metaphysics, at the street level of things, stand the hard human physics of it, and these aggressions, excesses and difficulties are at the heart of the new urban painting.

It would be difficult to overestimate the

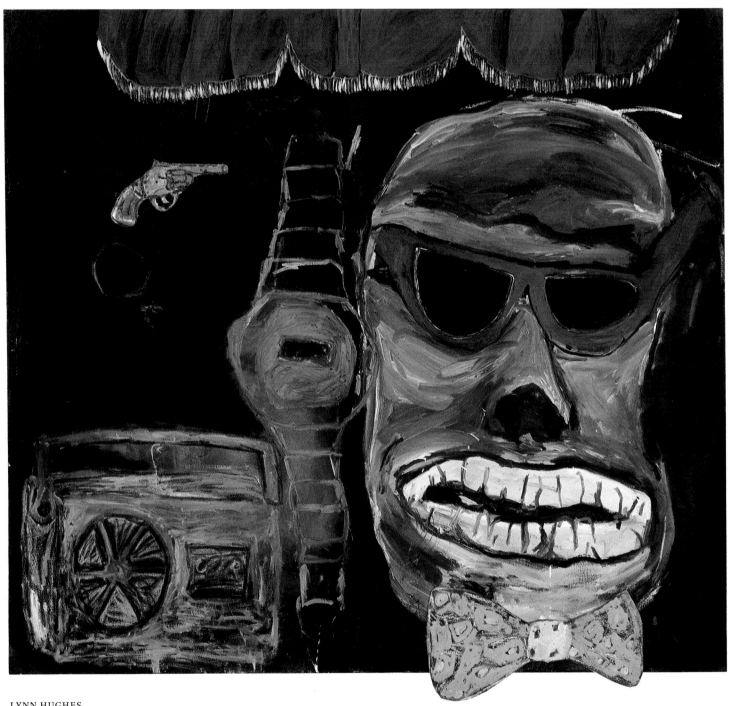

LYNN HUGHES
Tourist (1981)
Oil on canvas, 137 × 152 cm
Collection of the artist

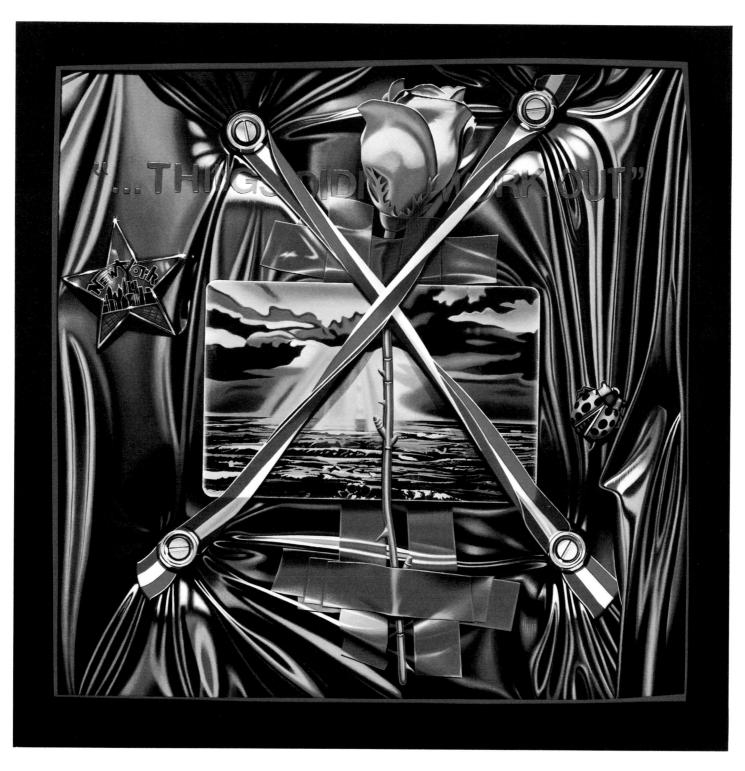

JOHN HALL
Long Island Sunset (1979)
Acrylic on canvas, 112 × 112 cm
Wynick/Tuck Gallery, Toronto

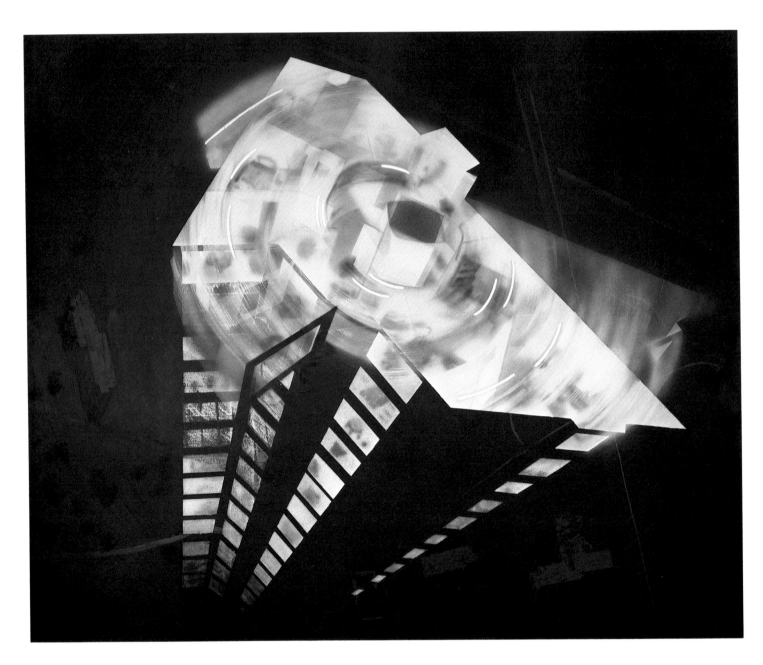

SHIRLEY WIITASALO
Expansive Expensive (1981)
Oil on canvas, 152 × 183 cm
Petro Canada Ltd., Calgary

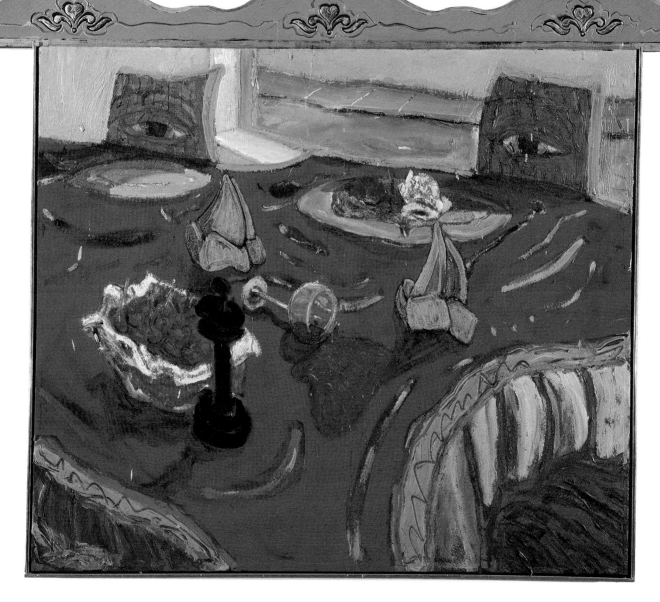

BRIAN BURNETT
What Everyone Needs (1982)
Acrylic on red velvet, 143 × 192 × 4 cm
Isaacs Gallery, Toronto

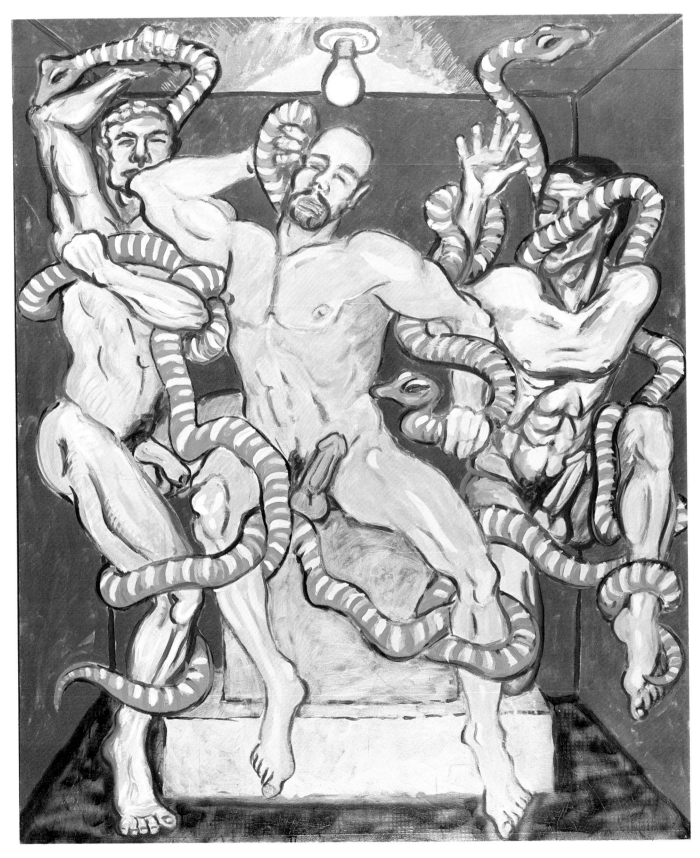

ANDY FABO, *Laocoön Revisited* (1981)
Acrylic and spray enamel on newspaper on canvas, 216 × 178 cm, collection of the artist

importance of this profound shift of attitude. Since civilization began, the city has been viewed as a zone of authentic liberation from the ignorance and superstition of village life, and a haven from the contingencies of nature. But in the early 1980s, for perhaps the first time, it has been virtually impossible to find an artist who could paint the city as haven or free zone, with any conviction beyond hostility. To be sure, some could be found who point to the opulence of city living. But Toronto artist Brian Burnett's tables laden with food, for example (painted, as though his point weren't clear enough, on red or orange crushed velvet instead of canvas), are so fat and dripping that they provoke chiefly disgust – and disgust, surely, at this image of voracious consumerism, is exactly what the artist wanted his viewer to feel.

More often, the moods pervading the new painting are of vexation or outright defiance. In one portrait, Toronto painter Simon Harwood has chosen to depict the same man twice. In the foreground, he appears thoughtful and composed, leaning on a table; in the background (the subconscious shadows of the picture) he is clearly anguished. It is as though each man were two, divided against himself. The messages in Andy Fabo's *Laocoön Revisited* (an appropriately melodramatic translation of the classical statue which fascinated romantic critic Gotthold Lessing), or in his pictures of the boxing ring, are more explicit: despite the talk of liberty and democracy, the homosexual man – and, by implication, everyone else who does not conform to the stylized expectations of mass urban civilization – is doomed to a life of uncertainty and oppression of the very sort cities were invented to relieve. Moreover, these degradations have been enshrined as principles of morality – more confusions, organized as law and order, and marshalled

against the individual. In Fabo's *Laocoön*, we are at last given a clear, harrowing view of the snakes in Glenn Lewis's garden.

Though Toronto has been the national focus of the new Canadian painting of the early 1980s, the anxiety it enshrines is hardly limited to Toronto. In her remarkable *Lost River Paintings,* Montreal artist Landon Mackenzie presents nature as a dense darkness haunted by violent dogs or wolves who seem to be only further condensations of the darkness. No longer can we dream towards the Yukon, the mystical North of song, legend and longing, as a place of refuge from the city. The same fears would stalk us there. Mackenzie's paintings demonstrate the invasion of nature by what we fear in the city, and enact the invasion of the city by paintings which tell us at last what we have always known about both culture and nature, beyond all urban culture's promises to push back and subdue the fearful.

Meanwhile, in Vancouver performance artist and painter Gathie Falk's representations of gardens and water, we find perhaps the most subtle, disturbing statements of the dilemma. The surfaces are all bright and summery, glistening in the summer sunshine – lambent skeins of peaceful ripples, or mown fields, speaking to us in their imagery of the forgiveness and humility nature is said to restore to us. Yet this bucolic romance is troubled by an upheaval which seems to be surging from the ground and depths, undoing the very molecules just below the surface. Finally we see nature caving in at the metaphysical centre of itself, drawing the tentative, shining and tamed surfaces of civilization down into its dark core, and leaving little doubt as to the fate of the personal, the individual, in this human universe turning upon itself and beginning to devour.

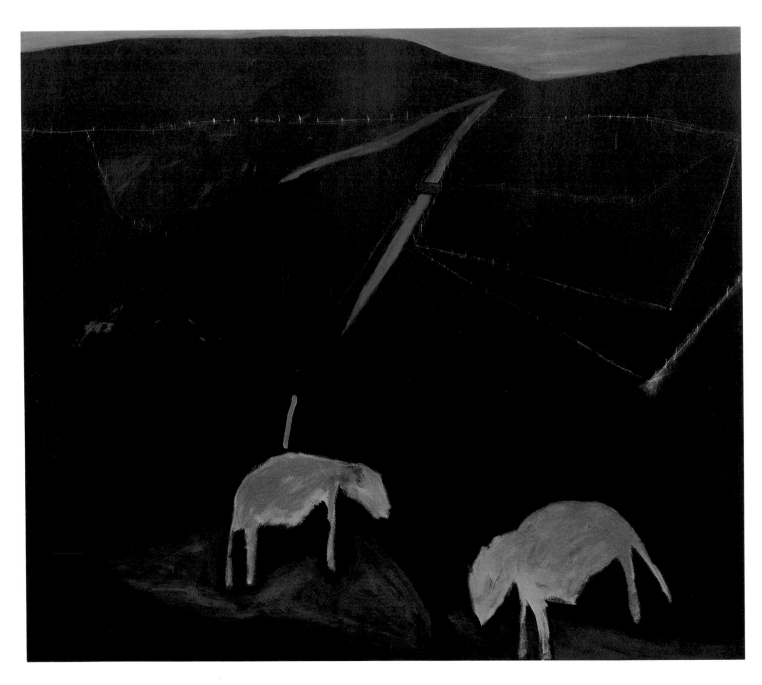

LANDON MACKENZIE
Lost River Series #4 (1981)
Acrylic on canvas, 193 × 224 cm
Collection of Sheila Mackenzie

GATHIE FALK, *Pieces of Water: El Salvador* (1982), oil on canvas, 198 × 168 cm, collection of the artist

GARRY NEILL KENNEDY
Untitled (1977)
Acrylic on canvas on masonite, 76 × 76 × 5 cm
Art Gallery of Ontario, Toronto

What art has been in Canada is defined in large measure by art elsewhere. Since the Second World War especially, Canadian artists have shown a general openness to international art currents. During the 1950s, surrealist influences were apparent in the work of the Québec artists who called themselves Automatistes, while various modes of abstraction, barely intuited before the war in the work of Lawren Harris, were firmly implanted by the 1950s and early sixties. It can be said that this openness and awareness on the part of the Canadian artists parallelled Canada's newfound political maturity and presence in the international arena in the postwar period. Other, related changes were taking place as well, particularly in the field of communications. Before the war, information about new artistic developments was to be gained largely through the traditional colonial expedient of trips abroad to observe and study. Now, however, the proliferation of well-illustrated art magazines, especially from the United States, made the new art more readily available than it had ever been, at least in reproduction. It also brought the theoretical discussion surrounding that art, both in the judgements of the critics and in the statements of the artists, to the attention of artists in Canada. Thus, they could become familiar not only with the look of the new art but also with its intellectual underpinnings.

In this way a rather one-sided traffic in ideas occurred, although some countercurrents were felt, notably in the influence of communications theorist Marshall McLuhan upon American artists. As the ascendant position of New York City in the international art world became clear, the situation intensified, for Canadian artists were particularly eager to see exhibitions of American abstract expressionist and colour-field painting in Canada. In 1957, the influential critic Clement Greenberg was invited to several

artists' studios in Toronto, and a few years later returned to Canada to teach at the Emma Lake summer school. The penetration of a specifically American discourse on modernism affected the way a growing number of Canada's artists viewed their own art. In the 1930s, Lawren Harris had sought a transcendent modernism based on a vision of the Canadian northland, and in the 1940s,

Rethinking the Art Object
Diana Nemiroff

Paul-Émile Borduas had linked his breakthrough into abstraction with an impassioned denunciation of the narrowness of Québec society. By the 1950s, however, the Québec painter Guido Molinari defined the intellectual framework of his painting by reference to the purely formal problems of colour and pictorial space.

There were, in fact, two branches to the critical thinking which accompanied the aesthetic revolution of abstraction in the 1950s. One was subjective, seeing in the work of art the expression of the artist's inner psychic states; the other was formalist, stressing the autonomy and self-sufficiency of the art object. By both accounts, the content of modern art – and abstract painting or sculpture is but an extreme case – was more and more removed from the stuff of everyday life and experience. From Cézanne through Picasso to Jackson Pollock, the look of modern art changed dramatically, becoming less the reflection of the world around us than the creation of a new, independent world of forms and colours with no outside reference. Yet while this change was taking place, the traditional categories of painting and sculpture remained untouched.

DIANA NEMIROFF

In the mid-1960s a radical reaction began, one which entailed a complete rethinking of the art object. The reaction, which challenged the inviolability of these categories, took the form of a new emphasis on the ideas of a work of art. Idea art, or conceptual art, as the phenomenon came to be called in the sixties, found a prophet in the expatriate French artist Marcel Duchamp. Always an iconoclast, it was Duchamp who in 1917 had signed an ordinary urinal with the name R. Mutt and attempted to have it exhibited as a work of art. The urinal was one of the first of the Readymades: everyday objects chosen by him on the basis of a "reaction of visual indifference...a total absence of good or bad taste...in fact a complete anesthesia." They were dadaist anti-art gestures, an explicit dismissal of art-making. Duchamp stood for rupture, discontinuity, the new, rather than progress in art, which he thought a specious idea.

Conceptual art should be seen, then, as a means of liberation from the long and weighty traditions of art. As the idea came to take precedence over the physical object, the traditional barriers between the disciplines of painting, sculpture and so on broke down. Artists reasoned that if the idea was what counted, art need be no more than the evidence that a given idea had been conceived. If this evidence had to take material form, it needn't bear any resemblance to the traditional stuff of art-making, but could use any material, including writing and snapshots, or any objects found lying around and deemed appropriate, including the artist's own body. Moreover, the events to which the idea gave rise might be acted out in private or in the company of a few friends, or in some remote or unexpected place, and the evidence such as it was might be of essentially ephemeral materials. So the questioning of the art object also resulted in a questioning of the art galleries and museums whose function was to collect, display, preserve or sell those objects. Documentation might provide

information as to the nature of the event, but it was meant more as a sign than as an object in itself, and often it could be distributed better through books and magazines than through galleries. So-called idea art is, in spite of its name, not necessarily intellectual or literary, although it is occasionally so. It announced not so much an emphasis on intellect as a de-emphasis on the material – yet this "dematerialization" of the art object paradoxically turned out to be a means of getting at new forms.

Around 1966, Vancouver artist Iain Baxter began to challenge the notion that art should imply things like paintings and sculptures at all. Baxter's main strategy has been parody. His most brilliant and most purely conceptual work was the N.E. Thing Co., founded by him and his wife, Ingrid, in 1966 as an aesthetic umbrella or corporate identity for their many activities. Though from the present point of view a great deal of his later work is as ephemeral as a one-liner, at its best Baxter's work is an effective send-up of the stuffiness of the art system. His investigations of the extended meaning of packaging – of the ways in which a word or label influences how we perceive our environment – have been both amusing and telling. With the N.E. Thing Co., the Baxters packaged the idea of an artist as a "Visual Sensitivity Informer," and art as "Visual Sensitivity information." They saw the world as "basically one very big ball of information" which could mean different things depending on whether it was processed in a practical or a sensitive manner. From this point of view, art is visual information sensitively processed, and the artist someone who knows how to handle visual information sensitively.

The N.E. Thing Co. set out to change people's perceptions, getting them to look at the world in a fresh and unusual way. Developing the company theme, the Baxters organized their activities under a number of different departments – Research, Thing, Accounting, ACT, ART, etc. The ACTs and ARTs

were categories used in the company's inventory of cultural artifacts; the initials stand for Aesthetically Claimed Things and Aesthetically Rejected Things. N.E. Thing Co. issued ACT and ART certificates, like Good Housekeeping Seals of Approval (and their inverse), according to whether or not the artifact met its "stringent requirements of sensitivity information." Many known works of art were thus rejected, while objects found in the everyday environment and normally taken for granted were photographed, stamped and issued a certificate of merit. The corporate model was indeed a revealing satire of the way the art world appropriates for itself a privileged viewpoint from which to direct our consumption of what it determines to be art. It is a fitting model, moreover, of the view of the art system from one of its peripheries, Baxter's hometown of Vancouver. The provincial artist, receiving information on the activities of the putative centre through New York-based media, is in an ideal position to describe the weaknesses of the system. The centre can't do this; it thinks it's everywhere.

At the core of the Baxters' activities in the 1960s and early seventies is an attitude of playfulness. Their various projects represent a celebration of the ordinary through the imposition of an art framework on everyday life.

To show that art is *a way of looking* rather than an object to be looked at, the Baxters designated their *1/4 Mile Landscape* (1968) with three signs placed at intervals alongside a real highway in southern California. The first sign alerts drivers to the approaching work. "YOU WILL SOON PASS BY A 1/4 MILE N.E. THING CO. LANDSCAPE," it says, while a second sign tells travellers to "START VIEWING." At the end of the quarter-mile strip, a final sign says "STOP VIEWING." Thus, the work is no more than a conceptual frame around an arbitrarily chosen segment of a real landscape. In one way this is an extra-long work of art; in another it is not so different from the signs the Parks

Department places along the roadside to indicate noteworthy views, except what the Baxters are calling attention to is less the view itself – which appears from the documenting photographs to be rather ordinary – than the changed kind of looking which "art" is supposed to involve.

Baxter's use of the term "Visual Sensitivity Informer" instead of artist, and his interest in looking at the everyday world as a work of art, is related to the outlook of the Fluxus group, a loosely connected network of artists, writers and musicians in different fields whose varied activities blurred distinctions between media and whose aim was to erase the artificial separation of art and life. They refused to see art as a separate category. Their "anti-art" attitude favoured indeterminacy, chance and the poetic possibilities of everyday life. They encouraged the arts to break out of their separate categories and envisaged new forms in which the visual arts, theatre, music and poetry might come together to create a total environment.

In trying to extend the idea of art and to think beyond the traditional distinctions of painting, drawing and sculpture, Baxter, like other artists, was led into the area of communications. Contemporary life is full of mobility and change; and many contemporary artists have been interested in the rapid exchange of ideas, rather than embalming ideas in fixed objects. Baxter admits a large debt to Marshall McLuhan, who admired the artist's ability to see things in a new light and predicted an important role for artists in helping the rest of society assimilate the technological changes introduced by new media. By 1969, the N.E. Thing Co. was developing conceptual works for transmission by telex and telecopier. The aim, as Baxter suggests in a later interview, was to explore the way in which information media alter our perceptions and relationship to the world around us: "By using media, you can penetrate anywhere, and be in touch, and that's what the world is all about right now."

BILL VAZAN
Artist's model of *Worldline* (1971)
Installation, worldwide

196

By a curious twist, however, much of the art that was intended to penetrate everyday life, closing the gap between the two by means of art-as-information, turned out to have more to say about art itself than about the world "out there." Pursuing an interest in documentation, information art took on some of the blank, inexpressive look of newspaper photos. It offered the artist the role of recorder, rather than interpreter, of the everyday world, looking to the banal for insight. This, too, may be a strategy, a reaction against the conventionalized refinement of much abstract painting of the 1960s.

Bruce Parsons's *Bogland House* (1973), a composite photodocumentation piece on the town of Lamaline, Newfoundland, where Parsons was living, is part of a larger, sociologically oriented project. But the visual component, in which information is transformed into bits of visual data and organized into mute lists of houses and faces, tells almost nothing of the lived experiences they represent, nor of the artist's attitude to them. In a similar vein, Michael deCourcy of Vancouver compiled 360 photographs of the city in a sort of annotated street map of images familiar to the artist, called *Vancouver Background* (1974), and Jean-Marie Delavalle took several series of slides through the windowscreen of his studio in Boucherville, Québec, from both outside and inside, as a means of "knowing surrounding reality." As the point of view does not vary within each series, what we in fact become aware of is the progress of time through minute incidents which occur, as well as the framing of the screen analogous to the framing of the camera.

Works such as these seem to propose some kind of conceptual mapping of reality. But a map is a tool meant to orient us, to help us get from here to there. Where do the jottings of information art take us? In their preoccupation with dumb facts they contribute merely a literalist pointing at the random sights and events of the world,

rather than illuminating that reality. Where did it come from, this conception of information that abjures meaning? Does the answer lie in the prominence of new communications media in twentieth-century technology? With the development of those media came a unifying theory – information theory, which is concerned with the quantitative measure of information, and with the laws which govern systems designed to communicate or manipulate information. Meaning per se is irrelevant to these manipulations; indeed, a basic idea in information theory is that information can be treated very much like a physical entity.

Looking at the grids of uniformly sized photographs which make up works like those just mentioned, we can see the influence of these ideas. Such works present images as accumulated data, but they do not eliminate subjectivity; they merely give it an objective gloss and reduce it to the relatively trivial (and literal) matter of a specific point of view. In so doing they reveal more about the essentially formal preoccupations of art than they do about reality.

A rather more interesting example of the interpenetration of art and technology is Bill Vazan's *Worldline,* which deals with extensions of space outside the normal perceptual field. Vazan worked from 1969 to 1971 on the calculations of the piece, enlisting the help of countless people, including a civil engineer, gallery directors in locations around the world, as well as the services of map libraries and surveying offices. The work, installed in galleries in twenty-four different countries, traces a zigzag course around the world, suggesting a parallel to the communications networks which crisscross the globe. The visible element consisted of taped angles applied to the floors of the various galleries, with the arm of each angle pointing geodetically to its neighbouring locations on the imaginary line. But the excitement of the work lay in its invisible aspect: its invitation to the

MICHAEL DE COURCY
Vancouver Background (1974)
(photos by Michael deCourcy,
Taki Bluesinger and
Gerry Gilbert; titles
by Gerry Gilbert)
Two-colour photoserigraph,
305 × 406 cm
Canada Council Art Bank
& Vancouver Art Gallery

The New York Tim

'Populati
Edges W

By B. DRUMMOND AYRES J

Special to The New York Times

MASCOUTAH, Ill., April
—Like most Americans, La
rence Friederich has pick
up and moved two or th
times.

Some of the places
dates are beginning to
now that he is 54 years
But one thing is still cl

Inevitably, he has
drawn westward.

At the moment, he l
a 466-acre farm
about five miles eas
east of Mascoutah. H
corn and wheat a
beans and there is
not his white fram
not his wife makin
in the kitchen, no
tagging along b
tractor — that d
him from any of
other hard-worki
farmers.

Except that t
a man from th
reau drove up
said:

"The way
there is a poi
that marks
center of the

In Census
that point
grees, 27
N., and Lo
minutes, 7

In ever
point is
miles e
where a
States
pin if 2
placed
sented
Ameri
the la
ed or

In
guag
ther
is t
the
Fr
cu
fo

The New York Times/Neal Boenzi

homes on Staten Island, where construction for further development is now the subject of a many-sided debate

ity Hall Dominance of S.I. Plan Is Fought

By EDWARD C. BURKS

Richard T. Connor, the
nond Borough President,
it, the Lindsay admin-
ion has been handling
ast Staten Island devel-
nt plan "like a fellow

sion has actively promoted
this development concept. As
one city official puts it:

"On Staten Island we've
seen these little houses
marching down toward the

DICTIONNAIRE 4

The constitutional structure of built form
may be observed as separate from the images
and events themselves, as if they had some
autonomous life of their own. They can be
seen to be codified in the production of
things; it is their vocation. But these
images also show that it is the context of
these forms —how they were produced as
buildings, for whom these buildings exist,
and how they are lived in— that give them
meaning: the autonomous meaning of form
exists only as desire.

26, 1971

PAGES

s sold for a pittance

gee may never go home

MELVIN CHARNEY
Excerpt (Plate 4) from *Un Dictionnaire: Learning from the Wire Services* (1970–78)
Montage, graphite on photocopied newspaper, and written texts:
104 plates, each 28 × 34 cm
Collection of the artist

imagination to visualize the unseen connections that link us, and which no gallery could contain.

In Vazan's words,

The idea of the tape line is that it cannot be seen in its entirety in any visual sweep and even an around-the-world trip will reveal only parts of it. Recourse is to completion by thought, memory, the actual landscape in between, etc. Each tape will be the marker in that part of the world for the imaginary line. Each location will have a visual floor piece as a work on its own and will be yet a segment of the world-girdling line.

As to the reality of imaginary lines, he asks us to think of "global parallels and meridians (space and time), International Date Line; surveying triangulation marks and base lines; flight corridors and water channels (navigation); political demarcations (borders); plotted satellite and space probe trajectories; proxemics, etc."

Worldline's success as a conceptual work of art lay, paradoxically, in creating a visual symbol for those abstract lines. It opened a discourse with other disciplines which went well beyond the dull imitation of the media and the dreary compilation of "information." The excitement felt by participants all over the world when the components of the piece were installed suggests that it gave real meaning to McLuhan's concept of the global village.

Two works by Montreal artist/architect Melvin Charney fall squarely within the realm of questioning which led artists to the "dematerialization" of the art object. The first is his early *Memo Series* (1969–70) which proposed alternatives to a conventional memorial to the history of Canadian aviation, examining and questioning the idea of a memorial. The other is his monumental *Dictionnaire* (1970–78).

The idea of the latter work is quite simple. Like all dictionaries, it is a conceptual mapping of a language, in this case that of architecture. Subtitled *Learning from the*

Wire Services, it consists of images taken from photographs of news items which were transmitted by wire. To quote Charney's description:

The images show people and buildings caught …in upheavals. The buildings are wrested from their immediate surroundings, and projected into the news media where they assume a larger-than-life connotation. The significance of an event, and the sheer number of viewers who may see it, assign to these buildings the attributes of power. And while the physical fact of a building may remain constant, an event transforms the way it is perceived. It becomes a metaphor of consciousness, and acquires a monumental aura.

According to Charney, then, the monumental qualities of a building may be built into it, as is usually the case with architecture, or may result from some form of displacement, be it accidental or temporal, which highlights the building's iconic presence. Charney is interested in monumentality of the latter kind. He finds in his collection of images a system of meanings contained within itself and brought out through a process of cross-referencing – as is the case in any dictionary. What begins here with the notion of the architectural monument ends as a monument to the image as the trace of the collective memory.

Both Vazan and Charney have been involved with the signs and symbols of community in other works as well. Vazan's mazes, tracked by his footprints in the snow or made of stone boulders, and Charney's reconstructions of architectural fragments, attempt to layer an archetypal or heroic significance into the contemporary urban environment.

The move toward dematerialization is not the only way in which the art object has been rethought in recent years. During the 1970s, a number of artists developed strategies that questioned the way in which formalist criticism focussed attention on the

object. While the object's formal qualities might be described and analyzed, the connections between form and artistic will may remain essentially mysterious. New strategies were designed, therefore, to turn attention away from the object and onto the purely material processes of making a painting or sculpture, in order to demystify them. The American artist Sol LeWitt's assertion that "the idea becomes a machine that makes the art" exemplifies a strategy of this kind. It was a call for unconditional objectivity in art-making and a rejection of individual subjectivity. LeWitt's ideas are not complex; generally they are no more than banal procedural prescriptions of tautological simplicity. Fixed as titles to the completed works, they become exhaustive descriptions of the processes of making them, which intend to collapse the distinction between form and content and make critical interpretation redundant. At the same time, such an approach appears radically to redefine and limit the subjective element of a work.

This same will to anonymity may be seen in Halifax artist Garry Neill Kennedy's attempt, in works that he did in the mid-1970s, to define a zero degree of painting. His method, related to those of LeWitt, entails determining at the outset of each work certain rules or procedures suggested by the materials and processes of painting itself. Once these rules are chosen, Kennedy's intellectual role is ended, and the making of the painting relies solely on the carrying out of the prescribed moves. The resulting visual information, which may be quite complex, is tied to the initial logic. Consider as an example Kennedy's description of the process of making *Untitled* (1977; see page 192):

The diagonal thread is followed from the top left corner to the bottom edge of the painting revealing the diagonal structure of the canvas. Leaving this thread unpainted, and with brush strokes following its direction, the canvas is painted overall. Excluding the next thread (which has one coat of paint on it) and

with brush strokes following the same direction, the canvas is again painted overall with a different colour. This procedure is followed until all threads to the right of the diagonal are painted a different colour. However, after about the twentieth thread (or coat of colour) all visible traces of threads have vanished, but by using the earlier information as a guide to determine thread width, the painting continues until all the threads are painted. There are about 680 threads painted – the same number of coats of paint. The coats of paint get progressively smaller in area until the final coat (red oxide) which is on the extreme top right is only one thread-width wide.... The painting is finished when the last thread is painted.

Aside from his paintings, Kennedy has done many installations which take the work of other artists for their starting point. In *Canadian Contemporary Collection, Average Size – Average Colour: Thirty-Three Drawings* (1978) he performs a quantitative analysis – this time of the work on permanent display in the Signy Eaton Gallery of the Art Gallery of Ontario – in an effort to reduce the idealist assumptions of the originals to a materialist basis. That this in no way represents their qualities is evident, but, from Kennedy's point of view, irrelevant.

The piece is related in spirit to the work of Rober Racine, a Montreal artist. In one project, he proposed to transcribe and quantify all the novels of Flaubert. The resulting information was to be used to calculate the dimensions of a structure resembling an irregular set of stairs, which would be, in effect, a translation of each novel's structure into physical terms. For the novel *Salammbô* – the only one in the end to undergo the transformation – Racine's labour involved three distinct phases. In the first he counted the number of sentences in the book, as well as the number of paragraphs and the total number of words. Then he made a complete manuscript copy of *Salammbô* on pages of the same size and shape as those used by Flaubert. In the

DIANA NEMIROFF

202

second phase, the building of the staircase, he used the results of the counting exercise to determine the height and width of the steps and risers: the number of words per chapter represented the area of the riser, the number of sentences per chapter its width, while its height was figured by dividing the area (words) by the width (sentences) to get the average words per sentence; the depth of the step was then calculated on the number of paragraphs per chapter. For the final phase – a nonstop reading of the novel in its copied manuscript form – Racine used the staircase as a platform, declaiming the first chapter from the first step, and so forth, until after reading the final chapter from the last stair, he leaped to the ground.

What is the reason for this obsessive activity? I have suggested that the staircase is a translation of the novel into physical terms. Yet unlike an ordinary translator, Racine is not concerned with finding an equivalent for the spirit of the text. His literal dismembering of the text seems to express a desire for an exclusively material or physical experience of writing. The novel seems to interest Racine not as a text but as an object, divested of all meaning but the most literal and anonymous.

It is the marathon performance which clarifies Racine's intentions. This reading is not a translation but a citation, not of the book, but of Flaubert's own working method, which entailed reading aloud the passages he had written to hear how they sounded. Similarly, the laboriousness of Racine's calculations and transcriptions finds its counterpart in the labour Flaubert – a slow and dogged writer – expended on each sentence he wrote. Racine's "quotation" of Flaubert has, therefore, two levels. On the one hand it consists of an arguably futile copying of the text of the book; on the other, it draws attention to certain aspects of Flaubert's working method and gives these a spatial dimension. The end of all Racine's slightly crazy activity is no copy, but a new work, far removed from the original *Salammbô*.

The obsessive attention to the physical process of making a work, and the suppression of the artist's ego through the adoption of anonymous, task-like procedures – evident in these pieces by both Kennedy and Racine – occur also in the work of two other Halifax artists who, like Kennedy, teach at the Nova Scotia College of Art and Design.

Gerald Ferguson has been engaged on what he calls *Maintenance Paintings* since 1979. His description of them – "a series of paintings in a variety of sizes and colours, on standard supports, using latex paint, installed in a reasonable manner and whose reinstallation and maintenance (repainting) is at the discretion of the end users" – reveals a rejection of both the subjective aspects and the uniqueness of the work of art.

The painting becomes no different from any painted object which must be kept up and repainted from time to time. The element of parody implicit here should not be overlooked. A recent group of *Maintenance Paintings* which Ferguson called "bad" paintings were intended as a critique of the recent revival of expressionist painting, particularly that which equates a violent and clumsy execution with artistic authenticity.

Ferguson's and Kennedy's paintings may be ugly, beautiful, or merely boring. Whatever delectation may occur is incidental to the aims of this analytic process art. We may say, in a sense, this is not painting, it is "painting": the mind maintains a detachment from the object, in order to institute a questioning of the idea of art.

Eric Cameron has undertaken a similar questioning in his work. *The Thick Paintings (to be continued)*, on which he has been working since 1979, are at this moment mysterious and misshapen lumps of white pigment calcified into hard, irregular shapes which give little hint of what lies within them. When Cameron first began painting ordinary things lying around the house – a

ROBER RACINE
Detail from *Salammbô* (1979–80)
Wood construction, drawings, manuscript pages and performance
Installation at the National Gallery of Canada, Ottawa

shoe, a lettuce, a cup and saucer, and so on – with layer upon layer of white paint, he anticipated a fairly predictable expanding or thickening of the core object. Instead, a new kind of thing slowly grew as the reality of the physical substance of the pigment asserted itself. The original subject gradually receded, and the shape began to express the mechanical and chemical processes of applying the layers of paint and their subsequent drying.

In making the paintings, Cameron has restricted his involvement to the initial but unimportant choice of objects. From this point on, their evolution is a matter of deliberately mechanical process; they are "to be continued" because even the act of judging a painting to be finished would be an expression of the subjective will which Cameron wishes to avoid. It would appear that through this radical disavowal of self he has produced paintings which challenge the meaning of representation. *Lettuce* is not a painting of a lettuce. The original lettuce, which no doubt has long since withered within the core of the new object, was merely a starting point for a work which means to be the literal manifestation of certain physical processes.

Yet it seems that when the subjective element is most vigorously suppressed, it has a way of creeping in through the back door. Cameron's paintings are not pictures, but objects, and it is precisely as objects that they take on a presence which has undertones of anthropomorphism. Is there not in his work a central metaphor, however unintended? The process of obscuring a central core with layer upon layer of foreign substance surely recalls, through a mechanism of reversal, the psychoanalytic enterprise of peeling away the conscious layers of experience to get at its unconscious core. Cameron has recognized this in the title of another work, the mirror-reflected image of the words *Et in Arcadia Id*. In substituting Id for the Ego of the inscription in the painting *The Arcadian Shepherds* by the seventeenth-century French painter Nicolas Poussin, he

questions the mirror function of art. The mirror now has lost its perfect transparency. Its representations are deformations, giving us back the image not of ourselves but of our desires.

A great deal of what has gone on in modern art may be understood as an attempt to replace the notion of art as a mirror of reality – usurped in the nineteenth century by photography – with a new idea equally compelling. If art is not a mirror, what then is its relation to reality? The two major responses of twentieth-century artists – art as an expression of inner reality, and art as its own reality – have been challenged by the artists under discussion here, and by others, because both alternatives seemed to sever art from meaningful contact with the world. Conceptual art's emphasis on the idea becomes significant from this perspective as the herald of a shift in attitude – though it has tended to get caught in a web of language and signs which again say more about art than about anything else. The "analytical-process" art which surfaced around the same time, as a means of de-emphasizing the symbolic formal value of the object, is likewise a token of the desire to close what is imprecisely felt as a gap between art and life.

Yet, in the twentieth century, our understanding of reality itself has also radically changed. Nietzsche's terse sentence, "God is dead," expresses the loss of certainty which characterizes the modern age. The call for rupture with past art expressed by Duchamp and others may, paradoxically, be prompted by a desire to return to certainty – to the absolute verity of the Idea. Yet with the simultaneous realization of the impossibility of rupture comes a sense of irony and impotence that is in its essence antihumanist. Unable to erect belief structures, we turn to excavation. Our central metaphors are archaeologies: Marxism and Freudianism; each operates through a process of displacement.

For both Marx and Freud, an act of

DIANA NEMIROFF

representation is at the core of the human relationship to the world. "Reality" is a picture of the world we build for ourselves; its image is a relative thing. How we "frame" the world depends, then, on our position in it. The critiques of representation offered by Marx and Freud have also influenced the questioning of artists. The effort to dematerialize the art object and to render the art-marking process self-explanatory has been replaced by a desire to examine the conventions of image-making, and to use the conventions of representation against themselves.

Representation emerged quite early as a critical issue in the work of Michael Snow, a Toronto artist who is known internationally for his experimental films. Snow has always worked in a variety of media, however, and he has stressed the multidisciplinary nature of his work, saying, "I'm not a professional artist. My paintings are made by a filmmaker, my sculptures by a musician, my films by a painter, my music by a filmmaker, my paintings by a sculptor, my sculptures by a filmmaker, my films by a musician, my music by a sculptor…who sometimes all work together." This dizzying roundabout of association does not mean that he sees himself as a mixed-media artist. The overriding idea is rather, in each medium, "to bring about experiences in the 'spectator' that could only be provoked by that particular medium."

Snow's book *Cover to Cover,* for instance, which is a volume of photographs without text, came out of his asking himself, "What is a book?" The result is a book about the experience of reading a book, an object which plays on its own double nature as thing-in-itself and container of narrative.

Cover to Cover is at one level a journal, following Snow through a few hours at home and on a visit to his dealer. This ordinary, illusionistic level of reading is subverted throughout the book by a variety of devices which make us conscious of it as an object. Initially, each view of Snow from the front is followed overleaf by one from

the back; the door he stands in front of and slowly opens is a visual analogy to the leaves of the book on which the pairs of images are printed, and his opening the door is like our turning the pages. In a later sequence, an image we have been following is shown to be, literally, a page; we see hands, presumably Snow's own, turning the pages of the same book we have been looking at. Circularity is the principle at the core of Snow's strategy here: somewhere in the middle of the book the images on the page slowly rotate 180 degrees. Now to go forward in our reading we must go backward, turning the book upside down and looking from right to left, until in the final sequence, Snow at his dealer's picks up the book upside down and presents it to the camera. So the book closes with the image which opened it: the door. We've read it front to back and back to front: in sum, from cover to cover. Description can convey little of the book's complexity and wit. Its closest analogues are those stories whose subject is their own telling; like *Cover to Cover,* they trace a maddening but delightfully circular path.

A delight in multiple layers of meaning is typical of Snow's work – which is united in all its manifestations as a sort of theme and variations on the mutual interpenetration of reality and its representations. Since the mid-1960s he has put much of his energy into filmmaking and photography, two areas where the activity of framing – as a metaphor for thought and perception itself, which frames reality at the same time as it appears to provide a perfect mirror of it – is most obvious. Most of his work in film and photography is based on a desire to defamiliarize these media, to rob them of what we might call their transparency, their tendency to efface themselves and convince us that what we see is a perfect reflection of reality.

One of Snow's most complex, philosophical works is a film whose full title is *Rameau's Nephew by Diderot (Thanx to Dennis Young) by Wilma Schoen* (1974). It is built on the

MICHAEL SNOW
Dennis Burton in
Rameau's Nephew by Diderot
(Thanx to Dennis Young)
by Wilma Schoen (1975)
16 mm colour film with soundtrack,
260 minutes long
Canadian Filmmakers
Distribution Centre, Toronto

principle of the fugue, that musical form in which a theme is taken up and developed by the various instruments or voices in succession according to the strict laws of counterpoint. As the title tells us, the film is based on (but not an interpretation of) the famous work by Denis Diderot. The affinity implied between Snow and the Enlightenment philosopher perhaps lies in the all-inclusive nature of both their projects. As Diderot aimed to compile an encyclopedia of all knowledge, so Snow describes his ambition, in *Rameau's Nephew,*

to make an authentic TALKING PICTURE, *i.e., true to its description, it moves for its 'content' from the facts of the simultaneities of recorded speech and image; it is built from the true units of a 'talking picture' – the syllable and the frame. All the possible image-sound relationships centering around people and speech generate the movie….*

One scene gives a particularly good idea of what Snow means by this. Here, a man reads an incomprehensible text; as he continues and we begin to catch familiar syllables, we realize he is speaking English, but the words have been divided and elided in an arbitrary way. The process is mysterious until a voice intervenes and asks the speaker if he would agree that "reality has the same limitations as our means of observation." The speaker repeats these syllables with different word boundaries, providing a key to unlock the mystery. Reality as we perceive it, Snow seems to be saying, is a mental construction, an interpretation or translation. Change the framing slightly (as Snow does with the stress contours and spacing of the syllables the speaker reads) and we scarcely recognize it – that is, until we learn the new system.

Perhaps the attraction of film and photography for Snow lies in their capacity to function as both window and mirror. They seem to speak equally of the world and of the mind perceiving it, and this balancing is central in Snow's work. Its significance

might be summed up by his remarks on Cézanne: "the complicated involvement of his perception of exterior reality, his creation of a work that both represents and is something, thus his *balancing of mind and matter*…are exemplary for me."

It is instructive to compare Snow's *Authorization,* a self-portrait from 1969, with a seventeenth-century self-portrait by Poussin. The French painter's *Autoportrait* is a classic example of representation which simultaneously alludes to and effaces its means, aiming for perfect transparency or illusionism. The painter is seen, palette and brush in hand, in front of a couple of canvases. Our point of view is the privileged one of the painter himself, who sees his image in a mirror which is never shown but is tacitly implied as identical with the surface of the painting. Snow's *Authorization* begins (and ends) with an actual mirror. To make the work, he taped off, on the surface of a mirror, a rectangle which just coincided with the area framed within the viewfinder of his Polaroid camera. Then he proceeded to take five pictures, fixing each photo, as it was made, within the taped-off area on the mirror – all except the last, which is stuck under the frame in the mirror's top corner. Each of the images replicates the mirror image, the first containing only the initial reflection of Snow photographing himself, while the subsequent ones also contain the other photos. In the fifth photo the "original" reflection has been completely hidden by its successive representations. And as Snow focussed on his reflection in the mirror rather than on its surface, each photograph represents the others progressively more blurred, until the first photo, as seen through the medium of the last, is no more than shadows.

Snow plays here with two modes of visual representation: the picture as window and the picture as mirror. By confounding these, he introduces a perplexing circularity into the work which stems from the paradoxical relationship of the viewer to the scene. Insofar as the work is a window, it implies a

DIANA NEMIROFF

208

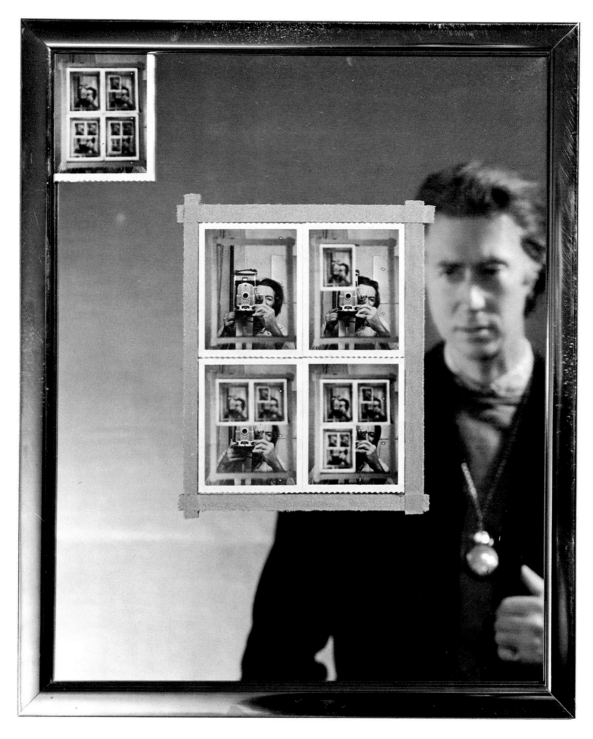

MICHAEL SNOW
Authorization (1969)
Black & white Polaroid prints, cloth tape, mirror and metal, 55 × 45 cm
National Gallery of Canada, Ottawa

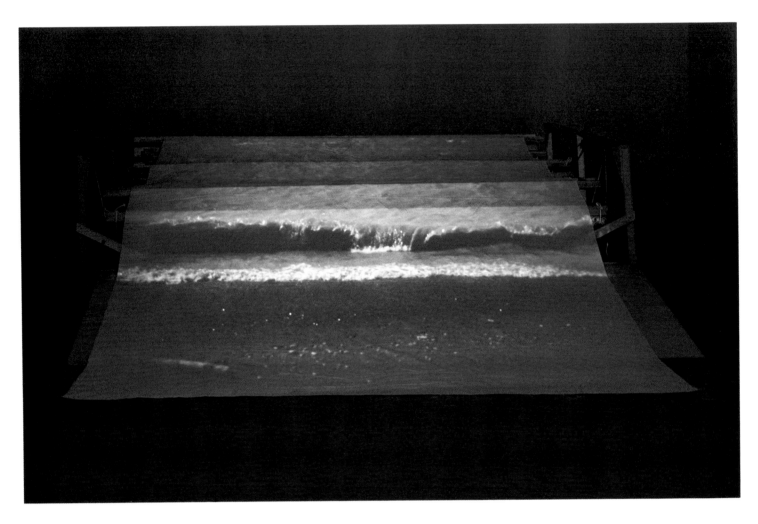

MURRAY FAVRO
Synthetic Lake (1973)
Mixed media construction with electric motor and 16 mm film, 447 × 301 × 90 cm
National Gallery of Canada, Ottawa

viewer, the eye/I who sees and represents what is before him, and is a subjective vision. But as a mirror, the work simply reflects the world before it. If we (or Snow) stand in front of it, we are absorbed into the reality it reflects independently of our seeing. *Authorization* contains both these modes and introduces a third, the picture as surface, which is represented by the successive blurring of each of the photographed images fixed to the mirror. Even the pun in the title is a witty contribution to the eye/I confusion, referring simultaneously to the creative process of the artist/author as well as to the validating role of the objective camera/eye.

Unlike Poussin, who wished to conceal his medium (even while alluding to it with the reference to the canvas within the painting), Snow openly displays his, playing image and mirror off against each other.

The witty and sometimes humorous balancing of two illusions occurs frequently also in the work of Murray Favro, a sculptor from London, Ontario. Favro reinvents the familiar and, in so doing, makes it strange. His work has developed from plaster reconstructions of fairly simple domestic objects, onto which he projects a coloured image of the original object, through more complex installation and projection pieces where movement is introduced, to the invention of fanciful devices such as the *Perpetual Motion Machine* of 1977. Favro himself has pointed to the study of machines as one of the major influences on his work. Some of his more literal re-creations–the large (over six metres long) *Sabre Jet,* for instance–seem like projects out of a Boy's Monthly or amateur inventor's magazine, but in other works a greater complexity is involved. In *Synthetic Lake* (1973), for example, he projects moving pictures of breaking waves onto a contraption consisting of a series of canvas-covered, pulley-driven rollers. The mechanical motion mimes the projected image, yet the net result is a sort of double negative, transforming itself into a positive: reality that has to be seen to be believed.

Such conceptions of the art object do not replace painting, but they do propose an essentially different idea of aesthetic knowledge. This "art of situations" is essentially a theatrical and collaborative one; it seems to invite artist and viewer alike to adopt the roles of storyteller and actor.

One Toronto artist who has extensively explored storytelling as a vehicle for her art is Vera Frenkel. Like Michael Snow, she is interested in investigating shifts in perception which result in shifts of meaning. But here the similarities end; we need only contrast Snow's remark that he is "not interested in making work that can't be explained," with Frenkel's statement that her work "is located in that network of the irresolvable." Frenkel is the more literary of the two. Where Snow constructs paradoxical objects that are relatively self-contained, so that everything the spectator needs for his share of the dialogue is before him, Frenkel deals in skeletal situations, fragments of stories, where the viewer is expected to provide the plot. Her work is, in fact, about interpretation, about the spaces between the facts which prompt the construction we place upon events. "Lies and truths," she has said, "are the same facts in different contexts." The context is what we supply.

This interest in contexts, in open-ended situations which provoke our involvement, is expressed in the physical form of Frenkel's work. Both *No Solution: A Suspense Thriller* (1975–78), and *The Secret Life of Cornelia Lumsden: A Remarkable Story,* begun in 1979, are ongoing works in which an investigation gradually takes shape; each consists of an assortment of everyday objects, repeated images, videotaped enactments of the story so far, and textual commentary. Frenkel acknowledges words and things as the inventions they are. She uses popular forms of storytelling–the exposé and the detective story–and exploits their mythic potential. At the same time, she turns these forms inside out, exposing their artifice. Her suspense thriller, for instance, has no solution. She provides a cast of characters and the hints of a story. (There

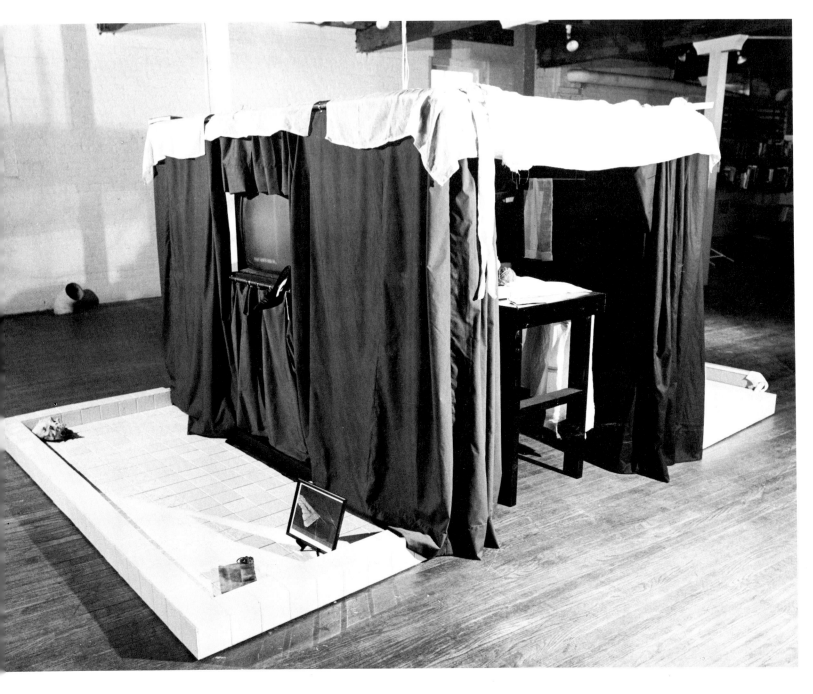

VERA FRENKEL
Signs of a Plot: A Text, True Story and Work of Art (1978)
Part Five of *No Solution: A Suspense Thriller*
Mixed format installation with puppet theatre and two video monitors

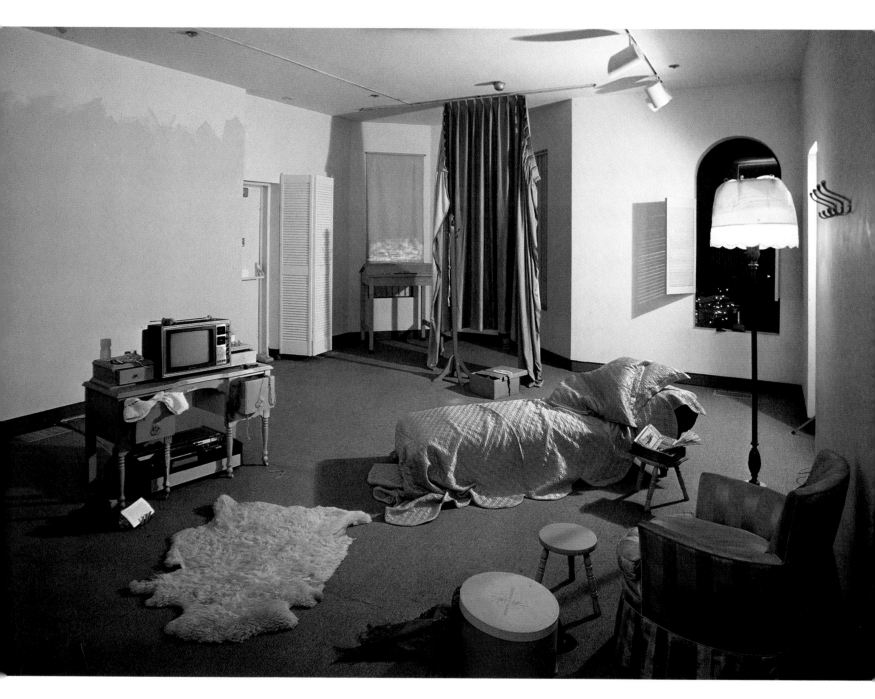

VERA FRENKEL
Her Room in Paris (1979)
Part One of *The Secret Life of Cornelia Lumsden: A Remarkable Story*
Mixed media installation with video monitor

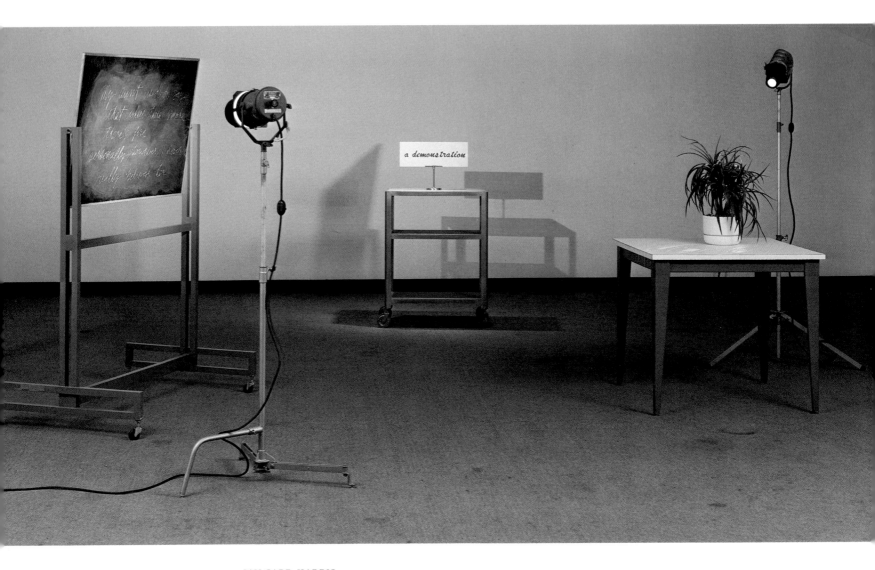

IAN CARR-HARRIS
A Demonstration (1981)
Mixed media installation
Collection of the artist

has been a disappearance; foul play is presumed.) The players enact stereotypical roles right out of any detective novel: the detective (Reasoner); the reporter (Bright); the housekeeper (Nellie Rubric); the victim (Sample Art Broom); the look-alike medium (Art Bruhm); the filmmaker (Rush); the psychiatrist (Neugantz) and the mystery woman (Blackpearl). Out of their collective presumptions a plot (the truth?) is erected; yet all is demolished when at the end they discover they have investigated the wrong thing. The real murder comes at the end. Nellie, the housekeeper, is killed by the storyteller, "because she knows too much." The work might be read as a kind of allegory about making art. Reasoner, the detective, brings a questing spirit and a willingness to shift his attention as events demand. He represents too the ideal spectator for this kind of work – a collaborator-participant who will work with the artist-storyteller to erect the fiction around the props provided.

Where Frenkel, through her videotapes and through the "to be continued" aspect of her installations, clearly introduces a narrative element, Ian Carr-Harris's installations are more like frozen theatrical tableaux. Yet there are stories here too.

In his notes for a 1981 work, entitled *A Demonstration,* he affirms his interest "in simple moral values and questions of expectation and desire, particularly as they are institutionalized in vernacular language and objects." In *A Demonstration,* the catalyst for reflection is a cliché scrawled on a blackboard: "My aunt used to say that where there's smoke, there's fire." The words, and the stage-like presence of the objects which make up the tableau, create a feeling of expectancy. It seems that something has happened, or is about to. But Carr-Harris allows doubt to enter, adding to the saying these words: "Personally, however, I never really believed her." So the situation remains open, and we are left to draw our own conclusions.

This open-ended quality is typical of Carr-Harris's installations. They ask

questions and prod us, often humorously, into trying to unravel the "dilemmas of desire" he presents to us. He is interested in the psychological dimension of objects: how they embody the way people challenge each other. His installations have a certain elegant economy which might strike us as beautiful, but he is not primarily interested in formal questions. In the installation, aesthetic meaning is not felt to be somehow embodied in the object, as is the case with painting and sculpture. The objects function more like props, inviting the active engagement of the viewer. Meaning is a product of this collaborative situation.

Frequently, the artist may become an actual part of the work. In rethinking the art object, prompted by a desire to extend art further and further into real life and to question the limits of art's conventions, many artists over the past decade have been doing performances. These pieces are especially ephemeral; generally the artist's own person becomes the vehicle of the artistic statement. The artist may play many roles – storyteller, actor, even object. In this respect a performance artist is something like the wandering poet or minstrel of the Middle Ages. He – or she – reminds us that before being an object, art is a way of speaking of and in the world.

The themes of performance, therefore, are as various as the number of stories there are to tell. Perhaps, however, the utopian theme of art for art has grown tired, undermined by the conflicts which everywhere press upon us in a world in which Keynesian certainties collapse, SALT talks fade and MX missile controversies rise, the Third World asks for its share, and the media run rampant, inundating us with empty information.

Montreal artist Tim Clark has done a number of performances which deal with the theme of moral conflict. In a recent performance at the National Gallery (November 1982), Clark, naked to the waist except for a sinister black leather gauntlet and harness, and chained to a pole, knelt on

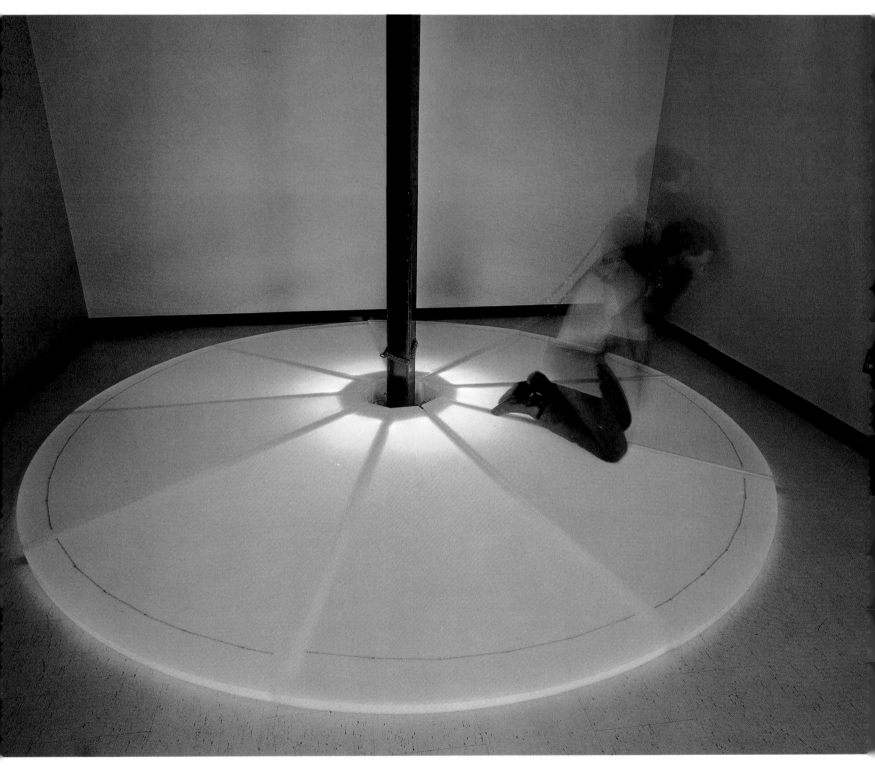

TIM CLARK
Letter One from Héloïse (1100–1163) to Abélard (1069–1142) (1982)
Performance at the National Gallery of Canada, Ottawa

216

all fours and barked out the barely comprehensible words of an anguished twelfth-century document, the first letter from Héloïse to Peter Abélard, ending it all with a howl of anguish and grief.

Clark's performance is not simply a reading or a re-enactment of Héloïse's letter (or her feelings). He has placed her words within a new interpretive structure which seeks, through its own forms, to illuminate the moral dilemma experienced by Héloïse in the convent, caught between her desire and her religious convictions. Héloïse's sentiments, which express a code of being that is lofty, passionate and transcendent, are uttered by Clark in a setting whose symbols – the gauntlet and chain – express the debased condition of man, enslaved by his own acquiescence to the omnipresent but frequently unacknowledged language of power in society.

This is an extreme view, yet much recent questioning of the conventions of representation has turned upon a new awareness of the role of this language of power as it is covertly embodied in art. The rethinking of the art object has been a lengthy process. Art as idea, information art, art as process, installations and performances have constituted some of the various manifestations of this inquiry which has sought to question and redefine the limits of art. In closing the "gap" between art and life, the inviolable status of the art object has been tested, and the traditional categories of painting and sculpture have often given way to hybridized art forms which incorporate new technologies such as film and video or which otherwise transcend the old categories. If the art object has not disappeared, it has been radically changed; it is less object-like than it was.

One of the corollaries of this rethinking has been the extension, or re-extension, of art's critical concerns, going beyond the object to touch upon the culture as a whole. The attention artists have focussed on the media has been particularly instructive, especially insofar as it has made them

mistrust the power inherent in all representations as definitions of how we see ourselves. The critique of representation advanced by recent art responds characteristically by using representation "against itself to destroy the binding or absolute status of any representations."

A work in which such a critique is implicit is Suzy Lake's photo series *Are You Talking to Me?* (1979). Her earlier works have portrayed Lake in various conditions of constraint – by an elaborate harness that turned her into a human puppet in *Choreographed Puppets* (1977) or the tight cords binding her figure in *ImPositions* (1978). In *Are You Talking to Me?* the restraint is a more subtle one: the imposition of silence. The work consists of nearly identical images of Lake's face showing her apparent emotional distress. The multiple images are installed around the gallery walls so as to surround the viewer, creating both a literal and a figurative circularity. The repeated images function as mirrors, collapsing the distance between viewer and image – and yet, paradoxically, the distance remains absolute. This is not ourselves, but another. The mode is that of the confessional, in which the viewer/listener sees all but remains unseen, a situation not unlike the photographic session in which the body's need to reveal itself is complemented by the (invisible) camera's impartial witnessing. It controls – imposes silence upon – everything it surveys.

Works like Jeff Wall's *Picture for Women* (1979) or Max Dean's *Pass It On* (1981) can also be seen to function as critiques of representation. So can Sorel Cohen's *An Extended and Continuous Metaphor* (1982).

Dean's installation is the most straightforward of the three. The viewer waits in an anteroom for a blue light to signal that she or he may enter a second room. (There is also a third room. We notice its doorway in the little passage between the first two. It is there that the artist waits, out of sight.) In the second room there is a Polaroid camera mounted on a stand. It is

SUZY LAKE
Untitled (Mephisto Waltz): from the photo-installation *Are You Talking to Me?* (1979)
Black & white photographs with acrylic, 279 × 109 cm and smaller
Art Gallery of Hamilton, Ontario

timed to take a picture every five minutes. There is also a working bathtub, there are towels, and there is a curved surveillance mirror above the tub. Anything the camera cannot see directly is reflected by the mirror and thus captured in the photograph. Obviously, we are being invited to take a bath, something we are not likely to do in a public place. But if we did, the camera would capture our image in a photo which we could, if we wished, leave to titillate the artist when he came in to tidy up the room.

The work makes reference to the history of art, to those countless images of undressed women seen (and implicitly possessed) by men in the figure of the artist. Here the means of all-seeing control – the automatic camera and the surveillance mirror – stand in for the artist, whose covert voyeuristic role is revealed as he himself is displaced.

Jeff Wall makes even more explicit use of art-historical examples of men watching women. His *Picture for Women,* a large, backlit cibachrome transparency like those we see in billboards, is based on Edouard Manet's *Un Bar aux Folies-Bergère* (1881) and is at the same time a critique of the attitudes hidden therein which still exist today, most plainly in media representations of women. In Manet's painting the sensuous waitress is caught between two gazes – that of her male customer, reflected in the mirror behind her, and our own, which stands in for the painter's, in front of her. And of course by means of the mirror, Manet tells us that the customer, the painter, and ourselves are all one: it is a male world that places the waitress, servant of man, where she is, and which represents her.

In Wall's work the situation is similar, but the relationships are changed. Now the central confrontation is between the viewer and the camera, the eye brought out of hiding and revealed in all its omniscient indecency. The mirror too has shifted places. The "objectivity" of vision in Manet's painting was the result of a convention of the picture plane as a transparent window through which we surveyed the scene. The mirror was one of the "facts" depicted. Now the mirror becomes identical with the picture plane. No longer concealing itself as the transparent window, it is revealed as a mirror reflection of our attitudes. The surface of the mirror/picture in *Picture for Women* is the surface on which a complex network of gazes is revealed: the woman looking guardedly at the camera, the artist who focusses on her, and the camera lens which absorbs the two. But a fourth gaze is also introduced: our own, which is no longer exclusively male, as we see ourselves reflected in the image of either the man or the woman. No longer a picture *of* women, but a picture *for* women.

The introduction of the fourth term, the viewer, into the representation is essential to the task much recent art gives itself – that is, to break down the authority of the representation – and we find it again in Sorel Cohen's *An Extended and Continuous Metaphor.* Here Cohen plays with the idea of the portrait, enacting the multiple roles of painter, model, viewer and the represented image through a sequence of colour photographs. At first, the circularity of the process might remind us of Michael Snow's *Authorization.* Important differences distinguish them, however. On one hand, Snow's image brings the temporal process of its making into our space; on the other, it suppresses the fourth term, the viewer, in its representation. Snow's view here is all views; it possesses universal authority. Cohen is not much concerned with the sequence of time per se, and she imposes no strictly linear reading upon her images. Rather, it is the process of production and reception of the image that occupies her. The fact that she plays all the roles tells us further that she does not intend a literal or mimetic significance. Indeed, although she does not explicitly call it one, we might liken it to an allegory. The images possess a level of significance which is in principle detachable from the descriptive sense, and it is this level of significance which Cohen

deliberately emphasizes and manipulates. She is in effect using the familiar terms of painting to symbolize the changed relationship of artist, art object and audience in art. The specific site of this change, which we must be aware of if we are to appreciate the allegory, is in performance, where the artwork becomes an event rather than a process.

In performance art there is no object – yet the form is in essence a hybrid, which may incorporate aspects of theatre and dance, technologies like film and video, or installation-like settings of visual props. At its core is the person of the artist, the performer. Unlike a work of theatre, a performance cannot in theory be played by any other actor-interpreter. Because this is so for theatre, it can be said to have an object – the play. It is doubtful, however, that this distinction has any eternal necessity. Performance exists as a provisional or suspended state between the arts it momentarily embraces; the term serves to designate an area – currently inhabited mostly by visual artists – in which the boundaries of the traditional arts are stretched and enlarged. As such, it is intrinsically hostile to any rigid definition which seeks to impose limits. We might best understand this identification of performance with the person of the artist through William Butler Yeats's enduring question, "How shall we know the dancer from the dance?" In performance too, as Cohen has noted, "the producer (artist) and the product meld to the point where the artist's posture becomes the actual artwork." But for this to happen, the presence of an onlooker, as witness either to the event itself or to its photographic documentations, becomes crucial in order to receive and acknowledge the process as art. Thus the reception of the work of art is made integral to the work itself.

Historically, this represents a radical shift. What is frequently left out of the history of art is the history of its reception, its social destiny. In the heyday of conceptual art, when the object was being discarded as superfluous to the operative idea, the question of what was art became quite vexed. "Art is what the artist makes" and "Art is what I say it is if I'm an artist" were not very satisfactory responses. They were, nonetheless, attempts to rescue for the artist the power implicit in defining art – a power which lay almost exclusively in the hands of museum and gallery curators, critics and collectors, private and corporate. The social history of art is the history of its institutionalization within the network of galleries, museums, art magazines and corporate boardrooms. Performance art demonstrates that rethinking the art object involves redefining this process of reception, locating the place of "art" in this tacit agreement between artist and viewer. Thus the process is not merely a matter of expanding the idea of the object's form. As Melvin Charney and others have noted, "all art production, as valid cultural production, must call into question the institutions that support it." In this sense, all criticism is institutional, as Duchamp demonstrated with his Readymades. The urinal – signed like a work of art – was a slap in the faces of those who would make a fetish of the unique object. Anti-art gestures do not herald the end of art; rather they announce the advent of a drastic rethinking of what art can be. So idea art, in speaking of the dematerialization of the object, was a sign that a radical shift in attitude was taking place. The look of recent art has changed dramatically. Extending in time and in space, incorporating process and change, art has become less eternal, more contingent, even ephemeral. Yet if the questioning we have been considering has shaken the avant-garde faith in the self-sufficiency of art, it has compensated for this loss by returning to art a sense of its presence in the whole fabric of our culture.

EDOUARD MANET
Un Bar aux Folies-Bergère (1881)
Oil on canvas, 95 × 127 cm
Courtauld Institute Galleries, London (Courtauld Collection)

JEFF WALL
Picture for Women (1979)
Cibachrome transparency and fluorescent light, 165 × 224 cm
Collection of the artist

SOREL COHEN
An Extended and Continuous Metaphor #8 (1983)
Mixed media, 122 × 366 cm
Collection of the artist

Notes

These notes record the sources of most of the quotations which appear in the text. They are identified here by page number and catch phrase. When a source is cited several times in the same essay, it is identified in full in the first citation, and in abbreviated form thereafter. Some of the works referred to are cited in fuller form in the Suggestions for Further Reading.

THE TRIUMPH OF THE EGG

11 Ann Davis: *A Distant Harmony* (Winnipeg Art Gallery, 1982)

12 *Kinder, Kirche, Küche:* "Children, church and kitchen," a slogan ascribed to Kaiser Wilhelm II, for which feminists may wish to hang him in posthumous effigy. The Nazis, if I am not mistaken, later altered the phrase to *Kinder, Küche, Kraft,* thus managing to affront two groups at once.

19 the Plasticiens' manifesto: quoted in Dennis Reid, *A Concise History of Canadian Painting,* p. 281

41 Anna Freud: quoted in the *New York Times,* 10 October 1982, p. 24

A SENSE OF PLACE

45 "modernism in Canada": Dennis Reid, *A Concise History of Canadian Painting,* p. 174

46 "The great purpose": Barry Lord, *The History of Painting in Canada,* p. 138

46 "the conquest of nature": Northrop Frye, *The Bush Garden* (Toronto: Anansi, 1971), p. 201

46 "too bad that West of yours": Lord, *The History of Painting in Canada,* p. 177

46 "The real Canadian scene": Reid, *A Concise History of Canadian Painting,* p. 204

47 "unoccupied landscape": Lord, passim

51 "a minor colonial school": Lord, p. 207

53 "The last place": Paul Duval, *High Realism in Canada,* p. 145

59 "In life, particular situations": George Woodcock, *Ivan Eyre,* pp. 29 & 33

62 "Paradoxically": *Artscanada* 222/223 (October/November 1978), p. 20

65 "Painting isn't an aesthetic operation": quoted in *Jack Shadbolt: Seven Years* (Vancouver Art Gallery, 1978)

76 Wilson Duff: in *Bill Reid: A Retrospective Exhibition* (Vancouver Art Gallery, 1974)

THE ALTERNATE EDEN

80 "serene and uplifted planes": cited in Robert Fulford & Joan Murray, *The Beginning of Vision: The Drawings of Lawren Harris* (Vancouver: Douglas & McIntyre, 1982), p. 43

81 "a sharpened awareness": Paul-Émile Borduas, *Écrits/Writings, 1942–1958,* pp. 73–74

83 "We were terribly innocent": cited in Joan Murray, *Painters Eleven in Retrospect* (Oshawa, Ontario: Robert McLaughlin Gallery, 1979), p. 7

89 "those shimmering fields": Town in conversation, December 1982

89 "what have I got to lose": cited by Terry Fenton in *Jack Bush: A Retrospective* (Toronto: Art Gallery of Ontario, 1976)

89 "sufficient illusion of depth": Clement Greenberg, "American-Type Painting," in *Art and Culture* (Boston: Beacon Press, 1961), p. 226

89 "the greatest disaster": cited in Murray, *Painters Eleven in Retrospect,* p. 79

89 "If it scares you": cited in Murray, p. 76

94 "A bristling form": Jack Shadbolt, *Act of Art* (Toronto: McClelland and Stewart, 1981), unpaged

94 "palpitant reverie...legendized": Jack Shadbolt, "The Activity of Art: A Personal

Response to History," *Artscanada* 198/199 (June 1975), p. 30

94 "to inject a spark": Arthur McKay, "Emma Lake Artists' Workshop," *Artscanada* 244/245, March 1982, p. 103

95 "new kind of flatness": Clement Greenberg, *Art and Culture,* p. 226

99 "The prairie makes mystics": Norman Zepp in *Otto Rogers: A Survey* (Saskatoon: Mendel Art Gallery, 1982)

99 "continuing pursuit": cited in *Otto Rogers: New Paintings and Sculpture* (Lethbridge: Southern Alberta Art Gallery, 1978)

99 "a mysterious connection": George Moppett, interview with Otto Rogers, cited in *Otto Rogers: A Survey*

101 "language in general": cited in Pierre Théberge, *Guido Molinari* (Ottawa: National Gallery of Canada, 1976), p. 41

101 "the problem of colour-light": cited in Théberge, p. 17

103 "only powerful balances": cited in Théberge, p. 23

103 "the emotional reality": this and subsequent quotations from Molinari are from Théberge, pp. 42–50

104 "What I wish to do": cited in Danielle Corbeil, *Claude Tousignant* (Ottawa: National Gallery of Canada, 1973), p. 14

104 "It's not what you see": cited in Roald Nasgaard, *Yves Gaucher: A Fifteen-Year Perspective, 1963–1978* (Toronto: Art Gallery of Ontario, 1979), p. 41

107 in the pages of *Time* magazine: see Philip Fry, *Charles Gagnon* (Montreal: Musée des beaux-arts, 1978), p. 39

111 "between the realities": Fry, p. 35

111 "Art really deals with communion": cited in Fry, p. 91

111 Dennis Burton: cited in Joan Murray, ed., *Dennis Burton Retrospective,* (Oshawa: Robert McLaughlin Gallery, 1977) p. 13

112 Avrom Isaacs: cited in Barrie Hale, *Toronto Painting, 1953–1965* (Ottawa: National Gallery of Canada, 1972), p. 15

112 has always thought of himself: Coughtry in conversation, January 1983.

116 "the joy of painterly painting": cited in Joan Murray, *Gordon Rayner Retrospective* (Oshawa: Robert McLaughlin Gallery, 1978), p. 50

119 "a painting can only be understood": cited in *Canada/Ron Martin/Henry Saxe* (Ottawa: National Gallery of Canada, 1978), p. 9

119 "by throwing ourselves": cited in *Canada/Ron Martin/Henry Saxe,* p. 10

119 "took a long sharp knife": Gathie Falk, cited by Ann Rosenberg in "Pieces of Water," *The Capilano Review* 24 (1982), p. 55

REDEFINING THE ROLE

(This essay has profited in various ways from the assistance of Sorel Cohen, Greg Curnoe, Tim Guest, Stephen Inglis, Elizabeth McLuhan, Alan McKay, Wayne Morgan, Bruce Parsons, Clive Robertson, Ron Shuebrook, Marcel St. Pierre, Normand Thériault and Scott Watson. – C.T.G.)

123 "We refuse to be ghettoed": *Refus global,* in Paul-Émile Borduas, *Écrits/Writings, 1942–1958*

124 "I belonged to my village": Borduas to Claude Gauvreau, in *Écrits/Writings, 1942–1958*

149 "and become a worker": *It's Still Privileged Art* (Toronto: Art Gallery of Ontario, 1976)

THE SNAKES IN THE GARDEN

158 Alvin Balkind, Jo-Anne Birnie Danzker and Frank Davey: see *Living Art Vancouver* (Vancouver, 1980) and the introduction to *Tish Nos. 1–19* (Vancouver: Talonbooks, 1975)

159 Brad Robinson: "Evidence of Intermedia at the Vancouver Art Gallery," broadside printed by Coach House Press for insertion in *Artscanada* 146/147 (August 1970); reprinted in *Pacific Rim Consciousness* (Burnaby, B.C.: Simon Fraser University, 1975)

163 "the green world": Glenn Lewis, "Survival Paradise," in Marie Langford, ed., *Paradise/Le Paradis* (Ottawa: National Film Board, 1980)

165 "It is the very emptiness": quoted in *Art & Correspondence from the Western Front* (Vancouver: Western Front, 1979)

168 "metaphysical sculptures": the phrase is A.A. Bronson's

175 "Video in the beginning": in Peggy Gale, ed., *Videoscape* (Toronto: Art Gallery of Ontario, 1974)

RETHINKING THE ART OBJECT

194 "reaction of visual indifference": *Salt Seller: The Writings of Marcel Duchamp* (New York: Oxford University Press, 1973), p. 141

194 "basically one very big ball": cited in Marie
Fleming, *Baxter²: Any Choice Works 1965–70*
(Toronto: Art Gallery of Ontario, 1982), p. 36

195 "By using media": Baxter interviewed by
Robin White, in *Ten Canadian Artists in the
1970s* (Toronto: Art Gallery of Ontario, 1980),
p. 23

201 "The idea of the tape line": Bill Vazan,
Worldline 1969–71 (Montreal: William Vazan,
1971)

201 "The images show people": *Melvin Charney,
Oeuvres 1970–79* (Montreal: Musée d'art
contemporain, 1979), p. 21

202 "The idea becomes a machine": cited in
Ursula Meyer, ed., *Conceptual Art* (New York:
Dutton, 1972), p. 157

202 "The diagonal thread": *Garry Neill Kennedy*
(Toronto: Art Gallery of Ontario, 1978)

203 "A series of paintings": *Gerald Ferguson:
Paintings* (Halifax: Eye Level Gallery, 1980)

206 "I'm not a professional artist": *Michael Snow*
(Paris: Centre Georges Pompidou, 1978), p. 23

206 "to bring about experiences": letter from
Snow to Nemiroff, dated 4 March 1983

208 "the complicated involvement": quoted in
Brydon Smith, ed., *Michael Snow/Canada*
(exhibition catalogue of the 35th Venice
Biennale, 1970), p. 45

211 "not interested": Snow quoted by J. P. Tadros,
Le Devoir, 27 April 1970

211 "network of the irresolvable": Vera Frenkel,
Lies & Truths (Vancouver Art Gallery, 1978), p. 9

215 "simple moral values": *Ian Carr-Harris: Recent
Work* (Halifax: Dalhousie Art Gallery, 1982),
p. 9

217 "against itself to destroy": Frederic Jameson,
"In the Destructive Immerse," *October* 17
(Summer 1981)

221 "the producer (artist)": Cohen, unpublished
statement, 1982

221 Melvin Charney and others: see Chantal
Pontbriand's interview with Charney,
Parachute 13 (Winter 1978), p. 28

Suggestions
for Further Reading

Artscanada, 1943–83. Formerly *Arts Canada,* formerly *Canadian Art.* Published bimonthly by the Society for Art Publications, Toronto.

BORDUAS, PAUL-ÉMILE. *Écrits/Writings, 1942–1958,* ed. François-Marc Gagnon. Halifax: Nova Scotia College of Art and Design, 1978.

BRADLEY, JESSICA, ed. *Pluralities/Pluralités 1980.* Ottawa: National Gallery of Canada, 1980.

BRONSON, A.A., & PEGGY GALE, eds. *Museums by Artists.* Toronto: Art Metropole, 1983.

BRONSON, A.A., & PEGGY GALE, eds. *Performance by Artists.* Toronto: Art Metropole, 1979.

BURNETT, DAVID. *Iskowitz.* Toronto: Art Gallery of Ontario, 1982.

DOW, HELEN J. *The Art of Alex Colville.* Toronto: McGraw-Hill Ryerson, 1972.

DUVAL, PAUL. *Four Decades: The Canadian Group of Painters and Their Contemporaries, 1930–1970.* Toronto/Vancouver: Clarke, Irwin, 1972.

DUVAL, PAUL. *High Realism in Canada.* Toronto: Clarke, Irwin, 1974.

FENTON, TERRY, & KAREN WILKEN. *Modern Painting in Canada.* Edmonton: Hurtig, 1978.

FLEMING, MARIE L. *Baxter²: Any Choice Works.* Toronto: Art Gallery of Ontario, 1982.

FRENKEL, VERA. *Lies and Truths.* Vancouver: Vancouver Art Gallery, 1978.

FRY, PHILIP. *Charles Gagnon.* Montreal: Musée des beaux-arts de Montréal, 1978.

GAGNON, FRANÇOIS-MARC. *Paul-Émile Borduas.* Ottawa: National Gallery of Canada, 1976.

GAGNON, FRANÇOIS-MARC. *Paul-Émile Borduas, 1905–1960: biographie, critique et analyse de l'oeuvre.* Montreal: Fides, 1978.

GALE, PEGGY, ed. *Video by Artists.* Toronto: Art Metropole, 1976.

GRAHAM, MAYO. *Some Canadian Women Artists.* Ottawa: National Gallery of Canada, 1975.

HALL, EDWIN S., JR., MARGARET B. BLACKMAN & VINCENT RICKARD. *Northwest Coast Indian Graphics.* Vancouver: Douglas & McIntyre, 1981.

HARPER, J. RUSSELL. *Painting in Canada: A History.* Toronto: University of Toronto Press, 1967, rev. ed. 1970.

HEATH, TERRENCE. *Uprooted: The Life and Art of Ernest Lindner.* Saskatoon: Fifth House, 1983.

The Inuit Print. Ottawa: National Museum of Man, 1977.

Jack Bush: A Retrospective. Toronto: Art Gallery of Ontario, 1976.

Jean-Paul Riopelle: peinture 1946–1977. Paris: Centre Georges Pompidou, 1981.

LEWIS, GLENN. *Bewilderness: The Origins of Paradise.* Vancouver: Vancouver Art Gallery, 1978.

LIPPARD, LUCY R. *Overlay: Contemporary Art and the Art of Prehistory.* New York: Pantheon. 1983.

Living Art Vancouver. Vancouver: Western Front/Pumps/Video Inn, 1980.

LORD, BARRY. *The History of Painting in Canada: Toward a People's Art.* Toronto: NC Press, 1974.

MACNAIR, PETER L., ALAN L. HOOVER & KENNETH NEARY. *The Legacy: Continuing Traditions of Canadian Northwest Coast Indian Art.* Victoria, B.C.: British Columbia Provincial Museum, 1980.

Michael Snow: Werke/Works 1969–1978, Filme/Films 1964-1976. Lucerne: Kunstmuseum Luzern, 1979.

MURRAY, JOAN, *Painters Eleven in Retrospect.* Oshawa, Ont.: Robert McLaughlin Gallery, 1979.

NASGAARD, ROALD. *Structures for Behaviour: New Sculptures by Robert Morris, David Rabinowitch, Richard Serra and George Trakas.* Toronto: Art Gallery of Ontario, 1978.

NASGAARD, ROALD. *Yves Gaucher: A Fifteen-Year Perspective, 1963–1978.* Toronto: Art Gallery of Ontario, 1979.

Parachute, 1975– . Published quarterly by Les Editions Parachute, Montreal.

Québec Underground, 1962–72. 3 vols. Montreal: Mediart, 1973.

REID, DENNIS. *A Concise History of Canadian Painting.* Toronto: Oxford University Press, 1973.

ROBERT, GUY. *L'Art au Québec depuis 1940.* Montreal: La Presse, 1977.

RUSSELL, JOHN. *The Meanings of Modern Art.* New York: Museum of Modern Art, 1981.

SCHNEIDER, PIERRE. *Riopelle: signes mêlés.* Paris: Maeght, 1972.

SHADBOLT, JACK. *In Search of Form.* Toronto: McClelland and Stewart, 1968.

SILCOX, DAVID P., & MERIKÉ WEILER. *Christopher Pratt.* Scarborough, Ont.: Prentice-Hall, 1982.

SINCLAIR, LISTER, & JACK POLLOCK. *The Art of Norval Morrisseau.* Toronto: Methuen, 1979.

SNOW, MICHAEL. *Cover to Cover.* Halifax: Nova Scotia College of Art and Design, 1975.

SWINTON, GEORGE. *Sculpture of the Eskimo.* Toronto: McClelland and Stewart, 1972.

THÉBERGE, PIERRE. *Greg Curnoe.* Montreal: Musée des beaux-arts de Montréal, 1982.

THÉBERGE, PIERRE. *Guido Molinari.* Ottawa: National Gallery of Canada, 1976.

TOMKINS, CALVIN. *The Bride and the Batchelors: Five Masters of the Avant-Garde.* New York: Viking Press, rev. ed. 1968. Reprinted London: Penguin Books, 1976.

TOWNSEND, WILLIAM, ed. *Canadian Art Today.* London: Studio International, 1970.

Vanguard, 1972– . Published nine times a year by the Vancouver Art Gallery Association, Vancouver.

WITHROW, WILLIAM. *Contemporary Canadian Painting.* Toronto: McClelland and Stewart, 1972.

WOLFE, TOM. *The Painted Word.* New York: Farrar, Strauss & Giroux, 1975.

WOODCOCK, GEORGE. *Ivan Eyre.* Don Mills, Ont.: Fitzhenry & Whiteside, 1981.

ZEMANS, JOYCE. *Jock Macdonald: The Inner Landscape.* Toronto: Art Gallery of Ontario, 1981.

FURTHER READING

Index

This index includes the names of all artists mentioned in the text, but the year of birth (and, where known, of death) is provided for Canadian artists only. Boldface numerals indicate illustrations.

Photographic Credits

ART GALLERY OF ONTARIO: Borduas, *Abstraction en bleu* (gift of Mr & Mrs S.J. Zacks, 1961); Favro, *Van Gogh's Room* (purchase, 1975); Rabinowitch, *Seven Left Limits* (purchase with assistance from Wintario, 1977).

ATTANYI COLOUR PHOTOGRAPHY LTD: Wiitasalo, *Expansive Expensive.*

IAIN BAXTER: Baxter, *Bagged Place.*

SUSAN CAMPBELL: Racine, *Salammbô.*

C. CATENAZZI, Art Gallery of Ontario: Lochhead, *Dark Green Centre* (gift from the McLean Foundation, 1965).

L.V. CAVE, National Gallery of Canada: Snow, *Lac clair.*

JAMES CHAMBERS, Art Gallery of Ontario: Frenkel, *Signs of a Plot;* Kiyooka, *Barometer #2* (gift from the McLean Foundation, 1964).

MELVIN CHARNEY: Charney, *Les Maisons de la rue Sherbrooke, Un Dictionnaire.*

TIM CLARK: Clark, *Letter One from Héloïse* (courtesy of *Parachute*).

COURTAULD INSTITUTE GALLERIES: Manet, *Un Bar aux Folies-Bergère.*

M. DE COURCY: DeCourcy, *Vancouver Background;* Gilbert & Lewis, *The Look;* Neil, Untitled performance.

RICHARD DESMARAIS: Janvier, *Nobody Understands Me.*

RENÉ T. DIONNE, Laurentian University: General Idea, *The Unveiling of the Cornucopia.*

ANDY FABO: Fabo, *Laocoön Revisited.*

C. FOX, Alberta College of Art: McKeough, *Defunct.*

GLENBOW MUSEUM: Fafard, *A Merchant of Pense;* Ferguson, *One Million Pennies.*

JIM GORMAN, Vancouver Art Gallery: Magor, *Four Boys and a Girl.*

DON HALL: Wyers, *These Good Old Thrashing Days.*

ROBERT KEZIERE: Lee-Nova, *Menthol Filter Kings;* Morris, *The Problem of Nothing;* Shadbolt, *Bride, Winter Poppies;* Smedley, *White Pleasure.*

E. LAZARE, Edmonton Art Gallery: Curnoe, *For Ben Bella* (Canada Council Director's Choice purchase, 1968); McKay, *Flux.*

GLENN LEWIS: Lewis, *Nine Mythological Steps in the Universal Garden;* Trasov et al, *Mr Peanut with Art Rat and Candy Man, Mr Peanut with the Brute Saxes.*

W. MC LENNAN, Museum of Anthropology, U.B.C.: Reid, *Raven and the First Men* (Walter & Marianne Koerner Collection).

AL MCWILLIAMS: McWilliams, *Rumination on a Set of Circumstances.*

ERNEST MAYER, Winnipeg Art Gallery: Ashevak, *Spirit* (a work acquired with funds from the Winnipeg Foundation.)

TREVOR MILLS: Snider, *Spar.*

THOMAS MOORE PHOTOGRAPHY, INC.: Bolduc, *Tamil;*
Borduas et al, *Refus global;* Boyle, *Midnight Oil;* Breeze, *The Home Viewer #4;* Burnett, *What Everyone Needs;* Carr-Harris, *A Demonstration;* Chambers, *Lombardo Avenue;* Comtois, *Colonne;* Coughtry, *Afternoon Lovers (for Pablo Neruda);* Ewen, *Forked Lightning, Moon over Tobermory;* Eyre, *Moos-O-Men, Valleyridge;* Fafard, *Don;* Falk, *Pieces of Water: El Salvador, Pieces of Water: Surplus Cheese;* Gagnon, *Inquisition FMRR;* Gaucher, *Vert 1;* Hall, *Long Island Sunset;* Hassan, *Desaparecidos;* Johnson, *Vacation #1;* Kurelek, *The Ukrainian Pioneer;* Lake, Untitled (Mephisto Waltz); Lewis, *Great Wall of 1984;* Macdonald, *Rust of Antiquity;* McEwen, *Espace minuté de jaune et mauve #3,* Mackenzie, *Lost River Series #1;* Meigs, *Burning Island;* Meredith, *Blue and Yellow;* Nakamura, *Infinite Waves;* Pratt, *Shop on an Island;* Proch, *Manitoba Mining Mask;* Rayner, *Persian Book;* Reitzenstein, *Quartz Dig;* Rogers, *Mondrian and the Prairie Landscape;* Ronald, *Gypsy, J'accuse;* Sawchuk, *New New Testament;* Scott, *Jobless, Feral;* Shadbolt, *Transformations II;* Smith, *West Coast M-5;* Steele, *The Gloria Tapes;* Tousignant, *Gong #36;* Town, *Park #1, Snap #101;* Werden, *Portrait of Eric Metcalfe as Dr Brute.*

MUSÉE DES BEAUX-ARTS DE MONTRÉAL: Borduas, *Les Yeux de cerise d'une nuit d'hiver;* Colville, *Church and Horse* (purchase, Horsley & Annie Townsend bequest and anonymous donor).

NATIONAL GALLERY OF CANADA: Bloore, *Painting #11;* E.J. Hughes, *Beach at Savary Island;* Lindner, *Uprooted;* Molinari, *Angle noir, Bi-sériel orange-vert;* Snow, *Rameau's Nephew.*

NATIONAL MUSEUM OF MAN: Odjig, *The Indian in Transition* (National Museums of Canada neg. S79-3831).

LARRY OSTROM, Art Gallery of Ontario: Bush, *Dazzle Red;* Favro, *Synthetic Lake;* Iskowitz, *Uplands B, Yzkor;* Kennedy, *Untitled* (AGO purchase with assistance from Wintario, 1978); Wieland, *The Water Quilt.*

EBERHARD E. OTTO: Cicansky et al, *The Grain Bin* (donated by the Saskatchewan Arts Board); Snow, *Authorization.*

SARNIA PUBLIC LIBRARY AND ART GALLERY: Binning, *Fanciful Seascape.*

SPOONER PHOTO ART: Stump, *The Pain of the Indian.*

GABOR SZILASI: Cohen, *An Extended and Continuous Metaphor #8;* Lynn Hughes, *Tourist;* Wainio, *The Age of Enlightenment.*

TORONTO DOMINION BANK: Borduas, *Sans titre.*

VANCOUVER ART GALLERY: Eric Metcalfe et al, *Pacific Vibrations.*

BILL VAZAN: Vazan, *Stone Maze, Worldline.*

JEFF WALL: Wall, *Picture for Women.*

HELENA WILSON: Frenkel, *Her Room in Paris.*

This book was designed by Robert Bringhurst

and set into type by West Graphika Limited, Vancouver,

using fonts supplied for the purpose by H. Berthold AG, Berlin.

Colour separation, platemaking and printing were performed

at Herzig Somerville Limited, Toronto. Both the trade edition

of ten thousand copies and the presentation edition of

one hundred were bound in Toronto at the Bryant Press.

The type is Pontifex, a face designed in the mid-1970s

by Friedrich Poppl, who died unexpectedly in Wiesbaden

while the initial planning for this book was underway.